HERITAGE FROM BELOW

Heritage, Culture and Identity

Series Editor: Brian Graham,
School of Environmental Sciences, University of Ulster, UK

Other titles in this series

Fortifications, Post-colonialism and Power
Ruins and Imperial Legacies
João Sarmento
ISBN 978 1 4094 0303 6

Towards World Heritage
International Origins of the Preservation Movement 1870–1930
Edited by Melanie Hall
ISBN 978 1 4094 0772 0

Selling EthniCity
Urban Cultural Politics in the Americas
Edited by Olaf Kaltmeier
ISBN 978 1 4094 1037 9

Local Heritage, Global Context
Cultural Perspectives on Sense of Place
Edited by John Schofield and Rosy Szymanski
ISBN 978 0 7546 7829 8

The Dynamics of Heritage
History, Memory and the Highland Clearances
Laurence Gouriévidis
ISBN 978 1 4094 0244 2

Landscape, Race and Memory
Material Ecologies of Citizenship
Divya Praful Tolia-Kelly
ISBN 978 0 7546 4957 1

Unquiet Pasts
Risk Society, Lived Cultural Heritage, Re-designing Reflexivity
Edited by Stephanie Koerner and Ian Russell
ISBN 978 0 7546 7548 8

Heritage from Below

Edited by

IAIN J.M. ROBERTSON
University of Gloucestershire, UK

ASHGATE

Published by
Ashgate Publishing Limited
Wey Court East
Union Road
Farnham
Surrey, GU9 7PT
England

Ashgate Publishing Company
Suite 420
101 Cherry Street
Burlington
VT 05401-4405
USA

www.ashgate.com

British Library Cataloguing in Publication Data
Heritage from below. -- (Heritage, culture and identity)
 1. Civilization--Philosophy. 2. Culture--Origin.
 I. Series II. Robertson, Iain J. M.
 306'.01-dc23

Library of Congress Cataloging-in-Publication Data
Robertson, Iain J. M.
 Heritage from below / by Iain J. M. Robertson.
 p. cm. -- (Heritage, culture and identity)
 Includes bibliographical references and index.
 ISBN 978-0-7546-7356-9 (hardback) -- ISBN 978-0-7546-9045-0
(ebook) 1. Culture. 2. Ethnicity. 3. Social values. 4. Identity
(Psychology) 5. Cultural property. I. Title.
 GN357.R64 2012
 306--dc23

2011040600

ISBN 9780754673569 (hbk)
ISBN 9780754690450 (ebk)

Printed and bound in Great Britain by the
MPG Books Group, UK.

Contents

Notes on Contributors

Piotr Bienkowski is a cultural, heritage and museums consultant, Honorary Professor in the School of Arts, Histories and Cultures at the University of Manchester, and Co-Director of the International Umm al-Biyara Project in Petra, Jordan. His current practice focuses on community participation in arts, culture and heritage, and the importance of intercultural dialogue and debate in fostering understanding and social cohesion. Previously he has been Acting Director of The Manchester Museum, Professor of Archaeology and Museology in the University of Manchester, and Head of Antiquities at National Museums Liverpool. His background is in Near Eastern archaeology, and for 30 years he has been researching and excavating in the southern Levant, particularly Jordan, on which he has published a dozen books and over a hundred papers. A key research focus in recent years has been the ethics, decision-making and involvement of interested communities around human remains in archaeology and museums, and more generally on the issue of authority and knowledge in archaeology and museums and how heritage institutions can share authority and decision-making with communities working within different paradigms of knowledge.

Roy Jones is Professor of Geography, Dean of Research and Graduate Studies and Co-Director of the Sustainable Tourism Centre at Curtin University in Perth, Western Australia, where he has worked since 1970. He is an historical geographer with research interests in rural change, heritage and tourism. From 2001–2009, he was Human Geography Editor of *Geographical Research; Journal of the Institute of Australian Geographers.*

Catriona M.M. Macdonald is Reader in Late Modern Scottish History at the University of Glasgow. Her research interests lie in the social, cultural and political history of modern Scotland, and the research from which her chapter emerged was funded by the Carnegie Trust for the Universities of Scotland. Dr Macdonald's principal publications include *Whaur Extremes Meet: Scotland's Twentieth Century* (2009), which won the Saltire Society's History Book of the Year Award in 2010; *The Radical Thread: Political Change in Scotland, 1885–1924; Unionist Scotland* (1998) and (with E.W. McFarland) *Scotland and the Great War* (1999).

Brian S. Osborne is Professor Emeritus of Geography at Queen's University, Kingston, Ontario, Canada, where he has taught since 1967. His research has addressed aboriginal history, evolving landscapes, and the role of the 'culture of communications' in the development of a Canadian sense of place. Professor

Osborne's current research examines how the symbolic representation of people and place through constructed narratives, monumentalism, and performed commemoration contribute to the construction of identities. This also relates to the role of the commodification of heritage and culture in post-industrial societies, and the impact of tourism as both an economic opportunity and a threat to sustainable communities.

Dave Reeves is a freelance writer and public historian. He founded *The Moving Finger*, a peripatetic community publishing company in 1988. Working with communities and local authority departments he has edited and published over 40 books of community writing, reminiscence and oral history. In 2006 he created *Ballads for Bomere Heath*, a collection of written and recorded poems based upon oral histories from a parish in Shropshire, commissioned to involve both long-term residents and incomers in the heritage of the area and the creation of a Parish Plan for the future. It was published as a CD-ROM and can also be accessed at <http://www.bomereheathballads.co.uk/>. His latest publication, *Grounds for Improvement*, is a DVD/exhibition using oral history from two former mental institutions in Walsall with poems acting as commentary. He is a partner in, and presenter for, the online literary radio station *Radio Wildfire* <www.radiowildfire. com>.

Alan Rice is Reader in American Cultural Studies at the University of Central Lancashire. He is interested in the workings of transnational subaltern memory and in the memorials, physical, artistic and conceptual that African Atlantic peoples have constructed on three continents over three centuries. This research includes work on literature, visuals arts, gravesites, memorials and museums and some of it appeared in his first monograph *Radical Narratives of the Black Atlantic* (Continuum, 2003). Alan has acted as an advisor to museums in Liverpool, Lancaster and Manchester and has been involved as a public academic on the *Slave Trade Arts Memorial Project* in Lancaster. He has also given public lectures and keynote presentations in Britain, Germany, the United State and France and contributed to documentaries for the BBC, Border Television and public broadcasting in America. His latest publication, *Creating Memorials, Building Identities: The Politics of memory in the Black Atlantic* has just been published by Liverpool University Press.

Iain J.M. Robertson is Senior Lecturer in history at the University of Gloucestershire. His work on *Heritage From Below* brings together his two key research interests: that of the study of the varying ways the past is put to use in the present and histories of collective action and protest. The physical meeting point of these two strands is the Cuimhneachain Nan Gaisgeach memorials on the isle of Lewis in the Outer Hebrides. Iain has published widely on both research strands and was also the co-editor (with Penny Richards) of *Studying Cultural Landscapes* (Ashgate, 2003).

Graham Seal is the author of a number of books and articles on bushrangers, badmen, highwaymen and other outlaw heroes, including *The Outlaw Legend: A Cultural Tradition in Britain, America and Australia* (Cambridge University Press, 1996). He is Professor of Folklore and Director of the Centre for Advanced Studies in Australia, Asia and the Pacific at Curtin University, Perth, Western Australia.

H. John Selwood is a Senior Scholar was formerly Professor of Geography at the University of Winnipeg and now holds an Honorary Research Fellowship at the University of Western Australia. After qualifying as a planner in Canada, he completed a PhD in Geography at the University of Western Australia and has regularly returned there to conduct research on a range of rural and regional development topics in addition to undertaking comparable studies in the Prairie provinces of Canada.

Gunhild Setten is as Associate Professor at the Department of Geography, Norwegian University of Science and Technology, Trondheim. She has broadly studied agricultural practices and identities, cultural heritage and landscapes, as well as undertaken research on conceptual practices within human geography with a particular focus on 'landscape' and 'place'. Her work has been published in journals such as *Cultural Geographies, Geoforum, Norwegian Journal of Geography, Environment and Planning A* and *Geografiska Annaler*.

Elisabeth Skinner became interested in local history when studying for a degree with the Open University in the late 1970s. With a passion for the village where she had lived from the age of three, in 1981 she inspired the setting up of a very successful village history society and began working with others to build the village archive. She gave several series of evening classes on the history of Sheepscombe which she then turned into the first draft of a book. The book laid gathering dust for 20 years while Elisabeth got to grips with a new career teaching community governance at the University of Gloucestershire. She picked up the draft again in 1997 and finally published the book *Sheepscombe: One Thousand Years in this Gloucestershire Valley* in 2005.

Acknowledgements

Heritage from Below is a concept I've been working with for some time now. Something of this has been formulated in the course of my research work into the memorials to nineteenth and twentieth-century land disturbances erected by Cuimhneachain Nan Gaisgeach on the isle of Lewis in the Outer Hebrides in the early 1990s. Much of it however, has emerged from the many stimulating conversations I have had with students on the (now sadly defunct) Heritage Management degree course at the University of Gloucestershire. I would like to thank them all for being the most enthusiastic, engaged and stimulating group of students it has ever been my privilege to engage with. I'd also like to acknowledge the key role played by my colleague, Richard Harper, in the development of the Heritage Management degree and its students. This book would not have seen the light of day without them. (Iain J.M. Robertson)

Dave Reeves would like to acknowledge Dr Hilda Kean and the organisers of the national Public History Conference 2007: Radical & Popular Pasts, held at Ruskin College Oxford, for the opportunity to present the paper 'News that Remains News: Pasts that Remain Present' which culminated with the poem *Why We Need To Keep Digging*.

Brain S. Osborne wishes to acknowledge and thank Dr Jason Kovaks for his continued interaction with me on matters of commemoration, and my son, Gavin T. Osborne, for sharing with me our discovery of Reesor and our forays into labour history.

Roy Jones would like to thank Associate Professor Bobbie Oliver for advice on the Fremantle wharfies chapter.

Gunhild Setten is greatly indebted to those who let her into their houses and homes. She also wishes to thank Iain Robertson for his constructive suggestions throughout the process of finishing the chapter.

Elisabeth Skinner is grateful for the use of the Sheepscombe History Society archive and acknowledges the contributions of members of the Society to her chapter.

For Andrea, Elizabeth and Katherine Robertson

and

Mona Robertson

Introduction: Heritage from Below

Iain J.M. Robertson

I think in a community like this your sense of identity, your sense of culture is the only thing that keeps you here.

Q: And what gives you that sense of identity and culture?

The ground does, absolutely nothing else. I walk down the croft which has been in our family since the sixteenth-century and even as a young girl I used to walk down the croft and think if only everybody, I mean it was home, it was always home to me its still home to me, um, if every single person who ever called this home could come back and stand shoulder to shoulder on this croft how far would they span? – A long way aye – Its the same ground I'm tilling today to plant potatoes and its the same ground they tilled, same footsteps, same places. *[pause]* It gives you a very strong sense of yourself and who you are and where you come from. There's nothing worse than having that vacuum in your life … [Land] is the only thing that keeps us clinging on by our fingernails to these rocks, these windy rocks.[1]

Heritage is about more than visitors, audience and consumption. It is about more than access to economic resources. It is about people, collectivity and individuals, and about their sense of inheritance from the past and the uses to which this sense of inheritance is put. It is about the possibilities that result from that deployment of the past. The idea of heritage from below rests on these and on the realisation that, whilst the economic realm cannot be wholly separated from heritage, there exist uses of the past in the present that are only minimally related to the economic and that such uses can function as cultural resources for counter hegemonic expressions. The origins of this volume lie in the realisation that these factors and processes have not always been captured by, and have only ever been partially discussed in the academic literature, seduced, more often than not, by the nationalist, top-down, commercial and tourism-focussed perspectives of the mainstream manifestations of heritage that together constitute a hegemonic discourse. This collection explicitly aims to move beyond and reject this discourse.

There is a two-fold purpose to this opening chapter. In part the intention is to address the lacuna just identified, although since this is also the major aim of the remaining contributions to this book discussion here will be necessarily

1 Interview, *Marissa Macdonald*, Lewis, 6 April 1998.

attenuated. Second, the intention is to essay a few lines by way of introduction to the individual chapters. This, however, will also be brief as the view taken here is that the most effective introductory remarks are those which set the contexts for the individual chapters for it is this which forms the link between otherwise interestingly divergent case studies. Each chapter is united in the realisation of the relative absence of engagement with heritage from below rather than from above and in the possibilities offered by expressions of heritage from below. Although, in order to quell from the very outset accusations of naivety, it needs to be clearly stated that manifestations (and even less so the success) of the more radical possibilities are rare and utilisation of heritage in the ways suggested here, more often than not remain latent. But, as Bienkowski, Jones, Osborne, and Rice all demonstrate in this volume, anti-hegemonic possibilities do exist and exist as resources for expressions of identity and ways of life that run counter to the dominant.

Encapsulated in the opening quotation is this essence of heritage from below. Here is a claim to a way of life based on past practises that embody a nexus of interconnections between identity, collective memory and sense of place made meaning *full* by landscape. This sense of place identity does and did come from access to land and from a particular view of landscape but, crucially, it is a landscape of activity: embodying an assertion of the right to work the same land as that worked by past generations. Articulated here, then, is a current way of life made more meaningful by a sense of inheritance from the past. It is, centrally and critically, a sense of inheritance that does not seek to attract an audience. Rather, it is an expression of, and draws on the ordinary and quotidian that, furthermore, is underscored by embodied practice: '... the same ground I'm tilling today to plant potatoes ... same footsteps, same places'.[2] The heritage from below expressed here is an assertion of a right to dwell: an engagement with and expression of landscape as an enduring record of the lives and works of past and present generations who have dwelt within it. Landscape made meaning full by the tasks performed in it.[3] More than that, however, the sense of inheritance represented in the crofting way of life (as articulated here) is also an assertion of counter hegemonic expressions. Social conflict in the Scottish Highlands in the late nineteenth and early twentieth centuries centred on attempts to re-assert and expand the crofting tenantry's access to land that had been previously denied to them. As discussed elsewhere (Robertson 2005, 2008), the successful maintenance of the crofting form of agriculture through acts of social protest has been commemorated and therefore claimed as

2 Ibid.

3 In this I am drawing in particular on the work of Tim Ingold (1993, 1995, 2000), the crux of which (owing a considerable debt to Heidegger's notion of dwelling) is that it is always contextualised lived practises, principally but not exclusively work tasks, that create spaces, places and landscapes. For the deployment of Ingold's conceptualisation in spatial and heritage studies see, for example, Cloke and Jones (2001), Crouch and Parker (2003), Holloway (2003), Wylie (2005) and Halfacree (2007).

heritage (from below) throughout the Hebrides. In that the interviewee quoted above is an active crofter who validates her day-to-day activities by reference to an inheritance from the past, and in that she took a significant role in the creation of monuments to social protest on the Hebridean island of Lewis she directly links both senses of articulation associated with heritage from below outlined here.

As a concept and a category which has seldom been discussed hitherto, heritage from below draws on (and is apparent in) certain forms of heritage practice. In attempting to broaden and deepen discussions around the 'work' that heritage can do, this chapter and this book are both informed by recent developments in the social sciences, and are firmly based on key perspectives within heritage studies. The intention here, then, is to engage with and explicate something of this concept and this category (see also Robertson 2008) and to introduce what follows. More than that, however, these introductory remarks seek to establish the important context upon which the chapters of this collection are based.

From Early Days to Heritage as Process

The story of the study of heritage is generally very well known and need not long detain us here. Key early texts came from Lowenthal (1985, 1988), Wright (1985) and Hewison (1987) and all may be said to have taken a broadly pessimistic perspective on the twentieth century turn to the commercial, consumption orientated heritage already outlined and which has been best captured by Hewison (1987). The concept of a 'heritage industry' was his and this inevitably lead him to argue that 'instead of manufacturing goods, we are manufacturing *heritage* [his italics], a commodity nobody seems able to define, but which everybody is eager to sell'. Moreover, in this commodification 'the heritage industry … draws a screen between ourselves and our true past [and stifles] … the culture of the present' (Hewison 1987: 9–10).

A robust and convincing rebuff to this pessimistic viewpoint came initially from Raphael Samuel (1994). Firmly placing himself in a tradition that can at least be traced back to the editorial for the first edition of the *History Workshop Journal* (Editorial Collective 1976), Samuel's understanding of the rise of heritage was firmly couched as an attack on 'history' as practiced in the academy. This, he believed had become far too narrow which had then led to 'inbreeding; introspection; sectarianism' (Samuel 1994: 3). Knowledge had become locked up in professional academic circuits and thus became the preserve of the oligarchic few. His views appear to have changed little from those expressed in the earlier editorial in which it was openly stated that the intention behind the long-term objectives of the *History Workshop Journal* was to bring the profession of history much more closely into alignment with people's lives, in order to escape from the limiting effects of the fact that 'the great bulk of historical writing is never intended to be read outside the ranks of the profession' (Editorial Collective 1976: 1). The collective further believed that the boundaries between teaching

and research needed to be dissolved and that both should be utilised for wider social purposes. In *Theatres of Memory* (1994), however, Samuel offers a more proactive, deeply worked through antidote. Here he called for the recognition of the ghosts in the history writing machine, by which he meant expressed the need for equal weight to be given to popular memory and advocated the democratising power that would be released 'if history was thought of as an activity rather than a profession' (1994: 17). In all of this, heritage becomes central.

Samuel's argument, and (somewhat ironically) it was pivotal in the development of the academic exploration of heritage, was that the rise of a much more broadly defined heritage – culturally more pluralist and radically different from previously hegemonic versions – was an effective counterblast to the elitism of 'history'; drawing as it (heritage) does on a much wider range of 'unofficial knowledge' (1994: 3–50) that receives at best grudging acknowledgement from the practitioners of 'real history'. These unofficial forms of knowledge range from the oral tradition, through children's theatricals to the set-piece historical debates, and reveal history to be a 'social form of knowledge' grounded in an 'ensemble of activities and practices' (1994: 5–11). From this, heritage, promulgating an 'inconceivably more democratic' version of Englishness than any previously enacted and which the 'heritage baiters allow' (1994: 160–163 and 259–271), is seen to emphasise the 'spirit of local places' and the 'little platoons' rather than 'great society' (Samuel 1994: 158). This proved to be an inspirational polemic. And, while we may now criticise Samuels' vision for being too monocular, there is no denying the power of his analysis, nor the possibilities that it opened up. Here we find the foundations upon which the hugely important Public History MA programme at Ruskin College, Oxford, was built. Established by Hilda Kean in October 1996 (sadly after the death of Raphael Samuel) this both drew on and then produced the history of the 'little platoons' that is understood in this volume as heritage from below. Furthermore, the MA programme also released and realised something of the practical (non-academic) counter-hegemonic possibilities embraced by this present work.

This, however, was something not fully articulated by Samuels' work on heritage and, with the benefit of hindsight, it is possible to see that what these early discussions amounted to was the creation of the first important dualism within heritage studies: between the optimistic and pessimistic camps, although it must be conceded that this is a rather crudely drawn summary of a much more nuanced academic argument. This notwithstanding, commentators have come to realise that the binary opposition alluded to here is a rather crude representation of the way in which the past is experienced and consumed in the present.

The notion of consumption is central to the second major dualism that is present within the study of heritage: the realisation that the past in the present exists as both 'a cultural and an economic good' (Graham, Ashworth and Tunbridge 2000: 5). Here too, whilst there may be significant elements of conflict between these two realms, it is important to stress that this dualism does not operate wholly conflictually since both feed off and interact with each other. Nevertheless, as

Dicks asserts (following Jacobs 1994), the danger with this dualistic perspective, privileging one over the other in our discussions, is that it risks underplaying the extent to which 'the economic and cultural are bound up together' (2000: 66). To overcome such problems, Dicks suggest that we should redirect our deployment of polarities in heritage representations towards those between the local and particular and the general and generic. This would appear to be the more satisfying approach not least because it highlights the need at any heritage site for 'visitor-friendly accessible and affirmative stories' coupled with 'locally recognisable particular historical accounts' (Dicks 2000: 66).

Here, however, Dicks ventures into the territory of another vital heritage concept – that of dissonance (Tunbridge and Ashworth 1996) – without ever fully engaging with it. This may well have been the consequence of her mistaken belief that the existence of dissonance within our heritage representations has been so widely recognised and discussed that it is enough to simply acknowledge its omnipresence. To do this, however, is to veer towards lazy thinking. The very fact of its omnipresence, as much in representations of heritage from below as in any other presentation of the past in the present, demands discussion.

At the most basic level dissonance is equated with the recognition of conflict and contestation within every heritage representation; between and within all spatial scales and collective identities. This is an understanding that was accepted relatively early in studies of the deployment of the past in the present. It has proved to be an important point of departure for many subsequent discussions and has been shown to underlie even the most local of heritage representations[4]. As our understanding developed problems inherent in this polyvocality of heritage and in this contestation over past resources became easily visible, particularly as they related to key questions of social identity, the relationship between local history and wider political consciousness, and between local and proto-national identifications. These are made apparent in a number of key works, not least in Crooke's (2005) study of heritage-based community activity in Northern Ireland and in Morrissey's (2005: 71) study of a 'marginalised and largely erased from public memory' aspect of British colonialism in Ireland. The focus here is on the Connaught Rangers, one of a number of Irish regiments that served in the British Army between the eighteenth and early twentieth centuries. Morrissey explores the impact of the First World War on the regiment and on the 'different heritage' that this represents and suggests that an opportunity has been missed to add an additional layer of complexity to 'the multiple "heritages" of Ireland and indeed Irish nationalism' (2005: 83). This missed opportunity, signified by the fact that the major heritage centre in the region fails to engage fully with this aspect of the regiment's past, is the result of the limiting and constraining forces that we conceptualise as dissonance. The consequence of this is that the potential to embrace the 'inclusiveness to which we all aspire' (Montague 1989 quoted in Morrissey 2005: 82) can only remain latent.

4 See, for instance, Hall and Robertson (2006).

Discussions around proto-national identities such as we have just encountered point to two key aspects in the early discussions around the nature and implications of heritage. In terms of the spatial scale at which such representations have been made, the focus has been firmly on the role of heritage in identity establishment and maintenance at the national level. Unfortunately this has meant that, until comparatively recently, discussion of the manifestations of heritage at the local scale has been somewhat superficial despite the fact that it is in the local context that the relationship between heritage and identity establishment and maintenance is often most meaningful. One example of this is the comparatively brief treatment by Graham, Ashworth and Tunbridge of the relationship between heritage and local identity notwithstanding the title and central aim of their book: 'to trace and explain the relationships between heritage and geography' (2000: 1). Further, this primary focus on national identity has been paralleled by the interrogation of heritage as a social and cultural process at that scale. For Dicks (2007) this has been one of the most significant developments in the field and yet she believes (2000: 67) it is an approach which shares the weaknesses of the much criticised 'cultural effects model'. Consequently, Dicks asserts, within cultural and media studies, attention has switched to the view of the audience as able to 'decode and reinterpret media discourse' (2000: 67). This is certainly an approach that has entered the heritage literature (see, for example, Bagnall 2003); nevertheless the earlier 'heritage as representation' approach has proved resilient. Beginning with Greg Ashworth (1998) manifestations of the past in the present came to be understood as social and cultural constructs in which the power to make the interpretation is a privileged one held within dominant social groups. It is further argued that such groups capture the necessary cultural capital, of which the past as heritage is a vital part, in order to validate their hold on power. The past, socially and culturally constructed, is being put to use to serve the interests of the hegemonic group.

It is the work of Laurajane Smith, however, that has been key to the move of the heritage debate towards the ground identified by Dicks. Smith's work is both deeply rooted in the perspective just outlined but she is also commendably alive to new ways of thinking. Widely cited (see for instance the many citations in the recent *Ashgate Research Companion to Heritage and Identity*, Graham and Howard 2008) Smith's major contribution (2006) has been the thorough evisceration of what she terms the Authorised Heritage Discourse. This is a significant thesis and one of its strengths is that it provides a measure by which examples of heritage management can be unpacked and the socio-cultural work that heritage does can be better understood. Moreover, in stressing the fluidity of both heritage and identity, Smith argues strongly for the understanding of heritage as 'something vital and alive … a moment of action' (2006: 83). Smith's thesis, therefore, is a significant advance and one which allows us ways of understanding the processual and active nature of the heritage experience.

This developing trend is a consequence, in part at least, of the somewhat belated attempts to conceptualise the significant and long established shift within heritage

practice towards 'democratisation'. Taking inspiration from, and running roughly congruent with the rise of history from below (in which Samuel was instrumental and an obvious link between the two), this shift towards 'vernacular heritage' has had an impact on heritage practice that is not always reflected in the academic literature. This is a sentiment seemingly shared by Paul Ashton and Hilda Kean (2008). Taking the view from academic history, Ashton and Kean address what we might see as a vernacular and collaborative history that is both participatory and recognizing of the fact that ordinary people are active agents in the creation of their own history. Linked to wider processes of cultural de-differentiation, and of the democratisation of the 'tourist gaze', vernacular heritage addresses the ordinary and the everyday in order to 'offer "ordinary people now" the chance to encounter "ordinary people then"' (Dicks 2000: 37). Thus, the vernacular heritage encounter can now embrace 'the most parochial and quotidian of local lifestyles' in a form that need not be confined to the folk museum. Indeed, even erstwhile 'auratic' (Dicks 2000: 39) and rural heritage sites work with the vernacular approach although this approach remains a particular emphasis industrial heritage.

The work assembled here is underpinned by the belief that, whilst this focus on the industrial is understandable, it is the nature of the heritage 'offer' that is focused on in these representations and in our commentaries that should be questioned because of the narrow range of vernacular heritages that are conventionally addressed. It is a central argument of this collection that vernacular heritage can be found in a diverse and powerful range of fora. Catriona Macdonald, for instance, locates the vernacular in the carnivalesque language of rights, values and traditions deployed by students in Scottish Universities. In so doing Macdonald addresses important questions over the very presumptions underpinning the discipline and its theoretical approaches; most notably the idea of heritage as a dynamic process. This allows her to engage with discussions that are at the heart of this book. Heritage is formulated from much more than the material realm. It is found and articulated through our rhetoric, spaces and performances. It is, critically, bound up in power relations and in hegemonic discourses. Heritage from below is both a means to and manifestation of counter hegemonic practises. And one of the most important, dynamic and powerful expression of such practices is to be found in the opening chapter of this volume. Here Piotr Bienkowski reads off archaeological and animist knowledge in the debate surrounding the treatment of the dead human body. He suggests that, dating from the European Enlightenment, the human remains discourse has been based on a hegemonic world-view which sees the dead body objectively as depersonalised evidence, as a 'thing' to be excavated, analysed and displayed. As post-colonial archaeology across the world increasingly interfaces with crucial social and political issues – repatriation, requests for reburial, human rights missions, genocide and exhumation of the recently dead – archaeologists are coming into conflict and developing working relationships with individuals and communities holding a range of divergent beliefs about the nature of death and the dead body. Bienkowski further argues that the world-view implicit in archaeology and archaeological exhumation (which

wields huge institutional, scientific and cultural authority) can and does conflict with alternative world-views (the alternative 'heritage from below') which often operate on a local, community level – focusing particularly on animist world-views in which the dead retain personhood. He concludes with an important reminder that all relationships with the past are fraught with tension.

The turn to vernacular heritage practice undoubtedly opens the way for expressions of heritage from below, but, to a lesser extent within practice and to a greater extent within the conceptualisation of this turn, the possibility of heritage as a force for democratisation and as a progenitor of social change has been embraced less readily. The most potent failure lies in the fact that, in their case studies, most commentators draw on essentially commercialised sites although there is the occasional notable exception. Atkinson (2008), for instance, argues that a key role in this potential for democratisation is played by heritage trails and sound walks (one of the most celebrated of these is *Memoryscape* – see Butler n.d.). If done well these offer an understanding of the lives that once animated places and spaces and a more open and accessible form of heritage. Taking this further, whilst he is careful to acknowledge the problems associated with the practice of memory that heritage undertakes, Atkinson believes that emergent ways of conceptualising this memory work, in particular the fluidity written into this thinking, may well prove more resilient than earlier norms. And, making full use of the liquid metaphor, he argues for a sense of memory 'that ebbs and flows around society and ... wells up in all kinds of places. ... It may seep from strange unexpected niches and artefacts, or it may deluge from sudden events – like heritage fairs, festivals or re-enactments'. Whatever form it takes, 'if we conceptualise social memory as this continuous, ebbing presence, we can begin to study it wherever it is produced' (Atkinson 2008: 388–389).

Atkinson's work, then, offers the possibility of the creation of contesting voices that produce a more resonant and inclusive set of social memories. As already noted, however, this approach is not unproblematic. In common with Nash (2000), one of Atkinson's foci here is the 1996 Festival of the Sea in Bristol. In particular he explores the interventions of local community groups, activists and artists in the politics of this festival and suggests, in yet another demonstration of the ubiquity of the concept, that what can be seen in this is the impact of 'dissonant heritages' (Atkinson 2008: 385). For Atkinson this is a more active form of dissonance than that allowed by Tunbridge and Ashworth (1996) and there is merit to this perspective; summarising and reinforcing, as it does, the position of others in the fluid and dynamic nature of social memory – always in the making. It is unfortunate, however, that he chooses to situate his perspective within the frame of dissonant heritage since this proves too restrictive and passive for his more dynamic conceptualisation. Dissonance is a presence in all manifestations of heritage, and social memories can be both dissonant and present an active challenge to the dominant discourse but are not intrinsically dissonant in the way that dissonance is intrinsic to heritage. To avoid confusion and conflation it

would have been perhaps better to have chosen a label that made this important distinction clearer.

This notwithstanding, Atkinson's emphasis on the fluidity of social memory, on the consequent democratisation challenge to heritage, and the focus on the everyday (see below), is of considerable significance. In bringing all of this together he is not only building on the tentative steps first taken by Dicks (2000) and Smith (2003) but is also drawing key recent debates in the social sciences into heritage studies and in far greater depth. It is of equal significance, however, that Atkinson entered into this debate in the belief that much work in this area remains somewhat limited and does not fully reflect heritage practice. Howard (2009), on the other hand, argues that it is this practice that is itself an issue. His view is that such has been the proliferation and diversification of heritage following the democratising turn to 'vernacular heritage', that there is now a 'surfeit' of the past. Furthermore, he believes that the museum's old hegemonic and positivist stance was more robust than the current empathetic and constructivist approach which is open to 'national or tribalist aims' and which is in danger of embracing 'the generalised politics of memory'. The consequence of this, Howard feels, is an undermining of both 'historical understanding' (the nature of which is never fully discussed) and the museum as 'reliable vehicle of public illumination' (2009: 29). This is a provocative stance and one in which Howard fails to specify which public he had in mind, for if heritage representations tell us anything it is that some "publics" are inevitably excluded. For Buciek and Juul (2008), for instance, only rarely has the role of immigrants in local heritage representations been subject to scrutiny. In their welcome effort to do just that Buciek and Juul explore the 'contribution of immigrants to the nation-building process' (107) in Denmark. What their case studies show is the invisibility of a heritage of immigration and the subsuming of immigrant narratives to the master narrative of Danishness. Drawing on their discussion of the town of Frederiksværk, however, Buciek and Juul reveal minor-key markers and mnemonics of historical presence that cut across the grain of this master narrative. These include the Serbian social club and the shopping mall, but most importantly, the private house. And here Buciek and Juul reveal a dualism that mirrors and underscores that of their narratives of identity. Outwardly the house is deliberately non-distinctive and stands as symbol of integration. Inwardly it is the artefacts within the home that are key. Photographs; pictures; shrines often acquire a sacred character and serve to mediate between their owner's individuality and their social and cultural integration. As such, and as a reminder of the 'pre-Diaspora' self (Buciek and Juul 2008: 113, quoting Povrzanovic Frykman), the house becomes the 'real', albeit hidden, heritage. This leads Buciek and Juul to argue for the concept of 'monuments of distance' (115) that act as expressions of the heritage of excluded groups and as mnemonics of movement, of the journey, both to and from the host nation and which are, consequently and inescapably from below.

Houses, quotidian and vernacular, and the artefactual memories they embody, are one of the most important loci for the performing of heritage from below. It is

entirely appropriate, therefore, that the house as locus for and means of negotiating the dialogue between personal and communal heritage is a focus of Setten's chapter in this volume. Here Setten raises a question that resonates throughout heritage discourse: who owns heritage? In this instance this involves 'analyzing how a traditional house type *becomes* heritage by being *defined* as heritage, and how owners and residents juggle their private ownership and the moral claims on their house made by the larger public' (Setten, this volume, emphasis added). A different, but no less powerful manifestation of the house as locus for heritage from below is found in the chanter by Jones and Selwood. Focusing on a range of Western Australian coastal sites, this chapter begins from the premise that the beach and coast have played a central role in Australian iconography for more than a century. As the population became increasingly mobile and travel to isolated and scenic coastal sites became easier, families, and sometimes larger groups, would journey from the cities and from inland farming areas to favoured bays and beaches where they would either camp or erect basic shelters. These then became the sites of quintessentially Australian holiday experiences. These informal and sometimes illegal settlements and camp sites are now under threat, both from more mainstream coastal urban and tourism developments and from the more widespread application of standardised building, planning and environmental management regulations. For many of the campers and 'shackies', who may have been visiting the same sites for generations, this threat is not merely to their holiday experience and to simple building structures, but to their way of life and even their heritage. This heritage, Jones and Selwood argue, is quintessentially 'from below' in that the 'shackies' see theirs as a carnivalesque existence. They occupy a physically and culturally marginal space that is outside the mainstream and hegemonic and resonant of Hardy and Ward's (1984: 33) English plotlanders where 'on the one side were people of modest means defending pathetic homes on land that none had previously wanted in any case; and on the other a bureaucratic machine without compassion, growing with every new bye-law and parliamentary clause'.

In both the Norwegian and Australian case studies, then, and, indeed, this book as a whole, we look to a heritage that eschews the commercial in favour of the (often counter-hegemonically) cultural. To engage with a sense of heritage from below, then, is to seek to push the heritage meaning debate further along. That debate has progressed far beyond the crude foundational optimistic/pessimistic dualisms and yet it remains underdeveloped in certain vital areas. There exists a layer and expression of heritage, tangible or (often) intangible, that offers the possibility (only rarely fully realised and then inevitably shot through with dissonance) of alternative constructions of the past to that of the hegemonic. These counter hegemonic landmarks can be written into the landscape in support and expression of certain local identities and thereby both galvanise and cohere local communities around alternative constructions of identity and narratives of place. As heritage from below, such landmarks can celebrate, perpetuate and make material oppositional meanings and practices. This then provides the opportunity (seldom taken) to celebrate and memorialise *from within* the lives and thoughts

of those otherwise hidden from history. Heritage from below, then, acts as both an analytical category and a practice; recognised as both an opportunity for the expression of *other* heritages and identities, and a possibility for the assertion of a structure of feeling that runs counter to the hegemonic.

The idea that heritage can be conflictual and contested is not a new or original claim (see, for instance, Ashworth and Larkham 1994, Tunbridge and Ashworth 1996, Graham, Ashworth and Tunbridge 2000). But too often the context within which we investigate this contestation and conflict remains firmly that of the dominant (heritage) discourse. The argument here is that there is a layer of heritage contestation that takes place in the face (and outside the material manifestations of) that dominance and as a challenge to the hegemony of that discourse. This is a layer of contestation that has too often passed unnoticed in the academic literature and which blurs the dualisms (optimistic/pessimistic; authorised/subaltern) that continue to adhere to the contestation we see as intrinsic to any manifestation of heritage.

An excellent example of this is provided by Pendlebury, Townsend and Gilroy (2009) in their discussion of the heritage listing of the Byker welfare-state housing estate in Newcastle upon Tyne (England). This, they assert, only superficially fits with the too-easy dualism of Smith's authorised/subaltern forms of heritage discourse, whilst a deeper reading reveals a more nuanced understanding. UK legislation meant that the estate could only be listed for its 'architectural or historical interest' (Pendlebury, Townsend and Gilroy 2009: 193) but this was not the reason why Byker residents valued the estate as heritage. Their values spoke more to 'issues of time and attachment to place, community kinship and propinquity and the qualities of place in terms of the Erskine design and housing stock' (195). Key here, therefore, was the absence in the formal listing of descriptions of the role of community and of the qualities and values expressed by that community. And here, once again the question of 'ownership' is raised. Listing, as a 'highly bureaucratic top-down process' (198), tends to take the ownership of conservation out of the hands of those whose environment is being conserved. And yet, as with Setten's study (this volume) of the *jærhus* in Norway, there was no simple dialectic authorised/subaltern process at play in Byker. Listing did not have the consequence of the rejection of conservation from within the community; rather it offered the possibility of acting as a rhetorical conduit for communal values and memories that we might here recognise as expressions of heritage from below. For Pendlebury, Townsend and Gilroy, therefore, the fact that UK legislation only permitted a rather exclusionary set of criteria 'did not mean that discourse about the history of Byker is entirely controlled by an externally imposed Authorised Heritage Discourse nor that listing has no local relevance' (2009: 199). They recognise instead a more nuanced narrative in which insiders were able to actively mediate the heritage professionals' dominant discursive perspective.

These concerns notwithstanding Smith's conceptualisation of the dissenting perspective in the form of 'subaltern heritage' (2006: 35) is a powerful concept that opens the way for understanding our engagement of the past as an active,

emotional and embodied process (see below) that, as with the Byker example, subtly re-works the heritage space as it re-works the heritage visitor. Here Smith usefully extends these subaltern discourses not only to groups such as the Black Environmental Network but also to non-material and intangible forms of heritage. There are, however, important limits to this concept. These are apparent in Smith's case studies[5] which, as important as they are, are confined to traditional representations of the heritage discourse. Heritage from below encourages a broader perspective and, as the chapters in this volume make clear, reconfiguring subaltern heritage as heritage from below is both a re-working of the power possibilities inherent in heritage and a more resonant re-working of the positive form such dissenting expressions can take.

Something of the same criticisms can also be levelled at Dicks' (1996, 2000) attempt to capture and conceptualise the ways in which visitors can undercut the dominant representations at industrial social history museums. In a wide-ranging discussion that draws on the Rhondda Heritage Park as a case study, Dicks focuses on many different facets of the creation of the park but the most significant of these for the present study is her exploration of the local structures of feeling in relation to the park. Here attention is drawn to memorialism – defined as an essentially local discourse of heritage.

The Rhondda Heritage Park appears to have begun as an essentially local, non-professional project to turn a recently closed mine into a museum. In ambition it was very similar to that of the majority of volunteer run museums[6] for whom the audience was essentially composed of insiders. The intention was to seize the heritage agenda and force the local authority to 'recognise the ordinary, lived histories of the locality' (Dicks 2000: 153). For Dicks, this is memorialism in operation. It is about local testimony as lived experience: personal and emotional recollection of the ordinary and mundane. As such, any memorialist memorial serves as a counterpoint to the romanticism of the past so prevalent in other non-memorialist monuments and museums. In this and in other areas of Dicks' work, there are close connections between memorialism and heritage from below. There is an emphasis on contested constructions of local identity, on differential emphases between cultural and economic resources and on vernacular heritage. But where heritage from below departs most significantly from memorialism is in its recognition of the expression of claims to inheritances that draw most heavily from the cultural realm, that have rarely been recognised in the academic literature on heritage, and which contain strong counter hegemonic possibilities. The case studies engaged with here then point to a form of heritage that would

5 See also Smith's recent paper on the social values of the large-scale English country house in which 'themes of comfort, humility, deference and … the sense of associating with "like people"' (Smith 2009: 47) loomed large in her case study results.

6 I would like to thank Bridget Yates for her many useful discussions and input around the topic of community-run museums. That more of it is not included in this chapter is entirely the author's fault!

often seem to be characterised by a greater sense of homogeneity than have the forms identified hitherto.

It has to be conceded, however, that recent research has raised questions over the extent to which heritage consumers actually wish to experience the transgressive and counter-hegemonic; the representation from below. As Gibson and Pendlebury argue, the work of Shore has shown that Asian residents in Gloucester feel 'no sense of exclusionary barriers' to traditional heritage representations and express no 'need for reformist inclusionary policies' (Gibson and Pendlebury 2009: 11). In addition, and in the same volume, Smith has shown that country house visitors tend to reject subaltern narratives 'because they destabilise, if not call into question, the social values being rehearsed by the performance of both conserving and of visiting the country house' (Smith 2009: 47). These surveys then, represent a challenge to the social movement aspects of heritage from below and to other transgressive heritage categories because they reveal an ongoing 'reaffirmation of a social and cultural order that reinforces social and cultural exclusion and marginalisation' (Smith 2009: 48). Such a challenge, however, is only to be expected precisely because the counter-hegemonic by its very nature cannot be expected to offer a comfortable experience. The lack of fit with, if not to say the outright challenge to established symbols, structures and meanings inevitably means provocation and all the challenges to communication and acceptance this implies. Furthermore, it is the nature of the heritage site and the visitors it consequently attracts, which may well shape the extent to which the counter hegemonic perspective is embraced. It is, therefore, where we look for our heritage examples that becomes crucial. To look only at large scale and/or commercial and tangible sites is to place limits on the counter hegemonic possibilities written into the expression of the past at these sites. To look beyond such sites, then, to workers memorials; to the local consumption of outlaw heroes; to the intangible heritage of a performance poet; is to recognise and capture expressions of heritage from below free from such limitations.

Therefore, whilst explanation through categorization remains an important tool, it is vital to constantly reinvigorate our conceptual perspectives. It should be obvious by now that the notion of heritage from below relies heavily, as does much of the most recent literature, on important recent work in the social sciences. Thus far, however, discussion of the possibilities offered by notions such as performativity, embodied experience, the vernacular, mundane and quotidian, has been somewhat limited. This will now be addressed.

From Passive Consumption to Performativity;
From Set-piece to Mundane Heritage

Within the social sciences, and largely under the influence of the work of Nigel Thrift (1996, 2003, 2007), one of the most stimulating conceptual turns has been away from the fixation on representation and towards what has become known

as non-representational theory. The emphasis in what is a wide-ranging, dense and much discussed literature is on taking human (and non-human) practices seriously, on acknowledging the fact that the world is always in the making and on the acceptance that our practices are always embodied. Such emphases have given rise to a focus on performativity as it relates to identity making. Thus the view is that 'identities are continuously brought into being through their performance' (Hubbard et al. 2004: 348) and that our identity is what we *do*. Heritage, wrapped up in and constitutive of identity as it is, can be understood as an active and dynamic central part of the performance of our sense of self (individually and collectively).

Thrift (2003) suggests that drawing on performative approaches admits academic practice to insights hitherto inaccessible through other perspectives. He highlights three such 'moments of life': affect (emotion); 'the frames that surround and locate us ... [and] the immediacy of the now' (2003: 2020), which, along with other equally important moments, come to constitute the social networks which shape subjectivity. This permits the recognition of a world that is far messier than hitherto imagined and in which order, pseudo-order and near inchoateness can all exist at the same time. In all of this, Thrift asserts, space is vital, (and heritage may well be usefully substituted for space here) not least because it is the medium of expression and the means to political statements. And yet 'the fabric of space is so multifarious that there are always holes and tears in which new forms of expression can come into being' (2003: 2023). These are precisely the holes and tears that heritage from below can and does exploit.

Articulated in this way, the allure of the performative approach to heritage studies, and heritage from below in particular, is both obvious and compelling. The powerful dissonance motif is given renewed authority, not least from the realisation that people can perform new forms of expression onto space. This, as Bagnall has convincingly argued, often occurs at heritage places, and centres around the performance of both individual audience members and heritage managers: 'those employed to perform and stimulate memories' (2003: 93). Alongside the potential for new forms of expression, the key aspect of this perspective for heritage from below is that the recognition of heritage as performance refigures heritage work as an active process. Therefore the emphasis here shifts from an understating of heritage visits as passive consumption towards the notion of the 'act' of visiting which, of itself and along with all other aspects of heritage management, becomes a cultural performance in both obvious (national rituals; live, costumed interpretation) and less obvious ways. From this perspective we can recognise these active and dynamic elements as sometimes enabling an understanding of the museum experience as counter to that of the dominant discourse. More powerful than that, however, would be the performativity and meaning manufacture that emerges from heritage constructed from within (and, by implication, from below). And what on occasion may well emerge is what Blumer has indicated as 'specific social movements' – organised, structured and self-aware counter hegemonic groups. For such movements to begin participants need to be 'jarred loose from

their customary way of thinking and believing' (Blumer 2009: 66–67). This is something entirely within the compass of heritage, as its role in hegemonic identity formation clearly indicates. Through the active and performative emotional engagement with the past heritage can draw attention, it can arouse feelings and impulses and it can give direction to those impulses. Certain expressions of a sense of inheritance from the past, therefore, would appear to have the capacity to function as a resource for social movements and also as the dynamic product of these movements.

As with any other academic literature, the work on social movements has embraced a number of theoretical perspectives. One such has been 'resource mobilisation theory'. As articulated by McCarthy and Zeld (1977) (and many others), and expressed here very generally, the theory suggests that for discontent to be translated into social movements requires access to either the mental or the material resources that enable collective action. Equally importantly Piven and Cloward (1979) show us that transgressions of social and hegemonic norms do not require formal organisation. In addition, McCarthy and Zeld (1977) stress the significance of contributions and institutions external to the discontented group to the development of social movements. It follows, therefore, that heritage has a dual significance here. In the first instance discontent can be actively expressed at heritage sites that operate within the authorised discourse as visitors actively, emotionally and imaginatively map their own consumption of heritage sites. More importantly, alongside the confirmative, visitors will also rejectively map such sites, using personal and family memories to question and quite possibly reject the narratives in place. In other words, visitors selectively construct 'worlds based around their own experiences' (Bagnall 2003: 96). But, and perhaps more importantly, at those heritage sites that operate outside and as direct challenges to the authorised heritage discourse the discontent thereby engendered is inevitably all the more powerful.

One of the most interesting recent debates within the study of social movements has been over the restoration of emotion to the understanding of crowd action. In many aspects this is a return to a position abandoned in the 1960s when, largely under the influence of resource mobilisation theory, scholars took a rationalist perspective on such movements and treated protestors as rational actors devoid of emotion. Largely under the influence of the cultural turn, however, emotion has been readmitted on the grounds that it is 'part of the "stuff" connecting human beings to each other and the world around them' (Goodwin, Jasper and Poletta 2001: 10); functioning to both motivate and channel action. Heritage and heritage visits, we might suggest, have the capacity to engender both long and short term emotions which, following Thrift (2003) enable embodied cultural performances of identity manufacture and maintenance.

To look for heritage from below, however, can also be to look away from social movements and from visits to sites. It is to look instead towards the mundane and everyday forms of heritage. One strand of this is apparent in the cultural geographies of Edensor (2005a, 2005b), Crouch (2003, 2010a, 2010b) and Wylie

(2005) and in 'the classically phenomenological manoeuvre of placing the self in the body and embedding the body in landscape' (Wylie 2005: 240). Thus, for Wylie (2005) landscape (and we can and must extend this to the past in the present), in that it is both lived and practiced, is always in the making; never fixed or passive. As such, this sense of landscape as becoming is critical to our recognition here of the latent possibilities for counter-hegemonic expressions that inhere to heritage representations (tangible or intangible). Such recognition is enhanced by the drawing into our discursive practices work by commentators such as de Certeau (1984) and Iain Sinclair (1997) who draw attention to the presence of the fragmentary, the ephemeral and the 'urban ghosts and hauntings' that constitute a significant element of 'the histories of our contemporary places' (Atkinson 2008: 385). For Atkinson, key too has been the work of Maspero who took a seemingly methodologically absent train ride through the Parisian suburbs in order to access the geographies of these everydays. Like Sinclair, Maspero engages with mundane spaces 'but textures them with their pasts and animates them with people's stories' (Atkinson 2008: 385). As Sinclair states 'urban walking is a way of contacting the ghosts and levels of a city, the past and the future' (Sinclair 1996; quoted in Pinder 2001: 12).

One of the clearest statements of the worth of this approach to quotidian heritage, particularly as it is manifest in embodied practice (and hence key to the recognition of heritage from below) comes from Crouch and his interrogation of allotment work. The strength and utility of this comes from the fact that, unlike Maspero, Carol's (Crouch's subject) landscape is of her everyday. The fascination here is that Crouch has focussed on an activity that is essentially conservative and which, despite allotment holding's radical origins and occasional ecological and land movement associations, eschews 'liberatory cultural practices'. Nevertheless it is precisely this closing up of space that makes this taskscape so attractive for Crouch because of the 'opening up the self, going further, and rethinking life' (2003: 1949) that appears to be conducted within it. Such is the clarity of this statement that it is worthwhile quoting at length.

> Carol describes what she does, and what she makes of this activity, through how she spaces herself; her body engages in intimacy of space significantly on her own terms, with movements amongst multisensual encounters. Carol touches, bends, and kneels; she moves her body and spaces the gaps, and their objects, between vegetation, earth, insects, the air and herself. She finds her feeling of life through what her body does there. ... Carol is not thinking everything through, but at each moment confronts works and performatively encounters through a feeling of doing. ... It is in the encounter. (2003: 1953)

Crouch here is focusing on the everyday and it may be suggested that heritage does not constitute the everyday, but this is only the case if we adopt a cripplingly narrow view of what heritage is and does. Heritage is the individual and the everyday; it is performance. We can perform alternative constructions of the past.

These alternative constructions are regretfully only rarely engaged with, however, even in those literatures that suggest otherwise.

Critically therefore, performed repetition can be seen as a key way in which people articulate and construct their sense of their pasts and historical identities. In this, moreover, the emphasis is often placed on domestic spaces, routine material culture and the mundane as prime sites of everyday memory work. Illustrative of this is Skinner's chapter in this volume in which she draws on the concept of local distinctiveness to argue that the process of writing a parish history, drawing as it does on the domestic and mundane, can write memory from within. Similarly, Reeves finds inspiration for his performance poetry in routine material culture and the everyday of the past. Jones and Selwood see, in their 'shackie' settlements, the very stuff of heritage from below and of mundane domestic spaces. Many of the chapters in this volume, then, draw their inspiration, implicitly if not explicitly, from the performativity perspective and from the work of commentators such as Edensor whose photo study of industrial brownfield sites revealed these as liminal spaces for 'invention, play, excitement and other activities' (Atkinson 2008: 388).

From Performativity to Heritage from Below

This volume seeks to add to our case studies of the ways in which the past is performed in the present in the belief, in part at least, that the range of illustrative examples that continue to be drawn on elsewhere remains frustratingly narrow and mainly focused on transgressive acts performed from within the hegemonic and the dominant discursive texts. Thus it is that Atkinson's intervention (2008), welcome as it is as a case study of a mundane heritage space, is disappointing in so far as it focuses on the redevelopment of dockyard landscapes in the port of Hull. For here, once again, we see a focus on the commercial and spectacular; as the redevelopment of de-industrialised landscapes nearly always are. Equally inevitably this raises a series of important questions over the nature of the mundane and this particular space as mundane heritage. The most significant of these must be over the extent to which it is possible to *create* the mundane. Surely the mundane is just there? And from this, is it possible for commercially focused redevelopment that draws on the past to produce mundane heritage? The temptation is to reply in the negative.

Attempts to build counter-hegemonic perspectives from within the dominant discourse therefore must be questionable at best. This notwithstanding, commentaries that focus on attempts to build counter hegemonic perspectives from without, as alluded to here by Rice, Reaves and (especially) Bienkowski, remain rare. Where the focus rarely falls is on the unheralded or uncelebrated heritage (such as Edensor's brownfield, liminal spaces noted above). This is the 'stuff' of heritage from below. If this heritage is made material, or if it is material, then this occurs almost spontaneously and (seemingly) organically. It is heritage without fuss and with minimal commercial interest. Some aspects of Jones and

Osborne's workers memorials in this collection make precisely this point as do the squatter shacks discussed by Jones and Selwood. What emerges from this is that heritage from below operates most obviously and successfully at a sub-national scale. It is directed from and for localising communities although it should not be assumed from this that there is an automatic fixity to what might be understood as 'local'. In this instance local should be taken to refer to not just (perhaps not even at all) the physical form but also to sub-national identity groupings and to identity groupings that do not treat space as the primary referent. These are precisely the groupings that put community heritage projects in place and which look to local and quotidian places and spaces for their memory work. Similarly, it must be acknowledged that only rarely is the heritage directed solely at the localised. There are nearly always *others* to attract and inform. Here too is yet another manifestation of the dissonance that seemingly inevitably inheres to all forms of heritage.

Something similar can be said of the projects set up by organisations such as Common Ground and funding streams such as the Local Heritage Initiative. Both are, and were, resolutely local and both had, and have, the aim of producing resolutely local outcomes for, to borrow Dicks' phrase, 'generations of insiders' (2000: 155). It would be naïve, however, to accept that this produces unproblematic outcomes. Wright (1993), for instance, has cautioned Common Ground to resist the blandishments of the rural idyll and, as I have suggested elsewhere (Robertson 2008), Common Ground's work reveals that even projects that aspire to enable the voice from within often appear to demand external professional intervention. Common Ground's founding philosophy of local distinctiveness was also a key part of the approach taken by the LHI. Established in 2000, and closed to new applications in 2006 (Lessons Learnt 2006), this was a grant and advice programme in England funded by the Heritage Lottery Fund and the Nationwide Building Society. Local Distinctiveness was one of the four key aims of the LHI as it sought to 'create a holistic programme that could add a new dimension to the understanding and appreciation of heritage at a local level' (Lessons Learnt 2006: 8). Explored in a little depth, however, and drawing on the programme's own statistics, a number of observations can be made. In the first instance, even though 37 per cent of funded projects were located in urban or urban fringe environments (Lessons Learnt 2006), it is perhaps unsurprising that this programme should be firmly aimed at the rural environment, with its dominant trope of timeless conservatism. The consequence of this focus, moreover, would suggest that much of the counter-hegemonic potential of such funding streams was lost (albeit acknowledging that the rural/urban; conservative/counter-hegemonic dichotomy postulated here is a necessarily crude one). Similarly, although some of the regional figures were markedly different, overall only 33 per cent of funded projects were located in what the LHI identified as 'disadvantaged areas' (Lessons Learnt 2006: 21). And, of these, just under one half fell into the top two quartiles of the Office of the Deputy Prime Minister Index of Multiple Deprivation.

Something similar emerges when consideration is given to the categories of heritage embraced by the LHI projects. Here some confusion is apparent. The LHI identified five broad areas of eligibility: built; archaeological; natural; industrial; customs and traditions. Significantly there appears to have been some hesitation over what the last category signified and it was to become redefined as 'cultural'. Notwithstanding the nomenclatural confusion this category would appear to be the one most likely to encompass projects that fall within the ambit of heritage from below and, laudably, 65 per cent of projects included a cultural element within them (Lessons Learnt 2006). The problem with this, however, lies precisely in the nomenclatural confusion. Whilst all the other categories had an air of certainty and fixedness about them – there is no difference between them and the categories defined as the 'scope' (Lessons Learnt 2006: 5) of the LHI – this is not the case for the cultural area. The redefinition noted above suggests official uncertainty over what constitutes cultural heritage and over how this might fit with the somewhat conservative values captured within the LHI. And, when we further explore some of the sub-categories that the LHI identified as falling within this area: 'stories, poems, songs, dialect, recipes and traditions' (Lessons Learnt 2006: 7) these are hardly suggestive of counter hegemonic possibilities.

This notwithstanding, through its own evaluation the LHI was able to claim significant impacts in broadening both the social base of and the non-expert engagement in heritage activity. Some 40 per cent of projects, it would seem, comprised people new to 'heritage work' (Lessons Learnt 2006: 140). Once again, however, the detail reveals a somewhat less encouraging picture. In their final report, the Local Heritage Initiative claims to have 'reached a new audience, beyond the traditional "history society" and environmental action groups' (Lessons Learnt 2006: 23). This may be strictly true but there is equally no doubt that participation was dominated by traditionally 'active' groups. Over 75 per cent of successful applications (Lessons Learnt 2006) were made by what the LHI termed as 'voluntary groups' such as local 'friends of' groups, Parish Councils and other community organisations. And, whilst many of these groups may well have been new to Heritage Lottery Fund or Countryside Agency funding, it is highly unlikely that this represents a broadening of the social base of grant applicants.

Overall, it is impossible to deny both the laudable intentions and positive outcomes of the LHI. With its active engagement with the philosophy, principles and personnel of Common Ground, the programme was undoubtedly designed to be open to the possibilities of what is understood here as heritage from below. Indeed, many of the programme's outcomes and impacts are those we might look for from a heritage from below perspective. And yet, because of its rural focus, because of its variable performance in disadvantaged areas, but perhaps above all because the programme continued to operate from within the dominant heritage discourse rather than from without, then the Local Heritage Initiative would seem to remain firmly closed to the radical possibilities offered by heritage from below.

Official recognition of, and support for heritage from below therefore remains fleeting at best and oppositional at worst. This is unsurprising. By its very nature

heritage from below is often itself oppositional and is often best expressed in the illusive, ephemeral and everyday. It is not the 'stuff' of official funding streams, being perhaps closer in spirit to the anti-monument movement. This artistic movement aspires to the rejection of fixed sites of memory in the belief that (in an echo of Nora 1989), traditional memory sites in their identity work actively 'discourage engagement with the past and induce forgetting rather than remembering' (Gillis, 1994: 16). The aim of heritage from below, therefore, is the obverse of this: to stimulate heightened memory work through the production of radical designs which 'not only invite more interaction, but challenge the status of memory as a knowable object' (Gillis 1994: 16). Gillis, further uses the example of the vanishing monument to the victims of Nazism in Hamburg to suggest that it is unsurprising that the strength of this movement is to be found in Germany 'where the issue of memory has such huge significance and where ... the struggle intensifies rather than diminishes' (1994: 16). And it is in Germany, and in the work of another Hamburg artist, Christoph Schaefer, that we find one of the most recent and fascinating anti-monuments. In a variety of locations in the Ruhr Schaefer built a multipart work that sought to recapture for the political left, and bring back into memory, the Red Ruhr Army – the revolt of March-April 1920 in reaction to the Kapp Putsch. Between June and August of 2010 Schaefer (n.p.) worked 'to correct the ... memory- and oblivion situation' through the use of materials and techniques associated more often with urban place marketing to see if such erstwhile conservative media could be utilised for more radical ends. Thus Schaefer draped the water tower in Essen, which was the location of a significant defeat for the Red Ruhr Army, with red flags to poise the counter-factual question 'what if'. He also deployed temporary advertising boards alongside the main road, Westfalendamm, in Dortmund, replacing the normal commercial messages with a mutable narrative of the revolt. Finally, and again in Dortmund, Schaefer replaced the adverts on the side of a tram with politically-inspired slogans such as 'this is bad air' (Hoffmann n.p.). Here, then, radical art in the form of an anti-monument – temporary, fluid and ephemeral – meets radical politics in a clear attempt to write heritage from below; to express local identity by drawing on a sense of a radical inheritance from the past. As Schaefer says

> Is the March revolution / the Ruhr rebellion not as important for the history of the Ruhr – as the discovery of the charcoal or the invention of the seamless railway-wheel? The important industrial zone in 1920 had the potential to stop Germany from moving to the right. More than that: to give the development of socialism a different direction. (Schaefer 2010: n.p.)

In attempting to generate alternative memory work and in celebrating and commemorating illegality, these anti-monuments aim to create distinct and ephemeral landscapes of belonging that drew on landmarks to the memory of an alternative culture. They are fascinatingly redolent of heritage from below therefore.

In a similar vein, it can be suggested that memorials which are (literally and figuratively) hidden and seldom visited offer the same, albeit unintentional, subverting possibilities. As with the workers memorials discussed by Jones and Osborne in the present volume the memorial to a small scale mining disaster in the Forest of Dean in Gloucestershire was erected for and by the local community. Like many mining areas the Dean was, and is, framed by strong local customs and a still-dominant mining place image, notwithstanding the fact that the last deep mine closed in 1965 and very few 'free mines',[7] the bedrock of custom and culture, remain open. The memorial in question commemorates the Union Pit disaster, the largest loss of life in a Dean mining accident in which, in 1902, four men were killed, two of whom were brothers. For the sculptor, Matt Baker, the project was put in place not only to commemorate the centenary of the accident but also to help raise the profile of Free Mining at a time when the tradition was under threat of total eradication (having ended as a viable, fully-worked tradition some while earlier). The monument was site-specific being erected on the site of (or very near to) the site of the old mine. For the sculptor the fact that very little remained to 'place' the mine and disaster meant that 'the work was about creating a sense of place and the atmosphere of the disaster, and what the tradition meant to the people who lived there'. Additionally, the process of creation was of itself part of this place making. As the sculptor worked on the site 'all the old boys wanted to come and see the young lad chipping away, and so they came and they told me their stories. For me, all of those stories went into that piece of stone' (Baker 2008: n.p.). What is very evident here, then, is a project very reminiscent of Common Ground's attempts to intervene in processes of local distinctiveness – using place specific art to create a sense of local heritage. Clearly this was a meaning-full and place making project. And in contrast to much of Common Ground's work this was a wholly local initiative. But as the chosen location of the memorial is on an obscure and under-used forest footpath, away from any roads, and because there is nothing to indicate that a memorial might be found on it, then the memory work that this memorial may be said to do, must be questionable at best. It may have worked only for those who initiated the project. In the context of heritage from below, however, this may not be as problematic as it might at first appear. Whilst we must agree that the original intention would have been to achieve more overt memory work, the unintended consequences of this memorialisation are equally interesting. When you move through the Forest of Dean you move through an erstwhile Arcadian landscape: sylvan and dominated by silviculture. An arcadia, moreover, that is emblematic of tropes of English national heritage and identity.

7 By tradition men who had been born in the Dean were 'free' to mine where they chose within the Royal forest. Such is the nature of the industry that it is difficult to be precise about how many mines (or 'gales') are currently being worked. It is certainly less than five. There is a very useful web site which lists all the known gales that have been recorded as worked since the eighteenth century <http://www.lightmoor.co.uk/forestcoal/Coalopen.html>.

The Dean is the site for Wordsworth's *Lines composed a few miles above Tintern Abbey on revisiting the banks of the Wye during a tour, 13 July 1798* and of his deep attachment to the landscape of the valley of the River Wye more generally. This poet and his poetry are innately associated with the rise of contemporary and hegemonic constructions of heritage, the heritage industry and English national identity.[8] And yet, when you move through the Forest of Dean you also stumble across locally, nationally and internationally significant relics of an industrial past.[9] In this arcadia, however, any possibility of an alternate reading to that of the hegemonic – the dominant rural landscape trope of English national identity – is limited at best. The industrial is enveloped into the rural and the rural trope envelops the industrial. A different movement through the Bixslade part of the Dean will, however, involve a different encounter. This encounter will be with the memorial to the Union Pit disaster; the presence of which passes virtually un-marked. This un-planned and chance encounter with an un-celebrated and in-effectual (on the face of it) mnemonic opens up the possibility of something other than fixed-meaning memory work. Here the encounter is with Sinclair and Maspero's 'ghosts'. The Union Pit memorial has become a ghost memorialisation carrying traces of past memorialisation which, at the same time, acts to subvert and undercut the fixed, tangible and hegemonic memory/memorialisation work of the rest of the Dean's heritage sites (even those, such as the miners memorial at New Fancy colliery, ostensibly 'from below'). To stumble over this monument would involve provocation; would be to call into question your perception of the landscape through which you were moving; would be to offer an alternative construction of a past way of life and of present heritage.

A similar but more deliberate destabilising memorialisation is discussed by a number of authors in this volume. In her discussion of student rituals Macdonald draws attention to the primacy given to presumptions of materiality when it comes to museum display and to spatial and temporal stability when thinking of the work heritage may do. Students and student life defies much of this and yet their rituals, as Macdonald shows, drew explicitly upon a sense of inheritance from the past. This, in turn, draws attention to the dynamic and performative aspects of the heritage process and, indeed, to the subversive. Reeves too, in his performance poetry, achieves an ephemeral (in a good way) and grounded telling of the past that stands as memorial to past actors (in every sense of the word) hitherto written out of history. It is, however, with the work of Alan Rice that this sense of destabilising ghost memorialisation, or as Rice has it, a 'guerrilla memorialisation', finds its clearest articulation in the present volume. In a wide-ranging and extensive study

8 See, for instance, Bate (2000), Graham et al. (2000), Lowenthal (1985) and Samuel (1994). Samuel is particularly scathing in his commentary on the 'latter-day Wordsworthians' who opt for the Gregorian chant on the 'Walkman commentary' which accompanies their 'pilgrimage to Tintern Abbey' (1994: 172).

9 In the 1850s at Darkhill Iron Works in the Dean Robert Mushet perfected the Bessemer process for the mass production of steel. It is now a Scheduled Ancient Monument.

Rice uses case studies of a number of memorials (broadly defined) to highlight the ways in which the traditional role of the memorial can be re-worked to draw attention to that which has been elided. From this Rice addresses the need to extend and deepen the dialogue between history and memory and argues that, in an echo of Samuel, other mnemonic forms must be called upon in an effort to embody the past with 'a more accurate and human face' (Rice this volume) and to permit the articulation of dissident memory.

Viewed in the round, one of the main aims of this book is to make a contribution to ongoing attempts within the heritage literature to escape from an easy reliance on a series of questionable dualisms: optimistic/pessimistic; economic/cultural; subaltern/authorised. The chapters in this volume start from the premise that the latter – the most nuanced and convincing of these – can be shown to narrow our perspective on manifestations of the past in the present which consequently results in missing expressions of heritage beliefs that inform identities that seek to challenge the dominant. It must be conceded however that the heritages expressed from below which are discussed here have a tendency (if not unanimity) to fall into Samuel's optimistic camp. But what also unites the diverse range of case studies and perspectives brought to bear here is their refusal to uncritically and unsubtly accept this view. Thus the presence and disruptive element of what others identify as dissonance is readily acknowledged and shown to be present in even the most hermetically sealed and spatially constrained heritage representations, although the wholly negative aspects of associations is often challenged here. A central aspect of the thinking that underlies ideas of heritage from below is, therefore, an inability or a failure to accommodate. It is, however, not always helpful to readily identify this as dissonance precisely because of the negative associations that this label brings. Furthermore, it is not necessary to operate within a radical or counter-hegemonic perspective to perform the past in ways that run counter to the dominant. Local heritage groups, housing types, silver nomads in Western Australia are all expressive of values that do precisely this. Nevertheless, as others in this collection powerfully and convincingly demonstrate, expressions of heritage from without and below can act as tools and resources for counter-hegemonic social movements. There is a latent power to heritage and to heritage expressed from without and below that, whilst it is seldom recognised or utilised, remains potent. The remainder of this book addresses itself to that potency.

References

Ashton, P. and Kean, H. 2008. *People and Their Pasts*. London: Palgrave Macmillan.

Ashworth, G. 1998. Heritage, identity and interpreting a European sense of place, in *Contemporary Issues in Heritage and Environmental Interpretation*, edited by D. Uzzell amd R. Ballantyne. London: The Stationery Office, 112–132.

Ashworth, G. and Larkham, J.G. 1994. *Building a New Heritage: Tourism, Culture and Identity in the New Europe.* London: Routledge.

Atkinson, D. 2008. The heritage of mundane places, in *The Ashgate Research Companion to Heritage and Identity*, edited by B. Graham and P. Howard. Aldershot: Ashgate, 381–395.

Bagnall, G. 2003. Performance and performativity at heritage sites. *Museum and Society* [Online]. 1(2), 87–103. Available at: http://www2.le.ac.uk/ departments/museumstudies/museumsociety [accessed 30 October 2009].

Barker, R. 2008. *Starting at the Beginning* [Online]. Available at: http://www. publicartscotland.com/reflections/10 [accessed 3 November 2009].

Bate, J. 2000. *The Song of the Earth.* London: Picador.

Blumer, H. 2008. Social Movements, in *Social Movements: A Reader*, edited by V. Ruggiero and N. Montagna. London: Routledge, 64–72.

Buciek, K. and Juul, K. 2008. 'We are here, yet we are not here': The heritage of excluded groups, in *The Ashgate Research Companion to Heritage and Identity*, edited by B. Graham and P. Howard. Aldershot: Ashgate, 105–124.

Butler, T. n.d. *Memoryscape* [Online]. Available at: http://www.memoryscape.org. uk/index.htm [accessed 10 December 2009].

Cloke, P. and Jones, O. 2001. Dwelling, place, and landscape: An orchard in Somerset. *Environment and Planning A*, 33, 649–666.

Crooke, E. 2005. The construction of community through heritage in Northern Ireland, in *Ireland's Heritages*, edited by M. McCarthy. London: Ashgate, 71–88.

Crouch, D. 2003. Spacing, performing and becoming: Tangles in the mundane. *Environment and Planning A*, 35, 1945–1960.

Crouch, D. 2010a. Flirting with space: Thinking landscape relationally. *Cultural Geographies*, 22(1), 5–18.

Crouch, D. 2010b. The perpetual performance and the emergence of heritage, in *Culture, Heritage and Representation*, edited by E. Waterton and S. Watson. London: Ashgate, 57–74.

Crouch, D. and Parker, G. 2003. 'Digging-up Utopia?' Space, practice and land use heritage. *Geoforum*, 34, 395–408.

de Certeau, M. 1984. *The Practice of Everyday Life*, trans. Steven Randall. Berkeley, University of California Press.

Dicks, B. 1996. Regeneration versus representation in the Rhondda: The story of the Rhondda Heritage Park. *Contemporary Wales*, 9, 56–73.

Dicks, B. 1999. The view of our town from the hill: Communities on display as local heritage. *International Journal of Cultural Studies*, 2(3), 349–368.

Dicks, B. 2000. *Heritage, Place and Community.* Cardiff: University of Wales Press.

Dicks, B. 2007. Review of L.J. Smith *Uses of Heritage* in *Museum and Society* [Online]. 5(1), 58–59. Available at: http://www.le.ac.uk/ms/m&s/Issue%2013/ reviews.pdf [accessed 23 October 2009].

Edensor, T. 2005a. *Industrial Ruins: Space, Aesthetics and Materiality*. Oxford: Berg.

Edensor, T. 2005b. The ghosts of industrial ruins: Ordering and disordering memory in excessive space. *Environment and Planning D: Society and Space*, 23, 829–849.

Editorial Collective, 1976, Editorial. *History Workshop Journal*, 1(1), 1.

Gibson L. and Pendlebury, J. 2009. Introduction: Valuing historic environments, in *Valuing Historic Environments*, edited by L. Gibson and J. Pendlebury. Farnham: Ashgate, 1–18.

Gillis, J.R. 1994. Memory and identity: The history of a relationship, in *Commemorations*, edited by J.R. Gillis, Princeton: Princeton University Press, 3–26.

Goodwin, J., Jasper, J.M. and Poletta, F. 2001. *Passionate Politics: Emotions and Social Movements*. Chicago: University of Chicago Press.

Graham, B. and Howard, P. 2008. *The Ashgate Research Companion to Heritage and Identity*. Farnham: Ashgate.

Graham, B., Ashworth, G.J. and Tunbridge, J.E. 2000. *A Geography of Heritage*. London: Arnold.

Halfacree, K. 2007. Trial by space for a 'radical rural': Introducing alternative localities, representations and lives. *Journal of Rural Studies*, 23(2), 125–141.

Hall, T. and Robertson, I.J.M. 2006, Memory, Identity and the Memorialisation of Conflict in the Scottish Highlands, in *Heritage, Memory and the Politics of Space: New Perspectives on the Cultural Landscape*, edited by N. Moore and Y. Whelan (eds). Farnham: Ashgate.

Hardy, D. and Ward, C. 1984. *Arcadia for All: The Legacy of a Makeshift Landscape*. London and New York: Mansell.

Hewison, R. 1987. *The Heritage Industry: Britain in a Climate of Decline*. London: Methuen.

Hoffmam, J. *Christoph Schäfer 'Auslaufendes Rot – Anti-Monument für die Rote Ruhr Armee'* [Online: Springerin]. Available at: http://www.springerin.at/dyn/heft_text.php?textid=2410&lang=de [accessed 3 November 2009].

Holloway, J. 2003. Make-believe: Spiritual practice, embodiment, and sacred space. *Environment and Planning A*, 35, 1961–1974.

Howard, P. 2009. Historic landscapes and the recent past: Whose history? in *Valuing Historic Environments*, edited by L. Gibson and J. Pendlebury. Farnham: Ashgate, 51–66.

Hubbard, P., Kitchin, R. and Valentine, G. 2004. *Key Thinkers on Space and Place*. London: Sage.

Ingold, T. 1993. The temporality of the landscape. *World Archaeology*, 25, 152–174.

Ingold, T. 1995. Building, dwelling, living: How animals and people make themselves at home in the world, in *Shifting Contexts: Transformations in Anthropological Knowledge*, edited by M. Strathern. London: Routledge, 57–80.

Ingold, T. 2000. *The Perception of the Environment: Essays in Livelihood, Dwelling and Skill*. London: Routledge.

Jacobs, J. 1994. Negotiating the heart: Heritage, development and identity in postimperial London. *Environment and Planning D: Society and Space*, 12, 751–772.

Lowenthal, D. 1985. *The Past is a Foreign Country.* Cambridge: Cambridge University Press.

Lowenthal, D. 1988. *The Heritage Crusade and the Spoils of History.* Cambridge: Cambridge University Press.

McCarthy, J.D. and Zeld, M. 1977. Resource Mobilization and Social Movements: A Partial Theory. *American Journal of Sociology*, 82, 1212–1241.

Morrissey, J. 2005. A lost heritage: The Connaught Rangers and multivocal Irishness, in *Ireland's Heritages*, edited by M. McCarthy. Farnham: Ashgate, 71–88.

Nash, C. 2000. Historical geographies of modernity, in *Modern Historical Geographies*, edited by B. Graham and C. Nash. Harlow: Longman, 11–40.

Nora, P. 1989. Between memory and history: *Les Lieux de Mémoire.* *Representations*, 26, 7–24.

Pinder, D. 2001. Ghostly footsteps: Voices, memories and walks in the city. *Ecumene*, 8(1), 1–19.

Piven, F.F. and Cloward, A.A. 1979. *Poor People's Movements: Why They Succeed, How They Fail.* New York: Vintage Books.

Pendlebury, J., Townshend, T. and Gilroy, R. 2009. Social housing as heritage: The case of Byker, Newcastle upon Tyne, in *Valuing Historic Environments*, edited by L. Gibson and J. Pendlebury. London: Ashgate, 179–200.

Robertson, I.J.M. 2005. Land, people and identity, in *Ireland and Scotland: Order and Disorder, 1600–2000*, edited by R.J. Morris and L. Kennedy. Edinburgh: John Donald, 189–202.

Robertson, I.J.M. 2008. Heritage from Below: Class, Social Protest and Resistance in *The Ashgate Research Companion to Heritage and Identity*, edited by B. Graham and P. Howard. Aldershot: Ashgate, 143–158.

Samuel, R. 1994. *Theatres of Memory, Volume 1.* London: Verso.

Schaefee, C. 2009. *Diffusing Red – Anti-Monument for the Red Ruhr Army* [Online]. Available at: http://www.saloon-la-realidad.com/christophschaeferprojekte/au slaufendesrot/red-ruhr.htm [accessed 3 November 2009].

Sinclair, I. 1997. *Lights Out for the Territory.* London: Granta Books.

Smith, L. 2006. *Uses of Heritage.* London: Routledge.

Smith, L. 2009. Deference and humility: The social values of the country house, in *Valuing Historic Environments*, edited by L. Gibson and J. Pendlebury. Farnham: Ashgate, 33–50.

Thrift, N. 1996. *Spatial Formations.* London: Sage.

Thrift, N. 1997. *Non-Representational Theory: Space, Politics, Affect.* London: Routledge.

Thrift, N. 2003. Performance and … *Environment and Planning A*, 35, 2019–2024.

Tunbridge, J.E. and Ashworth, G.J. 1996. *Dissonant Heritage: The Management of the Past as a Resource in Conflict.* Chichester: John Wiley.

Wright, P. 1985. *On Living in an Old Country.* London: Verso.

Wylie, J. 2005. A single day's walking: Narrating self and landscape on the South West Coast Path. *Transactions of the Institute of British Geographers*, 30(2), 234–247.

Chapter 1
Archaeological Knowledge, Animist Knowledge and Appropriation of the Ancient Dead

Piotr Bienkowski

Introduction

This paper explores the ways in which archaeological exhumation and analysis of ancient human remains grew out of a particular, contingent set of understandings of the human body, of death, and of burial, and the implications of this when set against alternative world-views which construct death, and the meaning of the dead body, in quite different ways. Such an analysis is timely given the increasing ways in which archaeology – particularly mortuary and forensic archaeology – across the whole world is interfacing with crucial social and political issues, such as repatriation, requests for reburial, human rights missions, genocide and exhumation of the recently dead, in which archaeology and archaeologists come into contact and develop working relationships with individuals and communities holding a range of divergent beliefs about the nature of death and the dead body, and where a relationship with the dead is often an important component of cultural identity. Although the discipline of archaeology has made great strides in acknowledging such divergent understandings in theory, especially the affective presence and emotive materiality of the dead body – at least in some countries, in some universities and in some sub-disciplines – it remains true that the essential nature of archaeological exhumation is rooted in a particular set of Enlightenment (and, later, colonial) attitudes which potentially conflict with alternative world-views in practical situations. Essentially, I am concerned with exploring how the world-view implicit in archaeology and archaeological exhumation (which wields huge institutional, scientific and cultural authority) can and does conflict with alternative world-views (the alternative 'heritage from below') which often operate at a local, community level – focusing particularly on animist world-views in which the dead retain personhood – and examining the practical consequences of this tension for building relationships in the present and with the past.

I explore five aspects of this issue. Firstly, I list and summarise alternative world-views (using the language and categories of Western philosophy): the different ways in which humans construct the world, the fundamental nature of being or reality, which in philosophical terminology is called ontology. This leads,

secondly, to a focus on the human body: what is it, what value does it have, and how do the different world-views understand the live body and the dead body? Needless to say, implicit in these different world-views are variant understandings or constructions of life and death and the meaning of burial, and that is the third aspect I explore. Fourthly, I analyse the philosophical foundations of archaeology, especially the practice and conceptualisation of archaeological exhumation and analysis. These are deeply embedded within a particular world-view, thus leading to potential polarisation and tension when archaeological exhumation engages or conflicts with adherents of alternative world-views in sensitive human rights situations and through calls by different cultural or local communities for repatriation, reburial, and involvement in decision-making around human remains. A final part summarises recent and current ethical, theoretical and practical developments, in particular the increasingly pro-active involvement of community groups around British human remains in the United Kingdom, who are effectively challenging the ontological basis of the decision-making criteria of archaeologists and museums.

World-views

There are different ways of seeing the world, different world-views, in a sense different languages with which to explore reality. This point is fundamental to the present analysis, since archaeology as a discipline developed within the framework of one particular world-view, which in many ways is incompatible with alternative world-views (Byrne 2009). When archaeologists work within social relationships dealing with sensitive and controversial issues, it is vital to be aware of the ontological background of their discipline and its philosophical assumptions; similarly, archaeological and heritage institutions generally wield their authority based on a particular ontology or form of knowledge, and often do not acknowledge the legitimacy of alternative ('non-scientific') ontologies and the communities that adhere to them, which can lead to discriminatory practices based on a hierarchy of world-views and types of knowledge (Smith 2006: 11, Byrne 2009: 69).

The moral philosopher Mary Midgley argues that proponents of different world-views often take it as axiomatic that their own world-view is self-evident, the only one possible, an *a priori* truth: '... we assume that the ideas we are using are the only ones that have ever been possible. We think either that everybody uses these ideas or that, if there are people who don't, they are simply unenlightened, "primitive", misinformed, misguided, wicked or extremely stupid' (Midgley 2005: 151).

This is particularly true of the rational, scientific approach, which 'allows only a small set of premises. It is assumed that all explanations will be of one type that they must all be expressed in a single language' (Midgley 2005: 296). As humans, we have no way of knowing that one world-view is any more correct than

another, except for our own self-belief, or faith: there is no *a priori* proof for the validity of one against the other, only metaphysical assumptions and hypotheses which are effectively incapable of being proved empirically. Yet it is often difficult or even impossible for people to grasp the possibility of forms of understanding different from those in which they have been trained. Human brains have a tendency towards reification, to see things to be more real than they are, to treat organisational properties and group norms, things that depend on human decision and action, as though they were discrete entities with an independent existence (cf. Maxwell 1984: 204–5).

> Someone who has been educated more or less exclusively in terms of a particular world-view will not normally be fully aware that this is the case, since this world-view will be transparent to them. The world *as seen through this particular lens* will appear to them to be just *the world as it objectively is in itself.* It is only by acquiring the experience of seeing the world through different lenses that this distinction comes to be understood. (Midgley 2005: 14, original author's italics)

Michel Foucault (1970) in his early work demonstrated that all societies tend to be prisoners of particular, contingent epistemes of thought that provide a conceptual framework for what can be thought and for what it is acceptable to think. But all the different world-views have struggled with essentially the same basic questions about the human condition: what is the nature of reality, and how can we know it? It is still the case in the twenty-first century that the central issue in these questions is unresolved: that is the phenomenon of consciousness and how it relates to matter, the body, life and death – what tends to be called the 'mind-body problem'. Indeed, a leading authority has argued that as humans we are constitutionally incapable of finding the answer to this fundamental question about ourselves and how we relate to the world (McGinn 2004). None of the world-views is completely satisfactory philosophically, nor do any of them appear to account adequately for all the empirical data. But how alternative world-views conceptualise these relationships is central to my discussion about the meaning of burial and the practice of archaeological exhumation.

In the Western philosophical tradition, there are essentially four different foundational assumptions about the fundamental nature of the world, and the mind-body problem, which lie at the heart of different world-views:[1]

- Mind and Body are two separate substances (dualism);
- Only Body, or Matter, exists (materialism);

1 For comprehensive guides to the mind-body problem, cf. Heil and Mele 1993, Warner and Szubka 1994. Velmans 2000: 9–47 analyses the implications of the different world-views for our understanding of consciousness. For a convenient, though slightly biased, précis of the main strands of the different world-views, see de Quincey 2002, esp. pp. 45–9 and 90–95.

- Only Mind exists, everything else is an illusion (idealism, or immaterialism);
- Mind and Matter always go together: Matter is intrinsically sentient (panpsychism, or animism, or panexperientialism).

One or another of these lies at the heart of different world-views and different religions, or the lack of a religious belief. In terms of our relationship with the world, these are the most fundamental ideas that we cling to, either unconsciously, in that we are unaware that we hold these beliefs and we assume that this is just the way the world is; or we have a clear, articulated opinion about the 'rightness' of our particular view. There is no empirical evidence or proof for these metaphysical questions – we cannot know for certain which of these positions is true. But in choosing one, and in building a world-view upon it, even subconsciously, we are choosing one metaphysical position over another.

Strictly speaking, ontologically, these four positions are bounded and incompatible; but human life and understanding are complex, and there is a sense in which these positions can co-exist, overlap, or become slightly fuzzy, as individual humans move between professional, institutional, private and religious worlds, or between fixed theology and popular religion. But, in my experience of discussions and consultations around human remains with adherents of different world-views, the ideas tend to become fixed and polarised when we need to find a basis on which to make decisions, often in opposition to alternative strongly held world-views. Furthermore, what appear to be discrete, bounded ontological positions within a Western philosophical framework do not always easily describe the world-views of other cultures, ancient and modern. I am not claiming that all non-modern non-Western people are out-and-out animists, believing explicitly in the oneness of matter and spirit, the fluidity of living essences, cyclical time, and a similar view of death and dying.[2] This is not an anthropological study of cultural difference: my reason for using the categories of Western philosophy here is that (Western) institutional hegemonic authority over human remains (with some exceptions, see below), while recognising the diversity of beliefs regarding the dead in other cultures and subcultures, nevertheless bases its authority very firmly on Enlightenment attitudes and a philosophical and scientific objectivity founded in dualism and materialism. Being slightly provocative, scientific objectivity and the quest for knowledge in relation to the dead are often irreconcilable with other world-views, and yet their authority has a certain privileged, self-evident status – in the same way that Smith (2006: 11) argues that the 'authorised' heritage discourse in general promotes Western elite cultural values as being universally applicable. In order to critique that authority, and to highlight the philosophical validity of alternative world-views and thus argue for their 'counter-

2 See, for example, the ideas of dividual, partible and permeable personhood summarised in Fowler 2004: 23–52, which might be subsumed within the Western panpsychist or animist category, but that does not really do them justice and is not a full explanation of the beliefs.

hegemony', that philosophy and its associated attitudes towards the dead must be deconstructed using its own language, categories and assumptions – and I use the word 'deconstructed' deliberately, not as an alternative term for 'analysed' as it is now so often lazily used, but in its essential, even brutal sense in which meaning 'is shown to deconstruct its own claim through unrecognised twists of implication' (Norris 2002: 22).

Dualism

Technically, the word 'dualism' can be used for any theory that has at its basis two radically distinct concepts or principles. In the philosophy of mind, dualism refers to the view that human beings are made up of two radically distinct constituents: body, constituted by matter like other natural objects; and an immaterial mind or soul. Matter and mind are different substances and exist separately. Dualism was principally expounded by the seventeenth-century French philosopher Rene Descartes in his *Meditations on First Philosophy* (Descartes [1641] 2001), in which, through his original method of systematic doubt, he set out to establish what it is possible to know.[3] Descartes concluded that he himself was simply a thinking being: his body, though attached in some way to his soul or self, was not a part of his thinking self, but a distinct physical mechanism: 'it is certain that I am really distinct from the body, and can exist without it' (from his Sixth Meditation).

In this sense, we can see how Descartes' rational approach of systematic doubt, leading to certain and reliable knowledge came to be the philosophical foundation of Enlightenment knowledge and of 'Science' (allied with Francis Bacon's new empirical experimental science) (Appleby et al. 1996). The notion that humanity was separate from nature, already implicit in the Old Testament and hugely influential within Christianity (Passmore 1971: 8–13), was heavily underlined by Descartes' dualistic philosophy: 'There exists nothing in the whole of nature which cannot be explained in terms of purely corporeal causes devoid of mind and thought' (Descartes, in Alquie 1973: 502 note).

Humans were effectively separate from their bodies and from matter generally, and therefore they could be relied upon to be objective observers, searching for a single, verifiable truth.[4] Only material things which they could perceive and

3 The full title, translated into English, is *Meditations on First Philosophy in which the existence of God and the real distinction between the soul and the body of man are demonstrated.*

4 The myth of objectivity permeates rational academic enquiry, and owes its tenacious hold largely to Descartes' dualistic separation of humanity from matter more than 300 years ago, despite Gadamer's (1989: 265–307) plea for the recognition of subjectivity in hermeneutics. But now even physics is running against the limits of the narrow focus of supposed objectivity, and in quantum mechanics physicists are accepting the idea that an observer, and the observer's choice of what to observe, are a causal factor in the events they study (Midgley 2005: 329, 333). As a leading authority on quantum theory writes: 'the main

measure were real; if something could not be perceived or measured then it was not real or significant. Not only was this the emergence of 'Science' and of Western Modernity, but also of archaeology and of museums, since the philosophy and practice of archaeology and museology were made possible by the rigid order, measurement and objectification of Modernity's scientific approach (Thomas 2004; see below,. But the philosophical implications of dualism for humanity's relationship with the rest of nature were profound: only humans had souls and were thus intrinsically important; matter and the body were separate and discardable; and nature was there as a resource to be measured and used by humanity.[5]

Materialism

Materialism is the theory that matter alone exists: material objects, their states, properties and relations. As a doctrine it has a long pedigree, first proposed by the ancient atomists Democritus and Epicurus, and in the modern era notably by Thomas Hobbes (1588–1679), who was critical of Descartes' dualism (Morris 1991: 17–21). In many ways, ever since Descartes, Western philosophy had struggled with the mind-body problem, and how a 'mind' that has no space and occupies no mass could interact with matter which has mass and occupies space. Certainly by the 1960s, if not earlier, materialist philosophy and science had concluded, indeed felt that it was axiomatic, that 'mind' was just a fiction, a physical property of the material brain: mind and body did not in fact interact, since 'mind' was caused physically by the brain, and therefore no explanation was necessary (e.g., Rosenthal 1971, Hardcastle 2004). According to one overtly biased account: 'feelings were "reduced" to electrochemical interactions in the brain, nervous and hormonal systems. The world became one giant machine ... Its only value was its potential for exploitation by science and technology to serve the functions of industry, commerce, and government' (de Quincey 2002: 5).

In the west today, we live in a world that essentially has a materialist framework. Only matter is significant: 'mind' or 'consciousness' are explained as a physical function of the brain, and 'spirit' or 'soul' are explained as a construct of human cravings for meaning. Complexity is reduced to simplicity, science is unified, and scientific truths are reducible to truths of physics and chemistry, what McDougall nearly 100 years ago (1911: xi) characterised as 'the mechanistic dogma'. The

lesson of relativity and quantum theory is that the world is nothing but an evolving network of relationships' (Smolin 2000: 19–20).

5 It is significant, for example, that Descartes rejected the view that humans were animals. For him, animals could not think, therefore they had no souls, and were essentially automata, operating without consciousness, and thus were a legitimate resource for humans, who alone had souls. Maxwell (1984: 124) speculates how different the history of Western philosophy and Western humanity's attitudes to the non-human world might have been had Descartes owned a pet – which he did not – and experienced for himself that animals are not machines.

sociobiology of the 1970s – the systematic study of the biological basis of all social behaviour (Maxwell 1984: 133–72) – and the current 'new' science of Evo Devo – evolutionary developmental biology (Carroll 2005) – have materialism as their philosophical core. It is very much in reaction to this materialism of a 'meaningless universe' that the modern movements of environmentalism, anti-Science and New Age religions have developed (de Quincey 2002: 13–18).

The materialist argument concerning 'mind' is that consciousness 'emerges' in suitably organised biological systems (Searle 2004); but critics of this view argue that consciousness is something qualitatively different that cannot just 'emerge' but must be added to the collections of particles or molecules and their arrangements (cf. Beckermann, Flohr and Kim 1992, Midgley 2001, 2003, Velmans 2000). Nevertheless, materialism has become integrated into modern science, literature and arts, and lies at the philosophical foundation of most academic disciplines, to the extent that any alternatives are regarded as unintelligible and even outrageous (Skrbina 2005: 265, Mathews 2009). A key example for our present purposes is archaeology: as a discipline, although with its historical roots in dualism, it is now effectively materialist, dealing with inert entities (Thomas 2004: 202–22). As Thomas writes, in a statement very pertinent to the present analysis: 'the existence of archaeology is grounded in a modern attitude to the physical world, and it must be an open question whether the adoption of a radically different engagement with materiality would be compatible with anything that we could still recognise as archaeology' (Thomas 2004: 210; and see below).

Idealism

Idealism, sometimes referred to as immaterialism, is the view that only minds, mental representations, consciousness or spirit exist: material objects and their properties are reduced to mind and states of mind (Foster 2004). Although this ontology has been largely ignored until recently by contemporary Western philosophy and science,[6] it has a Western philosophical pedigree in the metaphysics of George Berkeley (1685–1753), who coined the word 'immaterialism' and who argued that to be is to be perceived (Berkeley [1710] 1962). More importantly for our purposes, however, is that it is a world-view found in many eastern religious traditions. Matter is either an illusion or an emanation from spirit. In absolute idealism, the nature of ultimate reality is spirit or pure consciousness, and the world of matter is an illusion. In Hindu tradition, *maya* (Sanskrit for 'wizardry' or 'illusion') is a sort of cosmic dream. The system of philosophy called Vedanta, completed about 800 CE, regarded the whole phenomenal world as a product of

6 The theoretical physicist and systems theorist, Fritjof Capra, in his influential book *The Turning Point* (1983) which argues for a fundamental reappraisal of the core assumptions about human consciousness and a holistic world-view more consistent with the findings of modern physics, is hugely influenced by the idealistic value system proposed by the sociologist Pitirim Sorotkin (1937–41). See Capra 1983: 13–16; also Goswami 1993.

maya, so that the world-soul, the impersonal Brahma, an eternal spirit without being or end, is the sole existing reality. This philosophical system continues to be the majority Hindu belief today (Macdonnell 1924).

Panpsychism

Derived from the Greek for 'all soul' or 'all mind', panpsychism is the view that a mental element – sentience, consciousness, spirit – is present in everything that exists, from the subatomic to the galactic.[7] Panpsychism has a long history, from the pre-Socratics, through the Renaissance, Gottfried Wilhelm Leibniz (1646–1716), and notably to Alfred North Whitehead (1861–1947) and Charles Hartshorne (1897–2000) in the twentieth century (Clark 2004, Skrbina 2005).[8] Although (until recently) dismissed by most rational Western science as primitive and romanticised,[9] panpsychism, like dualism, materialism and idealism, is a metaphysical world-view which can be neither proved nor disproved – indeed, philosophers of mind and psychologists acknowledge it as legitimate and constructive and a potential solution to the mind-body problem and to the problem of consciousness (e.g. McGinn 2004: 782, n. 2, Velmans 2000). There have been several recent scientific approaches to panpsychism within the framework of quantum theory (see e.g. Hameroff and Penrose 1996, Bohm 1990, overview in Skrbina 2005: 188–206, also Skrbina 2009), essentially arguing that quantum

7 David Ray Griffin (e.g. 1998) prefers the term 'panexperientialism', while de Quincey (2002) has coined 'radical naturalism'. Another alternative is 'animism', from the Latin for 'breath', 'soul', 'spirit', which tends to be used in religion and anthropology, frequently still in a pejorative sense: the word, though first coined by the German physician and chemist Georg Stahl (1708), was introduced into religious and anthropological discourse by the anthropologist E.B. Tylor (1832–1917) in his seminal work of 1871, *Primitive Culture* (Tylor 1913). It referred to what Tylor regarded as the earliest stage of the evolution of religion, common among primitive peoples, 'the belief in souls and spirits' (McDougall 1911: viii–x, Harvey 2005: 3–29). Harvey (2005: xi) attempts a modern redefinition of 'animism' as a recognition 'that the world is full of persons, only some of whom are human, and that life is always lived in relationship with others'. 'Panpsychism' is more common for philosophical theories that all matter contains an element of mind. Velmans (2000: 274–5) coins the phrase 'continuity theory' for panpsychism, on the grounds that consciousness co-emerged with matter and co-evolves with it, as opposed to discontinuity theories such as dualism and materialism which claim that consciousness emerged at a particular point in evolution.

8 A contemporary of Descartes, Anne Conway, one of the very few women Enlightenment philosophers (although her *Opuscula philosophica* was published posthumously in 1690), critiqued Descartes' metaphysics and set out an alternative panpsychist system. In opposition to the new philosophies of the seventeenth century, Conway argued that body was not 'dead matter' but a substance endued with life, spirit and body being one and the same thing (Hutton 2004: 3).

9 For the reasons behind this rejection, see Mathews 2009.

theory implies that elementary particles have consciousness or at the very least certain primitive mind-like qualities.

Panpsychism lies at the core of the beliefs of many contemporary cultures – e.g. Australian Aborigines, New Zealand Maori, Native Americans, cultures in parts of Africa, Asia, Central and South America, and modern Pagans and Eco-Pagans (defined as nature-celebrating spiritualities) (Harvey 2005: 33–95). Common to all these is a belief that consciousness, defined variously as a weave and web of energy moving with intention or as a means by which experience is recorded, is inherent in nature, and that humanity is nothing special, simply a part of nature (Harvey 2005: 187–94, Abram 1996: 78). Philosophically, its fundamental assumption is that it is inconceivable that sentience or consciousness could ever emerge or evolve from wholly insentient physical matter; thus, if consciousness and matter exist now, they must always have existed in some form. The central tenet of panpsychism[10]or animism is that all matter is intrinsically sentient: matter and consciousness are not separate, but always go together, and all forms of matter have an associated form of consciousness (Skrbina 2005, de Quincey 2002: 48–9, Midgley 2001, Velmans 2000: 275, McDougall 1911). Since the use of the term 'panpsychism' is normally restricted to philosophical discussions, and 'animism' is commonly used within anthropological, religious and cultural discourse, the term 'animism' will be used throughout the rest of this chapter.

The Human Body

What is a human body, what value does it have, and does that value change depending on whether the body is alive or dead?

My concern with these questions is not the archaeological or anthropological study of embodiment, which is a growing field (cf., e.g., the papers in Hamilakis, Pluciennik and Tarlow 2002, Leder 1990). Instead, I want to highlight the tension between the conceptualisation of the value of the body (especially the dead, buried, then exhumed body) inherent in archaeological practice, and the value of the (dead) body in alternative world-views.

In Cartesian dualism, the body is simply a mechanism, to which the soul or self is somehow attached during life. It is the soul that is immortal, not the body. Descartes was motivated by a concern for immortality, and his dualistic view is still the basis for Christian theology: it is the soul not the physical remains that matter, and the fate of the body has no effect on resurrected life. In a sense, for Descartes, the living body was not essentially different from the lifeless: it was a kind of animated corpse, a functioning mechanism. In separating thinking from materiality, the Cartesian model of embodiment has made the dead body,

10 For a rigorous analysis of the premises of panpsychism by an analytical philosopher, see Nagel 1979. For a similar analysis by a psychologist, see Velmans 2000, especially pp. 273–6.

the machine body, paradigmatic (Leder 1992). The dualistic dead body is a mechanism, devoid of meaning, a resource, a 'thing' to be used. In this sense, the dead body is no longer a 'person'.[11] In every way except one, the materialist view of the body is identical: the single exception is that materialism recognises no separate mind or soul that survives – everything is a biological mechanism, which at death ceases to have value or personhood.

The idea of a 'person' largely used within ethics today is the one worked out by Immanuel Kant ([1785] 1991: 90–92, sections 428–32). The Kantian person is a rational being, capable of choice, endowed with dignity, worthy of respect, having rights, and to be regarded always as an end in itself, and not as a means to the ends of others. As Midgley (2005: 136) points out, this definition deals with rational qualities and makes no mention of human form or descent, and the spirit behind it would not allow us to exclude intelligent aliens or disembodied spirits.[12] But, in the dualistic/materialistic world-view, it does exclude the dead as persons, which means that the dead body must, logically, be a 'thing', according to the stark antithesis between persons and things which Kant originated. 'Things' can legitimately be used as means to human ends in a way in which 'persons' cannot. 'Things' have no aims of their own; they are not subjects but objects (ibid.). Traditionally archaeology, as an archetypal dualist/materialist practice, treated dead bodies as 'things', for its own ends (Hubert 1992, 1994, Fforde 2004: 154–6), although more recently the personhood of the dead in some cultures has been recognised and acknowledged (e.g. Zimmerman 1998, Fowler 2004: 79–100).

Idealistic conceptualisations of the body, and of death, do not really impinge on archaeology, and are not relevant to the main thrust of this paper. For example, in Hindu philosophy, the body is just a cosmic illusion: the true nature of the self is in reality identical with Brahma. Furthermore, at death Hindu bodies are cremated and usually deposited in sacred rivers, so cannot be exhumed through archaeology (Macdonnell 1924, Ghosh 1989). 'Being' is permanent: 'that which is can never cease to be' (quoted from the *Bhagavad-Gita* by Carse 1980: 133). The process of cremation (fire) and scattering in a river (flood) is cosmological, assimilating the individual into the process of cosmic regeneration (Parry 1994: 30–31).

In animism, there is no separation between mind and body within a human: they are one. Sentience, or consciousness, is everywhere: within nature, within individual, cohesive humans, and even human cells communicate with each other according to their own purposes, without conscious choice on the part of the human individual. I refer to this as 'the integrated body'.

11 Bynum (1995) notes that the Western dualist tradition identified the body – in effect something to be abhorred – with nature and the female and was by definition misogynist. In contrast, ordinary people in the Middle Ages had no particular notion of the body, rather such ideas were 'characterised by a cacophony of discourses'.

12 Harvey (2005: 99–114) re-defines animism as a recognition of the personhood of non-humans such as animals, plants and sometimes inanimate objects and places. For non-human personhood, see also Bird-David (1999).

At death, in the animist world-view, there is no separation between 'spirit', or 'consciousness', and 'matter'. In a world-view that does not separate anything, in which even the notion of the 'individual' is inaccurate,[13] in which everything is connected, what remains is the totality of their experience and of their relationships (Abram 1996: 15–16, 166–7, Restall Orr 2005). It remains in the shared consciousness of the community, their heritage, the land, and in the corpse. When a person dies, part of the community dies, but not all of it. The dead body is still integrated, still a person.

There is therefore, ontologically (though not always in real-life situations, where contradictions abound), a stark polarisation between the dualist/materialist view of the dead body as a mechanism, no longer a person, just a 'thing' to be used, and the animist view of the dead body as continuing to be an individual's consciousness, of continuing value, still a person. From the former perspective, it could be argued that our moral responsibilities towards the dead body are limited, since it is merely a 'thing' which does not feel anything. From the latter perspective, what is the logical conclusion of the continuing personhood of the dead, and how does it affect our responsibilities towards the body: does the body, and the person, continue to 'feel'? It is instructive to re-visit Jeremy Bentham's famous question concerning our moral responsibilities towards animals, and ask it of the dead: 'The question is not, can they talk? nor, can they reason? but, can they suffer?' (Bentham [1781] 1996).

Can the dead suffer? This is not an emotionally loaded, irrational question: the only sense in which we can answer 'no' definitively is if we privilege a dualist/materialist world-view. Within an animist world-view, the dead exist within the living (the land, the community, the descendants), but also some would say that they can suffer as individuals. In the same way that scientific research has demonstrated experimentally that plants respond to stress, and thus hold memory and feel anxiety in their cells despite the lack of neural structures (e.g. Holmes and Yost 1966, Applewhite 1975, Trewavas 2003) – although how they feel that stress is beyond our ability to know since they do not have the language to express the experience and describe the sensory 'qualia' – so too for the animist the same is true of the dead. In a world-view that experiences nature as a fabric of existence, if any part of that fabric is stressed the effects are felt throughout the weave in its proximity – and so the particularly sensitive among the living (e.g. the animist seers and shamans) can feel that stress (Harvey 2005). In this sense the dead are not 'neutral': they can and do speak, but not everyone can understand (*contra* Hanson 2007). Tarlow (2006: 203) therefore asks if we should extend our moral

13 I am reluctant to use the now accepted term 'dividual', which some use to refer to human indivisibility from the world (e.g. Bird-David 1999, Strathern 1988), preferring the concept of the 'integrated body'. 'Dividual' was coined by McKim Marriott in his work on Indian caste and personhood (Marriott 1976), referring to persons constantly altered by social interaction and the transmission of 'substances' from one body to another. This seems to have a much more restricted and contingent sense than 'the integrated body'.

responsibilities to include the dead, who from some perspectives are not 'past' at all but actually 'present'.

Life, Death and the Meaning of Burial

The terms 'life' and 'death' are socially and culturally contingent and not self-evident. Their meanings – and consequently the meaning of burial and of exhumation – depend entirely on world-view. Within dualism, materialism and animism, what is life, and what is death? Are they separate? Is the distinction biological and measurable, or is it merely a cultural construct?

As noted above, Descartes was fundamentally concerned with proving the existence of God and the immortality of Man, and the body was simply a useful mechanism during life. Thus, in Cartesian dualism, the death, or dissolution, of the body is self-evident and unproblematic;[14] but the soul, or spirit, does not die, it survives and 'passes at once to the more spiritual atmosphere of the Heavenly Kingdom...Our earthly body has served its purpose and returns to the earth whence it came' (Macintyre 1924: 99). For the dualist, the critical issue concerning death is the one raised by Pope Pius XII, addressing an international congress of anaesthetists: at what point, in the intensive care unit, does the soul actually leave the body? (Pope Pius XII 1957).

In materialism, there is no 'soul' or 'spirit' to muddy the waters of life and death. The human life that we have now is all there is, all there ever will be. The death of a human being is the end of the human being: it is absolute nothingness, an existence without thought, the end of consciousness and of all experience (Bauman 1992: 2–18). In the words of the archetypal postmodern materialist, the sociologist Zygmunt Bauman, death is the state of '... a void or fullness *without me to tell it as such*. It is my death that cannot be narrated, that is to remain unspeakable. I am not able to experience it, and once I go through it, I shall not be around to tell the story' (Bauman 1992: 3, original author's italics).

Materialism, securely embedded within a scientific view of life, attempts to measure the process of death precisely and merely debates how to define clinical death in terms of entropy change, whether through cardiac stoppage, brain death, or, since the 1970s in the west, brain stem death (Bernat 1984, Harris 1985: 240–41). A characteristic materialist view which links life, consciousness and experience fundamentally to the workings of the human brain is:

> Man's consciousness and personality depend absolutely upon the functioning
> of the brain and cease to exist when the brain, and the body as a whole, dies.

14 Paradoxically, despite his belief in the discardability of the human body and the immortality of the soul, Descartes' scientific work was motivated by the threat of the perishability of the human body, and he worked to overcome disease and increase life span (Leder 1992).

For consciousness is a temporary by-product of the mammalian nervous system when this has evolved to a certain level of complexity, and there can accordingly be no question of the conscious personality surviving the death of the body. (Hick 1985: 150)

In an animist world-view, the death of the integrated body is not a final cessation, but a transformation, and animist cultures have many different explanations of that transformation, whether into disembodied spirit(s), 'ghosts', animals, decay and regeneration, energy or spirit beyond the limitations of human time and space, or the dissipation of consciousness into subatomic particles (Harvey 2005, Abram 1996, Restall Orr 2004). The person's consciousness does not vanish from the phenomenal world but remains as an animating force in the dead body, in the landscape and in the community (Abram 1996).

In some ways, it is perhaps inappropriate within animism to use two such radically polarised terms as 'life' and 'death'. They are not so distinctly separate: life (perhaps a better word is 'being') is recognisable in many forms, processes and actions. In that sense, death is not a fixed state opposed to life, but a transformation of the living and their relationships.[15] In most if not all animist cultures, the death of a person merely transforms the nature of the relationship with the living. The fact that they are 'dead' is the least important aspect: mourning, contact and connection continue through different mechanisms such as myth, ritual, and shamanistic mediation (Harvey 2005). The dead, as 'ancestors', continue to be part of the community, they continue to have value, their stories are sacred: they are still *persons*.

Turning to the meaning of burial within the different world-views,[16] within the strict aims of this paper which looks towards the possibility of eventual exhumation, I want to ask a very restricted question: how important is the continued coherence, or 'sanctity', of the burial? – and thus, the effect on individuals and communities holding different world-views when the dead are exhumed and (re-)emerge into the world of the living.

Within a dualistic Christian framework, the fate of the burial, and of the remains of the deceased, have no impact at all on the resurrection of the soul. Indeed, the Christian burial rite almost entirely concerns the repose of the soul of the deceased. The burial place itself is a memorial, since the nineteenth century in the west mostly situated away from population centres and so less obviously a part of the community. As Ariès (1974) points out, in terms of attitudes towards death from the nineteenth century on, burial places were less about the fate of

15 Echoed by Nietzsche 1974: 168: 'Let us beware of saying that death is opposed to life. The living is merely a type of what is dead, and a very rare type'.

16 For cultural responses to death, and for changing burial practices and beliefs in general, see Ariès (1974). See also Harrison (2003: xi) for the custom of burial providing the definition of what we think of as humanity. '[H]umanity … is a way of being mortal and relating to the dead. To be human means above all to bury'.

the deceased than about a reminder to the living that they themselves were still present, still surviving. In contemporary dualistic Christianity, the body can be either interred or cremated, and, other than a general feeling that human remains should be treated with respect and reverence,[17] the fate of the body is theologically irrelevant (although it should be noted that actual practice and beliefs vary from theological doctrine in being multiple, discordant and inconsistent). Indeed, the Church of England acknowledges that the excavation and study of human remains is an important source of scientific information, although it restricts this to graves over 100 years old: that concern is for the sensibilities of surviving close family members, and not for the fate of the deceased (Mays 2005).

Shorn of the need for theological meaning and resurrection, a materialist burial is simply a memorial for a human being who does not exist any more in any sense. It functions as a mark of respect for the deceased, but perhaps more as spiritual comfort for the still living:

> The practising of commemorative rites has a reassuring effect on those who practise them and watch everybody around practising them as well: what they do now to their predecessors will be done to them by their own successors. The remembering of today will themselves, come their time, be remembered. Collective memory will in the future, as it does now, outlast individual life, and the future dead will then, as they do now, go on living in the spirits of those who are not dead yet. What we do unto others will be done unto us. (Bauman 1992: 52)

The exhumation of a materialist burial has no effect on the fate of the dead person who has ceased to exist. It affects the still living, who often identify with the fate of the exhumed body, and tend to express a preference that the same fate does not befall them: 'what if that were me?'[18]

The integrated body, in the animist world-view, is still connected with the community and with the land. Through burial, the body seeps back into the earth, dissolving cell by cell – either through inhumation, or by cremation is released back into spirit, breath and wind. Each body, and each bone, tooth or heap of ash, contains the stories not only of the individual, but of a people and its landscape. They are the heritage and ancestral treasure of the community that must be allowed

17 Teague (2007) explores the issues of respect around the decision-making process in the treatment of human remains within the framework of Rawls' *Theory of Justice* (1999) – the idea of justice as fairness. For the problem of respect for human remains, and how it is defined and manifested, see also Scarre 2006: 182, 2007: 142–3, Tarlow 2006: 208, and Bienkowski 2009. For 'respect for the dead' and how it is viewed in contemporary medicine and bioethics, see Harris 1985: 219–22.

18 Although the archaeologist Sir Mortimer Wheeler, when asked how he would feel if his body were to be exhumed as part of an archaeological project, famously replied 'Well, I'll be dead, won't I? They can do what they like' (quoted in Finn 2007: 28).

to release back into the earth (Abram 1996, Restall Orr 2005). It is important to stress here the attachment of the dead to their community and to their land. For example, the animist world-view of Australian Aborigines is based on sites and places, not on time and history, and their narratives about the lands and life, called 'Dreamings', include ancestors now dead who are still included in the community (e.g. Swain 1995, Abram 1996,). The exhumation of a dead person, or any part of the dead person, or the earth into which his spirit has dissolved, is a desecration and disturbance of the dead person, and a violation of an ancestor felt by the whole community.[19] For this reason Australian Aborigines, New Zealand Maori, and Native Americans in recent years have felt so deeply the need to repatriate and rebury the remains of their ancestors held in Western museums: those dead are still persons, and they belong back in their community, as an integral part of that community, dissolving into their ancestral lands (Fforde 2004, Hubert and Fforde 2002, Crissman 1994). In the United States, the passing of the Native American Graves Protection and Repatriation Act (NAGPRA) in 1990 acknowledged the spiritual needs of Native Americans with regard to the dead, and created a new relationship between the tribes, government, archaeologists and museums (McManamon 2002). In parts of Africa, too, history is experienced as an uninterrupted continuum (Kense 1990), and the connections are felt through ancestor veneration, kinship relations and sacred locations: the present is not separate from the past but is experienced through ancestors, objects and landscapes imbued with spiritual significance (Kankpeyeng, Insoll and MacLean 2009).

A large part of the conceptual misunderstanding between Western academics and indigenous peoples relates to the experience of connection between living and dead across long spans of time: how, Western academics ask, is it possible to experience any individual or community connection with people who have been dead hundreds or even thousands of years? The key to this misunderstanding lies in different experiences of time. Those who work closely with indigenous peoples stress that, whereas Western scientists see time as linear, a sequence of events linking generations of people, for many indigenous peoples time is circular. The philosopher Henri Bergson, working within the framework of Western philosophy, critiqued the scientific concept of time – linear and divisible into equal and measurable intervals – as ultimately a fiction, to be distinguished from the intuitive experience of (real) time ('real duration'). Linear measurable time is confused with space, where events can be laid out alongside another and quantified. Real duration as experienced by consciousness cannot be quantified, since past and present states form an organic interconnected whole, binding the past to the present. It is such real duration, linking past with present, linking the dead with those still living, that is experienced by indigenous peoples: such direct experience of ancestors through consciousness by animist cultures

19 A Native American Pawnee, Riding In (1996: 238–40), refers to the study of 'stolen' human remains as 'abominable acts of sacrilege, desecration, and depravity' (quoted in Groarke and Warrick 2006: 173).

sits outside the category of scientific linear measurable time, which is simply inapplicable to their experience (Bergson 1960, see also Pearson and Mullarkey 2002, Guerlac 2006). Whereas in the west people are usually concerned only with a very few generations into the past – maybe as far as their grandparents – indigenous peoples regard ancestors who died hundreds of years ago as still members of the group living today (Pullar 1994).

Yet, archaeologists working with the dead in sensitive, emotional and often stressful social situations across the world (e.g. Hanson 2007, Crossland 2000, 2002, Sanford 2003, Sant Cassia 2005) should acknowledge that such animist beliefs – including experience of connection across long spans of time – are not confined to so-called 'exotic' cultures that heritage institutions in the west feel honour-bound to placate in apology for previous colonial exploitation (Sadongei and Cash 2007: 99): animism is a philosophically valid world-view held and experienced by many in the west and elsewhere today, who feel just as strongly about the disturbance of those whom they regard as their ancestors, and who have a continuing relationship with those dead who might be exhumed through archaeology (e.g. Harvey 2005). As Verdery (1999) points out, in contemporary eastern-Europe kin, descendants, territory and burial sites are inseparable from each other: everything is connected, and acknowledging those connections is vital if archaeologists are to build effective relationships in sensitive social contexts which deal with the dead – especially, but not exclusively, the more recent dead.

Archaeology and Archaeological Exhumation

Understanding this potential tension between world-views is crucial, because archaeology and museums were historically set up on dualist/materialist foundations: as disciplinary practices, they tend to objectify 'things', including dead bodies, and treat them as evidence, museum specimens and displays. Archaeologists and curators often tend to refer to a body, revealingly, as 'it'. This attitude is still inherent in archaeological and museological training and practice.[20] Julian Thomas (2004) has demonstrated in detail that the Cartesian development of 'objective' Science made possible the development of archaeology as a discipline from the eighteenth century onwards. Archaeology, as a form of scientific, rational enquiry, was supposed to be context-free, objective, 'involving causes and effects, fixed in linear time' (Thomas 2004: 41), creating new knowledge from the observation and measurement of material things (ibid. 53).

Whether plundering Egyptian tombs and amassing collections of mummies, or excavating prehistoric barrows in England, early archaeologists treated human remains as an archaeological object, depersonalised, 'a thing' to be excavated,

20 For the use of different vocabularies which reveal respect or its lack with regard to human remains, cf. Cassman, Odegaard and Powell 2007: 1; also Brooks and Rumsey 2007: 264.

studied, analysed, dismembered, displayed in a show-case with an explanatory label, or put in a box in a museum storeroom with a number, like other 'things', and with other 'things'.[21] From the Enlightenment on, human bodies and body parts were displayed in museums as part of scientific, ethnographic, archaeological or medical exhibitions (Brooks and Rumsey 2007). This is a perfect reflection of the Cartesian dualism from which archaeology sprang, and, with the development of the 'New Archaeology' in the 1960s, based on logical positivism, archaeology again perfectly reflected the materialistic world-view of its time (Thomas 2004).

Reflecting this dualist/materialist world-view, archaeology as a discipline, a practice and a discourse objectified the excavation of burials and the disturbance of burial sites, regarding it as beneficial and relatively unproblematic. In its pursuit of objective, documented 'knowledge', in most countries (other than the United States under the NAGPRA legislation, and in Australia and New Zealand with their policies of repatriation to source communities), despite procedures of ethical and legal discussion and permission, archaeology continues to retain many human remains indefinitely – often even those without useful contextual information – on the basis that future research questions and methods make their continuing availability and analysis useful (Lackey 2006, Bienkowski 2007a). 'Research potential' takes precedence over ethical recognition of the intentions of past human beings. The idea that many ancient burials and funerary remains were deliberately deposited with a presumed intention not to be disturbed is an issue that is occasionally raised theoretically, but with no resulting practical change (Bahn 1984, Scarre 2006, 2007, Tarlow 2006: 210): except in the United States, Australia and New Zealand, authority to excavate, retain and research human remains continues to lie completely in the hands of archaeologists, despite the interests and occasional protests of other interest groups and communities (Bienkowski 2007a).[22] Yet the 'research potential' argument has been used and discredited since the nineteenth century, when the British Museum was accused of having dark cellars crammed full of 'skulls filthy with dust' so 'ingeniously catalogued' that it was 'difficult to ascertain the number even of the specimens' (quoted by MacDonald 2005: 184). As MacDonald comments, '[s]o much for the argument that some kind of disembodied research-based science required these bones' (ibid.).

Increasingly, though, these expectations of archaeologists across the world are being challenged – for example in the Middle East, with growing tensions and controls over the excavation of Muslim or Jewish burials (Nagar 2002);[23] with

21 'One collected skeletons much the way one collected butterflies or rocks': a typical and revealing quote referring to the systematic excavation of Aboriginal graves in the early 1900s (quoted in Byrne 2004: 247).

22 The issue does have effects on the personal level: Finn (2007) describes her increasing emotional discomfort in excavating human (and animal) remains.

23 Two recent international workshops in Jerusalem have explored local state policy and approaches to graves in the region: 'Holy Sites – Graves and Cemeteries: Bridging

the repatriation of indigenous human remains from Western museums for reburial in their originating communities (Fforde, Hubert and Turnbull 2002); and more recently with some Pagan communities in the United Kingdom advocating for the reburial of ancient pre-Christian human remains and for involvement in decision-making around those remains (Bienkowski 2007a, Sayer 2009; see further below). Many archaeologists still reject those communities as 'unrepresentative' and 'biased', brand them as 'romanticised', accuse them of being against academic research and of preventing legitimate access to archaeological evidence,[24] and dismiss their interests and claims as political posturing by marginalised communities (Woodhead 2002: 342–7). The following quote is characteristic:

> Anyone who takes these claims seriously has a level of credibility that makes them an ideal prospective purchaser of the Brooklyn Bridge. What is at the basis of these claims is merely a vague generalized feeling about "spirituality of Indians" that is being effectively used in the political arena. (ACPAC 1989)[25]

The key point is that such reactions and accusations by (some) archaeologists only have validity from within their own disciplinary world-view of dualism or materialism, which objectifies knowledge and depersonalises human remains and their connections to contemporary individuals and communities. This is a clear and obvious example of the tensions and misunderstandings created with the clash of polarised world-views: in this case, I would suggest, with some archaeologists, trained within their particular discipline, being so embedded in a dualist/materialist world-view that they regard it as self-evidently legitimate and axiomatic, and reject all other views as 'fringe' or 'New Age' (Lilley 2009: 57) that frustrate their legitimate access to 'evidence' – a clear parallel to the power/knowledge claims of experts who have the authority to 'speak' about or 'for' other forms of heritage (Smith 2006: 11–12). As Layton observes (1994), just because human remains are considered to be of value to science, this does not mean that science consequently has rights over them. Archaeologists are only one among several interest groups with competing claims regarding human remains – and in that sense the concept of archaeological 'stewardship' is inappropriate (Groarke and Warrick 2006).

Religious Viewpoints and Activist Initiatives' (December 2006), and 'Respect for Burial Practices and Graves in the Holy Land' (June 2007). The discussions included the growing controversy around the excavation of grave sites (Stoyanov 2008).

24 Cf. the development of the repatriation debate chronicled by Fforde (2004); Zimmerman (1994); also Bienkowski (2007a) for recent developments in the United Kingdom.

25 For similar arguments from the pre-NAGPRA era in the United States, see Layton (1994). Much the same arguments – using similar language – are still being made in the United Kingdom today: see, for example, Smith and May (2007), or Sayer (2009: 199) who states that modern British Paganism 'is as much a lifestyle decision or a vehicle for political protest as it is a belief'.

Looking Ahead

Summarising the key arguments above, in archaeological exhumation, and particularly in the use of ancient human remains in scientific study and in museums, the deceased is no longer regarded as a person: their moral status has changed. As a leading bioethicist, John Harris, has explained, it is 'persons' that matter morally. It is not 'life' that is important, but personhood (defined as any being capable of valuing its own existence). At death, the being ceases to be a person, and loses their moral significance (Harris 1985: 241–2), which is how dualist/materialist archaeology treats the dead in terms of decision-making processes around the fate of the remains.[26] In the animist world-view, the moral status of the dead person continues: they are still part of the community, part of the land, they are ancestors whose stories are sacred.

In recent years there has been a change in the ethical climate on the treatment of human remains. As noted above, this was kick-started in the United States by the struggles of Native Americans that led to the signing into law of NAGPRA, and by Australian Aboriginal requests for repatriation (see Fforde, Hubert and Turnbull 2002). The latter originated in the growing political cohesiveness and power of indigenous groups in Australia, who eventually felt confident enough to demand the return of the remains of their ancestors. Although it was a process largely resisted by archaeologists, despite the Vermillion Accord,[27] who showed little appreciation of the different world-view inherent in Aboriginal culture, it gained political backing both in Australia and in the United Kingdom with a joint declaration in 2000 by the UK and Australian prime ministers. Within the United Kingdom this led eventually to the 2003 *Report of the Working Group on Human Remains* (DCMS 2003), the 2005 *Guidance for the Care of Human Remains in Museums* (DCMS 2005), and the 2005 *Guidance for Best Practice for Treatment of Human Remains Excavated from Christian Burial Grounds in England* (Mays 2005). In parallel, within the United Kingdom, scandals about the use of body parts of dead children for research without the knowledge of their relatives led to the 2004 *Human Tissue Act*, which strictly regulates the research use of human bodies and body parts less than 100 years old.

26 Tarlow (1999) argues that the dead retain a social presence through various social and cultural animating processes, and consequently do retain a moral status.

27 The Vermillion Accord on Human Remains was adopted in 1989 at the South Dakota World Archaeological Congress Inter-Congress. The fundamental underpinning of its six principles is the notion of 'respect' both for the dead themselves and for the concerns of contemporary ethnic groups. The Accord is reproduced widely, in publications and on the internet, e.g. conveniently in Sadongei and Cash 2007: 101, and online at www.worldarchaeologicalcongress.org/site/about_ethi.php#code2 [accessed 11 January 2007]. As Zimmerman (2002: 97) comments: 'What have mostly not changed since the Vermillion Accord are attitudes about the primacy of scientific approaches to the past' (quoted in Scarre 2006: 182, n. 1).

In general, such ethical guidelines leave the ontological grounding of archaeological practice unchallenged, instead finding ways to ameliorate its effects. Nevertheless, within some areas of the archaeological discourse, in recent years too it has been recognised that the pursuit of archaeological knowledge can no longer be regarded as being intrinsically more valuable than the interests of the dead themselves, or the living communities for whom those dead are 'ancestors' or otherwise remain connected (e.g. Scarre and Scarre 2006, and other papers in the same volume, Layton 1994). The discourse of 'cosmopolitanism' in archaeology recognises the claims of 'connected' communities as primary and having greater weight than other stakeholders, including archaeologists themselves (Meskell 2009: 5–7); nevertheless, much of this discourse is concerned with privileging indigenous communities and a 'postcolonial cosmopolitanism', rather than a true 'postmodern cosmopolitanism' which would acknowledge that different world-views and ways of connecting with the past and with the dead can be found outside indigenous and postcolonial communities, for example in Western urban contexts where there exist communities who are connected in different ways. Key strands in anthropological archaeology are increasingly drawing upon complex understandings of the dead as having agency and sentience (e.g. Robb and Boric 2008), some of them developed from forensic archaeological work among contemporary communities in different parts of the world (e.g. Sanford 2003, Congram and Bruno 2007) – indeed some scientists see the dead body as retaining an individual's personality in some way (Hanson 2007). We are witnessing the first steps within archaeology and anthropology towards an acceptance that, by choosing to excavate human remains in an objectified social and political vacuum without taking into account the beliefs and interests of other individuals and communities, and by holding on to material evidence indefinitely, particularly human remains, archaeologists are in a sense themselves in danger of 'romanticising' the scientific paradigm, privileging the archaeological record – and their own disciplinary world-view – above all other concerns (Lilley 2009). As Byrne (2009: 86) puts it, there is a gulf between the 'imaginary world' of the archaeological discourse and the world of actual social practice within which archaeologists work.

But the ontological divide remains: Congram and Bruno (2007: 41–6) describe the 'noble lie of objectification' and the perceptual gap between, particularly, forensic archaeologists and the public. They claim that 'the passage of time erases empathy' and that we are 'after all, excavating the dead solely for the sake of the living'. Neither of these is the case in an animist world-view: visceral connections with the dead can be felt across millennia, and the dead themselves are experienced as having sentience and agency, and often feeling profound unease, sadness or fear that they have been removed from their burial place (Harvey 2005, cf. Finn 2007 for an archaeologist's empathy with the integrity of a burial).

The human remains discourse has parallels with, and of course is a part of, the wider heritage discourse analysed by Smith (2006). Just as the 'heritage gaze' is not so much a 'thing' as a set of values and meanings, so too human

remains are not 'things' but create and reflect multiple meanings and experiences. Archaeological exhumation, like heritage in general, is ultimately a cultural practice. The biggest challenge to the 'authorised human remains discourse' and its institutionalised expertise in the United Kingdom in recent years has been the pro-active and organised work of Pagan groups such as Honouring the Ancient Dead (HAD, see www.honour.org.uk, Sayer 2009). This is an advocacy group that works on behalf of a dispersed and diverse community, and with local communities (Pagan and non-Pagan), to develop dialogue and involvement with museums and archaeological units around pre-Christian human remains. In a sense HAD has taken Smith's (2006: 35) idea of 'subaltern heritage' – an alternative, local, non-expert response to the 'authorised heritage discourse' – a step further by challenging the ontological basis of institutionalised decision-making around human remains. HAD has challenged museums and archaeological units – many of whom resist actively or try to resist by simply not responding – to develop practical ideas and criteria to include spiritual interests in decision-making and programming, and to allow external communities a say in that programming. An example is HAD's response to the 2009 English Heritage/National Trust Consultation on the Request for Reburial of Human Remains at Avebury, Wiltshire (www.english-heritage.org.uk/server/show/nav.19819; Wallis and Blanin 2011).

While in its response HAD did not fully support the request for reburial made by another Pagan group (which was not seen as representative of the views of the Pagan community), it both challenged the use of the *Guidance for the Care of Human Remains in Museums* (DCMS 2005) as the criterion for decision-making, regarding it as inapplicable for human remains of British provenance, and at the same time fully backed the appropriateness of the reburial request on religious and spiritual grounds, based upon 'genuine, experiential, spiritual connection and the profound duty of care which such a deep connection evokes' (HAD: www.honour.org.uk/node/281).

Alongside HAD, which acts from a religious perspective, are other, geographically based groups such as parish councils and local historical societies with a strong sense of community and connection between past and present inhabitants, who are also demanding some say in the future of ancient British human remains (Bienkowski 2007b). In this way these groups are making an important statement that human remains are not only about evidence and public display which can be left to expert practitioners who speak 'for' those remains, but that there is a body of multi-vocal, non-archaeological knowledge that is equally relevant and equally valid: knowledge in which experience of connection to the dead is linked to place, to the dead of that place and/or of that community, and is an important part of the construction of community and cultural identity, often at a local level. Sayer (2009: 204), while critical of aspects of the Pagan approach, concludes that they are 'entitled to ask for respect to their attitude to the dead', and calls on archaeologists to develop a constructive contextual dialogue (see also more generally Sayer 2010).

Nevertheless, such dialogue would need to acknowledge the validity of alternative world-views. The intellectual and practical limitations of archaeology's dualist/materialist underpinnings have become a barrier, as archaeology increasingly interfaces in sensitive social and political situations and develops relationships with communities with different world-views and understandings of death and the dead body. Like the supposedly 'hard' sciences of relativity and quantum theory (see footnote 4), the practice of archaeology may need to develop to be more about subjectivity and relationships, relinquishing purely archaeological goals (e.g. Meskell 2009). As forensic and mortuary archaeologists, and museum curators, come into contact with a range of divergent beliefs, often in emotional and stressful situations, such as human rights missions dealing with recent war dead or disappeared persons, or repatriation and reburial requests, in which relationships must be negotiated and sustained (Wright, Hanson and Sterenberg 2005, Fforde, Hubert and Turnbull 2004, Congram and Bruno 2007), it should be recognised that the objectification of the dead body within archaeological practice is not just a practical methodology for carefully gathering evidence and dealing with technical matters and protocols (which admittedly might mitigate stress among participants: Hanson 2007): it is also embedded within a particular world-view that denies the personhood of the dead and the direct experience of the continuing relationships of the living with the dead. Recognising archaeology's world-view, and stepping outside it to see it clearly for what it is, facilitates easier recognition and acknowledgment of alternative beliefs. In this way archaeology, both as a practice and as a theory, can become less detached and objective, and be entwined into the web of social relationships around exhumation which may include grieving, mourning and ongoing connections with the dead.

It is archaeologists, museum curators and heritage managers who should take responsibility for understanding alternative world-views and taking positive action to include others in their discussions, programmes and decisions. It is not enough to listen and to claim to understand: institutionalised archaeology wields huge authority and too often expects anyone engaging with it to speak its own language, or otherwise risk being ignored and excluded from its 'authorised discourse' (see Lilley 2009). Institutionalised archaeology sets the criteria by which decisions are made and according to which the input of external communities (if any) is allowed and judged: practical recognition of the validity of alternative approaches to the dead means giving equitable value to alternative world-views, languages and decision-making criteria. Any constructive dialogue needs to be fully backed by institutionalised archaeology and heritage bodies, who should ensure that criteria for consultation and decision-making do not privilege the materialist world-view of archaeology, but give equal weight to criteria based on experiential connection, a different experience of time, and different conceptions of what it is to be alive and what it is to be dead. Otherwise, archaeology will remain a discriminatory practice, appropriating the ancient dead for its own purposes, within its own conception of what constitutes valid knowledge, and within its own set of hierarchical understandings of legitimacy and world-view.

References

Abram, D. 1996. *The Spell of the Sensuous: Perception and Language in a More-Than-Human World*. New York: Pantheon Books.

ACPAC. 1989. *ACPAC Newsletter*, July 1989. Garden Grove, CA: The American Committee for the Preservation of Archaeological Collections.

Alquie, F. (ed.) 1973. *Oeuvres Philosophiques de Descartes*. Paris: Gamier Frères.

Appleby, J., Covington, E., Hoyt, D., Latham, M. and Sneider, A. 1996. The scientific revolution and Enlightenment thought: Introduction, in *Knowledge and Postmodernism in Historical Perspective*, edited by J. Appleby, E. Covington, D. Hoyt, M. Latham and A. Sneider (eds). London/New York: Routledge, 23–28.

Applewhite, P.B. 1975. Learning in bacteria, fungi, and plants, in *Invertebrate Learning 3: Cephalopods and Echinoderms*, edited by W.C. Corning, J.A. Dyal and A.O.D. Willows. New York: Plenum Press, 179–186.

Ariès, P. 1974. *Western Attitudes Toward Death: From the Middle Ages to the Present*. Baltimore/London: Johns Hopkins University Press.

Bahn, P. 1984. Do not disturb? Archaeology and the rights of the dead. *Journal of Applied Philosophy*, 1, 213–26.

Bauman, Z. 1992. *Mortality, Immortality and Other Life Strategies*. Cambridge: Polity Press.

Beckermann, A., Flohr, H. and Kim, J. (eds) 1992. *Emergence or Reduction? Essays on the Prospects of Nonreductive Physicalism*. Berlin: De Gruyter.

Bentham, J. 1996 [1781]. *An Introduction to the Principles of Morals and Legislation*, edited by J.H. Burns and H.L.A Hart. Oxford: Oxford University Press.

Bergson, H. 1960 [1889]. *Time and Free Will: An Essay on the Immediate Data of Consciousness*, trans. F.L. Pogson. New York: Harper and Row.

Berkeley, G. 1962 [1710]. *The Principles of Human Knowledge* (ed.) G.J. Warnock. London: Collins.

Bernat, J.L. 1984. The definition, criterion, and statute of death. *Seminars in Neurology*, 4(1), 45–51.

Bienkowski, P. 2007a. Authority over human remains: Genealogy, relationship, attachment, in *The Disturbing Past: Does Your Research Give You Nightmares?* edited by J. Holloway and A. Klevnäs. *Archaeological Review from Cambridge*, 22(2), 113–30.

Bienkowski, P. 2007b. Care assistance. *Museums Journal*, June 2007, 18.

Bienkowski, P. 2009. The issues of custody and practical respect. Paper given at the conference 'The Care of Ancient Human Remains', Leicester, 17 October 2009, available at: http://www.honour.org.uk/system/files/HAD%20Conference%20paper%20-%20Piotr%20Bienkowski(2).pdf.

Bird-David, N. 1999. 'Animism' revisited: Personhood, environment, and relational epistemology. *Current Anthropology*, 40, S67–S91.

Bohm, D. 1990. A new theory of the relationship of mind and matter. *Philosophical Psychology*, 3(2), 271–86.

Brooks, M.M. and Rumsey, C. 2007. The body in the museum, in *Human Remains: Guide for Museums and Academic Institutions*, edited by V. Cassman, N. Odegaard and J. Powell. Lanham, MD: Altamira Press, 261–289.

Bynum, C.W. 1995. Why all the fuss about the body? A medievalist's perspective. *Critical Inquiry*, 22, 1–33.

Byrne, D. 2004. Archaeology in reverse: The flow of Aboriginal people and their remains through the space of New South Wales, in *Public Archaeology*, edited by N. Merriman. London/New York: Routledge, 240–254.

Byrne, D. 2009. Archaeology and the fortress of rationality, in *Cosmopolitan Archaeologies*, edited by L. Meskell. Durham/London: Duke University Press, 68–88.

Capra, F. 1983. *The Turning Point: Science, Society, and the Rising Culture*. London: Flamingo.

Carroll, S.B. 2005. *Endless Forms Most Beautiful: The New Science of Evo Devo and the Making of the Animal Kingdom*. New York: Norton.

Carse, J.R. 1980. *Death and Existence: A Conceptual Theory of Human Mortality*. New York: John Wiley.

Cassman, V., Odegaard, N. and Powell, J. 2007. Introduction: Dealing with the dead, in *Human Remains: Guide for Museums and Academic Institutions*, edited by V. Cassman, N. Odegaard and J. Powell. Lanham, MD: Altamira Press, 1–3.

Clark, D. (ed.) 2004. *Panpsychism: Past and Recent Selected Readings*. Albany: State University of New York Press.

Colwell-Chanthaphonh, C. and Ferguson, T.J. 2006. Trust and archaeological practice: Towards a framework of virtue ethics, in *The Ethics of Archaeology: Philosophical Perspectives on Archaeological Practice*, edited by C. Scarre and G. Scarre. Cambridge: Cambridge University Press, 115–130.

Congram, D. and Bruno, D.A. 2007. [Don't] smile for the camera: Addressing perception gaps in forensic archaeology, in *The Disturbing Past: Does Your Research Give You Nightmares?* edited by J. Holloway and A. Klevnäs. *Archaeological Review from Cambridge*, 22(2), 37–52.

Crissman, J.K. 1994. *Death and Dying in Central Appalachia*. Urbana: University of Illinois Press.

Crossland, Z. 2000. Buried lives: Forensic archaeology and the disappeared in Argentina. *Archaeological Dialogues*, 7, 146–59.

Crossland, Z. 2002. Violent spaces: Conflict over the reappearance of Argentina's disappeared, in *Matériel Culture: The Archaeology of 20th Century Conflict*, edited by J. Schofield, C. Beck and W.G. Johnson. London/New York: Routledge, 115–131.

DCMS. 2003. *Report of the Working Group on Human Remains*. London: Department of Culture, Media and Sport.

DCMS. 2005. *Guidance for the Care of Human Remains in Museums*. London: Department of Culture, Media and Sport.

de Quincey, C. 2002. *Radical Nature: Rediscovering the Soul of Matter*. Montpelier, VT: Invisible Cities Press.

Descartes, R. 2001 [1641]. *Meditations on First Philosophy*, trans. R. Rubin, 3rd ed. Claremont: Arete Press.

Fforde, C. 2004. *Collecting the Dead: Archaeology and the Reburial Issue*. London: Duckworth.

Fforde, C., Hubert, J. and Turnbull, P. (eds) 2002. *The Dead and their Possessions: Repatriation in Principle, Policy and Practice*. London/New York: Routledge.

Finn, C. 2007. The dead and the sleeping, how alike they are: A case for reverential archaeology, in *The Disturbing Past: Does Your Research Give You Nightmares?* edited by J. Holloway and A. Klevnäs. *Archaeological Review from Cambridge*, 22(2), 25–35.

Foster, J. 2004. The succinct case for idealism, in *Philosophy of Mind: A Guide and Anthology*, edited by J. Heil. Oxford: Oxford University Press, 821–836.

Foucault, M. 1970. *The Order of Things: An Archaeology of the Human Sciences*. London: Tavistock.

Fowler, C. 2004. *The Archaeology of Personhood: An Anthropological Approach*. London/New York: Routledge.

Gadamer, H.-G. 1989. *Truth and Method*. 2nd rev. ed., trans. J. Weinsheimer and D.G. Marshall. London: Sheed and Ward.

Ghosh, S. 1989. *Hindu Concept of Life and Death*. New Delhi: Munshiram Manoharlal.

Goswami, A. 1993. *The Self-Aware Universe: How Consciousness Creates the Material World*. New York: Putnam/Tarcher.

Griffin, D.R. 1998. *Unsnarling the World-Knot: Consciousness, Freedom, and the Mind-Body Problem*. Berkeley, CA: University of California Press.

Groarke, L. and Warrick, G. 2006. Stewardship gone astray? Ethics and the SAA, in *The Ethics of Archaeology: Philosophical Perspectives on Archaeological Practice*, edited by C. Scarre and G. Scarre. Cambridge: Cambridge University Press, 163–177.

Guerlac, S. 2006. *Thinking in Time: An Introduction to Henri Bergson*. Ithaca/London: Cornell University Press.

Hameroff, S. and Penrose, R. 1996. Conscious events as orchestrated space-time selections. *Journal of Consciousness Studies*, 3(1), 36–53.

Hamilakis, Y., Pluciennik, M. and Tarlow, S. (eds) 2002. *Thinking Through the Body: Archaeologies of Corporeality*. London: Kluwer Academic.

Hanson, I. 2007. Psycho-social issues and approaches in forensic archaeology, in *The Disturbing Past: Does Your Research Give You Nightmares?* edited by J. Holloway and A. Klevnäs. *Archaeological Review from Cambridge*, 22(2), 69–87.

Hardcastle, V.G. 2004. The why of consciousness: A non-issue for materialists, in *Philosophy of Mind: A Guide and Anthology*, edited by J. Heil. Oxford: Oxford University Press, 798–806.

Harris, J. 1985. *The Value of Life*. London/New York: Routledge.

Harrison, R.P. 2003. *The Dominion of the Dead*. Chicago, IL: University of Chicago Press.

Harvey, G. 2005. *Animism: Respecting the Living World*. London: Hurst and Company.

Heil, J. and Mele, A.R. (eds) 1993. *Mental Causation*. Oxford: Clarendon Press.

Hick, J. 1985. *Death and Eternal Life*. 2nd edn. London: Macmillan.

Holmes, E. and Yost, M. 1966. Behavioral studies in the sensitive plant. *Worm Runners Digest*, 8, 38.

Hubert, J. 1992. Dry bones or living ancestors? Conflicting perceptions of life, death and the universe. *International Journal of Cultural Property*, 1, 105–27.

Hubert, J. 1994. A proper place for the dead: A critical review of the 'reburial' issue in *Conflict in the Archaeology of Living Traditions*, edited by R. Layton. London/New York: Routledge, 131–166.

Hubert, J. and Fforde, C. 2002. Introduction: The reburial issue in the twenty-first century, in *The Dead and their Possessions: Repatriation in Principle, Policy and Practice*, edited by C. Fforde, J. Hubert and P. Turnbull. London/New York: Routledge, 1–16.

Hutton, S. 2004. *Anne Conway: A Woman Philosopher*. Cambridge: Cambridge University Press.

Kankpeyeng, B.W., Insoll, T. and MacLean, R. 2009. The tension between communities, development, and archaeological heritage preservation: The case study of Tengzug Cultural Landscape, Ghana. *Heritage Management*, 2(2), 177–97.

Kant, I. 1991 [1785]. *The Moral Law*. Translation of *Groundwork of the Metaphysic of Morals*, by H.J. Paton. London/New York: Routledge.

Kense, F. 1990. Archaeology in Anglophone West Africa, in *A History of African Archaeology*, edited by P. Robertshaw. London: James Currey, 135–154.

Lackey, D.P. 2006. Ethics and Native American reburials: A philosopher's view of two decades of NAGPRA, in *The Ethics of Archaeology: Philosophical Perspectives on Archaeological Practice*, edited by C. Scarre and G. Scarre. Cambridge: Cambridge University Press, 146–162.

Layton, R. 1994. Introduction: Conflict in the archaeology of living traditions, in *Conflict in the Archaeology of Living Traditions*, edited by R. Layton. London/New York: Routledge, 1–21.

Leder, D. 1990. *The Absent Body*. Chicago: University of Chicago Press.

Leder, D. 1992. A tale of two bodies: The Cartesian corpse and the lived body, in *The Body in Medical Thought and Practice*, edited by D. Leder. Dordrecht: Kluwer Academic, 17–35.

Lilley, I. 2009. Strangers and brothers? Heritage, human rights, and cosmopolitan archaeology in Oceania, in *Cosmopolitan Archaeologies*, edited by L. Meskell. Durham/London: Duke University Press, 48–67.

MacDonald, H. 2005. *Human Remains: Dissection and its Histories*. New Haven/London: Yale University Press.

Macdonnell, A.A. 1924. Immortality in Indian thought, in *Immortality*, edited by J. Marchant. London/New York: G.P. Putnam's Sons, 39–58.

Macintyre, R.G. 1924. The Christian idea of immortality, in *Immortality*, edited by J. Marchant. London/New York: G.P. Putnam's Sons, 80–100.

Marriott, M. 1976. Hindu transactions: Diversity without dualism, in *Transaction and Meaning: Directions in the Anthropology of Exchange and Symbolic Behavior*, edited by B. Kapferer. Philadelphia, PA: Institute for the Study of Human Issues, 109–137.

Mathews, F. 2009. Why has the West failed to embrace panpsychism? in *Mind that Abides: Panpsychism in the New Millennium*, edited by D. Skrbina. Amsterdam: John Benjamins, 341–360.

Maxwell, M. 1984. *Human Evolution: A Philosophical Anthropology*. London/Sydney: Croom Helm.

Mays, S. (ed.) 2005. *Guidance for Best Practice for Treatment of Human Remains Excavated from Christian Burial Grounds in England*. London: Church of England and English Heritage.

McDougall, W. 1911. *Body and Mind: A History and a Defense of Animism*. London: Methuen.

McGinn, C. 2004. Can we solve the mind-body problem? in *Philosophy of Mind: A Guide and Anthology*, edited by J. Heil. Oxford: Oxford University Press, 781–797.

McManamon, F.P. 2002. Repatriation in the USA: A decade of federal agency activities under NAGPRA, in *The Dead and their Possessions: Repatriation in Principle, Policy and Practice*, edited by C. Fforde, J. Hubert and P. Turnbull. London/New York: Routledge, 133–148.

Meskell, L. 2009. Introduction: Cosmopolitan heritage ethics, in *Cosmopolitan Archaeologies*, edited by L. Meskell. Durham/London: Duke University Press, 1–27.

Midgley, D. (ed.) 2005. *The Essential Mary Midgley*. London/New York: Routledge.

Midgley, M. 2001. *Science and Poetry*. London/New York: Routledge.

Midgley, M. 2003. *The Myths We Live By*. London/New York: Routledge.

Morris, B. 1991. *Western Conceptions of the Individual*. Oxford: Berg.

Nagar, Y. 2002. Bone reburial in Israel: Legal restrictions and methodological implications, in *The Dead and their Possessions: Repatriation in Principle, Policy and Practice*, edited by C. Fforde, J. Hubert and P. Turnbull. London/New York: Routledge, 87–90.

Nagel, T. 1979. Panpsychism, in *Mortal Questions*, edited by T. Nagel. Cambridge: Cambridge University Press, 181–195.

Nietzsche, F. 1974. *The Gay Science*, translated by W. Kaufmann. New York: Random House.

Norris, C. 2002. *Deconstruction: Theory and Practice*, 3rd edn. London/New York: Routledge.

Parry, J. 1994. *Death in Banaras*. Cambridge: Cambridge University Press.

Passmore, J. 1971. *Man's Responsibility for Nature: Ecological Problems and Western Traditions*. London: Duckworth.

Pearson, K.A. and Mullarkey, J. 2002. Introduction, in *Henri Bergson: Key Writings*, edited by K.A. Pearson and J. Mullarkey. New York/London: Continuum, 1–45.

Pope Pius XII. 1957. Medical and moral problems in the practice of resuscitation: An address to an International Congress of Anaesthesiologists, 24 November. Available at: www.sspx.org/against_the_sound_bites/religious_moral_aspects _pain_prevention.htm [accessed 4 February 2008].

Pullar, G.L. 1994. The Qikertarmiut and the scientist: Fifty years of clashing world views, in *Reckoning with the Dead: The Larsen Bay Repatriation and the Smithsonian Institution*, edited by T.L. Bray and T.W. Killion. Washington DC: Smithsonian Institution Press, 15–25.

Rawls, J. 1999. *A Theory of Justice*, rev. ed. Cambridge, MA: Belknap Press.

Restall Orr, E. 2004. *Living Druidry: Magical Spirituality for the Wild Soul*. London: Piatkus.

Restall Orr, E. 2005. *A theology of reburial*. Available at: http://www.honour.org. uk/?q=node/31 [accessed 8 February 2008].

Riding In, J. 1996. Repatriation: A Pawnee's perspective. *The American Indian Quarterly*, Special Issue on Repatriation, 20(2), 238–50.

Robb, J. and Boric, D. (eds) 2008. *Past Bodies: Body-Centered Research in Archaeology*. Oxford: Oxbow Books.

Rosenthal, D.M. (ed.) 1971. *Materialism and the Mind-Body Problem*. Englewood Cliffs, NJ: Prentice-Hall.

Sadongei, A. and Cash, P.C. 2007. Indigenous value orientations in the care of human remains, in *Human Remains: Guide for Museums and Academic Institutions*, edited by V. Cassman, N. Odegaard and J. Powell. Lanham, MD: Altamira Press, 97–101.

Sanford, V. 2003. *Buried Secrets: Truth and Human Rights in Guatemala*. New York: Palgrave Macmillan.

Sanford, V. 2007. Bridging the emotional gulf: Reflections on excavation of traumatic memories, in *The Disturbing Past: Does Your Research Give You Nightmares?* edited by J. Holloway and A. Klevnäs. *Archaeological Review from Cambridge*, 22(2), 13–23.

Sant Cassia, P. 2005. *Bodies of Evidence: Burial, Memory and the Recovery of Missing Persons in Cyprus*. New York/Oxford: Berghahn Books.

Sayer, D. 2009. Is there a crisis facing British burial archaeology? *Antiquity*, 83, 199–205.

Sayer, D. 2010. *Ethics and Burial Archaeology*. London: Duckworth.

Scarre, G. 2006. Can archaeology harm the dead? in *The Ethics of Archaeology: Philosophical Perspectives on Archaeological Practice*, edited by C. Scarre and G. Scarre. Cambridge: Cambridge University Press, 181–198.

Scarre, C. and Scarre, G. 2006. Introduction, in *The Ethics of Archaeology: Philosophical Perspectives on Archaeological Practice*, edited by C. Scarre and G. Scarre. Cambridge: Cambridge University Press, 1–12.

Scarre, G. 2007. *Death*. Stocksfield: Acumen.

Searle, J.R. 2004. The irreducibility of consciousness, in *Philosophy of Mind: A Guide and Anthology*, edited by J. Heil. Oxford: Oxford University Press, 700–708.

Skrbina, D. 2005. *Panpsychism in the West*. Cambridge, MA: MIT Press.

Skrbina, D. (ed.) 2009. *Mind That Abides: Panpsychism in the New Millennium*. Amsterdam: John Benjamins.

Smith, L. 2006. *Uses of Heritage*. London/New York: Routledge.

Smith, M. and May, S. 2007. Ancestors of us all. *Museums Journal*, January 2007, 18.

Smolin, L. 2000. *Three Roads to Quantum Gravity*. London: Weidenfeld and Nicolson.

Sorotkin, P. 1937–41. *Social and Cultural Dynamics*, 4 vols. New York: American Book Company.

Stahl, G.E. 1708. *Theoria medica vera*. Halle: Literis Orphanotrophei.

Stoyanov, Y. 2008. Conferences and workshops held at the Kenyon Institute. *Bulletin of the Council for British Research in the Levant*, 3, 24–8.

Strathern, M. 1988. *The Gender of the Gift: Problems with Women and Problems with Society in Melanesia*. Berkeley, CA: University of California Press.

Swain, T. 1995. Australia, in *The Religions of Oceania*, edited by T. Swain and G. Trompf. London/New York: Routledge, 19–118.

Tarlow, S. 1999. *Bereavement and Commemoration: An Archaeology of Mortality*. Oxford: Blackwell.

Tarlow, S. 2006. Archaeological ethics and the people of the past, in *The Ethics of Archaeology: Philosophical Perspectives on Archaeological Practice*, edited by C. Scarre and G. Scarre. Cambridge: Cambridge University Press, 199–216.

Teague, L.S. 2007. Respect for the dead, respect for the living, in *Human Remains: Guide for Museums and Academic Institutions*, edited by V. Cassman, N. Odegaard and J. Powell. Lanham, MD: Altamira Press, 245–259.

Thomas, J. 2004. *Archaeology and Modernity*. London/New York: Routledge.

Trewavas, A. 2003. Aspects of plant intelligence. *Annals of Botany*, 92, 1–20.

Tylor, E. 1913 [1871] *Primitive Culture*, 2 vols. London: John Murray.

Velmans, M. 2000. *Understanding Consciousness*. London/New York: Routledge.

Wallis, R.J. and Blain, J. 2011. From respect to reburial: Negotiating Pagan interest in prehistoric human remains in Britain, through the Avebury consultation. *Public Archaeology*, 10/1, 23–45.

Warner, R. and Szubka, T. (eds) 1994. *The Mind-Body Problem: A Guide to the Current Debate*. Oxford: Blackwell.

Woodhead, C.C. 2002. 'A debate which crosses all borders'. The repatriation of human remains: More than just a legal question. *Art Antiquity and Law*, 7(4), 317–47.

Wright, R., Hanson, I. and Sterenberg, J. (eds) 2005. *Forensic Archaeology: Advances in Theory and Practice*. London: Routledge.

Zimmerman, L.J. 1994. Made radical by my own: An archaeologist learns to accept reburial, in *Conflict in the Archaeology of Living Traditions*, edited by R. Layton. London/New York: Routledge.

Zimmerman, L.J. 1998. When data become people: Archaeological ethics, reburial, and the past as public heritage. *International Journal of Cultural Property*, 7, 69–86.

Zimmerman, L.J. 2002. A decade after the Vermillion Accord, in *The Dead and their Possessions: Repatriation in Principle, Policy and Practice*, edited by C. Fforde, J. Hubert and P. Turnbull. New York: Routledge, 91–98.

Chapter 2

Rhetoric, Place and Performance: Students and the Heritage of the Scottish Universities, 1880–1945

Catriona M.M. Macdonald

Elect no one who is related in any degree to a peer or baronet. Elect none of these quiet deceitful caterpillars, who look on the constitutional authorities as infallible, and who would lick the very dust beneath his feet to gain the favour of a professor. (University of Aberdeen, 1824)

Four years after the British media commemorated the 40th anniversary of 1968 – 'The Year of Revolt', 'The Year that Changed History', 'The year of the posturing rebel', 'The Year that Changed the World'[1] – it pays to be reminded that the students of the sixties were simply a modern – and arguably somewhat unrepresentative – manifestation of a tradition that was rooted in a long heritage.

Student numbers continue to grow: in Scotland alone higher education students in Scottish institutions numbered 187,645 in Session 2000–1, or nearly six per cent of the population aged between 5 and 65.[2] At the same time, university museums have been engaging more explicitly than ever before in identifying their unique contribution to the heritage industry. In 2000 the European University Heritage Network (UNIVERSEUM) was established following a recommendation by the Council of Europe, and a year later University Museums and Collections (UMAC) was founded – a specialised committee of the International Council of Museums (ICOM). Scotland itself supports a further body – University Museums in Scotland – that seeks to foster the preservation, care and interpretation of Scottish university collections which together amount to around 1.8 million items. Contemporary interest in this sector was confirmed recently, when in 2008 – partly in anticipation of the University's 600th anniversary – the University of St Andrews opened

1 *Guardian* <http://www.guardian.co.uk/news/1968-year-of-revolt> [accessed 17 January 2009]; *Guardian* <http://www.guardian.co.uk/observer/gallery/2008/jan/17/1?picture=332107888> [accessed 17 January 2009]; Tom Stoppard. *Sunday Times*, 16 March 2008; BBC World Service, 1968: The year that changed the world? <http://www.bbc.co.uk/worldservice/documentaries/2008/12/081216_1968_part_4.shtml> [accessed 17 January 2009].

2 Scottish Executive. Statistics on students in higher education at Scottish universities and colleges during the academic year 2004–05, <www.scotland.gov.uk/Publications/2006/04/28100117/4> [accessed 17 January 2009].

MUSA (Museum of the University of St Andrews) with the explicit aim of encouraging new audiences to learn from and enjoy the heritage of the university. In such an environment it would appear apposite to consider the extent to which a student voice has traditionally been heard in the historical narratives of Scotland's universities and the extent to which current theoretical approaches to the heritage of social groups and communities might apply to students.

While there are notable exceptions – among them the Bologna Student Museum[3] – the student community has typically not been well-served by university museums. In part this is a simple reflection of the extraordinary diversity of such institutions (University Museums UK Group, 2004). Many university museums have grown out of collections amassed in an *ad hoc* fashion over the centuries to support teaching, learning and research rather than an institutional interest in preserving its own heritage. Yet in part this state of affairs is also the consequence of a general failure on the part of European universities until recent times to integrate institutional memories into their future planning and more broadly to fully appreciate the potential that exists in their common heritage (Bulotaite 2003, Sanz and Bergan 2006). A third dilemma that has posed an obstacle to the development of a coherent approach to the heritage of university students is the lack of consensus on what exactly constitutes university heritage *per se*. So far only very general definitions have had any hope of wide support. In 2005, for example, the Committee of Ministers of the Council of Europe considered the heritage of universities to encompass:

> … all tangible and intangible heritage related to higher education institutions, bodies and systems as well as to the academic community of scholars and students, and the social and cultural environment of which this heritage is a part. The "heritage of universities" is understood as being all tangible and intangible traces of human activity relating to higher education. It is an accumulated source of wealth with direct reference to the academic community of scholars and students, their beliefs, values, achievements and their social and cultural function as well as modes of transmission of knowledge and capacity for innovation. (Committee of Ministers 2005)

Such a broad definition is fitting, given the variety of European higher education institutions, but it leaves much unsaid and many dilemmas unresolved when – at an operational level – university officials must make difficult decisions as to who and what best represents their institution in a period of dramatic change and where financial resources are to be invested. As for students, they appear here as just one interest group among many, and the inherent tensions between these groups are glossed over by the singularity of expression presumed to emerge from

3 The UMAC database also records the Museum of Student Life (University of Coimbra, Portugal), The Polytechnic Students' Museum (Helsinki University of Technology, Finland) and the Student Museum Archive (Lunds University, Sweden).

institutions. Ought one to presume, therefore, that the study of students simply does not lend itself to the heritage treatment?

Putting it simply, students are unruly but not impossible subjects for a heritage study.[4] The current limitations of the heritage industry and institutional approaches to student history identified above are only part of the story. As a group students lend themselves perhaps no more or less to memorialisation than any other collective, yet the dilemmas that the student identity poses for the perpetuation of heritage are real and profound, and draw us back to the very presumptions underpinning the discipline and its theoretical approaches.

Given:

- the transience of the student state in most life histories;
- the diversity of students as a collective;
- the frequency of conflict between students and other formal university authorities, and
- the spatial tensions inherent in the student identity, shared as it can be across localities, and nations;

conventional heritage approaches which presuppose an element of spatial and temporal stability within groups must be re-addressed and the primacy of the formal university context and the materiality of museum approaches should be questioned as the most fitting environment and approach for the study of the student past.

Despite the nightmares of many modern parents, no-one is a perpetual student – in the formal sense at least. For heritage scholars, the shared identity which grounds the interests of communities and the ease with which generations bequeath their traditions to the next cannot therefore be confidently assumed. Class, gender, ethnic and linguistic differences within the student body also challenge renderings of community that presume commonality in origins, opportunities and aspirations. Students, moreover, are also regularly both part of and set apart from the civic identity of University establishments depending on the interests at stake, and as members of a global scholarly 'brotherhood' often exhibit loyalties to interests beyond those evoked in familiar classrooms and quadrangles.

In acknowledgement of the challenges these qualifications pose to a singular rendering of student heritage, this study of university students in the period 1880–1945 addresses heritage as a dynamic process bound up in power relations where hegemonies exist only to be challenged and alternative renderings of tradition are ever present. Essentially, it is heritage as a 'form of communicative practice', more readily appreciated in rhetoric, space and performance than in material culture (Dicks 2007: 59). It follows Graham, Ashworth and Tunbridge in appreciating heritage as 'meaning rather than artefact', and in doing so foregrounds the capacity

4 Here I evoke the title of M.E. Boren's, *Student Resistance: A History of the Unruly Subject*.

heritage has to both express and generate social conflict, as differing meanings vie simultaneously for expression, acceptance and pre-eminence (Graham, Ashworth and Tunbridge 2000: 5). Addressing an era long gone, it is also hoped that this study will offer a readier measurement of the impact of heritage discourses, freeing meaning from unhelpful 'what might have beens', or at least those with more contemporary overtones. Emphasising the restricted time-period of this study also serves to highlight the bounded nature of the historical sense on which heritage rests. As Lowenthal noted, 'History is protean. What it is, what people think it should be, and how it is told and heard all depend on perspectives peculiar to particular times and places' (Lowenthal 1997: 105). The popularity of an historical sense is readily evoked in nineteenth-century platform oratory and was a fundamental feature of Romanticism's allure in these years (Samuel 1994). It would seem a most appropriate context, therefore, within which to examine the ways in which students refined a heritage from below.

Rhetorical Heritage

The language of rights, values and traditions employed by Scottish students in the late nineteenth-century and early twentieth century was contradictory. What might be styled as three rhetorical practices, by then deep-rooted in radical discourse, competed to ground student interests in established traditions and familiar idioms. Alternately, and with little attention to the inherent contradictions in the approaches, students appealed to constitutional conventions, traditions, and the absolutes of inalienable rights. The first and second of these reaffirm the indebtedness of students to antecedence – a necessary quality of meaningful heritage which ensures an invaluable resonance across a temporal gulf (Lowenthal 1997). And yet, like the radicals of three generations before, Scottish students 'tortured history to their own purposes' and utilised a 'highly selective' knowledge of constitutional law and the past more generally in the pursuit of authenticity, legitimation and authority (Epstein 1994: 3–28). In claims to established practice, they attempted to cement group cohesion and undercut allegations of their anti-establishment credentials, but it was a precarious consensus evidenced by regular lapses into appeals to a doctrine of rights and an idealistic vision of what the university (and the student) *ought* to be (Hobsbawm 1992).[5] As Epstein has made clear in another context, there was nothing necessarily incompatible in these approaches in the nineteenth century (Epstein 1994). Yet the imprecision and multivalence of students' linguistic repertoire draws attention to its highly contextual character and the diverse uses to which it was put over time.

5 Here again Scottish students claimed a precedent. The 'ancient' Scottish universities far more than their English counterparts followed the Bolognese model in which student interests had loomed large from medieval times.

After 1889 the constitutional idiom was more readily adopted by students in Scottish universities as the Universities (Scotland) Act of that year recognised the Students' Representative Councils (SRCs) of the four Scottish universities (Aberdeen, Edinburgh, Glasgow and St Andrews) as legitimate representatives of their respective student bodies in dealings with the university courts. In anticipation of the passage of the act, the annual report of the Glasgow SRC in November 1888 'confidently asserted that never did the Council command greater respect from the University authorities'.[6] Yet, student appeals for formal recognition had rested on rights rather than respect. In 1886 the Edinburgh SRC had petitioned the Secretary for Scotland, the university's Lord Rector and Scotland's Lord Advocate 'setting forth the opinions of the Students' Representative Council regarding the rights and claims of the students as forming an integral part of the University'.[7] Here a rhetoric of rights grounded claims for constitutional reform, and the absorption of student bodies into the decision-making processes of the university. But things were not always that straightforward.

St Andrews students during the Second World War repeatedly clashed with university authorities over the hosting of late dances. At face value this was a trivial matter, yet the SRC acknowledged in 1940 that 'the whole matter of autocratic control' went far beyond student socials. The real issue, they explained, was 'the right of students to have a say in the control of matters affecting their interests'. Admitting that the current legislation gave the Senate full disciplinary powers over students, the only solution, they proposed, was enhanced powers for the SRC: in other words, further constitutional reform and devolved authority. Instead, the Principal granted the students a Liaison Committee peopled by both students and Senate representatives. It was to be a 'channel for consultation' whose recommendations would still need to be ratified by the Senate and the SRC. Within days of its first meeting, however, complaints regarding restrictions on late dances were heard again at the SRC. Little had changed. In the end, despite a mass student meeting and discussions at Court, the SRC was driven to compromise, 'having already alienated the sympathy of members of the Court and jeopardised the position of the liaison committee'.[8] The incident proved that rhetorical appeals to constitutional precedent and a commitment to student rights came to naught when power interests were simply unevenly matched.

Claims to tradition were often the last resort of students when rights – constitutional, natural or historic – were less than convincing grounds of defence,

6 Glasgow, Glasgow University, Archive Services, Students' Representative Council Minutes (hereafter GUSRC), 24 November 1888.

7 Edinburgh, Edinburgh University Library, Division of Special Collections, Students' Representative Council Minutes (hereafter EUSRC), 12 November 1886.

8 St Andrews, St Andrews University Library Special Collections, Students' Representative Council Minutes (Hereafter StAUSRC), 15 October 1940, 14 November 1940, 19 November 1940, 13 December 1940, 21 January 1941, 25 January 1941, 5 February 1941.

particularly in the face of admonishment. The Executive Committee of the Glasgow SRC in November 1907 sympathised with university authorities in their condemnation of the disturbances that had marred the recent graduation ceremony, but emphasised that they believed that 'disorder at graduations is in large measure due to a feeling among the students that such disorder is traditional.'[9] Similarly, in December 1917 the Edinburgh SRC – while protesting against excessive disruption – recorded its 'entire sympathy with the traditional right of students to share in academic functions by demonstration'.[10]

The evidence above points to a rhetorical inheritance that appears to establish student politics as part of a recognisable radical tradition. Here, heritage seems to permit students to employ precedent, rights and tradition in pursuit of immediate claims, interests and goals. Yet it is a defensive impulse that encourages such a strategy. In claiming the past, students emphasised that they would not endanger the present or jeopardise the future. But in aligning their aspirations with those of the university they laid claim to interests already in the hands of established powers and partly in their gift (Macdonald 2009). At times, reinforcing the status quo was as much in the student interest as condemning it. After all, after 1889 the SRCs had been absorbed into the formal governance structures of the universities. Heritage from below could serve conservative aims as easily as radical visions (Cobban 1971).[11]

Heritage Landscapes

Space as much as language can be discursive, and spatial meanings associated with Scotland's universities were as unstable as the oratory of their student politicians (Arnade, Howell and Simons 2002). University landscapes were the sites of contests over the meaning of the material environment, the aesthetics of belonging and the performance rights of students therein. In all this heritage was central and temporality an intrinsic feature in the realisation of place (Parkes and Thrift 1980).

Throughout the period under discussion, students at the Universities of Aberdeen and Glasgow followed medieval continental precedent in dividing themselves into 'nations' depending on their place of birth. Yet instead of divisions being national – as was the case in Bologna, for example – they were ostensibly regional. In Aberdeen students after 1860 belonged to either 'Moray', 'Mar', 'Angus' or 'Buchan' – emphasising the overwhelming local origins of the Granite City's scholars (Harper 1992). Meanwhile, students at Glasgow aligned themselves with one of the following: Glottiana (for Lanarkshire students); Rotheseiana (for

9 Glasgow, Glasgow University, Archive Services, Students' Representative Council Executive Committee Minutes (Hereafter GUSRC (Exec)), 15 November 1907.

10 EUSRC, 14 December 1917.

11 Here too there are parallels with student protests in the medieval period.

students from Ayr, Renfrew and Bute); Transforthana (for students north of the Forth) and Loudoniana (for Angus men and those not encompassed by any of the other three). Here linguistic and spatial tensions are transparent and were made more so in the politicisation of such divisions which were used as constituencies (in Glasgow until 1977) in rectorial elections.

In acknowledging originary differences, however, students paradoxically realised their shared status as students of the university. The 'nations' had no meaning beyond their institutional significance, but this meaning was intimately bound up with the traditional rights of students to elect a rector. 'Belonging' – a central consideration in the process of meaning making in heritage environments – was thus far from unequivocal, and inherently political. In reaffirming differences in origin, students acknowledged the transience of the student identity and the peculiarities of their community. Indeed, counter to many assumptions regarding heritage communities, here, belonging did not mean that differences were to be dissolved, but accommodated, and even utilised as a structural element in building the student collective (Dicks 2000).

Other spatial dynamics were more straightforwardly connected to the built environment of the universities themselves and the towns and cities in which they were situated. Yet that did not mean that they were any less open to discursive interpretation and competing definitions. It is hardly surprising that students typically appreciated university spaces differently from their Masters. More importantly, however, disputes over space frequently reflected inherent tensions in power relations within the universities in which the student voice itself was marked by internal dissent. In Edinburgh in November 1932, an incident which became known as the 'Battle of the Dome' drew into sharp relief the ways in which disputes about space were both cause and consequence of conflicting interests within the university body politic.

In the early months of 1932 it had been confidently presumed that the rectorial election at the University of Edinburgh that year would be a quiet affair. In keeping with the precedent set during the election of Winston Churchill as rector in 1929, the traditional 'battle' which had taken place for generations in the quadrangle between supporters of opposing candidates, variously armed with peasemeal, soot, eggs and fish heads, was outlawed. And – in a break with the past – political associations were to relinquish their rights to nominate candidates.[12] These were reforms that had attracted the full support of the SRC. By October, however, cracks were beginning to appear in the new consensus: supporters of General Sir Ian Hamilton had circulated campaign literature (*The Hamiltonian*) that betrayed the Unionist credentials of their candidate, and in *Scottish Action* the supporters of Dr Pittendreigh Macgillivray emphasised their candidate's nationalist sympathies. By mid-October, Macgillivray's supporters had decorated the base of the gilded figure on the dome of the University with a St Andrews flag, only for it to be removed under cover of darkness on 29 October by the General's sponsors, who in

12 *Scotsman*, 5 October 1932.

turn replaced it with their own standard. In the interim, a further brave challenge to the new desire for orderly campaigning, was evidenced on the night of 27 October, when Macgillivray's followers erected a thirty foot long banner bearing the motto 'Vote for Macgillivray' on the roof above the university clock.[13] This too was removed by the 'Hamiltonians' on the morning of 29 October.[14]

The morning of the poll brought ample proof that tradition – in the form of fights and violent encounters – would overwhelm the decorum demanded by both the SRC and the university authorities. On the morning of the poll the supporters of Sir Iain Colquhoun attempted to imprison some 'Hamiltonians' in the dome of the University, causing several injuries. In the process several windows were smashed, a door was wrenched off its hinges, and several busts and plaster casts in the Fine Art department were destroyed. Thereafter, in the afternoon, a team of fifty 'Hamiltonians' armed with soot, ochre, decayed fruit, fish and eggs appeared in the quadrangle and goaded opposition supporters into a fight in direct contravention of the new regulations prohibiting such activity.[15]

The events of 1932, and the subsequent interpretations offered for both the actions of the students and the authorities, bear witness to the fact that there was no singular shared understanding of university spaces either within the student body or between students and the university authorities, and that conflicting understandings were greatly influenced by perceptions of traditional practice. Many student rioters in 1932 clearly believed themselves to be acting in accordance with established practice on such occasions and assumed rights of engagement at odds with contemporary directives and codes of conduct. In this they were opposed by their own formal representatives – the SRC – who passed the following motion on 11 November:

> That the SRC severely censures the action of those students who were responsible for the malicious damage done in the Department of Fine Art.

> That the SRC deplores any material damage done to University property as a result of violent demonstrations.

> That the SRC is, therefore, anxious to co-operate with the University Authorities in taking adequate measures to regulate Rectorial Fights in the future.[16]

The rioters were also opposed by fellow students who wrote to the local press of their opposition to the 'sheer vandalism' of their peers that had resulted in the

13 *Scotsman*, 29 October 1932.

14 Such concern with flags and banners very much accords with Hobsbawm's observation that 'most of the occasions when people become conscious of citizenship ... remain associated with symbols and semi-ritual practices', Hobsbawm 1992: 12.

15 *Scotsman*, 5 November 1932.

16 EUSRC, 11 November 1932.

destruction of plaster casts gifted to the university by an esteemed and well-loved Professor.[17] And yet, some critics were equivocal: Hugh Purves, a student, whilst opposing the destruction of university property, 'would not for a moment protest against inter-party 'rags' in the open, such as the Old Quad'. [18] Another student, writing as 'IV: Yr. Undergraduate', encouraged the formation of a rectorial committee that – should a fight be permitted – would specify 'which territories and times would be observed as neutral'. Even Sir Ian Hamilton – the eventual victor of the contest – considered aspects of the riots 'romantic'.[19] And the *Student* newspaper blamed lax security for the damage to the plaster casts, and described the discipline meted out to some rioters as 'ridiculous'.[20] Moral vocabularies of landscape are clear (Matless 1995).

The defence of traditional practice in recognised 'battle-grounds' was met with a defence of property rights and reputation on the part of the authorities. In between, the SRC attempted to defend its authority without alienating its constituency, by appealing to its legitimacy as a partner in the governance of the institution. At issue was the desire to establish a hegemonic interpretation of what the university meant and how best to defend it. But, without precedent to call on, the authorities' experiment in public relations was immediately at a disadvantage, and the SRC's evocation of its statutory powers, when met with student demands to maintain practices which to date had served them well and were identified as an important aspect of their identity, attracted little lasting support. In the end there were no clear victors in the Battle of the Dome, and heritage had no obvious champion.

Performing Heritage

Place was only one determinant of perceptions regarding the legitimacy or otherwise of the behaviours and practices of the student body. There was also a temporal dimension which meant that participants were not entirely free in their choice of performance. As Tilly has made clear, crowds in general have at their disposal 'a limited repertoire of collective action' specific to their age and subject to the judgements of their contemporaries (Tilly 1981: 19–21). Patterns of behaviour also have a long lineage, suggesting – as Thompson made clear – that the term 'riot', for instance, is both a blunt tool of analysis and 'an imprecise term for describing popular actions' (Thompson 1971: 107). With this in mind, it pays to reflect on the ways in which heritage was 'performed' by students, and acknowledge the conscious theatrical element in their activities which was open to multiple representations and interpretations within the university and beyond (Harrison 1988).

17 *Scotsman*, 8 November 1932.
18 *Scotsman*, 5 November 1932.
19 *Scotsman*, 8 November 1932.
20 *Student*, 22 November 1932.

Nowhere is the theatrical element of student heritage seen more clearly than in the torchlight processions that marked important events in the university calendar and brought students out of the cloisters and into the streets, and in the reception they accorded their rectors when these elected representatives delivered their inaugural addresses to the student body.

Torchlight processions

In 1907, 'Four Graduates' from the University of Edinburgh published their reminiscences of their student days, and reflected on a torchlight procession that marked the conclusion of a successful rectorial contest.

> Right and left the crowd surges along between towering cliffs of houses, their windows full of faces. The route lies down the Bridges, high over the old Nor' Loch, along the whole spacious length of Princes Street; then into the aristocratic West End squares – and here a professor or two will be called from his dinner table to receive a rollicking serenade – along George Street wakened from its wonted quiet, and finally up the Mound and the Lawnmarket to the Castle Esplanade.

> Here at last torch-ends are flung blazing into a heap, and round the fire and round it over wheel the wild figures: hands join in a great circle, and the groups range up to give three cheers for the Lord Rector. (Four Graduates: 141)

Under cover of night Edinburgh streets at the turn of the twentieth century were taken over by torch-wielding students in fancy dress celebrating the installation of a new rector.

Similar scenes were evident in Aberdeen. Here, the rectorial torchlight procession in 1893 was considered the best the city had ever seen.

> The costumes were very many and varied, ranging from an African Negro to and Archbishop in full canonicals. Every possible costume was there, Sultans, Costers (sic), Chinamen, Negroes, Old Ladies, "Slaveys", Red Indians, Turks and Scotch Elders. The streets were crowded throughout the entire route, and nothing but unqualified approval was heard on all sides. The procession finished up with a gigantic bon-fire at the Castlehill barracks, and a most weird and fantastic dance round the flames.[21]

Through ornamentation and action students in both these examples were following well worn radical practices that would have been recognised by both participants and observers alike. Yet, by the twentieth century, if not before, despite numerous instances of damage to property and raucous behaviour, for the most part students

21 University Archives, University of Aberdeen, *Alma Mater*, 22 November 1893.

on the march – in these instances at least - were not identified as a threat to civic order. Why?

While students were certainly subject to the law, for the most part they were often indulged by the authorities who turned a blind eye to behaviours which would have brought others in front of the civil courts. In part this can be explained by students' ambivalent relationship with the public spaces of their cities. They were both of the city, and subject to authority outwith the control of the municipality. They were certainly citizens of Scottish cities, and on occasion would display a keen sense of civic duty, yet it was widely appreciated that they also owed allegiance to their place of learning which set them apart from other residents. Even *en masse* this group did not seem to warrant serious policing: when they claimed the streets, they did so in disguise, and never held them for long.

The inaugural lecture

Yet students could and did pose more direct challenges to authority. Their common approach to the rectorial address is a case in point. Once elected, the one compulsory aspect of the job that victors both relished and regretted in turn was their inaugural address to the students. Many rectors relied overwhelmingly on their nominees (or Assessors) to represent their interests on University committees on a day-to-day basis, and typically, as irregular visitors to the universities that had honoured them, might put off their inaugural addresses sometimes for years. When the day of reckoning eventually dawned, however, the rector would have been immediately conscious of his limited role in a performance where once again students – at the interface of powerful interest groups in public spaces – attempted to make sense of and assert control over ceremonial.

That having been said, one ought not to assume that students themselves formed a uniform body on such occasions. Following Edinburgh's lead, a major priority for the infant Student Representative Councils in Scotland at the end of the nineteenth century was policing students during university ceremonies. Granting them authority to impose discipline and set high standards of behaviour at public events, the Senates of the Scottish universities attempted early on to use student representatives for their own purposes. In 1887 the Aberdeen SRC produced a printed programme to accompany Viscount Goschen's inaugural address. The tone of this extract is revealing:

ARRANGEMENTS FOR THE RECTORIAL ADDRESS

After much difficulty the Students' Representative Council have obtained the use of the Music Hall, on the following conditions, which must be strictly adhered to.

Primo. There must be no procession to the hall. After the address a procession will be formed in Golden Square.

Secundo. No one will be allowed to enter having in his possession Peas, Peasemeal, Flour, or any missile, Trumpets or any noisy instrument.

Tertio. Any one infringing the rules laid down for the conduct of the meeting, or conducting himself in a way unbecoming a student and a gentleman, will be summarily ejected by the Vigilance Committee of the Students' Representative Council, and will render himself liable to rustication by the Senatus Academicus for the remainder of the Session.

On this occasion the confidence of the university authorities in their new young allies was well placed. But this was not always the case. In 1891 Aberdeen's Principal Geddes acknowledged that students would be allowed 'a certain amount of liberty in demonstrations' before the platform party formed for the Lord Rector's inaugural address. However, only days later, he was compelled to admonish the students for damage caused to Lord Huntly's carriage on the night of the inaugural address, and the SRC was forced to seek legal advice on behalf of the culprits.[22] By 1929, the SRC were clearly uncomfortable in the role of academic disciplinarians. That year, when the Senatus imposed £10 fines on three students for misconduct during the rectorial address, the SRC accused the authorities of victimisation.[23] In Glasgow we get a sense of a similar dynamic at work. Here, initial enthusiasm in planning graduation ceremonies and rectorial addresses with the Senate soon gave way to suspicion. In November 1907 the Executive Committee of the Glasgow SRC emphasised to the Principal and to Senate that 'this Council, while willing as formerly to try to preserve order at graduations, repudiates the suggestion that it should give information to the authorities about leaders of disturbances'.[24]

The SRCs found it hard to serve two masters. We see this in disputes with Senate over the composition of the platform parties for inaugural celebrations, the positioning of student representatives on the platform, and the allocation of tickets to students. Scottish SRCs regularly found it hard to claim their place on such occasions. Is it any wonder that their fellow students also chose to ignore their admonishments?

For generations of Scottish students the sole purpose of the rector's inaugural address was the challenge it posed the student body to drown out his rhetoric in any way they could. Testimony abounds of rectorial addresses only half read to the student constituency, or hastily abridged by rectors anxious to leave the stage. Student 'high jinks' is a poor explanation for such behaviour, and an established

22 University Archives, University of Aberdeen, SRC Minutes (MSU 301/4/1), 14 February 1891.

23 University Archives, University of Aberdeen, SRC Minutes (MSU 301/4/6), 12 January 1929.

24 University Archives, University of Glasgow, SRC Executive Minutes (DC157/ 4/3/2), 15 November 1907.

tradition of rectorial heckling across the Scottish universities points to a more complex state of affairs.

One example must suffice. On 22 January 1904 the new Lord Rector of the University of Edinburgh, Sir Robert Bannatyne Finlay delivered his rectorial address in the university's McEwan Hall. The *Scotsman* described the scene

> The students, especially the younger section of them, who occupied the first gallery, behaved in so disgraceful and noisy a fashion that scarcely a word of the address which the Lord Rector had so carefully prepared for the occasion could be heard beyond the first few seats in front of the platform. The students evidently had not come to hear: they preferred to bawl themselves hoarse, to make noises on whistles and trumpets, and generally conduct themselves like a lot of what the late Professor Blackie used to call "senseless asses".[25]

Such 'perfect pandemonium' energised the writer of that day's editorial to demand the abolition of such addresses in the Scottish universities. Such sentiments were also echoed by letter writers: 'A Student', for example, bemoaned students' 'caddish' behaviour.

Others, however, were not so sure. A week before the address, *The Student* acknowledged that there was a 'division of opinion as to the conduct desirable on this occasion', and 'An Edinburgh Graduate', writing in the *Scotsman* qualified his condemnation of the students' behaviour by acknowledging that 'no man, with the golden memories of his own college days still fresh upon him will grudge the undergraduate his harmless frolic'.[26] Nevertheless, claims that the Edinburgh scenes were no worse than those in Glasgow or Aberdeen, did not appease the *Scotsman* – it was still recording its indignation a week after the address and applauding the sentence of rustication meted out to two of the student culprits.[27]

One might posit that the noise of the student body was an attempt to assert their control over proceedings; one might suggest that such freedom of expression speaks of an immature political constituency; one might proffer that such actions speak of political values at odds with convention or more fitting a political age long since gone. All are plausible explanations. What is certain, however, is the way in which such behaviour drew attention to official and unofficial appreciations of what the inaugural ceremony actually *meant*. For university and civic officials the inaugural address of a prominent rector was an occasion of some consequence when both university and city were 'on show'. While SRCs might do their best to involve students in ascribing this meaning to the ceremony, however, it is quite clear that frequently the greater part of the student body thought otherwise.

The fact that many inaugural addresses were delivered in premises outwith the university precincts – in music halls and theatres – also lent such occasions

25 *Scotsman*, 22 January 1904.
26 *Scotsman*, 25 January 1904.
27 *Scotsman*, 25 January 1904, 27 January 1904.

an air of novelty and set officialdom in a place in which its authority was set at naught and its values in vain competed with the conflicting associations of a strange environment. It was far easier for students to claim theatrical spaces as their own: such spaces – familiar to them in their leisure hours when as adults they acknowledged no master but themselves – were empowering.[28]

Conclusion

> Space and time are always and everywhere social. Society is always and everywhere spatial and temporal. Easy enough concepts, perhaps, but the implications are only now being thought through. (N. Thrift 1996, *Spatial Formations*)

Addressing the heritage of student politics demands that we relate to political registers that only rarely accord with conventional approaches and party interests, only intermittently lend themselves to representation in material culture (and then only fleetingly and with little thought to posterity), and seldom point in the same direction for very long. As a consequence, an anti-reductionist approach is called for which – in appreciating complex pasts – eschews the allure of a single narrative thread in pursuit of the expression of the polymorphic aesthetics of a shifting collective. Taking as its traces linguistic manifestations of value, spatial interpretations of authority and a certain (and changing) theatrical sense, it is challenging territory for the heritage researcher, and yet of inestimable value for a more thoroughgoing approach to the heritage of un/mis-represented groups in national discourse.

Heritage from below in this instance inverts the hierarchy of evidence typically appreciated as the discipline's primary interest. Memorialisation here is rare and does not generally signify consensus, at a basic level there is little to be preserved in the conventional sense, and transience and mutability mark many of the most iconic trophies of each generation. There is no clear periodisation, no unrelenting whiggish progress to unravel, no triumphalist pursuit of a single goal, and no stable essence in a community defined ultimately by its fleeting association with institutions over which it has little influence. Instead, values, traditions, rights, spaces, landscapes and performance cultures signal a very different heritage aesthetic – an aesthetic hidden and amplified in words, evoked and contested over time, rooted in space yet relevant to 'everyman', present in riot, yet not unknown in the status quo. Peculiar to a certain time and space, its meaning is unique to its age yet capable of recovery and restoration, at least in part. Getting closer to it demands that we foreground the contested knowledge heritage normally prefers as

28 The University of Glasgow held rectorial installations within the University precincts after 1958.

a back-drop. As a result, arguments are liberated as much as actors, and meanings are show-cased over material sureties.

Here's the rub. One is presented with the challenge that in deriving a methodology best suited to the heritage of these actors we will de-limit their power to speak down the generations with one voice. The liberationist narrative lurking beneath the promise of a 'heritage from below' will surely be compromised. Only the sympathies of the discipline will determine whether or not in the long term this is a price worth paying. In the short term, it pays to be reminded that we have the choice.

References

Aberdeen, University Archives, University of Aberdeen. *Alma Mater.*

Aberdeen, University Archives, University of Aberdeen. *SRC Minutes.*

Arnade, P., Howell, M. and Simons, W. 2002. Fertile Spaces: The Productivity of Urban Space in Northern Europe. *Journal of Interdisciplinary History*, 32(4), 515–548.

Boren, M.E. 2001. *Student Resistance: A History of the Unruly Subject.* London: Routledge.

Bulotaite, N. 2003. University Heritage – an institutional tool for branding and marketing. *Higher Education in Europe*, 28(4), 449–454.

Cobban, A.B. 1971. Medieval Student Power. *Past and Present*, 53, 28–66.

Committee of Ministers (Council of Europe) 7 December 2005. *Recommendation 13.*

Dicks, B. 2000. *Heritage, Place and Community.* Cardiff: University of Wales Press.

Dicks, B. 2007. Review. *Museum and Society*, 5(1), 58–59.

EAIE Forum. 2003. *The Heritage of European Universities.*

Edinburgh, Edinburgh University Library, Division of Special Collections. *Students' Representative Council Minutes.*

Epstein, J.A. 1994. The Constitutional Idiom, in *Radical Expression: Political Language, Ritual and Symbol in England, 1790–1850*, edited by J.A. Epstein. Oxford: Oxford University Press, 3–28.

Four Graduates. 1907. *The Old Quadrangle.* Edinburgh.

Glasgow, Glasgow University, Archive Services. *Students' Representative Council Minutes.*

Glasgow, Glasgow University, Archive Services. *Students' Representative Council Executive Committee Minutes.*

Graham, B. Ashworth, G.J. and Tunbridge, J.E. 2000. *A Geography of Heritage: Power, Culture and Economy.* London: Arnold.

Harper, M. 1992. The Challenges and Rewards of Databases: Aberdeen University Students, 1860–1880, in *Scottish Universities: Distinctiveness and Diversity*, edited by J. Carter and D.J. Withrington. Edinburgh: John Donald, 147–155.

Harrison, M. 1988. *Crowds and History.* Cambridge: Cambridge University Press.

Hobsbawm, E. 1992. Inventing Traditions, in *The Invention of Tradition*, edited by E. Hobsbawm and T. Ranger. Cambridge: Cambridge University Press, 1–14.

Lowenthal, D. 1997. *The Heritage Crusade and the Spoils of History*. London: Penguin.

Macdonald, C.M.M. 2009. 'To form citizens': Scottish students, governance and politics 1884–1948. *History of Education*, 38(3), 383–402.

Matless, D. 1995. The Art of Right Living: Landscape and Citizenship, 1918–1939, in *Mapping the Subject: Geographies of Cultural Transformation*, edited by S. Pile and N. Thrift. London: Routledge.

Parkes, D. and Thrift, N. 1980. *Times, Spaces and Places: A Chronogeographic Perspective*. Chichester: John Wiley & Sons.

Samuel, R. 1994. *Theatres of Memory, Vol. I: Past and Present in Contemporary Culture*. London: Verso.

Sanz, N. and Bergan, S. 2006. *The Heritage of European Universities*. Brussels: Council of Europe Publishing.

St Andrews, St Andrews University Library Special Collections. *Students' Representative Council Minutes*.

Thompson, E.P. 1971. The Moral Economy of the English Crowd in the Eighteenth Century, *Past and Present*, 50, 76–136.

Thrift, N. 1996. *Spatial Formations*. London: Sage.

Thrift, N. 1999. The Place of Complexity, *Theory, Culture, Society*, 16(3), 31–69.

Tilly, C. 1981. Introduction, in *Class Conflict and Collective Action*, edited by C. Tilly and L. Tilly. London: Sage.

University Museums UK Group. 2004. *University Museums in the United Kingdom: A National Resource for the 21st Century*.

Chapter 3

Consuming Outlaws, the Common Good and Heritage from Below

Graham Seal

Heritage concerns itself with particular, usually restricted, histories of places, objects and structures. In the process of erecting interpretations of these, the larger historical contexts in which they operate and which provide their meanings may be overlooked or given cursory treatment.

Also frequently overlooked are the less tangible unsanctioned aspects of heritage. These include the songs, stories, beliefs, uses and perhaps other activities that relate to particular heritage places and structures. These are often more part of the mythology rather than the history of heritage. They may be paid lip service in the category usually called 'intangible heritage' (UNESCO 2003), but this is rarely taken into account in interpretations and in eventual presentations. One reason for this is that these mythic dimensions of history are very much in the nature of heritage from below. They tend to be the forgotten, marginalised even suppressed meanings that disempowered groups have made and, frequently, maintained over time in unofficial and unsanctioned forms of knowledge and expression, including family, community and other forms of tradition.

The objection may be made that such alternative histories and meanings are frequently inaccurate when placed against the documented historical records. While this may often be true, it misses the important questions of why such beliefs originate and why they are maintained over often long periods by significant numbers of people and why, when appropriate circumstances arise, these beliefs and perceptions motivate serious outbreaks of social, political and economic disruption.

One especially stark example of the power of such mythologies can be discerned in the origins, perpetuation and consequences of outlaw heroes. The complex social, economic and political elements involved in the cultural processes that produce and maintain such figures provide a case study of how certain aspects of the heritage interpretations of outlaw heroes tend to avoid, elide and sometimes repress the reasons why such figures have been recurring for at least two thousand years and look like they will continue to evolve into the future. This cultural tradition takes various forms but remains remarkably consistent throughout time and over space. It extends from the *latrones* of the Roman Empire (Shaw 1984, Grünewald 2004) through shadowy figures of Dark Age myth (de Lange 1935, Crosland 1959, Bellamy 1973, Zatta 1999), through highwaymen (Spraggs 2001),

badmen of the west (White 1981, Steckmesser 1965) bushrangers (Seal 1996, 2001), *dacoits* (Devi et al.), *cangaçeiros* (Chandler 1978, Lewin 1987, Slatta 2004) and the outlaws of many other cultures (Barkey 1994, Brown 1990, Gravel 1985, Hobsbawm 1981/2000, Kheng 1988, Koliopulos 1987, Rafael 1999, Sant Cassa 1993, Wagner 2007, Wilson 1988) to the modern machinations of Osama bin Laden (Seal 2005). The hope for a 'better' world – however defined – continues to play a significant role in today's global politics, economy and culture. Despite this, there is little indication of the deeper issues of outlaw heroism to be found in the standard heritage interpretations, where such interpretations exist at all.

This chapter outlines the character and widespread nature of the outlaw hero tradition, a form of popular defiance motivated by perceptions of inequity, injustice and oppression. As well as appearing as an actor in the cultural script invoked by politics, economics and social disadvantage, the outlaw hero has often been represented in the commodified discourses of the media, heritage and tourism industries. These representations variously ignore or deflect consumer attention away from the powerful folk notion of 'the common good' that produces outlaw heroes across time and geography.

The Outlaw Hero

One of the most commonly encountered outlaw hero folktales is told in many parts of the world in ballad or story form. A poor old widow woman (or other socially vulnerable individual) cannot pay her rent. Nevertheless, the grasping landlord extracts the last penny she has, leaving her without the means of subsistence. Along comes an outlaw hero who, hearing of the poor woman's distress rides after the greedy landlord, holds him up along the highway and robs him of the widow's rent. The outlaw hero then returns to the widow and gives her back the rent money, sometimes along with the other rents collected by the landlord that day.

This widely-distributed motif of outlaw hero traditions is part of the legendry of the white South African outlaw hero named Scotty Smith, active during the 1870s and 80s; and that of the Scots Robert 'Rob Roy' MacGregor (1671–1734); of Captain James Hind (1616–1652), an English highwayman who was hanged and quartered for treason; of Dick Turpin; of the American Sam Bass and of Jesse James (Seal 1996). The wide occurrence of this story highlights the importance of folklore in the perpetuation of the outlaw hero. As well as this and other stories, outlaw heroes are typically the subject of ballads, folk beliefs and sometimes popular sayings, as in the Australian expression 'as game as Ned Kelly'. Folklore also interacts with the more formal communication channels of society and so we find, even from early times, written, then printed, then filmed, then televised and, most recently, digital tales of outlaw heroes and their real or imagined doings. These comparatively formalised expressions feed back

into folk tradition, producing an ongoing dynamic that ensures outlaw heroes a lodgement in most societies.[1]

Most cultures have created and sustained heroes of the outlaw type. Indeed, outlaws are among the most common and most constant heroes and, occasionally heroines, in all the world's folklores. Outlaw heroes are distinguished by their folkloric status as friends of the poor and oppressed. Robin Hood is only the most familiar and archetypal English-language example of the 'noble robber' (Dobson and Taylor 1997, Knight 1994) though all such heroes, in whichever language traditions, display Robin Hood characteristics to a greater or lesser extent. These include their having been forced into outlawry by the unjust actions of an individual or group; the ever-present notion of robbing the rich to give to the poor; being kind and generous to the dispossessed and the downtrodden; defying the forces of oppression and injustice; bravery; never offering unjustified violence and general cleverness that allows them, with the help of those social groups who support them, to outwit and outrun their would-be captors. Outlaws and their gangs have headquarters in forests, mountains or other places away from the everyday tracks and where they can hide from pursuit. Robin Hood has the greenwood, Butch Cassidy had 'the hole-in-the-wall' hideout and the Chinese Outlaws of the Marsh and the English Hereward has near-impenetrable swamps. There is often more than a touch of the trickster about outlaw heroes and heroines, whose folklore frequently includes feats of wonderful escapes from the forces pursuing them or near-supernatural breakouts from gaols or ambushes.

That mythology is also widespread in folk narrative told around the world. Floating tales like that of the grasping landlord and the poor widow are likely to be told and re-told wherever there are outlaw heroes. Additionally, each region and nation has its stock of stories in which the outlaw is forever eluding capture, escaping from prisons, defying the unjust and oppressive authorities and conducting his criminal activities with courtesy and élan. At a national level, the number of Australians whose grandfather/mother opened the railway crossing gates for the Kelly gang is amazingly large. Many individuals have claimed to be Billy the Kid, Dan Kelly or some other dead outlaw of their generation in a modern continuation of the folkloric reluctance to accept the death of the hero. The German Schinderhannes who operated along the Rhine was renowned for outwitting the wealthy and the forces of authority and was celebrated also for his great generosity to the poor and his courage. Schinderhannes, and numerous others, became the heroes of, as Mackay (1841) put it 'many an apocryphal tale' as did the Hungarian outlaw hero Schubry and many of the numerous *banditti* of Italy.

1 Some relevant studies include Steckmesser, Kent L. 1965. *The Western Hero in History and Legend*. Norman: Oklahoma University Press; Sharpe, J. 2004. *Dick Turpin: The Myth of the English Highwayman*. London: Profile Books; Seal, G. 1996. *The Outlaw Legend: A Cultural Tradition in Britain, America and Australia*. Melbourne: Cambridge University Press, as well as investigations of other outlaw hero traditions noted in the References.

Although outlaw hero traditions appear very similar across time and space, there are cultural and historical differences that fix their mythologies firmly in their specific contexts. In Chinese lore, for instance, the duration of the Middle Kingdom's historical experience and the complexity of its social arrangements led to an institutionalisation of banditry in gangs and secret societies (Antony 1989: 136–137, Billingsley 1988). Chinese outlaw heroes are also more likely than most of their western counterparts to be involved in political upheavals and to prosper, or not, depending on the side with which they ally themselves.

Outlaws renowned in the folklores of some cultures are portrayed as particularly aggressive and violent, as in the case of many eastern European figures. Others are assigned their heroic status because they represent the desire for revenge of one oppressed group against their oppressors, as in the case of the Indian outlaw, Baba Deva, a Gujarati Robin Hood operating between 1900 and the early 1920s. Born in Goral, near the Gulf of Cambay, he is said to have been inspired by an earlier outlaw figure named Sayadu Minyano and to have helped ignite Gandhi's protest and resistance movement. His legend is violent, his deeds include the murder of his sister and his wife. However, he also outwits the police who seek to capture him at his daughter's wedding by disguising himself as a woman and giving the bride away under the noses of the authorities, exactly the style so beloved of outlaw heroes the world over. Baba Deva's legendry also has a dash of resistance to British rule as one of its most appealing local elements, perhaps why the bandit is still renowned in song and story (Beck 1987: 212–219, Dorson 1971: 203–208).

Outlaw heroes in English-language cultures are overwhelmingly male. In other cultures, notably Hispanic and Indian, there are a small number of outlaw heroines, a recent example being Phoolan Devi, the 'bandit queen' of India, subject of journalism, books, films and politics. However, in the European tradition and its diaspora, the woman who dresses as a man and takes to robbing along the highway is a fairly constant figure, appearing in ballads of the female highwayman type. There is also more than a suggestion of the outlaw heroine about the Irish Grace O'Malley and, even if inflated, the American Belle Starr (Seal 2001b). Despite these occasional incursions of the feminine into what is a profoundly masculinised cultural domain, women appear in outlaw hero discourse mainly in support roles, usually as helpers (Hobsbawm 2000: 146–149).

As a number of researchers have suggested (Blok 1972, Singelmann 1975), while bandits are frequently little more than pawns in the larger power politics of their time and place, the fact that they are popularly balladised and generally celebrated by the disempowered sectors of society is itself the most revolutionary aspect of their existence. The enduring dream of a better life is the universal aspiration of the outlaw hero tradition. That dream is manifested at different times and places attached to often quite undeserving individuals. Yet the hope lives on across generations and continents, rehearsed again and again wherever oppression and injustice are felt and wherever people yearn for a new order that suits them better than the one they have. But most outlaw heroes also have a life and a legend that goes far beyond the confines of local, regional or even national folklore.

History and myth begin to entangle during the lives of outlaw heroes and in relation to the social, economic and political factors of their particular time and place. Their deeds, real and imagined, are widely celebrated and their often numerous failings largely ignored. After their demise the deep processes of myth-making begin to shape the outlaw hero in accordance with the already established tradition. The lives and legends of outlaw heroes are enmeshed in an ongoing interaction in which folklore, the media, art, literature, drama, tourism and the heritage industry dance with each other around the outlaw's image. The resulting conflicting and competing interpretations of the history and mythology of individual outlaws can produce local heroes, media stereotypes, romanticised ideals and even national icons (Seal 2009). These are the processes through which real and mythical outlaw heroes are retrospectively constructed to suit the needs of the various constituencies that relate to them and which consume them.

Consuming Outlaws

One of these constituencies is the heritage industry, closely allied with the tourist and media industries. Outlaw heroes are subjects of perennial fascination, exhibition and discussion in these discourses. But rarely do these representations engage the oppositional and resistant realities that impelled their actions and those of their supporters. The media mercilessly romanticises them, tourism exploits them locally and the heritage industry either ignores them or represents their actions in a sanitised and hence inaccurate manner. The lives and legends of outlaws are consumed for a variety of purposes that have rigidly constrained relationships to their disturbing social and political reasons for existing.

An important aspect of the afterlives of outlaw heroes involves commodification through various forms of consumerism and spectacle, including the mass media, literature, scholarship and art. Tourism is one of the most powerful of these forms of representation and commercialisation, especially in those areas and places associated with notorious episodes of outlawry. Even places associated with fictitious or largely fictitious events may become popular tourist drawcards, as has Langshan, the fabled stronghold of the Chinese outlaws of the marsh and, of course, what remains of Sherwood Forest. Most outlaw tourism destinations, though, are associated with historic individuals and events.

The James family home has long been a tourist attraction. Not far from Kansas City, Missouri, Jesse James and his legend still rides along the tourist trail. Jesse's birthplace at Kearney is the site of a museum, gift shop and audio-visual presentation in the authentically restored James family farmhouse. Jesse's grave can be viewed here along with the outlaw's relics, including his guns, boots, spurs, remains of his casket, some furniture and the very table on which his body was embalmed. One of the many James books has been dramatised and performed at the farm as an outdoor spectacle of family theatre, involving a cast of 20 actors. In Liberty there is a Jesse James Bank Museum where the curious can see the

institution the James gang robbed restored to its former glory, together with re-enactments of the event (Stiles 2002).

The Sicilian outlaw hero of the late 1940s was Salvatore Giuliano (Chandler 1988, Maxwell 1972). His family now operates a hotel in Montelepre named Il Castello di Giuliano. The hotel's website features an elaborate presentation of the famous Sicilian bandit's life and legend, complete with photographs and promotions for the book written by Giuliano's nephew and heir. His legend has also been kept alive by journalists, filmmakers and authors, many of whose productions celebrate Giuliano as 'the Robin Hood of Sicily'. This term is displayed proudly on the family website – 'The True Story of Salvatore Giuliano' (www.sicilian.net/salvatoregiuliano) – and accords well with the predominant image of the bandit, who is also now a tourist attraction in Montelepre, where it is possible to visit 'the places where Salvatore Giuliano's dreams of liberty died forever'. Mario Puzo's novel, *The Sicilian* (1984), later filmed by Hollywood (1987), was a fictionalisation of Giuliano's story that provided further gloss to his already well-burnished image.

These representations of the bandit celebrate him uncritically in the usual user-friendly Robin Hood style as 'the man who takes from the rich to give it to the poor'. Giuliano's role in the May Day 1947 massacre of 11 people, including a woman and three children at a Communist rally at Portella denna Ginestra is air-brushed away. An unsurprisingly different view of Giuliano is contained in the Italian Ministry of Justice Criminological museum, whose website describes Giuliano and others of his kind in post-war Sicily as 'misfits'. Both interpretations are right – and wrong, each failing to account for other. Neither present him as the avenger of underclass oppression and as the political threat that he became to the shaky status quo of that time and place.

Some areas are so imbued with outlaw heritage and legend that they trade on it as a central aspect of their tourism branding. The wild regions of Europe have extended histories of brigands using their ravines, mountains and forests as refuges and bases for their depredations.

The Andalusian region of Spain produced a number of noted heroes, including one known to the tourism business, at least, as 'the Islamic Robin Hood'. His name was Omar Ibn Hafsun who led a revolt of Christians converted to Islam (*muladís*) and disaffected Muslims against the authority of Cordoba and the Caliph in 883. The most famous Andalusian bandit was probably Diego Corrientes (1757–1781). (Pike 1988: 242–247) Since then his legend has continued and grown, polished by books, films and the usual popular and high art treatments, from street ballads to literature. So revered was Corrientes, 'the generous bandit', that street literature even represented his betrayal and execution in Christ-like terms (Ruff 2001: 35) Well into the twentieth century Andalusia continued to produce protestors and brigands, including *El Tempranillo* (the Early One) who is said to have demanded an ounce of gold from all who passed through his domain and to have declared 'The king may reign in Spain, but in the sierra I do'. A poacher and bandit known as 'Big Steps' died in a gun battle with police in 1934 and communist guerrillas

continued to wage war against Franco's regimes after the Spanish Civil War until the 1950s. Andalusia now trades heavily on its reputation as 'bandit country', complete with a Bandit Museum <www.absoluteaxarquia.com/attractions/museum bandit.html> [accessed 30 May 2009].

The graves of outlaw heroes, and sometimes those associated with them, may be sites of interest and commemoration, as already mentioned in relation to the commodification of American badman, Jesse James. This is also true of many of the English places associated with the mythical Robin Hood and the historical Dick Turpin. It is the case with the graves of the Australian bushrangers Ben Hall and Ned Kelly, among others. In some cases where no grave exists because the outlaw is buried elsewhere, lies in an unknown location or is simply mythical, large-scale tourism enterprises have been developed on or near significant outlaw locations. In Australia there is a well-developed tourism and heritage operation at Glenrowan in northeastern Victoria, the location of the bushranger's final showdown with the authorities (Seal 2001a). Here, and elsewhere in 'Kelly Country', are museums, displays, heritage tourism routes, a computerised theatre presentation and a variety of other attractions based on the facts and fictions of Ned Kelly's life and legend. Such small local museums and interpretation centres, often containing real or allegedly authentic outlaw hero artefacts, are a common occurrence. Robin Hood is variously exploited in and around what is left of Sherwood Forest and there is a Rob Roy Centre at Callendar in Scotland.

In India, they are not even waiting for bandits to die before appropriating them for tourism enterprises. In July 2008 it was reported that Rajasthan was considering a bandit tourism program in the Chambal valley, a notorious dacoit location. Recently captured bandits would entertain tourists and there was even an opportunity to drink chai with brigands along the 'Dacoit Trail'. 'Tourism chiefs in Rajasthan believe the chance to experience the legends of notorious criminals will draw in thousands of tourists for their "Robin Hood" appeal', it was stated <www. telegraph.co.uk/news/newstopics/howaboutthat/2281311/Bandit-tours-offered-in-Indian-state.html> [accessed 2 June 2009].

The outlaw hero as a heritage tourism commodity was given a thoroughly modern uplift between 2003–05 by the National Museum of Australia, which developed and mounted a large and ambitious exhibition of international outlaws. Titled 'Outlawed! Rebels, Revolutionaries and Bushrangers', the large and expensive exhibition played in Canberra, Melbourne and Brisbane with a full panoply of artefacts assembled from around the world, extravagant multi-media interactions and presentations, a large-scale public relations and marketing effort, an illustrated catalogue in book form (National Museum of Australia), a range of souvenirs, educational resource packages, games, and the like. The aim of the exhibition was to highlight the international and recurrent nature of social banditry, examine its causes and consequences and present its audience with a very cutting edge 'new' museum spectacle of entertainment and information. The exhibition was marketed both as an Australian drawcard, with an extensive selection of Australian bushrangers represented and also as an attraction for international

visitors – the outlaw hero as museum artefact. And while the exhibition was at pains to depict the realities of outlawry, its remit as a public institution and the consequent need to have a balanced display ensured a blanding out of the underlying tensions and conflicts that generate outlaw heroes. Emphasis was placed on the romanticised and 'boys' own' elements, necessary for hands-on and interactive media for children and adults. While some letters and other statements of outlaws expressing their sense of oppression were included, these were not linked to the underlying causes of most outbreaks of banditry – the fair access to and/or distribution of resources. Nor was there a great deal of attention paid to the often extensive networks of sympathizers that typically support outlaw heroes.

The media outlaw

As media have exploded across the globe since the late twentieth century, so has the demand for content to fill the apparently endless permutations of television (free-to-air, cable, satellite, digital, 3D), book publishing, newspapers and magazines, the World Wide Web, etc. Most outlaw heroes of any stature at all can boast extensive bibliographies, filmographies and at least some high art representations in painting, ballet, opera and classical music. These many and multiplying representations and commodifications testify to a wide and ongoing fascination with outlaw heroes. Whether celebrating them, execrating them, selling them or attempting to understand them, human beings around the world continue to be involved in the afterlives of outlaw heroes, either as producers or as consumers. What is the appeal? Certainly the ambivalence of these figures continues to divert us. Were they heroes or villains? Are their actions fact or fiction? Were they justified? What were the often-grisly details of their violence?

Questions of this kind continue to draw many into some relationship with outlaw afterlives. Mostly these are fleeting, perhaps through education, consuming media, especially film and television, visiting regional tourism sites, and the like. Occasionally, deeper and longer-lasting relationships are established, through scholarship, business, amateur enthusiasm, as seen in the sometimes impressively designed and very active websites dedicated to one or more outlaw heroes.[2] A good deal of the attraction is related to the perennial appeal of 'true crime' (Ruff 2001), though outlaw heroes have a special and unique place in these annals. They are, nominally, criminals but they are supported by significant groups and usually have extensive networks of sympathizers well beyond their local areas of operation. Their actions were – and still are – seen by many as the result of inequities of wealth and the abuse of power. That others may see such characters as merely criminals with no redeeming or validating features simply adds to their charisma. Human beings around the world all seem to revel in a good argument

2 Selected examples include <www.ironoutlaw.com>; <www.bailup.com>; <www.outlawsandhighwaymen.com>; <www.salvatoregiuliano.com>; <www.legendsofamerica.com/WE-JesseJames9.html>.

and one can be readily bought in most countries and cultures by mentioning the name of the relevant outlaw.

There have been many films produced in the history of the movie, not only by Hollywood but also by national cinemas keen to represent significant figures of history and myth to audiences equally as keen to consume such images. In some cases, film treatments of outlaw heroes are among the earliest productions of national cinemas (Restivo 1995–1996: 30–40). The mainstream Hollywood film industry has been a major source of filmic representations of outlaw heroes. Generally, as critic Mark Carnes has observed, Hollywood history 'is so morally unambiguous, so devoid of tedious complexity, so *perfect*' (Carnes 1996: 102). While this may be true of the general run of Tinseltown's sword and sandal epics and the like, it is not true of outlaw hero movies. These specifically trade on the ambiguity inherent in the notion of the noble robber. There are few outlaw heroes of any note who have not been the subject of at least one, usually more, feature films aimed at the ongoing fascination of audiences with the 'good criminal', whether he be a Jesse James, a Pancho Villa, a Stenka Razin or a Robin Hood.

While outlaws may or may not demonstrate aspects of the Robin Hood principle during their lifetimes, a significant number have been the subject of posthumous heroisation. This involves the intertwining of folk traditions with representations in literature, mass media (print, visual and electronic), art, tourism, museology and sometimes national and ethnic histories. The afterlives of outlaw heroes are constructed from their legends and the continual recycling of these through the different but colluding cultural processes of oral tradition and representation in more formal modes of expression. The intersection of the folkloric and the formal provides the motivating power for the tradition of the outlaw hero, creating and recreating his mythology to suit a variety of different needs and changing circumstances. Robin Hood can provide an appropriate symbolic focus for fifteenth century poachers, English Poll tax rioters, subversive Parisian power workers in 2004, 1950s television audiences and Hollywood movies, among other representations. Many outlaw heroes have similarly long-lived, powerful and multitudinous meanings that both derive from, and add to, their mythologies.

The resonances of the ancient tradition of the outlaw hero testify that the tradition is strong and is finding ways to evolve. Not only are there new outlaw heroes being produced, the old ones are showing no signs of going away either. Historians are still engaging with the history and mythology of Dick Turpin (Barlow 1973, Sharpe 2004). Similarly with the ever-growing image of Ned Kelly, subject of expensive feature films, Booker prize-winning literature, historical analyses and mainstay of Victoria's tourism trade. Tourism sustains the images of long-gone outlaws from Spain to Sardinia and from Sicily to the United States of America. Jesse James and Billy the Kid still inspire serious book-length studies. Many of these figures are profoundly implicated in their environing culture's sense of ethnicity and/or nation, including the afore-mentioned Ned Kelly and Dick Turpin, the Hungarian Sandor Rozsa, the Danish Marsk Stig, the Mexican Pancho Villa (Katz 1998), the Mexican-American Gregorio Cortez (Mertz 1974,

Paredes 1958/1990), among others. The most recent set of changed circumstances involves the growth of globalised fundamentalist terrorism and the treatment, in some quarters, of such figures as Osama bin Laden as heroes of the oppressed and the dispossessed.

In April 2003 a Frontline/World TV documentary team visited Calcutta to view a piece of traditional street musical theatre, or *jatra*, in which an Osama bin Laden character appeared as a hero and George Bush and his aides were portrayed as crazed, and bloodthirsty murderers: 'Let corpses of babies and old people – civilians – litter the streets!', one of the Presidential aids cries. Later scenes showed Americans in Afghanistan raping women, killing babies and getting drunk to celebrate. The *jatra* ended, some three-and-a-half hours later, with bin Laden appearing as 'a Muslim Robin Hood of sorts', protecting his people.

But this was not a piece of Islamic terrorist propaganda. The characters, 'good' and 'bad', were played by Hindu actors. It was a piece of folk entertainment that also included a love story between a couple of journalists. At the play's conclusion, the Indian-American journalist is so shocked by the actions of the Americans that he gives up his job and becomes an anti-war activist, eventually being gunned down by an American soldier as he demonstrates for peace in Afghanistan <www. pbs.org/frontlineworld/stories/india205/rath.html> [accessed July 2004].

It is not only Hindus in Calcutta who perceive elements of the outlaw hero in Osama bin Laden. The North American Hispanic populations have also developed a radically different image of the terrorist to that projected by the US government and mainstream media.

The *corrido* is a traditional ballad form of the Mexican-American border. One of the mainstays of the *corrido* tradition is the celebration of outlaw heroes, including Gregorio Cortez and Pancho Villa. In these ballads, and the extensive traditions they condense, the heroes are presented as Robin Hood figures who strive against American injustice and oppression. Not only are such *corridos* still a vital part of Hispanic culture, new *corridos* on current events are routinely composed, recorded and performed to vast Spanish-speaking audiences. One of the most popular of these continuities is the *narcocorrido*, in which the activities of Hispanic gun runners and drug smugglers are celebrated as forms of revenge and defiance of the American drug war which, it is believed, is simply a smokescreen to protect American government and business interests in the Hispanic world (Wald 2002).

Regardless of the accuracy of this belief, the *corrido* is the vehicle for a long and strong tradition of outlaw heroism. It is perhaps not surprising then that fairly soon after 9/11, a *corrido* celebrating bin Laden appeared. Titled 'Bin Laden, the CIA's Mistake', the song squarely lays the blame for 9/11 at the feet of the CIA. Other *corridos* have been composed on a similar theme <www.elijahwald.com/ corridowatch.html> [accessed 2 June 2006].

While we may not share such views, it is observable that situations which produce outlaw heroes invariably have many common features, most fundamentally

a belief or perception that dispossession, inequity and oppression has been visited on one constituency by another.

The Common Good

Most of the political aspirations and occasional machinations of those outlaw heroes discussed above are related to notions of equity. The right – assumed where it does not exist – of all members of a society to a reasonable share of its riches and access to its resources, is integral to the rationale of outlaw heroism. Robin Hood's fictional levelling of the wealth disparities of medieval England echoes again and again through the lives, deaths, legends and literature of bandit after bandit. Underlying this are the folkloric conceptions of the commons and of limited good – the common good.

The common good is sometimes found enshrined in legislation (whether observed or not) and sometimes in custom and precedent. It usually consists of a series of obligations and expectations between those who have most and those who have least in a particular society. We see the physical manifestation of these important assumptions in the long and bitter struggles over enclosure of common lands that were a feature of European societies from the early modern era (Beloff 1938, Ives 1988). Sometimes these tensions are articulated in episodes of social banditry. During the early nineteenth century, the Apulian outlaw hero Vardarelli wrote to the Mayors of Atella and Foggia demanding that the traditional peoples' perquisite of gleaning the fields be restored and that this means of subsistence not be fed to the cattle. The landlords 'shall allow gleaning to the poor people, or else I will warm their backsides …' and 'they should stop feeding their gleanings to the cattle and give them to the poor. And if they are deaf to this order I will burn down everything that they have.' (Angiolilo 197913–14). In India the development of a rigid hierarchy of caste determined who had what and who had not. Frontier societies' struggles over control of land and the resources of the land, whether agricultural or mineral, are a colonial manifestation of the same problems. These circumstances produced a large number of *dacoits*, many of whom were accorded the mantle of hero by those who saw them as avengers of their oppression (Rossetti 1982: 158–159).

The often suppressed politic of the common good can even be seen operating in the carnivalesqueries of the English 'mobs' of the seventeenth and eighteenth centuries. A form of combined street theatre, public festivity and barely constrained violence, a mob could assemble, it seemed, from nowhere in response to such stresses as a rise in the price of corn. Such assemblies easily turned into riots, threatening private property and public order. The authorities were ever vigilant in avoiding these events, or suppressing them when they occurred. Most feared of all mob activities were those associated with the public executions of notable criminals. The execution of Dick Turpin inspired the York mob to hijack the hanged body of the notorious highwayman and to spirit it away to a proper

burial rather than the pit of quicklime favoured by the authorities (Barlow 1973, Sharpe 2004).

While Turpin's extraordinary and ill-deserved popularity was occasioned by his career as a highwayman, he had previously been involved in poaching and smuggling, activities that were not associated in the popular mind with criminality. Poaching was usually considered to be a morally justifiable assertion of what many believed to be the common rights of all to wild animals. Smuggling, essentially extreme tax avoidance, was also not taken seriously as a criminal activity by many. The large numbers involved in poaching and smuggling, both as primary participants and within the extended economic chains of concealment, transportation, sale and consumption suggest the reluctance of many to accept the considerable legislative frameworks erected to control such activities. Allied with Turpin's successful manipulation of the outlaw hero tradition, these well-known realities of his activities played into the adulation of the mob and its unwillingness to allow the authorities to perform the final act of interment (McLynn 1991: 276, Thompson 1975).

In Africa conflict over control of land and resources, frequently involving ethnic identity, produced such figures as Obert Dhawayo in Zimbabwe during the 1970s, described by Lieutenant-Colonel Reid Daly, in command of the Selous Scouts sent to put down the unrest in the Ngorima Tribal Trust Land as one who 'was not regarded as a criminal at all by those formerly very law-abiding people, but rather as a sort of Robin Hood and everyone was willing to help, feed or hide him' (Ranger 1986: 384). Other African figures with similar reputations were Chitowka in Rhodesia during the 1960s (Ranger 1986: 377) and Mushalla, the 'Robin Hood of the Zambians' from the mid-70s until his 1982 death in an ambush (Crummy 1986: 7). At a slightly earlier period in Eritrea the Masazgi brothers gained a noble robber reputation between 1948 and 1952 (Fernyhough 1986, Hobsbawm 2000: 1–5). Wherever they are found, outlaw heroes are primarily the product of the conflicts that arise when the assumed obligations between social groups fail, are revealed as illusory or are broken down by war, catastrophe or sometimes through social and technological change.

In the post-modern era the sudden appearance of a digital frontier opened up new possibilities for a rush on electronic resources and rights. Some lucky prospectors and smart operators struck it very rich in the 'dotcom boom', just as some prospectors and pioneers had made their fortunes in earlier mineral rushes and land booms. As in those earlier days, the disparities and tensions between different sectors generated criminals who naturally robbed the rich. A few of these became Robin Hood figures, eluding authorities in the electronic thickets of the early Internet. The early Internet hackers formed a close-knit and secretive gang of nerds and geeks who espoused a crude form of egalitarianism and found they had the power to put this political notion into effect. Stealing time on other people's telephones, breaking into high security government computers and cracking the not very effective security provisions of banks and financial institutions, these cyberpunks were able to steal thousands of credit card

numbers and release them on the internet as a largely symbolic but nevertheless effective form of Robinhooding.

The early Internet was a kind of electronic commons before it began to be 'enclosed' by commercial interests as it is today. Many in the computer community viewed this appropriation with disgust, much as the villagers and farmers of an earlier era had responded to the loss of their common rights of grazing, fishing, foraging and scavenging as field and forest were delivered into private ownership. Just as farm labourers tried to do something about this appropriation, the cyberpunks used their skills to attack and undermine the enclosure of the Internet. Mark Abene and Kevin Mitnick were two hackers who came to be seen by those who supported them and by the media as Robin Hood figures struggling against the power of big business and government. Their politic, and those who thought like them, became known as cyberpunk. Like that of most outlaws it was the largely negative and destructive agenda of the powerless against the powerful, based on a poorly articulated but very deep sense of injustice and oppression (Hafner and Markhoff 1991).

The oldest and the most recent variations on the Robin Hood theme, as well as most of those in between are a response to a similar set of perceived inequities and dispossessions. Even where political ideology is absent or basic, the issues that drive the creation of outlaw heroes are unavoidably political in origin and intent. This is not to argue, as Eric Hobsbawm seems to, that such outlaws are all social bandits with a reform agenda. A few, perhaps more, certainly were. But most are the victims of forces far beyond their control, or even ken. In many cases, as demonstrated by anthropological and historical studies, outlaws are hopelessly enmeshed in the power politics of their time and place, constantly negotiating a thin grey line between financial and political interests for whom they are often pawns (Blok 2001: 14–28, Gallant 1999). That some of these individuals are seen by their supporters as champions of their sense of dispossession means not that they were all noble robbers, or even ignoble ones, only that there is a global cultural need, an imperative, for such figures to exist. They are therefore called into being, shaped from often unpromising clay and nurtured by the processes of myth during their usually brief lives and their often enduring afterlives. Their traditions then persist as a cultural resource to be drawn on by future generations as a means of understanding, articulating and acting on their sense of political disparity and discontent.

Conclusion

The circumstances that produce outlawry are the result of tension and conflict along social, political and economic faultlines in particular societies at particular moments. These outbreaks are usually violent, both physically and symbolically, and they rage along the fissures and ruptures within and between competing interests, over resources, empowerment. A very small number of such conflicts

produce heroic figures and these few are inevitably enmeshed in whatever power realities obtain. The serious and complex issues involved in these events and their consequences can be superficially and conveniently dealt with by the intersecting media, heritage and tourism industries through the romanticising and sanitising discourses of the 'Robin Hood' mystique, however it is articulated in different cultures. And this is usually what happens. The disturbing socio-cultural, political and economic issues that underlie such outbreaks and the heroisation of selected outlaw figures, are easily left out or, at best ameliorated, as the media, tourism and heritage industries seek ways to appealingly rather than confrontationally package and present such events to their audiences.

Outlaw heroes represent the making public of what James Scott (1990) called the 'hidden transcripts' which the powerless make defiantly public to those they consider their oppressors in often violent upsurge of their usually concealed discourses of fear, hate and inequality. Here, Scott weighs against Gramsci's argument that the subaltern classes collude in their own oppression, insisting that they are perfectly aware of it and only appear to submit in the public displays and discourses of the powerful. The continual appearance and reappearance of outlaw heroes across millennia and global space suggests that the hidden transcript of the outlaw hero is a deep, wide and potent form of popular resistance.

Finally, it is striking how many outlaw figures and their legends, born of border and related conflicts, are such popular tourist drawcards around the world. The experience of tourism itself is essentially a form of confrontation between cultures. Usually it is a friendly, if superficial, engagement between representatives of different nations and languages, frequently mediated through heritage in the form of museums, galleries, sites and presentations. There are always undercurrents of difference, the echoes of them and us, in these relationships and exchanges, making them vicariously resonate of the ambivalent attractions of outlaw heroes. But as tourism exchanges are usually radically less fraught than other kinds of intercultural interaction it is possible to speculate that they may have positive outcomes. The similarities between outlaw hero traditions around the world, despite their violence, are at least a form of common ground for communication. We have ours; you have yours. An understanding of the social, cultural and economic forces that produce such events and the myth that sustains them may contribute something towards their avoidance in the future. Accurate and realistic representations of the events, causes and consequences of outlaw heroes could be a constructive outcome of this particular heritage from below.

References

Absolute Axarquia. 2007. *Bandit Museum.* [Online] Available at: www.absoluteaxarquia.com/attractions/museumbandit.html [accessed 4 July 2007].

Angiolillo, P. 1979. *A Criminal as Hero: Angelo Duca.* Lawrence: The Regents Press of Kansas.

Antony, R. 1989. Peasants, Heroes and Brigands: The Problems of Social Banditry in Early Nineteenth-Century South China. *Modern China*, 15(2), April, pp. 136–137.

Barkey, K. 1994. *Bandits and Bureaucrat: The Ottoman Route to State Socialisation.* Ithaca/London: Cornell University Press.

Barlow, D. 1973. *Dick Turpin and the Gregory Gang.* London and Chichester: Phillimore.

Beck, B.E.F. 1987. *Folktales of India.* Chicago: University of Chicago Press.

Bellamy, J. 1973. *Crime and Public Order in England in the Later Middle Ages.* London: Routledge & Kegan Paul.

Beloff, M. 1938. *Public Order and Popular Disturbances 1660–1714.* London: Oxford University Press.

Billingsley, P. 1988. *Bandits in Republican China.* Stanford, California: Stanford University Press.

Blok, A. 1972. The Peasant and the Brigand: Social Banditry Reconsidered. *Comparative Studies in Society and History*, 1(4), September, 494–503.

Blok, A. 2001. *Honour and Violence.* Cambridge: Polity Press.

Brown, D. 1991. *Human Universals.* New York: McGraw-Hill.

Brown, N. 1990. Brigands and State Building: The Intervention of Banditry in Modern Egypt. *Comparative Studies in Society and History*, 32(2), 258–81.

Bryant, R. 2003. Bandits and 'Bad Characters': Law as Anthropological Practice in Cyprus, C. 1900. *Law and History Review*, 21(2), Summer, 244–269.

Carnes, M. (ed.) 1996. *Past Imperfect: History According to the Movies.* New York: Holt.

Chandler, B. 1978. *The Bandit King: Lampião of Brazil.* College Station and London: Texas A&M University Press.

Chandler, B.J. 1988. *King of the Mountain: The Life and Death of Giuliano the Bandit.* DeKalb: Northern Illinois University Press.

Crosland, J. 1959. *Outlaws in Fact and Fiction.* London: Peter Owen.

Crummy, D. 1986. *Banditry, Rebellion and Social Protest in Africa.* London: James Currey.

de Lange, J. 1935. *The Relation and Development of English and Icelandic Outlaw-Traditions.* Haarlem: H.D. Tjeenk Willink & Zoon.

de Vries , J. 1963. *Heroic Song and Heroic Legend.* London: Oxford University Press.

Devi, P. with Cuny, M. and Rambali, P. 1996. *I, Phoolan Devi: The Autobiography of India's Bandit Queen.* New York: Little, Brown and Company.

Dobson, R.B. and Taylor, J. 1997. *Rymes of Robin Hood: An Introduction to the English Outlaw.* 3rd rev. edn. Stroud: Sutton.

Dorson, R. 1971. *American Folklore and the Historian.* Chicago: University of Chicago Press.

Dykes, J.C. 1952. *Billy the Kid: The Bibliography of a Legend.* Norman: Oklahoma University Press.

Fernyhough, T. Social Mobility and Dissident Elites in Northern Ethiopia: The Role of Bandits. 1900–69 in Crummy 1986. *Banditry, Rebellion and Social Protest in Africa*. London: James Currey, 151–72.

Gallant T. 1999. Brigandage, Piracy, Capitalism, and State-Formation: Transnational Crime from a Historical World Systems Perspective, in *States and Illegal Practices*, edited by J. Heyman. Oxford: Berg, 25–62.

Guuliano family, available at: www.sicilian.net/salvatoregiuliano [accessed August 2008].

Gravel, P. 1985. Of Bandits and Pirates: An Essay on the Vicarious Insurgency of Peasants. *Journal of Political and Military Sociology*, 13, 209–217.

Grünewald, T. (trans. Drinkwater, J.) 2004. *Bandits in the Roman Empire: Myth and Reality*. Abingdon: Routledge.

Hafner, K. and Markoff, J. 1991. *Cyberpunk: Outlaws and Hackers on the Computer Frontier*. New York: Touchstone.

Hayward, A.L. 1735. *Lives of the Most Remarkable Criminals*. London: Reeves & Turner.

Hobsbawm, E. 1981 [2000]. *Bandits*. London: Weidenfield & Nicholson.

Ives, E.D. 1988. *George Magoon and the Down East Game War: History, Folklore and the Law*. Urbana/Chicago: University of Illinois Press.

Katz, F. 1998. *The Life and Times of Pancho Villa*. Stanford, California: Stanford University Press.

Kheng, Cheah Boon. 1988. *The Peasant Robbers of Kedah 1900–1929: Historical and Folk Perceptions*. Oxford: Oxford University Press.

Knight, S. 1994. *Robin Hood: A Complete Study of the English Outlaw*. Oxford: Blackwell.

Koliopoulos, J. 1987. *Brigands with a Cause: Brigandage and Irredentism in Modern Greece 1821–1912*. Oxford: Clarendon Press.

Kooistra, P. 1989. *Criminals as Heroes: Structure, Power and Identity*. Bowling Green: Bowling Green State University Popular Press.

Lewin, L. 1987. The Oligarchical Limits of Social Banditry in Brazil: The Case of the 'Good' Thief Antônio Silvino, in *Bandidos: The Varieties of Latin American Banditry*, edited by, R. Slatta. New York: Greenwood Press, 67–96 (originally published in *Past & Present*, 82, February, 1979, 116–46).

Liaqaut Ali Khan. 2005. Who is Feeding the bin Laden Legend? *The Hindu*, 4 January available at: www.hindu.com/op/2005/01/04/stories/2005010400 261500.htm [accessed November 2006].

Mackay, C. 1841. *Extraordinary Popular Delusions and the Madness of Crowds*. London: R. Bentley.

Maxwell, G. 1972. *God Protect Me From My Friends*. 2nd rev. edn. London: Pan Books.

McLynn, F. 1991. *Crime and Punishment in Eighteenth Century England*. Oxford: Oxford University Press.

Mertz, R. 1974. No One Can Arrest Me: The Story of Gregorio Cortez. *Journal of South Texas*, 1, 1–17.

Meyer, R. 1980. The Outlaw: A Distinctive American Folktype. *Journal of the Folklore Institute*, 17, 94–124.

National Museum of Australia. 2003. *Outlawed! Rebels, Revolutionaries and Bushrangers*. Canberra: National Museum of Australia.

Page, G. 1991. Was Billy the Kid a Superhero or A Superscoundrel? *Smithsonian*, 21 February, 137–48.

Paredes, A. 1958 [1990]. *With His Pistol in His Hand: A Border Ballad and Its Hero*. Austin: University of Texas Press.

Pike, R. 1988. The Reality and the Legend of the Spanish Bandit Diego Corrientes. *Folklore*, 99(11), 242–47.

Rafael, V. (ed.) 1999. *Figures of Criminality in Indonesia, the Philippines and Colonial Vietnam*. SEAP, Ithaca: Cornell University (Studies on Southeast Asia No. 25).

Ranger, T. 1986. Bandits and Guerillas: The Case of Zimbabwe, in *Banditry, Rebellion and Social Protest in Africa*, edited by D. Crummy. London and Portsmouth: James Curry/Heinemann, 373–396.

Restivo, A. 1995–1996. The Economic Miracle and its Discontents: Bandit Films in Spain and Italy. *Film Quarterly*, 49(2), Winter, 30–40.

Rossetti, C. 1982. The Ideology of Banditry. *Man* (New Series), 17(1), March, 158–160.

Ruff, J. 2001. *Violence in Early Modern Europe*. Cambridge: Cambridge University Press.

Sant Cassa, P. 1993. Banditry, Myth and Terror in Cyprus and Other Mediterranean Societies. *Comparative Studies in Society and History*, 35(4), October, 773–95.

Scott, J. 1990. *Domination and the Arts of Resistance: Hidden Transcripts*. Harvard: Yale University Press.

Seal, G. 1996. *The Outlaw Legend: A Cultural Tradition in Britain, America and Australia*. Melbourne: Cambridge University Press.

Seal, G. 2005. Osama bin Hood: Global Outlaw Hero Traditions and the Roots of Terror. Third International Conference on New Directions in the Humanities. Available at: h05.cgpublisher.com/proposals/177/manage_workspace [accessed July 2009].

Seal, G. 2001a. *Tell 'em I Died Game: The Legend of Ned Kelly*. Melbourne: Hyland House.

Seal, G. 2001b. *Encyclopedia of Folk Heroes*. Santa Barbara, Denver; Oxford: ABC Clio.

Seal, G. 2009. The Robin Hood Principle: Folklore, History and the Social Bandit. *Journal of Folklore Research*, 46(1) (2009), 67–89.

Segal, Robert A. (ed.) 1990. *In Quest of the Hero*. Princeton: Princeton University Press.

Sharpe, J. 2004. *Dick Turpin: The Myth of the English Highwayman*. London: Profile Books.

Shaw, B. 1984. Bandits in the Roman Empire. *Past & Present*, 105, November 3–52.

Sidel, J. 1999. The Usual Suspects: Nardong Putik, Don Pepe Oyson, and Robin Hood, in *Figures of Criminality in Indonesia, the Philippines and Colonial Vietnam*, edited by V. Rafael. Cornell University, Ithaca: SEAP (Studies on Southeast Asia No. 25).

Singelmann, P. 1975. Political Structure and Social Banditry in Northeastern Brazil. *Journal of Latin American Studies*, 7(1), May, 59–83.

Slatta, R. (ed.) 1987. *Bandidos: The Varieties of Latin American Banditry.* Westport, CT: Greenwood Press.

Slatta, R. 2004. Eric J Hobsbawm's Social Bandit. *A Contracorriente*, 1(2), Spring, 22–31.

Smith, Captain Alexander (pseud). 1719. *A Complete History of the Lives and Robberies of the Most Notorious Highwaymen.* London: S. Briscoe.

Spraggs, G. 2001. *Outlaws and Highwaymen: The Cult of the Robber in England from the Middle Ages to the Nineteenth Century.* London: Pimlico.

Steckmesser, K.L. 1960. Robin Hood and the American Outlaw, in *American Folklore*, edited by R. Dorson. Chicago: Chicago University Press, 533–539.

Steckmesser, K.L. 1965. *The Western Hero in History and Legend.* Norman: Oklahoma University Press.

Stiles, T.J. 2002. *Jesse James: Last Rebel of the Civil War.* New York: Alfred A. Knopf.

Tatum, S. 1982. *Inventing Billy the Kid: Visions of the Outlaw in America, 1881–1981.* Albuquerque: University of New Mexico Press.

Thompson, E.P. 1975. *Whigs and Hunters: The Origin of the Black Act.* London: Allen Lane.

Turner, V. 1975. *Dramas, Fields, and Metaphors: Symbolic Action in Human Society.* Ithaca: Cornell University Press.

UNESCO Convention for the Safeguarding of the Intangible Cultural Heritage. Paris, 17 October 2003.

Wagner, K. 2007. Thuggee and Social Banditry Reconsidered. *The Historical Journal*, 50(2), 353–76.

Wald, E. 2002. *Narcocorrido: A Journey into the Music of Drugs, Guns, and Guerrillas.* New York: Rayo Books.

Wallis, M. 2007. *Billy the Kid: The Endless Ride.* New York: Norton.

White, R. 1981. Outlaw Gangs of the Middle Border: American Social Bandits. *Western Historical Quarterly*, 12(4), 387–408.

Wilson, S. 1988. *Feuding, Conflict and Banditry in Nineteenth-Century Corsica.* Cambridge: Cambridge University Press.

Zatta, J. 1999. Gaimar's Rebels: Outlaw Heroes and the Creation of Authority in Twelfth-Century England, *Essays in Medieval Studies*, 16, 27–40.

Chapter 4
Under Lines and Sub Verse:
The Heritage Chronicled in
Unofficial Poetry and Verses from Below

Dave Reeves

Stories that tale off … don't always get lost
It's knowing how to read, how to listen, how to ask questions
What questions to ask

I was late today
Luckily nobody asked why
I'd got my answer – seemed reasonable to me –
"History is about late things"
but I was glad I never needed to say.

What's this place called?
What was it called?
(Letters to Leningrad never arrive)
Titles change by Chinese Whispers
meeting places move for reasons of security
I never got the message, stood nervous on a corner,
feeling more and more conspicuous … the others …
so I never spoke about it after, never reported it
the little kids asking "What did you do in the …"
Leave alone; don't disturb.

Stories that tale off … don't always get lost
It's knowing how to read, how to listen, how to ask questions
What questions to ask
When to ask them

How often do you see working people on TV
their real lives, that is, not Reality
a vérité fly in the ointment, not a fly on the wall
Who'd want to know about them?

"If you take your language and impose it
it is a sign of your authority"
Posh voices talking down to us
A public service not about the public at all

"Don't tell the researcher, they won't be interested
They've better things to do than be bothered with the likes of us
Don't waste their time with tittle-tattle
We'll talk about it later …"

Stories that tale off … don't always get lost …

We find no mention in the archive: no reference in the press
We speak through banners, through ballad
No Laureate's butt of sack for us: penny plain, tuppence coloured
We wear our Peterloo commemorative kerchief: our T-shirt Ché

And we discover that a raffle, an innocuous raffle,
was the way of raising funds for the wife of someone
who had been transported

"Oh I thought you knew that"
"I could have told you that …"

While only certain groups are authorised to speak
There is such richness to be found
such wealth of experience, humour and wit

Stories that tale off … don't always get lost
It's knowing how to read, how to listen, how to ask questions
What questions to ask
And then asking them … whatever.
Death to the monoform!

<div align="right">(Dave Reeves, Why We Need To Keep Digging, 2007)</div>

Celebratory verse has long been used by individuals in authority to communicate their versions of events, to transmit the values that they wish a society to be recognised for, and to preserve a record which they endeavour to promote as the sole cultural heritage of its citizens.

In Gaelic Ireland, Bards were retained to celebrate a patron, to glorify their employer's achievements (or embroider them), to record them for posterity and in at least one recorded instance to act as propagandist, helping to undermine and usurp an elder brother and chief. The skill of these bards saw that names 'of the patron himself, his father and grandfather, wife and maternal relatives, his place

of residence and the territory he rules over' were repeatedly woven into the verse structure so that any substitution would distort the rhyme scheme. This made them 'extremely difficult to forge', and built in a protection against the appropriation of their stories, and a re-editing of their version of events (Simms 1987: 58–65).

Sanang Setzen, the poetical historian of the Mongols, commemorated the death of Toghon Temür, the last of the Yuan emperors, in the Karakorum in 1370, eulogizing the glory of his empire by putting into his mouth a lament that he would no more see his '… vast and noble … splendidly adorned …' capital (Alexander 1988: 42).

The United Kingdom today still has a Poet Laureate appointed to celebrate the events that are officially considered worthy, a post which has existed, according to Collins Dictionary (Hanks 1879), since 'Ben Jonson was given a lifelong post as an official of the Royal Household in 1616', though others might argue for longer.

But while official poets have long been retained for the singing of great deeds, great battles, great victories, famous matches made, as Alessandro Portelli (Portelli 1991: viii) said 'there's more to history than presidents and generals, and there's more to culture than the literary canon'.

And it is the work that lies outside the literary canon that is my subject here.

The verses which appear at the beginning of this chapter were written during a conference at Ruskin College Oxford with the simple intention of summing up the day in verse, of commemorating it, of marking its' passing. With none of it prepared before the conference, the poem was meant for immediate oral delivery (hence the pun 'tale off' and its repetition as a motif). Into it are woven, not names of the great and the self-important, but quotes from and references to all of the presentations I attended during the day. It includes comments from papers presented on documentary maker Philip Donellan and tailors' wall hangings of the 1840s, from keynote speaker Ken Loach, and finishes with a quote from filmmaker Peter Watkins. It was given its first reading at the end of my own paper to the conference during the last session of the afternoon (Reeves 2007).

Such poems, springing directly from a particular environment, which sum up and encapsulate the events of the day, have formed part of my own practice since being invited in September 1996 to attend a conference organized to develop a funding bid for a proposed Millennium festival across the Black Country. Having sat in on various focus groups and workshops, listening to disparate opinions of what could be done and should be done across four very individual local authorities, I had the job of drawing all of the thinking together. The result was the poem *Barnstorming The Millennium* (Reeves 1996) which incorporated elements from the keynote address by Derrick Anderson, Chief Executive of Wolverhampton. He talked of the way that the festival might take three strands into consideration – the past informing the present, the present informing the future, and the past informing the future – and mentioned various proposed Millennium projects from around the world which were also seeking funding, including one to place giant pink plastic feet along the River Nile. He also spoke of the need to sometimes resort to the 'Special Brew' to be able to stimulate ideas for such speeches. I tied these in with

other strands I heard discussed as I moved from group to group, room to room, and, at the end of what had been a long, tiring day, tried to mix some humour in with the serious themes. As I walked up to the podium one person looked at me and said quietly 'rather you than me'.

["Barn's burnt down –
 now
I can see the moon."
 Masahide]

Last week someone came up to me and said
write something witty on this card.
It's the kiss of death
Like coming together and being asked to plan a celebration
to orchestrate a good time.
Who can dream
that grand, grand scheme
when asked to?
Put on the line you just feel like
so much washing hung out to dry.

The barn's full of grain
 waiting to be distilled into
 the special brew of inspiration.

Let the past inform the present:
 Messrs. Brindley and Telford
would like to point out that their intention in cutting their canals
was to move coal from the Black Country faces of the 30 foot seam
to the industry of Birmingham, to create a link,
 and not to have
giant pink plastic feet plonked in them in the name of art.

Let the future be informed by today:
We wuz all gid a diary
an' asked to write
Wat we got up to
on the very last night
of the last 1000 years.
I cudda bin profound
But instead I was 'onest, wrote,
"Got drunk and fell down."

Let the past inform the future:
boast our heritage
leave an echo through time.
Forget the face on Mars
forget the rings of Saturn
forget the Great Wall of China
let's celebrate local culture:
let's build a scratchin' that
can be seen from the Moon.

It's New Year's Eve
Sat alone, bereaved,
the fireworks thud like bullets in my heart
no large lottery hand dispenses
a million pounds of friendship
where's the special brew to reach these unreached parts?

I'd like to cast a spell that by the year 2000
we feel we've done something worthwhile for the Millenium
I'd like to cast a spell that by the year 2000
we've created something sustainable for the Milenium
(like a scratchin' that can be chewed for the next 2000 years)

I'd like to cast a spell that by the year 2000
everyone, but everyone can spell MILLENNIUM correctly.

Let's burn down the barns
ferment the grain –
And see the Moon.

<div align="right">(Dave Reeves, Barnstorming The Millennium, 1996)</div>

As with *Why We Need To Keep Digging*, the poem was written not to exalt any one person, or persons in authority, but to celebrate the hard work put in by lots of ordinary working people, and to hopefully commemorate it in a way meaningful to them.

The poet Adrian Mitchell is remembered for a quote in the introduction to his first collection of poems 'Most people ignore most poetry because most poetry ignores most people' (Mitchell 1964:8). With *Barnstorming The Millennium*, and subsequent poems, there has seemed a genuine desire on the part of audiences to engage with the piece further. While some of the texts have been reproduced later as broadsides and postcards, *Transformations* (Reeves 1998), a work with slideshow to celebrate the launch of a borough arts plan, was subsequently commissioned as a film due to the demand from people present. Such experiences suggest to me that if the verse connects with people, far from ignore it, they are

most definitely interested: as interested in seeing an event in which they have been involved commemorated as the ruling elites are in having themselves recorded.

However, this act of publishing what was originally an oral work in a more permanent format leads inevitably to some acknowledgment of the dictates of the new medium, some 'polishing' of the work, some correcting of mistakes glossed over during the initial spoken presentation. This might include punctuating what was in all probability an unpunctuated original, and generally attempting to get the gist of that original oral version across to the audience, in this new format, without losing the references to the particular that gave it immediacy, relevance and rhythmic drive.

Inherent in this transposition is the danger of giving way to an impulse to rewrite it as a page piece rather than a record of the oral – which is after all what it is, and why people have initially requested it – because, as Raphael Samuel suggests, all of our training 'predisposes us to give a privileged place to the written word, to hold the visual (and the verbal) in comparatively low esteem' (Samuel 1994: 268). With such rewriting we transform it into what we might call, with reference to Ludmilla Jordanova's description of 'subaltern studies' (Jordanova 2000), a 'subaltern' culture, judging it by the standards of the dominant literature which it runs parallel to, and in so doing distancing it from the very audience it was written to engage.

Initially I was one of those people who felt that poetry ignored them. At school I was introduced to the literary canon and what I read there seemed of total irrelevance to my life, a world unrelated to my experience. Here, it seemed, we were being taught to look up to culture rather than feel included in it. This was 'the' culture, our heritage, but I was bored by it and felt excluded. When I did attempt to engage with it in my own way, with the drama and story – i.e. trying to liven up a lesson on The Ancient Mariner by reading it theatrically – I was reprimanded. Yet now I learn that when Coleridge himself performed his work, rather than read it flatly, he 'launched out in his chanting voice' (Holmes 1999: 285).

So it was with great joy that whilst still at school – and still feeling disenfranchised – I discovered a form of poetry that I felt I could participate in, a form of expression that talked to me, did not bore me. A poetry that made me want to be part of it. One that helped me understand my own existence and offered cultural inclusion. This I didn't find in books but on the radio. The *John Peel radio show* on BBC Radio1 where I heard the English beat and Liverpool poets. Absorbed in what I heard, I thought, 'If that's poetry, I can do that …'.

My own first nervous public readings took place in venues which mixed poetry with acoustic folk and blues music. As these had grown out of earlier clubs where readers had performed with jazz accompaniment, so the venues I worked in changed again and I found a platform alongside electric bands playing through amplification. Such seemingly generational changes caused me to wonder where my work fitted in to a wider picture, where it might have its roots. Just as we research family histories to find out where we come from, to feel more comfortable

with where we are now, I wanted to know about the writers and declaimers of their verses who were my forerunners.

When the surrealist movement had felt the necessity to identify the artists from whom they considered themselves descended they had declared Bosch, the elder Bruegel, Dürer, Guiseppe Arcimboldo, Goya, Victor Hugo, Blake and Rousseau amongst their precursors (Alexandria 1970). Similarly writers that I knew were looking to the griots of Africa for their roots, the poets/ songwriters/ oral historians who can talk to the ordinary members of their community, reciting a person's family lineage, placing them in their history and including them in the culture.

As they sought their antecedents so I sought my own, and began to build a picture which resulted in my making the following statement in my publicity material:

> Horace records that in the Italy of his time a law and penalty were introduced to stop anyone being lampooned in verse. In Plautus's "Mercator" Demipho is afraid that the satirical street poets will come and recite before his door. The troubadours of Toulouse harangued the papacy for its hypocrisy so much that in 1209 Pope Innocent III declared a crusade and sent an army of 500,000 into Southern France. At Carcassonne jongleurs stood on the walls singing and playing as it was besieged. In all 300 towns and 200 castles were completely destroyed. (Reeves 2002b: 6–7)

I aligned myself with these influenced not through their actual writing, because I hadn't heard any of it, nor through their populist poetry, but through the attitudes I perceived that they had, the way that I imagined them positioned against the 'official' culture of their time. I saw them in opposition to a system similar to the one I felt had been intent on dragging me down, on excluding me.

Printed examples of this kind of writing were often only published in small numbers, most of those uncollected and unkept. Where examples are to be found, in chapbooks, broadsides, cheaply printed and more recently photocopied publications, they are rarely in the archive and, if they are, not in the literary collections of libraries, outside of that canon. What we can discover in them is a very different version of the world from that held up in the literary canon, and what they might be said to lack in literary merit they more than make up for in their enthusiasm, their conviction, their relevance to the lives of ordinary people.

A direct comparison of the 'official' and 'unofficial' versions of events as charted in verse, can be illustrated by the following two extracts. Poet Laureate Sir William Davenant lived from 1606 to 1668, was laureate from 1638, and was followed in that role by Dryden. In the poem *Aubade* (Davenant 1973) he gives us a world in which all is ordered and love is supreme, where all are in thrall to some star, have a proper and natural subservience. Stanza two tells us:

> The merchant bows to the seaman's star,
> The ploughman from the sun his season takes;

> But still the lover wonders what they are
> Who look for day before his mistress wakes.
> Awake, awake! Break thro' your veils of lawn!
> Then draw your curtains, and begin the dawn!

But another view of the same period, found in the Diggers Song published in 1650 and regularly attributed to Gerrard Winstanley (Hopton 1989), suggests that not everything, is in such good order.

> Your houses they pull down to fright poor men in town,
> And the gentry must come down, and the poor shall wear the crown,
> Stand up now, Diggers all. (Hopton 1989: 27)

Talking of the clergy, who it claims are calling it a sin that 'we should now begin, our freedom for to win' it says:

> The tithes they yet will have, and lawyers their fees crave,
> And this they say is brave, to make the poor their slave. (Hopton 1989: 28)

In these poems we have both writers addressing their audience with work rooted in their own experience, giving two competing world views. The laureates view can be said, like that of the Gaelic bards, to reflect the view of the world promoted by their paymasters, the unofficial ballad is addressed to, and speaks for, those who were not included in the central narrative.

Here, I would suggest, we have parallel traditions. The latter poem being an example of one generally unpreserved until the advent of a readily available method of recording it and, crucially, both a political reason for wider distributing it and a will to preserve the material. This conjecture seems to be supported by Tuama and Kinsella's (1981) observations that after the collapse of the system of bardic patronage in Ireland types of verse other than the formal, syllabic ones appeared apparently fully-fledged, with poems now frequently being a direct response to the social and political upheavals of the time, rather than praise songs and histories for those in power.

In the nineteenth century when printers were also publishers and local newspapers routinely printed poetry, pamphlets and chapbooks targeted at small geographical areas were produced and distributed. These often argued points of local importance, and it is possible to find whole political debates in verse. As part of one such poetical discussion we find *The Wooing of Wednesbury* ('Q.C.' 1868) a pamphlet published as part of the election campaign fought for an 1868 parliamentary election, the last in the UK to be fought under the hustings system. It provides 'pen and ink sketches of nearly 200 local celebrities,' parodies of members of the great and good of the town, in a publication that is also an electioneering pamphlet for one of the candidates. The anonymous writer went to great trouble to intrigue and interest the local population in the election, their success being

perhaps measured by the fact that publication ran to at least a third edition - as evidenced by a copy of the front cover of the publication held in the borough Community History and Archives Section, at Smethwick library[1] – and that the candidate it championed won the election. Examples of this genre of writing, found in the local collections of libraries, indicate that they were a widespread practice and part of a thriving dialogue: local verse for a local purpose. While it is doubtful that they were ever expected to enter the literary canon and often the references are parochial, they are celebrations of the locality and the writers' immediate society, a proud engagement with their community and ownership of their culture. They can be seen as part of a tradition of functional poetry by ordinary working people.

Though both of the two previous examples owe their availability as sources to the fact that they were captured in print, the majority of such unofficial texts will have been disseminated orally, and so are impossible to trace. However the arrival of portable sound recording equipment in the twentieth century led to the recording of a variety of spoken verses, notably in the United States of America where the work of collectors has given us a rich tapestry of raw voices and interpretations of folk art that would have been lost to posterity. Although these collectors were primarily interested in songs and instrumental compositions, there are recordings of spoken ballads and poems, giving us concrete examples of another kind of 'poetry from below' altogether.

In his book and CD combination, Bruce Jackson (2004) publishes a collection of 'toasts' – narrative poems from black oral tradition – which include a number of variations on verses about the sinking of the Titanic. Here we find the disaster looked at from the perspective of the have-nots whose only place in such a drama is more usually as an extra, as a servant rather than as one of the 'poor' passengers, a second class of victim even. Here we have poor as impoverished rather than poor as unfortunate.

> The central character is Shine, a crew member who appears from the "deck below", while the action proper begins with those in command – the captain and the seargeant – "havin' some words" (squabbling like fools when they should be tending to the ship). Shine tells them what is going on, but they reject his information. He in turn rejects them; "but there's one time you white folks ain't gonna shit on Shine", and leaves the ship with "a thousand millionaires lookin' at him". (Jackson 2004: 181)

Shine saves himself rejecting offers of money, sex and marriage from rich passengers who appeal to him to come back to the ship and save them. The language in *Titanic* is coarse, a kind of barroom braggadocio, and the writing would never be used as an example of 'good' poetry – although what is good poetry, and why, is another debate altogether – but it does show us the thinking of

1 Photocopy in Community History Archive Sandwell, Smethwick. Catalogue reference 329.94246.WED.

one stratum of the don't haves in society, the culture of those who expect no place in the archive and make no attempt to manicure the way that they will be perceived and remembered beyond the raucous instant. Here we also have indication that the alternative tradition of poetry from below is no more the preserve of one country or society than is the use of official poets.

While these three examples that I have offered are as varied as the styles of the artists that the Surrealists looked to as their predecessors, the differing traditions which they illustrate are united by their common intention to address an audience other than a literary, or official, one. Their disparate styles all ranged against the monoculture that I sought to escape from, the monoform of Peter Watkins. Together they create a body which informs and contextualises my own work. So whether I am writing about nuclear folly in High Wycombe (Reeves 1985), the building of one too many runways or the GM debate; am responding to a request to comment upon the days news by BBC Radio 5 for National Poetry Day (Reeves 1995); or by BBC Radio 3 to commemorate the 30th anniversary of the building of the Gravelly Hill Interchange in Birmingham (Reeves 2002a) – Spaghetti Junction as it is better known – I can identify elements of celebration, propaganda, satire and identity also apparent in those older 'unofficial' verses.

A Different Durum

Tortola, British Virgin Islands:
"ask any local where their favourite Italian restaurant is,
and they'll tell you 'Spaghetti Junction'.
just a short walk from the centre of Road Town,
with a spectacular, unobstructed view of the entire Inner Harbour,

Shuttered walls that open to the gentle, cooling trade winds
packed with locals and regulars that return year after year.

The staff remembers you – usually by name –
the music, atmosphere, and good times are out of this world".

> ... and you've plenty of time to dream of it
> snared in the basilisk stare
> of the tortuous spawn of a dolmen
> and a kraken
>
> hung on your dragline as the silk ensnares
> in its council
> in this web of receipt
> and dispersal

where Arachne and Anansi
and Weird and Gilly meet

…

There are days that you find
yourself at the mercy of the wind
run to some unintended destination
slip from the fork even as the maw encircles

but today it's the doldrums: becalmed
in some petrified arden
the rods of a fasces unbound
into an avenue of independent authorities

you want to get out and stretch your legs
hang over the balustrade
the beetling brow of a great cliff fell sheer
wave to the slam-dunkers in the park below
gaze out at the city's skyline,
to the Malverns, the Black Mountains, beyond

build camps (like a kid) sure that no one will
find them
in its nooks
join its secret world
interact
celebrate

…

but all you can do is
pray for release: idle involvement in
the mantra hum
the incensed fuming shimmering the distance
shaping your outlook

be part of an annal retained
where the scroll of our journey's enshrined
in the arc of the convenient

18 routes on 6 levels,
26,000 tonnes of steel,
250,000 tonnes of concrete and

300,000 tonnes of earth
8.2 million pounds to construct.

But at least the name is organic
constitutional in the structure
emerged rather than imposed
a traditional reclaiming of colonised space

Bored with the Tyre Wars gave us Fort Dunlop,
you turn to dream origins to pass the time: it's a
 Homage to every coffee cup ever wed its ring to a blueprint
 Memorial to the subtle ellipse of a plastercast leg mounting a bicycle
 Manifest of a spirograph childhood
 A sheetbend married to a sheepshank crossed with a round turn and
 two half hitches

 It's
 a dance m'car(b) – your car()
 car(), car(), car()
 bumper to bumper
 scythe slash silhouette
 across the skyline
 (with an older cut below
 locked into the city
 narrowboat, stickleback and shopping trolley
 a dance to a different durum)

 a feast of the overpass
 a bake of elflocks in foul sluttish air
 (Dave Reeves, *A Different Durum*, 2002)

While the lack of reverence shown for the prescribed subject in the above poem is not present in them, I can equally cite works such as those produced whilst resident writer in the community at Craven Arms and later at Bomere Heath, both in Shropshire, as part of this lineage. These were not satire or polemic but rather conceived, as was *Barnstorming The Millennium*, as ways to situate people within, and allow them to see themselves situated within a cultural context and to involve them in their own heritage.

The poem *4368* takes its title from the B-road which connects the communities worked with on the Craven Arms project, and makes use of local references such as the remembered colours of the livery once used on railway coaches in the town and the colouring of sheep being driven to market.

4368 ·

Corvedale: smooth surges beach in the eye ·

pastel sheep, rainbow droves, spoke to the hub of market ·

the false pillow of the distance, a bolster full of battles and dead wether ·

a black dog on wheels howling change ·

4368 ·

Craven Arms: a yearning crossroads ·

blood and custard coaches, plum and spilt milk houses ·

a carnival passes through, bass bin and door panel rattle ·

the static dance of the hillsides ·

4368 ·

Clun Valley: headlights twist and squall through windy lanes ·

the corrugation of fields, rusted with fresh ploughing ·

a bowling green crowns the hill, nestles in the lee of dominion,

cushions against the heavy shadow of the past ·

4368 ·

passion for landscape: passion that twines and inveigles, until you are lost in discovery ·

(Dave Reeves, *4368*, 2004)

The text was printed onto the walls of the gallery linking the work of seven artists as the road itself links the communities, in *Passion for Landscape* a project on which I was lead artist. The exhibition created great interest in the area, drawing the largest ever opening night audience for any exhibition at the Secret Hills Discovery Centre in Craven Arms.

In Bomere Heath this process resulted in a series of poems investigating the atmosphere and history of the parish and the concerns of residents, such as how incomers are included in the community. With some of the poems set to music a CD/CD-ROM, *Ballads for Bomere Heath* (Reeves 2006b) was distributed to every house in the parish as part of an attempt to engage people with their own community and in the construction of a parish plan. *Bomere Heath: this horse grazing*, takes the atmosphere of the area as its theme.

Bomere Heath:

This horse grazing

This encampment at the edge of the battlefield

Beyond the daygrind thrust and parry

The fret, the worry, the strife, the harry

The place where Hotspur died

This haven

This workplace
Field and forge and mill

This chameleon
 Fitting in and lying low
This colouring book
 The outlines carefully filled to the edges
Or scrawled across with enthusiasm,
 Crayoned with pride

This clawed pause
This weighing, and waiting, and levelling

Where for all you can rush
You can't rush things.

 (Dave Reeves, *Bomere Heath: this horse grazing*, 2006)

Also available on the internet as an interactive website, *Ballads of Bomere Heath* ends with *The Damson Pickers*, a piece constructed from an oral history interview, and used as a way to ask the reader/listener to consider the kind of community they would like to bequeath to the future.

Wartime. The damson pickers in question
Were a father and son picking damsons
At the back of the Wade Room in Bomere Heath

And they heard in the distance
A buzzing like a far off swarm
And it grew louder and louder
And a plane shot over their heads
Embedding itself in the ground
Sinking, so they say, never to be recovered

And sometimes if you listen hard
You might think you can still
Hear a distant humming
Like powerlines after a storm
Like a collective tinnitus
Like the wind, rush between the feathers of a buzzards wing
You listen hard and you can hear
The sound of you inside

You can hear what they heard, still
The silence that the hurtle of the intercity breaks

But what will they hear tomorrow?
What do you *want* to hear tomorrow?

What will you leave behind, your legacy: your tale?

(Dave Reeves, *The Damson Pickers*, 2006)

The question might just as well be addressed to those poets whose work forms the corpus of writing that runs beneath official culture. Like poems in the Diggers pamphlets; the nineteenth century political poems; and the toasts, my own work is more likely to be found in the local collections of libraries than in literature sections. Yet while it might be out of the limelight, there is a large body of such writing still existing in the places it always has, as a parallel tradition in pubs and the bars of community centres, peoples own homes and hired rooms, folk creating their poetry for their own consumption, their own edification, the expression of their own views. This is not poetry to glorify an individual or show an administration in a good light but, as the poet David Hart put it 'poetry being the very language we need to take on whatever it is life means' (Hart 1992: 3) – it runs beneath the official culture, giving unofficial and subversive opinions, underlining and emphasising other artistic values, seeking to engage and include rather than impress and overawe: an alternative poetical heritage.

References

Alexander, C. 1988. *The Way to Xanadu*. London: Phoenix.

Alexandrian, S. 1970. *Surrealist Art*. London: Thames and Hudson.

Davenant, Sir W. 1973. Aubade, in *The Oxford Book of English Verse 1250–1918*, edited by Sir A. Quiller-Couch. London: Oxford University Press.

Hanks, P. 1979. *Collins Dictionary of the English Language*. London & Glasgow: Collins.

Hart, D. 1992. Poetry in the Doctor's surgery. *Poetry News*, 1(2), 3.

Holmes, R. 1999. *Coleridge: Darker Reflections*. London: Flamingo.

Hopton, A. (ed.) 1989. *Digger Tracts 1649–50*. London: Aporia Press.

Jackson, B. 2004. *Get Your Ass in the Water and Swim Like Me: African American Narrative Poetry from the Oral Tradition*. New York and London: Routledge.

Jordanova, L. 2000. *History in Practice*. London: Arnold.

Mitchell, A. 1964. *Poems*. London: Jonathan Cape.

Portelli, A. 1991. *The Death of Luigi Trastulli and Other Stories: Form and Meaning in Oral History*. New York: State University Press.

'Q.C.' 1868. *The Wooing of Wednesbury, a Political Ballad by a Rejected Suitor*. Tipton: Wm Britten.

Reeves, D. 1986. High Wycombe, on *The White Dog of the Cynics* [audio cassette] cfz: Dudley. Red side, track 3.

Reeves, D. 1995. Communicating by Grunt is Not Enough. *Raw Edge Magazine*, (1), 18.

Reeves, D. 1996. *Barnstorming The Millennium* [privately distributed]. Dudley: Dudley Education Department.

Reeves, D. 1998. *Transformations* [video]. Oldbury: Sandwell MBC.

Reeves, D. 2002a. A Different Durum commissioned BBC Radio 3 for the programme *Concrete Spaghetti*, produced by Richard Bannerman. Broadcast on Friday 24 May 2002.

Reeves, D. 2002b. *An Engagement With History: The Wooing of Wednesbury and the search for a relationship with the past.* Unpublished MA dissertation, Ruskin College Oxford.

Reeves, D. 2004. *4368*, published as a wall text as part of the Passion for Landscape exhibition at Secret Hills Centre, Craven Arms, Shropshire, 14.2.2004 to 21.3.2004. Parts published as photographs on cover and throughout *Raw Edge Magazine*, 18, Spring 2004.

Reeves, D. 2006a. A Different Durum, in *Concrete Spaghetti: The Spaghetti Junction Poems* [pamphlet]. Birmingham: Poetry Central.

Reeves, D. 2006b. *Ballads for Bomere Heath* [cd/cd-rom]. Birmingham: The Moving Finger. Also published simultaneously online at: http://www.bomereheathballads.co.uk [accessed 4 February 2009].

Reeves, D. 2007. *News That Remains News: Pasts That Remain Present.* Paper to the Public History Conference: Radical and Popular Pasts, Ruskin College Oxford, 17 March 2007.

Samuel, R. 1994. *Theatres of Memory*. London: Verso. 268.

Simms, K. 1987. Bardic Poetry as a Historical Source, in *The Writer as Witness: Literature as Historical Evidence*, edited by T. Dunne. Cork: Cork University Press, 58–65.

Tuama, S.Ó. and Kinsella, T. 1981. *An Duanaire 1600–1900: Poems of the Dispossessed.* Portlaoise: The Dolmen Press.

Chapter 5

Intimate Knowledge:
Defining Heritage from the Inside

Elisabeth Skinner

In 1981 a group of villagers in the Gloucestershire valley of Sheepscombe took their first steps in a project to identify and preserve their own local heritage. They were inspired by the discovery of a notebook and some photographs and by a fascination with the history of their village. This chapter reflects on their experiences as they set up a local history society and sought to catalogue and understand their inheritance.

I was one of those villagers. In 1979, when studying with the Open University, I discovered that history could be about ordinary people – and people who lived in the place I loved. I was brought up in Sheepscombe from 1949 and had seen it change dramatically from a mixed rural economy to a village dominated by residents working in education, hospitals and businesses elsewhere. I grasped an opportunity to study its history over the next 25 years and helped to create Sheepscombe History Society. In 2005, I published a book, *Sheepscombe: One Thousand Years in this Gloucestershire Valley* (Skinner 2005).

This discussion shows how the activities of a local history society can have an impact on a village community. In this case, we held tea parties for villagers who lived here in the past, made contact with wartime evacuees, collected oral history, built a village archive and wrote several publications. A deeper understanding of the valley has strengthened our sense of identity and has brought people together, old and young, long established residents and newcomers.

Sheepscombe

Sheepscombe is a secret valley surrounded by beautiful beechwoods. The slopes are scattered with some 200 dwellings, many made of Cotswold stone. The village has a population of about 600. It lies two miles to the east of Painswick and five miles to the north of the market town of Stroud. In the seventeenth century, hamlets developed in the valley that was once a medieval deer park and local people scraped a living from farming and broadcloth weaving. The village grew as the woollen cloth-making industry of the Stroud valleys flourished, but its cloth manufactory failed in the 1830s and many people left to find work elsewhere; dwellings fell into disrepair and decay and poverty was rife. Towards

the end of the Victorian era, people escaping even then from city life, helped the community to rebuild.

Figure 5.1 Map locating Sheepscombe in the United Kingdom

Figure 5.2 Sheepscombe Valley before 1872 with evidence of quarrying on the northern hillside

Source: Photographer unknown.

For the first half of the twentieth century, Sheepscombe was a traditional rural community with several small farms and people working in countryside crafts and trades; there was some building work and a dozen households providing jobs in domestic service. The community was badly affected by men leaving to fight in the First World War while in the second war the valley was a haven for evacuees escaping from dangers elsewhere. After the war, and with the growth of private transport, the village changed. As in other communities across the south of England, traditional rural society gradually evaporated. The rural sociologist, Howard Newby, demonstrated in the early 1980s how the decline of "the village as an occupational community, centred upon farming" has led to social polarisation, the loss of rural distinctiveness and the submerging of individuals on low incomes with inadequate access to services (Newby 1985: 271–3). So as residents could travel to work and shops elsewhere, the valley became a place appreciated for the most part for its peaceful beauty and its lively social life.

Intimate Knowledge and Identity

Our search for a deeper understanding of our heritage was never about nostalgia or a lost golden age; it was a search for the lives of ordinary people who lived in our houses and worked in our community. Until now, many of those people were the 'disappeared' of history. One resident explains: 'It is about discovering the particular and human in connection with this place, comparing then and now in the way people lived their lives, and understanding the overlapping layers of change over time' (pers. comm. June 2009). Although I was initially unaware of the concept of local distinctiveness coined by Sue Clifford and Angela King at Common Ground, it is clear that our village group set out to define our locality from the inside, revealing the local detail that makes our place distinctive (Clifford and King 2006).

As I walk around the village today the detail is immense and 'full of significances' (Howard 2003: 116). Every corner holds a memory, not only of my childhood or my experiences as a parent but of people who passed this way long ago. For example, high on the northern hillside are the remains of a quarry where my own generation and then my children played imaginative games and made dens with no thought of the men who dug the lumps and bumps decades before. Each year labourers brought limestone rubble down from the hill and, having shovelled away the cream-coloured mud churned up over the winter, they rolled down a new white road surface of quarried stone. On the other side of the valley I live in a semi-detached house built in the 1890s overlooking the village green. As a child I lived next door, often playing under the massive oak tree planted by villagers to celebrate Edward VII's coronation in 1902. One wall through both houses is a clue to the row of earlier cottages that once stood on the site, a hint of the physical decay that penetrated the valley in the Victorian years. As dwellings

were deserted by people leaving to find work elsewhere; roofs fell in, the walls were recycled, the fittings vanished.

These detailed secrets of the past are well hidden and villagers today are surprised by the stories we have to tell. The new owners of one ancient cottage recently sold for nearly £700,000 could not have known that eighty years ago it had floors of bare earth, or that 180 years ago there were two other dwellings, since lost, at the end of their garden. Residents in a newly refurbished row of cottages might find it hard to imagine the work that went on there over the last 200 years including cloth weaving, a post office, a commercial laundry and a haulage and engine repair business with scrap yard. The fields, woods and valley slopes hold unexpected stories too. For example, the hilltop cricket field was used for strip farming in the early nineteenth century. The imprint of the mill leat is hidden among the buttercups; the mill yard is a pretty garden and the mill itself, nothing but a hump in the ground. Gardens on the south-facing slopes conceal medieval lynchets and evidence of a farm while the occasional apple or pear tree signposts an ancient orchard.

Every building, hedge or field, every cleft in the valley slopes has its story. For me this is 'intimate knowledge … gained over a long period of time through an extended encounter with place' (Holloway and Hubbard 2001: 75) that reflects the thoughts of geographer Yi-Fu Tuan. Tuan linked place with emotion, suggesting that 'this invests the individual with a deep sense of that place, making the place an extension of the individual' (ibid.). As one villager said, 'it takes time to feel rooted, settled; after twenty years we know that this is where we belong – it's the whole place, the landscape, it's complete; it's harmonious; it feeds the soul' (pers. comm. June 2009). There is no question that for those of us discovering our

Figure 5.3 The laundry business and post office in the early twentieth century
Source: Photographer unknown.

**Figure 5.4 Bert Canton's scrap yard with Dorothy the traction engine
in the 1970s**

Source: Photographer – S.G. Williams.

heritage Sheepscombe has become 'part of who we are, the way we understand ourselves and, literally, our place in the world'; in other words, it is part of our identity (Holloway and Hubbard 2001: 71).

Even so, no more than a dozen people living in the village today can claim to be descended from families who lived here before the Second World War and only four people belong to village families that go back beyond the twentieth century. Nine out of every ten adults living in Sheepscombe have come to the village from elsewhere and made it their home. Perhaps, as incomers, many of these people deliberately and self-consciously seek to become insiders through their emotional involvement and their search for the village story (Howard 2003). Surrounded by so much rapid and sometimes threatening change, or the chaos and degradation of the outside world (Holloway and Hubbard 2001) villagers seek to strengthen their sense of belonging by recognising and appreciating their local heritage.

Searching for Heritage

Heritage is everywhere in Sheepscombe but much of it goes unnoticed.

> Sometimes we forget that our everyday surroundings are nature's greatest store. History's biggest library. The filigree of rich understandings between people and

the land is not about scenery. It takes us below the surface to where the land might reflect back to us purpose and belonging. (Clifford and King 2006: ix)

Those of us who live here now need help if we are to understand the buildings, the landscape and the culture that we have inherited.

Our investigations all began when, in 1980, a copy of a notebook, written by a Russian teenager living in Paris in the second decade of the twentieth century, was sent to Sheepscombe School from Canada. It contained the child's memories of visits to the school from the Tolstoyan colony at neighbouring Whiteway around 1900. The photographs of the village she had known had been given to her as souvenirs by the photographer, the headmaster of the school. The package containing the notebook and the photographs arrived at the school where I was a part-time teacher and the headmistress showed them to me and wondered what to do with them.

**Figure 5.5 Village children on the frozen boating lake, formerly the mill
 pond of Wight's Mill**

Note: The Russian girl is sitting on the toboggan.
Source: Photographer – George Jolly.

I was fascinated by the photos showing a spacious landscape, rough road surfaces, the original post office, schoolchildren and their teachers. An idea for a village archive began to form and through the village magazine, I invited others to discuss

the idea over coffee. A few months later, Sheepscombe History Society was created. Its purpose was to collect and preserve material relevant to the history of the village and to promote an interest in our local heritage. From the outset the History Society attracted the active involvement of both established villagers and newcomers and people with a variety of social backgrounds. The original committee included four people with village ancestry, someone with nearly a century of connections, three well-established newcomers and me – my parents came from elsewhere but I was brought up in the village.

Support for the History Society came from right across the community and there were many opportunities for people to explain why they wanted to join in. We would chat at the regular archiving workshops as we organised, filed, catalogued and indexed the finds that came our way. We discussed shared interests during the evening classes I ran in the mid-1980s at the village school. Occasional village meetings, exhibitions and history walks generated intense discussion. It was clear that people had a variety of different motivations for their interest in local history. New villagers were keen to know more about the place they had adopted so that they could, more quickly and intensively, feel how much they belonged.

> As someone who "came in from outside" learning about Sheepscombe's past has helped me to develop a sense of identity with this community; and I think it is important to foster this amongst inhabitants who have largely moved in from elsewhere. As an activity, it brings me into contact with people who share the same interest. (pers. comm. June 2009)

Villagers who had known the place all their lives wanted to enjoy their memories and protect the memorabilia of their lives. It was not part of the plan, but an outcome of the relationship between these two groups was appreciative respect. Long-time villagers had something that new residents wanted – knowledge, stories, memories, images from the past. The activity of the History Society, sharing and building heritage, brought together groups from a polarised rural society (Newby 1985), groups that might otherwise have remained aloof.

There is no escaping the 'problem of gentrification, the way in which a place can be colonised by people in a higher income group than that which was previously there' (Howard 2003: 231) but the summer tea party held in alternate years since the early 1980s gives villagers from the past a clearer voice and those who have moved away a stronger connection with the modern village. We invite people who lived in the village decades earlier to join us at Sheepscombe Village Hall for tea, sandwiches and cakes; they tell us stories of their childhoods as they chat over a display of old photographs. Their histories, their photographs, their family and business records have added immeasurably to our understanding of the village in the first half of the twentieth century and beyond. In the 1980s pre-war residents were invited, but in 2008 the key date was 1950 and for the first time my father and I qualified to attend. Guests include wartime evacuees, many of them once children from Clacton-on-Sea contacted through the Essex press. People

come from nearby towns and villages, from counties across the UK and even from abroad. One evacuee was so moved by the experience that he gave £1000, spent on the village pond garden, to show his appreciation for the support of the village during the war.

Figure 5.6 Evacuees from Clacton working in a garden below the school
Source: Photographer unknown.

Managing the Archive

The Society has built up a phenomenal collection of documents, photographs, artefacts and oral history over the years. Much of the collection would have been lost or remained hidden without the village archive. One valuable find is a natural history of the valley published by a local woman in 1831 with an engraving showing the new church before the tower was built. Also precious are two daybooks written by farmer Thomas Lediard, recording his activities on the Ebworth estate in the 1870s, parish magazines from the First World War containing soldiers' letters from the battlefront, and the visitors' books of the vegetarian guest house from the 1930s and 1940s. The owners would never have thought of depositing these things in the county archives but were happy to give them to the History Society to be preserved in the village itself by people who will use them to appreciate and understand their heritage.

There are other treasures that families don't want to part with which would not have found their way into the public archives either, but owners willingly lend to the History Society. There are transcripts of deeds going back to the eighteenth

century providing clues to copyhold property ownership, tenancies, field names and financial matters. The original of a cross-written letter sent from Melbourne in 1841 by the clothier's son, was kept in a drawer by a Gloucestershire descendant of his brother. A little booklet written as a sermon by a vicar's wife, tells the story of Eliza Partridge and her involvement in village life in the 1860s; it was lent by a member of the Partridge family in the 1980s. Then there are copies of ten personal diaries written between 1910 and 1927 by Mrs Marie Jolly the schoolteacher given by her grandson. These diaries provide a kaleidoscope of insights into village life including the origins of the Women's Institute and the village hall, the fortunes of the cricket club, domestic routines, school activities and community celebrations.

The History Society also enables material held in national and county archives to become more accessible. It invested in a copy of the informative 1820 parish map from Gloucestershire Archives; the map is carried hither and yon to help us understand remnants of the village in the past, from field names and shapes to lost dwellings and family homes. Recently the original diaries of a teenage boy educated at Sheepscombe vicarage in the late 1830s have been transcribed at the British Library. The boy became Lord Carlingford, President of the Board of Trade in the early 1870s; his diaries contain remarkable glimpses of the village on the verge of economic collapse including the origins of school education in the valley and Whit Monday celebrations (Paterson 2009).

This is just a drop in the ocean of what Sheepscombe History Society has gathered since 1981 and certainly professional archivists might wince at the very thought of it stored in someone's bedroom. The security of the collection does give the committee some cause for concern but the importance of making the collection accessible overrides the fear of loss and damage. The archive is used by the village school and by secondary school children for local history projects, by home owners wanting to know more about their property and by descendants investigating their ancestry. It is also used by villagers pursuing their special interests as well as by the History Society itself as a resource for exhibitions, talks and publications.

The Society has not yet embarked on the seemingly impossible project of finding a suitable building to house the archive. There are no buildings that could be adapted for a heritage centre or museum such as those in Dulverton in Somerset or Mortehoe in Devon, while building a new extension to the village hall could be unpopular, impractical and over-ambitious for a small community. The idea of digitising original materials prior to depositing them with Stroud Museum or Gloucestershire Archives has also been discussed but the problem for a voluntary group is time, with competing commitments to work, family and other village activities. The History Society already has enough to do cataloguing new additions to the archive and promoting its findings.

Disseminating the Village Story

The Society publicises its discoveries in many different ways because it seems important to help residents, visitors and others who love this place, to see with new eyes the buildings, the landscape and the traditions that are part of our lives today. There are exhibitions, occasional talks and walks and a variety of publications. Recent talks include the memories of a childhood in Sheepscombe in the 1940s told by John Light, an excellent raconteur and grandson of Laurie Lee's Uncle Charles (Lee 1959). The village hall was filled to capacity for a talk by a member who has been researching Victorian Sheepscombe from the censuses of 1841 to 1901. A summer walk explored the steep hillside known as The Common, the past lives of a nature reserve called St George's Field and the hilltop cricket ground which claims to have one of the steepest drops from boundary to boundary of any in Britain. Other walks have also uncovered the Holywell, hidden away in a magical garlic grove, the secrets of the beechwoods surrounding the valley and the surprising stories of buildings that we think we know well.

We write about our work in the village magazine and have reproduced regular extracts from our most engaging sources such as Mrs Jolly's diaries and Mary Roberts' natural history. Just before the millennium one villager, deeply involved in the Table Tennis Club, suggested writing a booklet so that new members could appreciate the origins of the club in the 1930s. This idea has produced a series of booklets, enabling people to investigate their interests and this has drawn new people into local history. Five supporters of Sheepscombe Cricket Club researched and wrote its story while the local forester worked with three villagers to write a booklet about his woods. The Women's Institute is currently working on its own history while another villager has investigated the stories behind the names on the war memorial.

In 2005 I published *Sheepscombe: One Thousand Years in this Gloucestershire Valley*, a book I began writing in the mid-1980s. It started with the series of popular evening classes designed to examine the findings of History Society investigations in the first four or five years. The book based on the lectures was drafted and then shelved before being rediscovered in 1997 when the idea of writing a history for the millennium seemed attractive. The book represents 25 years of community effort in identifying and preserving evidence in the village archive but it became a personal mission and there were times when I thought that it was the most important thing left for me to do because the story of our heritage had to be told. Modern villagers encouraged me, saying they wanted to know about the ordinary lives of people who once lived in their homes.

It took seven years and hundreds of hours of writing, re-writing, editing and designing before the book was finally launched. Despite being such a personal odyssey, the book was a true community effort for I had the help of several villagers past and present who commented on drafts and worked with me on editing, style, content and design.

The book is not a compendium of everything we have discovered; I wanted it to tell an engaging and compelling story. Where possible, the people who knew this place speak for themselves. For example, the poverty and tragedy of the valley in the nineteenth century is evident in several sources. A young curate, Hugh Stowell, describes a village society in deep trouble including the horrific story of a child who died consumed by fire because oil from woollen cloth was embedded in her clothes. The first Sheepscombe vicar, Charles Neville wrote a poem about his wife as she supported local women and children in their daily lives. Charles Richins, whose parents died young after the failure of cloth-making, set up a Mormon church in the valley before leading his family's exodus to Utah. His descendants discovered that he spent just six weeks at school in Sheepscombe. Eliza Partridge was the daughter of a carpenter; she did well at school and became a teacher in the north Cotswolds. Mrs Gibbon wrote her sermon as a tribute to Eliza who died of typhoid, aged 22. The decline of the village was so severe that there were 58 empty dwellings at the census of 1851; many of these cottages were lost; it is only by examining the 1820 parish map that the depth of the decay becomes apparent.

Figure 5.7 Mrs Gibbon, the vicar's wife
Source: Photographer unknown.

Figure 5.8 Eliza Partridge, the village girl who became a teacher
Source: Photographer unknown.

The book tells these stories as best it can offering my own personal interpretation of the material. I chose which stories to tell and what to leave out and some of these choices have caused difficulty. People whose families lived here in the past want to know their story and are disappointed if it has been missed. A villager whose father fought in the 1914–1918 war was very upset because he was not mentioned while another regretted that she did not feature in the photographs.

I have used my own imagination and values to make sense of it all. Others might have done it differently. One reviewer recognised its worth as 'a beautifully produced labour of love' and understood the passion for a special place that underpinned the writing (Walrond 2007: 15). There is no shame in this. Heritage is a personal experience for both writer and reader who are drawn to understand their heritage precisely because it strikes a personal chord.

Another reviewer, Evelyn Lord of the British Association of Local History, was complimentary about a group of village histories including *Sheepscombe*[1] before criticising them for ignoring the wider context:

1 Lord refers to Sheepcote in error.

Despite their broad temporal coverage and narrow spatial scope these are not antiquarian publications but contain interpretations of the sources, adequate references, and bibliographies. They are detailed accounts by dedicated local historians working on their individual corners of the country. But are these books of interest to readers outside these corners? Some do contain valuable comparative material for local historians working on other villages, but this highlights one of the flaws in this type of publication. Each place is treated as being unique and only rarely do we see any comparison with other villages. … more historical context would perhaps bring the publications to a wider audience. Nonetheless, there is much valuable research in these books, which should not go unnoticed. (Lord 2006: 196)

Village histories are not written for the wider audience of professional local historians but for people who share an interest in a specific place. The readers are those who live here now and want to know better the place where they belong, those eager to understand where their ancestors came from and those who just pass through but have questions to ask about the place. The current chairman wants

to learn about the people who lived here and how they lived their lives. This interests me more than architecture or archaeology. It provides a context to help me better understand the village as it is today. It adds interest to be able to look around and know something about its visible features and how they got there. (pers. comm. June 2009)

Meanwhile another member sees the bigger picture for himself: 'I find the interaction between national political, economic and social events and the local scene fascinating. By discovering why real individuals from Sheepscombe went to Australia in the nineteenth century, we understand motivation behind our colonisation and how this was not just a solution to crime' (pers. comm. June 2009).

Sheepscombe Village Hall was packed, no chairs, people standing shoulder to shoulder, on the day the book was launched. Villagers past and present, local historians from neighbouring communities and descendents, all were impatient for the stories the book would tell.

Dividing Values

For many villagers today the activity of saving our heritage has been a significant element of our lives. The process has created its own meaning by bringing us together and strengthening our sense of community. But as always in a village, activities can cause conflict or create tensions and heritage is no exception.

Today people in the village have different opinions about the character of the landscape. Many incomers expect the countryside to be wild, unkempt and entirely natural with trees, verges and hedges growing untamed. Others complain,

regretting that we have lost the open landscape of fifty or a hundred years ago evident in earlier photographs, as the hillsides have become densely tree-laden and overgrown.

The Common, a steep northern slope overlooking the village, is the most significant example of dissonance where 'discordance or lack of agreement and consistency as to the meaning of heritage' is explicit (Graham et al. 2000: 24). This hillside is privately owned by the Lord of the Manor but managed by Natural England and the National Trust (who owns surrounding woodland) as a Site of Special Scientific Interest (SSSI). It gained this protection because of its value as fine limestone grassland rich in flowers and butterflies typical of the Cotswold landscape. Despite being an SSSI however, the Common is threatened by encroaching scrub of oak, silver birch, whitebeam, beech and bracken.

Figure 5.9 The valley in 2005

Note: The Common is the south-facing hillside among the trees to the left.
Source: Photographer – author.

The Common was kept clear of trees until the 1970s when traditional management practices were stopped, initially by incomers who did not appreciate their value. Unexpectedly there is no oral or photographic evidence of widespread grazing on the Common; the traditional method of removing last season's long grass was

burning. On a breezy dry evening in February or March the word would spread among village teenagers: 'We're burning the Common tonight, 7 o'clock.' The older, experienced boys decided that the conditions were right and called the rest of us to join them. It was fun, slightly risky and effective. It was how it had always been done, at least in living memory.

Then, in the 1960s, people started calling the Fire Brigade and sometimes the Police. They feared for the safety of their property and accused the teenagers of vandalism. It was not part of their heritage and they were unable to understand it. Gradually the older teenagers moved away, unable to buy homes locally, and the younger ones lacked the skills they needed to counter the tide of criticism. The burning stopped and very quickly the trees appeared and spread.[2]

Now that Natural England is in charge, their conservation experts have listened to our story but remain sceptical. By taking responsibility for this inherited landscape, the government agency is defining our heritage for us, and in doing so, deprives the village of a deeper cultural as well as physical inheritance (Graham et al. 2000). Instead Natural England has fenced the Common and introduced grazing by cattle for six weeks in the autumn. So the battle to save the grassland from trees is not yet won but at least the History Society can record the story of burning before it is lost forever.

The Moving Pavement

The Common conceals layers of heritage: natural history, managed landscapes, social and economic history and cultural traditions. 'What makes each place unique is the conspiracy of nature and culture; the accumulation of story upon history upon natural history' (Clifford and King 2006: ix). Many of us in Sheepscombe have worked hard to understand this conspiracy, seeking the honest story of our place. The story belongs to us, not to outsiders who often cling to unquestioned and distorted images of Henry VIII hunting in the valley or of the drunken hell-hole described by the curate with a religious agenda in the 1820s.

The couple who live where the child suffered fatal burns told me how, for them, the work of the History Society provides 'a deepening of your understanding – it connects you more – linking you, drawing you in, binding you to the place'. But understanding the past might also help with the future; one member asks 'How did people in the nineteenth century adapt and manage their lives as social and technical changes had an effect on the valley? Maybe there are lessons to be gleaned from our history for the future in a world affected by climate change and a shortage of oil' (pers. comm. June 2009).

2 The same story is told in neighbouring Cranham where 'elder residents prefer the old and tested ways whereby the dead grass and scrub was burnt to regenerate new growth' (CLHS 2005: 37). Dissonance continued in Cranham when fences, erected to contain grazing animals, were torn down in protest.

As villagers working from the inside we have made a small contribution, protecting the stories of the landscape and buildings and the artefacts, photographs and other archives that we have painstakingly collected over the years. 'For a variety of reasons some things, activities or people become imbued with that special kind of self-consciousness that turns them into heritage. Someone wants to save them, and that someone, in effect, puts them on a moving pavement ... [an] inexorable movement into the unknown' (Howard 2003: 208).

We study and promote local history out of a realisation that ordinary life in local communities is just as important as international conflict, trade and treaties. Local history reveals a lost society living through its own personal dramas; it gives a voice to those ordinary people who once lived on our own doorstep. We cannot know what will happen as a consequence of our efforts in future but we enrich our present lives by coming into a closer relationship with our heritage, inspired by a love of our place and a need to belong.

References

CLHS. 2005. *Cranham: The History of a Cotswold Village*. Cranham: Cranham Local History Society.

Clifford, S. and King, A. 2006. *England in Particular*. London: Hodder & Stoughton.

Graham, B., Ashworth, G.J. and Tunbridge, J.E. 2000. *The Geography of Heritage*. London: Arnold.

Holloway, L. and Hubbard, P. 2001. *People and Place*. Harlow: Pearson Education Ltd.

Howard, P. 2003. *Heritage: Management, Interpretation, Identity*. London: Continuum.

Lee, L. 1959. *Cider with Rosie*. London: Hogarth Press.

Lord, E. 2006. Review editor's round-up: Publications of 2005. *Local Historian*, 36(3), 195–200.

Newby, H. 1985. *Green & Pleasant Land?* 2nd edn. London: Wildwood House.

Paterson, R. 2009. *The Statesman from Sheepscombe: The Schoolboy Diary of Lord Carlingford 1838–1841*. Sheepscombe: Sheepscombe History Society.

Skinner, E. 2005. *Sheepscombe: One Thousand Years in this Gloucestershire Valley*. Sheepscombe: Sheepscombe History Society.

Walrond, L. 2007. Book Reviews. *Proceedings of the Cotteswolds Naturalists' Field Club*, XLIV(1), 124–125.

Chapter 6

From 'Shackies' to Silver Nomads: Coastal Recreation and Coastal Heritage in Western Australia

Roy Jones and H. John Selwood

Introduction

Throughout Australia's human history, proximity to the coast has been highly sought after as both an economic and a lifestyle choice. While small desert settlements and inland towns tend to predominate in more widely-held contemporary images of Aboriginal Australia, these images owe more to the inexorable displacement of a marginalised people to such locations than they do to Indigenous peoples' pre-conquest locational preferences. Prior to European settlement, Australia's Indigenous population was, hardly surprisingly, concentrated in those, predominantly coastal, areas which offered them the greatest range of resources to sustain their subsistence lifestyles (Hiscock 2007). Following European colonisation, the first settlers sought to maintain their (seaborne) connections with their homelands and, for two centuries, the Australian population has largely been concentrated in the coastal capital cities of the nation's states and territories (Rose 1966, Forster 2004).

Over the course of European settlement, there have been regular waves of population movement inland, as immigrants sought to take up land for agricultural settlement (Meinig 1970, Powell 1970) or to discover and develop mineral resources (Blainey 2003). But, over time, agriculture and pastoralism have become increasingly mechanised and corporatised and many mines have switched from the employment of a relatively permanent to that of a fly in-fly out workforce (Jones 2001). The populations of many inland country towns and of their associated family farms, and of many mining towns, are, therefore, declining and, in what demographer Bernard Salt (2001) terms the 'Big Shift', Australia's population is becoming increasingly coastal once more. This contemporary coastward move is affecting far more of Australia's shoreline than did the nineteenth and early twentieth-century development of the gateway primate cities and of their associated networks of smaller commercial ports, fishing settlements and regional administrative centres. This modern 'Seachange' (Burnley and Murphy 2004) movement, fuelled by an increasingly affluent, mobile, ageing and numerous population is generating strong development

pressures for second home, retirement home and tourism-related growth in many scenic coastal localities around the country.

In Western Australia, as elsewhere in the country, these contemporary coastal development pressures are regulated by laws, finance and bureaucracy. They involve land use zoning, the formal subdivision of land into building plots, land purchase, and commercial construction. But these processes do not always occur in 'virgin territory'. In many coastal regions of the state, and, indeed, the country, a number of scenic locations had already been colonised – albeit informally and seldom on more than a seasonal basis – by what might be termed recreational pioneers. In the course of the twentieth century, numerous Western Australian families and groups of friends had 'discovered' many scenic coastal sites endowed with good beaches or fishing, safe swimming or boating conditions, adequate – though, at first, certainly minimal – access levels and, initially, suitable camp sites. In the early twentieth century, many such coastal pioneers were farming families from adjoining inland properties who were seeking pasture for their stock in the drier months (Selwood et al. 1996) and who subsequently returned to these coastal locations for recreational reasons in the period between the harvest and the sowing of their winter wheat crops. As the population of the metropolitan centre of Perth grew from the mid century onwards, and as most coastal recreation spots closest to the city became engulfed in its urban sprawl, many city dwellers also started to look for holiday sites further north and south along the coast (Selwood and May 2001, Selwood and Tonts 2004, 2006). This process became increasingly feasible in the mid twentieth century as motor vehicle ownership levels rose, four wheel drive vehicles became more readily available and networks of tracks, if not roads, leading to these campsites were created, often by the recreational pioneers themselves.

Over time, a number of these families and groups began to construct holiday shacks at their camp sites. In the early twentieth century, it was common practice for 'pioneer' farmers in Western Australia's wheat belt and south west and for miners in the goldfields to construct their own timber and corrugated iron homes (Bolton 1994, Jones 2001, Gabbedy 1988). Many city-based Australians had also constructed or extended their own houses using similar materials during and around World War Two, when some or all of money, skilled labour resources and mainstream building supplies were scarce. While these structures were characteristically Australian, they were also an Antipodean variant of the English interwar plotland developments described by Hardy and Ward (1984: 2):

> It was invariably a world of single-storey houses, simply built and often using wood, though never refusing whatever material (corrugated iron, asbestos, precast concrete and bricks) lay at hand. Some could have taken their place alongside more conventional bungalows but others, a colourful kaleidoscope of shacks and shanties, were a world apart.

In the late twentieth century, however, as local councils sought to regularise their planning systems, as the state government began to articulate overall coastal planning strategies and as many of the sites of what had come to be known as 'shackie' communities became increasingly prized pieces of more mainstream real estate, the 'shackies' came to face growing challenges to what they saw as their idyllic and, in many ways, as a quintessentially Australian lifestyle. They had, like the nineteenth century squatters before them (Powell 1970), moved into areas that had been arbitrarily claimed by distant imperial or colonial authorities which lacked the means to control and administer them. These sites were generally not seen by the campers as the property of Indigenous Australians or, indeed, of anyone else; they were characteristically Crown Lands which, at the time, were not being used by any other elements of the settler population. Unlike the pastoral squatters, however, the shackies generally did not and do not posses the economic or the political power and influence to readily transform their situation of prior occupancy into a legally sanctioned right of, at least leasehold, tenure, even though they were likely to see their shacks and the land on which they stood as 'their' property. Unless they could work with the local and state authorities to upgrade their temporary dwellings to conform to government building and planning regulations and to legalise their tenure of the land upon which these structures were built, the state had the power to physically remove their dwellings and to resume their land.

In the course of this chapter, we will report on case studies where 'shackie' communities have progressed down both of these paths. On the south coast, at Windy Harbour, Peaceful Bay (Figure 6.1) and elsewhere, settlements that began, in the early and mid twentieth century, as camp and shack sites for predominantly rural families from the adjoining inland areas have gradually been incorporated into approved and formalised coastal settlements. Conversely, on the west coast, as at Wedge Point and Grey (Figure 6.1), large communities of several hundred shacks, and thus of several hundred shack families, which had been developed and used by (predominantly Perth-based) families for generations either have been, or will shortly be, totally removed by state and local authorities.

We will also consider a more remote and a more recent, but nevertheless analogous, phenomenon. Over 1,000 kilometres north of Perth, in the remote Gascoyne region, campers spend periods of several weeks or months on the beaches of pastoral stations adjacent to the Ningaloo (fringing, coral) Reef. Some of these are 'grey nomads' travelling around Australia in campervans, or with 4-wheel-drive vehicles and caravans. Others are (likewise frequently elderly) residents from the south of Western Australia who regularly spend their winters in caravans and/or in camps at Ningaloo (Jones et al. 2007). This practice is of relatively recent origin and postdates the opening up of the North West with bitumenised roads in the 1970s and 1980s. But some families can now recall camping there '20 seasons in a row' (Chandler 2008) and some campers/caravanners leave metal sheets inscribed with their names and the dates of their return in the following season at their campsites. As with the 'shackies' in the south of the state, these

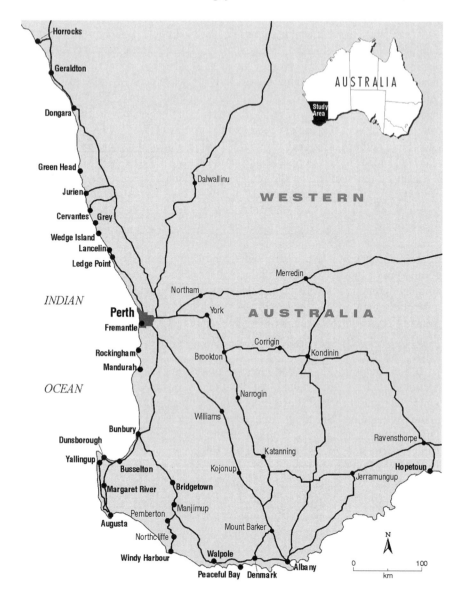

Figure 6.1 South West Australia
Source: Authors' own.

campers now face the prospect of seeing their hitherto untrammeled access to and use of these coastal sites restricted as the state resumes ownership of the Ningaloo coastal strip from the pastoralists who currently lease it, and as a coastal plan and a formal system of camping 'nodes' is put into place for this region.

All around the Western Australian coastline, therefore, and by what has been a fundamentally spontaneous process over several decades and generations, 'ordinary' Western Australians have camped, built shacks and taken the (possibly fortunate and privileged) opportunity to enjoy unsupervised and unregulated coastal holiday experiences. In a 'frontier' state, their right to camp, to fish and even to build 'shacks' largely went unquestioned for much of the twentieth century. For many Western Australians, these freedoms have therefore been seen as a component of their heritage. An alternative – and official – view, however, is that the flaunting of formal legal and proprietorial constraints in this way is a transgressive form of behaviour, and that, furthermore, such behaviour is characteristic of marginal groups, or at least of groups meriting marginalisation by wider society.

This issue of marginality, and in particular the concept of the coast/the beach as a marginal/liminal area in western thought more widely, will be considered further in the light of more detailed case studies of these southern, western and north western coastal areas. As a counterpoint to these case studies of embattled heritage from below (Robertson 2008), however, we will also include the perhaps more hopeful example of a shack community within the Perth metropolitan area (Figure 6.1) which has not merely been allowed to remain in place, but has been formally designated as a heritage site.

Southern Coastal Settlements – Moving to the Mainstream?

In the late nineteenth and early twentieth century, settlers moved into the Lower Great Southern region of Western Australia to develop farms and to establish a forestry industry. These developments tended to occur inland. Nevertheless some farm families were allowed to take out pastoral leases on the coastal scrub around Peaceful Bay to provide grazing for their cattle in the drier summer months. Residents from the nearby town of Denmark also camped at the bay to take advantage of the good local fishing. The area's reputation as a camping and fishing spot grew and, particularly after the track to Peaceful Bay was upgraded in 1954, the numbers of campers grew and some began to erect shacks at the site (Selwood et al. 1995).

This growth raised concerns locally and at the state level. In 1956, the engineer for the Denmark Road Board (the local authority – renamed Denmark Shire in the 1960s) reported his disquiet about the growing number of campers and the poor sanitation standards at the Bay (Denmark Road Board Minutes – 9/1/1956). In the same year the Department of Lands and Surveys expressed its concern at the proliferation of coastal shacks throughout the South West of the state. In an attempt to regularise the situation, the Road Board/Shire developed a subdivision plan for 160 small lots behind the frontal dune at Peaceful Bay. By 1963, these had all been taken up on ten year leases, largely by families from the local area who had been regular campers at the site. During the 1960s, the Shire used

income from the leases and grants from the Tourism Development Authority to improve road access and to develop water supply and drainage systems. When proposals for every dwelling to install and pay for septic tanks eventuated in 1961, a local Progress Association was formed to fundraise, to coordinate local volunteer projects and to lobby for infrastructure improvements. The association has since agitated to obtain improved telephone and refuse collection services for the settlement and has even brought about the expulsion of consistently disruptive tenants (Selwood et al. 1995).

By the 1990s, however, further change was occurring. The Shire approved a new subdivision for larger, more permanent second (or even first) homes; the leases on the original plots were extended from 10 to 21 years and the annual fee quadrupled to $600 per year (admittedly still well below market rates for equivalent property). The first calls were made by some residents to obtain freehold title to their plots and the custom whereby plots and shacks had characteristically been passed on to relatives and friends began to give way to sales through estate agents. These moves have facilitated two other changes. Firstly, Peaceful Bay has been 'discovered' by visitors from Perth. Even though the majority of leaseholders are still from the largely rural Great Southern and South Western regions of the state, the proportion of leaseholders from metropolitan Perth grew from 5 per cent in 1964 to 15 per cent in 1994 and continues to rise (Selwood et al. 1995: 155). At the same time, many shacks were inexorably being upgraded. With improved power, water, telephone and sewerage systems, bitumenised road access and rapid population growth in the nearby town of Denmark (Selwood et al. 1996) permanent occupation became increasingly feasible. This practice was non existent in 1964, but it had risen to include 5 per cent of the leaseholders by 1984 and 8 per cent by 1994.

Further to the west along the coast, a parallel but, so far, a more gradual process is occurring at Windy Harbour (Selwood and Tonts 2004, 2006). In the 1920s, workers from the timber towns to the north began camping and fishing at the coastal reserve at Windy Harbour. In the 1940s some locals began building shacks there. By the 1950s there were about 80 at the site and the local road board/shire sought to regularise the settlement by surveying blocks, laying out streets and (at least part) funding this through a system of annual one year leases. The squatter/ leaser settlement has continued to grow and there were around 220 second homes at the site in 2002 (Selwood and Tonts 2004). Development has not progressed to the same extent as at Peaceful Bay. Windy Harbour still depends on generators (which must be shut off at 10pm) for power and this state of affairs has caused divisions between those who see the 'basic' nature of Windy Harbour as part of its charm and those (currently in the majority (Selwood and Tonts 2004: 158)) who advocate its development as a more mainstream tourist and second home destination. Certainly, with the recent decline of local employment opportunities in the timber industry, tourism and second home development are seen by many as a desirable means of economic diversification for the area.

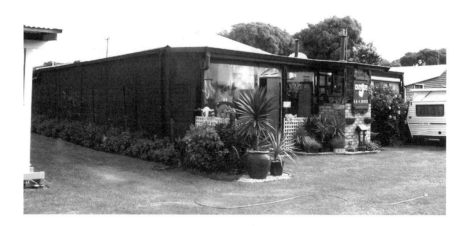

Figure 6.2 Shack at Peaceful Bay progressing to permanent occupance
Source: All photos authors' own.

In its Management Plan for Windy Harbour, the Shire of Manjimup (1999) appears to be leaning towards preservation, rather than further development. It advocates maintaining leasehold, and limiting development in terms of building size and design. However, the leases are being extended from one to 21 years and state building codes will require that standards of building safety and sewage disposal are raised significantly above those of the early postwar 'shacks'. Almost inevitably the extra costs of providing better services to the settlement will create pressures on the shire to allow further development to fund these imposts. Many residents of both the Denmark and Manjimup Shires view the extensive (and expensive) tourism and second home development elsewhere in the south west corner of the state with apprehension (Selwood et al. 1996). They fear that the character of their own smaller and more informal coastal settlements would be lost were comparable developments to occur locally. But it is clear that both Peaceful Bay and Windy Harbour are experiencing regulatory and development pressures which, albeit gradually, are drawing these idiosyncratic communities towards the mainstream.

West Coastal Settlements – Moving to Oblivion?

The coastline north of Perth likewise became the site of numerous shack settlements from the early/mid twentieth century onwards (May and Selwood

1992, Selwood and May 2001, Suba and Grundy 1996). Given the poor nature of the coastal soils, farmers from the adjacent inland only began to make the (at the time, two day) journey to west coastal camp sites in the interwar years. During World War II, however, tracks to some coastal sites were upgraded and wells were sunk to provide facilities for a military coast watch service. And in the immediate postwar years fishers' campsites and shacks were established as the Western rock lobster industry grew rapidly (Suba and Grundy 1996). This led to the gazettal of several townsites along the Central Coast during the late 1950s into the 1960s, some of which became legitimate communities. Jurien, for example, was gazetted in 1956, Leeman in 1961 and Cervantes in 1963 (Landgate 2009). However, others were never properly established, although several, for example Grey, became favoured sites for squatters. Because the Central Coast is only 100–300 kilometres north of the city, once 4WD vehicles became more popular its colonisation by Perth-based recreationists became increasingly intense. By 1997 the Grey Community Association (now Grey Conservation and Community Association) was claiming that, in summer, around 4,000 shackies/holidaymakers were using Grey (Figure 6.3) and a further 6,000 the nearby settlement of Wedge Point (Selwood and May 2001).

Possibly because of their greater numbers and their greater proximity to Perth, the west coast settlements received more critical government attention than did those on the south coast. In 1968, state cabinet set up a committee to report on the unlawful use of Crown land on the west coast north of Perth and the resultant 'Stokes' Report of 1970 recommended the removal of the squatters and their settlements (Suba and Grundy 1996). In 1980, legislation was enacted 'for the express purpose of providing the necessary means to remove squatters from public lands' (Suba and Grundy 1996). A *Government Position Paper on Coastal*

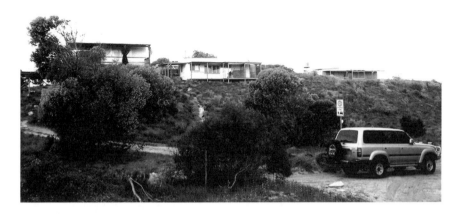

Figure 6.3 Shacks on shoreline coastal dunes at Grey

Planning and Management in Western Australia, released in 1983, stated that coastal squatter shack development was unacceptable. A state-wide policy for the administration of coastal squatter shacks, which was developed in 1988, forbade the construction of squatter shacks on crown land along the coast.

Although these measures were adopted by the state government, it was the shires, as the local planning agencies, that were required to implement them and to date progress has been patchy. The Shire of Gingin, which is closest to Perth, cleared all its shacks in the early 1980s, as did the Shire of Coorow in 1994, followed by Irwin and Carnamah in the mid-nineties. Both the threats to remove the shacks and their actual destruction had two, possibly predictable, results. The first was the 'domino effect' whereby shackies dismantled their properties in shires where they were under greater threat and reconstructed them in shires where such settlements were still tolerated or where lack of resources and poor coastal access made it difficult to police and control the illegal structures. The second was that the shack dweller communities, most of which already had well established local associations/pressure groups, were galvanised into seeking more fervently to protect and preserve their lifestyles and their interests. The strong social and community bonds that had developed between families who had been holidaying in these settlements for generations facilitated this process. The Grey Community Association had been formed in 1974 and, like its south coast counterparts, collected membership fees and, in a bid to gain respectability and acceptance, spent increasing amounts on improvements such as 'tip maintenance, removing car bodies, dune and rehabilitation, improving 'roads' and planting native trees' (the Grey Community Association Inc. *Submission to the Central Coast Planning Steering Committee*, July 1992: 2). Other settlements have done likewise and, in an era of rapid electronic communication, these groups can readily share information and coordinate their actions.

The status of the remaining west coast shackie settlements is still not totally clear at the time of writing. Leases issued to shackies in several shires have expired, but extensions have been granted in some cases and a few of the settlements remain in place. The state's official policies still call for their total removal, despite several reports (e.g. CALM 1999, Whelan Town Planning Consultants 1997) appearing to favour a more gradual mainstreaming of the settlements as has occurred on the south coast. Agreement on and, still further, action on the heritage value of these sites would seem to be even more uncertain. Heritage was first raised as issue in terms of the shack settlements planning by one of the current authors (Selwood 1991) and his report was enthusiastically supported by shackie community associations at the time. In addressing this issue, shortly afterwards, the government supported the production of a 'photographic and descriptive record' of the west coast shack settlements (Suba and Grundy 1996) which stated in its Executive Summary that 'the shacks have aesthetic value as a group which forms a unique cultural landscape, historic significance for their association with the opening up of the coastline and social value for their representation of a disappearing lifestyle'. In acknowledgement of their history, this disappearing

lifestyle was formerly chronicled on a display board, or 'interpretive centre' at the site of former shackie settlements in the mid section of the Central Coast (May and Selwood 2001, Figure 6: 388). However, by 2008, even that display board had disappeared with its replacement merely making reference to the government having removed the shacks, while outlining a landscape rehabilitation program and the creation of a number of picnic sites and recreation facilities in their place. At a time when the shacks are being removed in what is a controversial move by the state government, it would seem that this aspect of the area's history and heritage is being deliberately downplayed and, in the instance of the display boards, actively 'written out'. No casual camping is now allowed along this section of the coast and holiday makers and tourists are confined to established townsites and commercial caravan parks. Similar treatment has also been meted out to the former settlements in the northern portion of the Central Coast which is now serviced by a new coastal highway. Only a few licenced 'professional fishermen' now have the privilege of being able to retain shacks along the coast.

The same policy is being extended to the remaining portion of the coast centred on the communities at Grey and Wedge (Figure 6.1) which, until very recently, was inaccessible except to 4WD vehicles. Despite energetic lobbying by their respective community associations, the most recent government statements on the settlements still deny their appeals for a continued existence in anything resembling their current informal and unique form. The progress associations of the two communities did succeed in persuading the former State Labor government to re-visit the issue. However, only one meeting was held. The new Coalition (conservative) government, has held no further meetings, a good indication of its lack of commitment to the squatter heritage. Meanwhile, the coast road connection between Cervantes and Lancelin has now been opened and it appears only to be a matter of time before Grey and Wedge suffer the fate of the other squatter settlements along the Central Coast. In a last ditch effort to save the communities from complete destruction, a petition calling for heritage recognition is currently circulating in hopes of obtaining a stay of execution (Hill 2009, pers. comm.). Part of the petition requests that the State Legislative Assembly:

> Examine how other States of Australia, including South Australia, Tasmania and New South Wales have retained conforming Shack Site Communities in order to preserve these valuable assets for many Western Australians to have affordable coastal holiday destinations and continue to allow human interaction all but lost in today's society. (Wedge Island Protection Association 2009)

In spite of more sympathetic treatment meted out to shackie settlements elsewhere in Australia, the future looks bleak indeed for the squatter settlements of the Central Coast. In very distinctive circumstances, however, one shackie settlement has not only survived, but has been deemed worthy of preservation as a heritage site, as we document in the next section of this chapter.

Naval Base – Saved by the Smokestacks?

Many coastal/estuarine shack settlements were established within the Perth metropolitan area and the adjoining Peel region. During the late twentieth century virtually all of them were engulfed by the spreading tide of suburbanisation as Perth's population grew from less than 300,000 at the end of World War II to over 1.5 million in 2006. However, the Naval Base Caravan Park, which was established ca. 1933, has remained largely unchanged (City of Cockburn Municipal Heritage Inventory 2004). The main reason for this is its location immediately adjacent to the state's main heavy industrial area at Kwinana. This planned industrial/port complex has been growing since the early 1950s and the caravan park is next to (and, indeed, was partially swallowed by) the heavy industrial site. As such, it is located in the largely undeveloped buffer zone surrounding the industrial land at Kwinana and has ceased to be a desirable location for more conventional coastal development. Its survival is reminiscent of those heritage areas in inner cities that have survived due to their being overlooked by more recent development pressures with more distant localities being perceived as having greater amenity or functionality than did these older and apparently obsolete districts (Ashworth and Tunbridge 2000).

Somewhat atypically, Naval Base was a local government controlled recreation and camping reserve, rather than crown land as such, so residents did not 'squat' but paid a small council leasing fee from the park's inception. In virtually all other respects, however, it developed fairly rapidly into a shack-like Western Australian coastal holiday settlement. Almost from the start, the council allowed caravan owners – perhaps illegally – to build permanent extensions onto their caravans. As has occurred on the south coast, the contemporary shacks are becoming progressively more uniform in style, or being virtually replaced by new structures. However, in true shackie tradition, they are still not individually serviced by mains power, running water and sewerage. The listing in the City of Cockburn Municipal Heritage Inventory describes one shack (named "Gudday") as having been built for $100 in a weekend with the nails being the only new materials used (Figure 6.4). The park is immediately adjacent to the beach and swimming, snorkeling and fishing are among the residents' main activities.

In social terms too, it remains a typical shackie settlement, with many extended families having used their shacks for generations; there is an active community association which aims 'to protect the lifestyle we all love' (City of Cockburn Municipal Heritage Inventory 2004) and, at Christmas and Easter, the residents all celebrate collectively. The Cockburn Council has facilitated the preservation of this settlement and community in several ways beyond its inclusion of the site on the municipal heritage inventory in 2004. The leasing rates remain low ($650 per annum in 2004). A maximum building size parameter of 5.2 metres by 5.2 metres is enforced – a regulation complemented by an 'unwritten rule' that any new extensions must only be to the east or west so as not to block residents' views of the ocean.

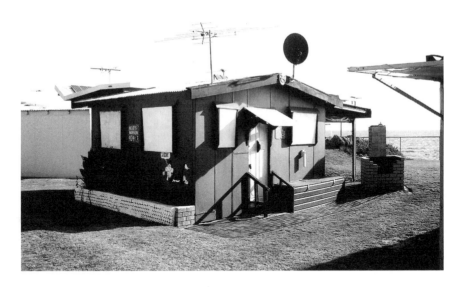

Figure 6.4 'Gudday' shack, Naval Base Caravan Park

In political and planning terms, the 1990s was a period of uncertainty because the site was threatened by further industrial and port expansion, further complicated by a number of other planning studies looking into broader issues of coastal development. During this period, no transfers of ownership of the shacks were allowed, leading to the residents forming a pressure group to protest the threat to their community. Although the public outcry from the local residents at Naval Base probably had little impact on the decision, a relative slowing in Western Australia's economic growth rate in the 1990s meant that proposals for the more immediate expansion of port facilities in Cockburn Sound were at least suspended, and in 2000 sales resumed with 35–36 of the total of 178 shacks changing hands for sums ranging from $5,000 to $18,000 in 2000–2001 (City of Cockburn Municipal Heritage Inventory 2004).

In 2001, the Labor party returned to power in Western Australia and the Heritage Council adopted a more inclusive view of what constituted the state's heritage, listing, for example, Solidarity Park, a union protest site (Jones, this volume). In a move that, in the heritage listing documentation, at least implied an acknowledgment of the removal of shackie communities elsewhere, the site was included on the City of Cockburn Municipal Heritage Inventory (2004: 3). The 'Statement of Significance' reads as follows:

> The Naval Base Caravan Park has aesthetic, historic, representative, social and rarity cultural heritage significance. The Naval Base Caravan Park is located on

a narrow strip of land that forms part of the Beeliar Regional Park. The holiday centre has scenic views across Cockburn Sound to Garden Island. The caravan park is well maintained and the shacks have a uniformity of scale and size that along with the coastal setting gives the place considerable aesthetic appeal.

The Naval Base Caravan Park has been used for recreation by many generations of families from not only Cockburn but from a wide range of metropolitan and country locations. It has exceptional social historical value as a popular and well used holiday destination.

The caravan park has representative significance as a good example of holiday camps which used to exist along the Western Australian coastline but have disappeared in the face of development.

The Naval Base Caravan Park is now an anachronism in the Perth Metropolitan Area. There are no longer any other holiday camps of this type existing along the coast. This place therefore, is unique and has significant rarity heritage value.

Ironically, the recent changes in Cockburn's regulations pertaining to the Caravan Park are making it less of an anachronism and reducing its unique qualities. Upgrading of the shacks is occurring at an accelerating pace as owners now enjoy greater security of tenure and work to meet more stringent building regulations. Shacks which were once required to be on wheels and transportable, are being replaced by more permanent and frequently prefabricated or 'pattern book' structures. As a result, the settlement is rapidly losing its idiosyncratic appearance and being transformed into a more conventional looking compact holiday chalet subdivision. These developments could well lead to the loss of any valid claim to heritage value based on the settlement's distinctive vernacular architecture. Given that a significant component of the heritage designation is said to rest on the community's 'exceptional social historical value,' whereas the shacks can now be marketed freely to the highest bidder (one shack overlooking the water was being advertised for $90,000 in the summer of 2009), their heritage value is also becoming less compelling a feature. In reality, it seems that the local authority has only limited commitment to the heritage listing.

Of far greater significance from a broader heritage perspective, is the recent recognition that Naval Base is located virtually on the site of the original townsite of Clarence, or Peel Town, the first, albeit ill-fated, European settlement of the Swan River Colony. Archaeological digs have already exposed thousands of specimens in the immediate vicinity (Amalfi 2006). As a result, much of the area is likely to be designated as a site of national historical importance in a manner that has the potential to overshadow its shackie heritage.

Naval Base Caravan Park has been preserved, at least for the time being. Meanwhile, a new, but analogous, coastal planning controversy has arisen over 1,000 kilometres to the north.

The North-West – the Last Frontier?

The experiences of many campers on the 300 kilometre long stretch of beaches and bays adjoining Ningaloo Reef at Australia's North-West Cape provide a number of both contrasts and similarities with the shackie settlements further south. The contrasts largely result from the area's greater remoteness and environmental harshness, the similarities from the campers' attitudes and values concerning both their coastal recreational experiences and their Australian heritage. The Gascoyne region, in which North-West Cape is situated, was initially settled by pastoralists and fishers, rather than by farmers and timber workers. In the course of the nineteenth century, the coastline adjoining Ningaloo Reef was allocated to a small number of pastoral leaseholders who were largely dependant on sea transport to move their wool and to maintain contact with Perth over 1,000 kilometres to the south. By World War I, the area also housed a small number of more or less ephemeral fishing, prawning, pearling and whaling operations. An American Submarine base and an Australian air base were set up on the Eastern side of North-West Cape during World War II. The Australian and American governments subsequently agreed to develop a Cold War communications base in the area and the base and its associated town of Exmouth were both opened in 1967 (Jones et al. 2007).

By that time, the area was becoming far less isolated. Major iron ore mining developments were occurring in the adjoining Pilbara region leading to a rapid build up of both population and infrastructure. The state wide road network was gradually upgraded. The route from Perth was bitumenised as far as Carnarvon (the regional centre of the Gascoyne, some 400 kilometres to the south) in the late 1960s and at the same time the Shire of Carnarvon permitted – or, more accurately, failed to prevent - the development of a small tourist resort/camp site next to the reef at Coral Bay. By the 1980s, the roads to Exmouth, Coral Bay and, indeed, around Australia had been sealed and a growing range of tourists began to visit North West Cape (Jones et al. 2007).

While many tourists based themselves in Exmouth and Coral Bay, an increasing number sought a camping and fishing lifestyle not dissimilar from those of the southern 'shackies'. Except for a relatively small number of, mainly fishers', shacks at Gnarloo station to the south of the reef, caravans, campervans and tents replaced the shacks. Furthermore, although the campers were occupying crown land, this was being leased to pastoralists who acted as intermediaries, charging the campers small fees, but also offering them some services such as rubbish disposal sites. This was, arguably, contrary to the terms of their leases which were, fundamentally, for pastoral and not tourism purposes. Finally, while some of the campers came from the Gascoyne or the adjacent Pilbara region, the majority were from far more distant destinations (Remote Research 2002). Some were 'grey nomads' travelling around Australia, but the majority were from Perth and the south of the state.

However, these differences should not obscure the many similarities. Many are regular visitors (Chandler 2008) and return to the same sites year after year, often leaving markers stating the dates of their return. As with the shackies, these regular visitors exhibit strong senses of community, linking up with other long term campers with whom they socialise and for whom they provide support, sharing expertise (e.g. for vehicle repair and the maintenance of generators, fishing craft and gas appliances) that would only otherwise be available 100 kilometres or more away in the nearest town (Chandler, pers. comm. 2009). They seek an untrammelled, simple and self-sufficient seaside experience, obtaining much of their food by fishing and eschewing the more regimented camping experiences available at designated and highly regulated sites on adjacent coastal land directly controlled by the state Department of Environment and Conservation, yet many cooperate with the pastoralists on conservation projects. Like the shackies, they frequently stay for long periods. Surveys conducted in 2001 and 2002 (Remote Research 2002) indicated that the average length of stay was 47 days and, for many older campers from the south of the state who wintered in the North-West, it could be considerably longer.

Of most relevance to this chapter, however, is the similarity in the processes of increasing government regulation of both the coast and the camps, processes which, at Ningaloo, contain elements of both mainstreaming and obliteration of these informal campsites. As in the shack settlements further south, the rapid growth in camper numbers led to official concerns. On the two most popular pastoral stations, Ningaloo and Waroora, the number of campsites grew from 131 in 1995 to 318 in 2002 (Armstrong 2003). These campsites are located in an extremely fragile and valuable natural environment. The coastal dunes on which they are located are easily damaged by the campers' 4-wheel-drives. The near-desert vegetation is sparse, limited in its potential to provide the campers with firewood and unlikely to recover if the dunes are significantly disturbed. Furthermore the coral reef, one of the most pristine on the planet, is extremely close to the shore. In surveys conducted in 2001 and 2002 (Remote Research 2002) many, if not most, campers reported that they disposed of rubbish and human waste in ways that would not prevent the violent, if infrequent, rainstorms and the characteristic high winds from carrying much of this material out to the reef with potentially serious ecological results.

Not surprisingly therefore, the state government saw these 'unmanaged campers' – as opposed to the managed campers on the sites directly under the Department of Environment and Conservation's control – as being in need of regulation and regularisation. In general terms, the state had been granting increasing levels of environmental protection to both the reef and the coast since the 1960s, culminating in a decision to propose the area for World Heritage listing in 2008 (Jones and Shaw 2008). More specifically, a protracted, unsuccessful and politically divisive battle to establish a major resort at Coral Bay (Jones et al. 2007) led to the government producing a major planning strategy for much of the Gascoyne coast (WAPC 2004). In anticipation of the renegotiation of all of the

state's 99 year pastoral leases in 2015, this strategy proposes to resume not only a two kilometre strip of coastal land, but also to regain ownership and control of other environmentally and/or culturally sensitive land from the existing pastoral lease areas. It then seeks to redistribute the Ningaloo Reef campers to a series of 'nodes' along the coastal strip under the direct control of the Department of Environment and Conservation, thus mainstreaming the sites that it retains and obliterating the remainder in a single operation.

At the time of writing 'wilderness' camping on the reefside pastoral stations is still occurring. The popular 'Four Corners' ABC television current affairs programme screened an episode on this controversy in August 2006. The campers who were interviewed emphasised both the freedom and the 'Australian-ness' of this coastal experience. Many of the interviewees were 'grey nomads' who were circumnavigating Australia by caravan and campervan. They were able to look back on times when this type of recreational experience could be enjoyed more widely and a number of them cited Ningaloo as the 'last place' in the country where it survived. Ironically the programme was highly effective in publicising Ningaloo to the interstate travelling public.

Conclusion: Heritage from Below vs. Regulation from Above

In *The Coast Dwellers*, a volume which Philip Drew (1994) subtitled *a radical reappraisal of Australian identity*, the author contended that 'the beach is the twentieth century's rejoinder to the bush, a wet tradition of sun, surf and sand, a tradition based on freedom and pleasure' (Drew 1994: 114). Drew's arguments draw on the longstanding demographic reality of Australia's coastal population distribution and on the many literary references (notably by Western Australian authors Robert Drewe and Tim Winton) to the centrality of the beach and the coast to the Australian imaginary.

Problems arise, however, when some people's 'freedom and pleasure' is perceived as occurring at the expense of other social values, such as environmental protection, public order or even (since sewerage is a recurring theme in the disputes over the shackie settlements and unmanaged campsites) public health. Drew's (1994: 116) assertion that '(t)he beach is for everyone. That is why it is so free. Going to the beach we leave society and its constraints behind.' raises two questions that are central to the disputes between the shackies and wilderness campers on the one hand and the public authorities on the other. When the numbers of shackies and campers were small and competing demands on the coastal land essentially non existent, these beaches and campsites/homesites could indeed be for 'everyone' – or at least for anyone who wished and was able to frequent them. Furthermore, while the early shackies and campers could and did 'leave society and its constraints behind', society and its constraints have gradually caught up with them as both the Western Australian population and the effective demand for coastal land have grown significantly in recent decades.

In *Places on the Margin*, Shields (1991: 89–90) talks of 'carnival forms' which:

> offered a completely different, non official…extra political aspect of the world, of man and of human relations; they built a second world and a second life outside officialdom' (Bakhtin 1984: 5–6) in which all people were reduced to the common denominator of participants. This world 'inside out' was often in the form of feasts linked to the cycle of the seasons.

This quote accurately describes the way in which the shackies and campers perceived their recreational experiences and echoes Hardy and Ward's (1984: 27) contention that 'the association of plot-ownership with freedom rests less on the material fact of ownership as an end in itself and more on opportunities to create a small world of one's own choosing'. However, both freedom and the creation of a world of one's own choosing are pleasures more readily available to elites. Were society to sanction such pleasures for the masses, the world would be turned upside down, rather than inside out. In this context, Shields (1991: 90), writing on Brighton, notes the establishment's concerns with carnival forms in a seaside setting:

> Carnival is the occasion for the enactment of alternative, utopian social arrangements. It was for this reason that Victorian essayists so hotly condemned working-class behaviour on the beach where lewd "fun" became a threat not only to the social order of classes but also the discipline which was taken to be synonymous with "civilization".

For shackie and camper groups to attempt to maintain their recreational lifestyles in what are increasingly coming to be seen as prized environments can therefore be seen as a threat to the social order. Any movement to protect their lifestyles can thus become a heritage from below initiative and, indeed, a battle identical to those of the English plotlanders where 'on the one side were people of modest means defending pathetic homes on land that none had previously wanted in any case; and on the other a bureaucratic machine without compassion, growing with every new bye-law and parliamentary clause' (Hardy and Ward 1984: 33).

Nevertheless, the real story of these shackie and camper settlements cannot be simply encapsulated by the, admittedly important, dimensions of national iconography and socioeconomic – or socio-political – conflict. A broader historical and geographical contextualisation is required. These sites are, quintessentially, what Shields (1991: 3) terms 'marginal places' in both space and time. They 'have been "left behind" in the modern race for progress (and) evoke both nostalgia and fascination. Their marginal status may come from out-of-the-way geographic locations, being the site of illicit or disdained social activities or being the Other pole to a great geographical centre'. The shackies and the campers are undertaking activities that are illicit in a number of ways. Their dwellings are disdained by those who favour more mainstream, and more expensive, recreational pursuits. These

settlements certainly evoke nostalgia among those who use them and a degree of fascination from wider society. But the greatest threat that they face is that they are no longer in out-of-the-way geographical locations frequented only by those who can not afford, or who choose to live according to a more basic lifestyle and are prepared to 'go the extra mile' to achieve that objective. As one long term West coast shackie noted: 'In the old days a different breed of people owned the shacks, everyone knew everybody, there were barbecues and get togethers. As the years went by the peace was spoiled by the ski boats and motor bikes and the old times gradually went' (J. James – letter 16/8/1995, cited in Suba and Grundy, 1996).

It is a truism that the old times will gradually go, but it is also to be hoped that the memories, and thereby the heritages, of several generations of West Australians of a very special type of coastal holiday experience can be preserved not only in their minds but, at least in some modified forms, on the ground (Figure 6.5).

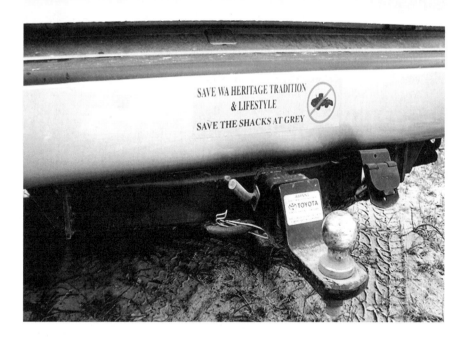

Figure 6.5 Lobbying to save the heritage shacks at Grey

References

Amalfi, C. 2006. Spotting Graves in Space. *Science Network: Western Australia.* [Online] Available at: http://www.sciencewa.net.au/index.php?option=com_content&task=view&id=857&Itemid=587 [accessed 1 July 2009].

Amoeda, R., Lira, S., Pinheiro, C., Pinheiro, F. and Pinheiro, J. (eds) 2008. *World Heritage and Sustainable Development.* Barcelos, Portugal: Green Lines Institute for Sustainable Development.

Armstrong, G. 2003. End of 'Grass Castle' Kings. *The Sunday Times*, 3 August, 17.

Ashworth, G. and Tunbridge, J. 2000. *The Tourist-Historic City: Retrospect and Prospect of Managing the Heritage City.* Oxford: Elsevier Science.

Bakhtin, M. 1984. *Rabelais and His World.* Bloomington: Indiana University Press.

Blainey, G. 2003. *The Rush that Never Ended: A History of Australian Mining.* 5th edn. Carlton: Melbourne University Press.

Bolton, G. 1994. *A Fine Country to Starve in.* Nedlands: University of Western Australia Press.

Burnley, I. and Murphy, P. 2004. *Sea Change: Movement from Metropolitan to Arcadian Australia.* Sydney: University of New South Wales Press.

Chandler, P. 2008. 21 winters in a row; travel narratives of return-visitors to the Ningaloo area. Paper delivered at the *International Australian Studies Conference.* Queensland University of Technology, Brisbane.

Chandler. 2009. pers. comm.

City of Cockburn. 2004. *Municipal Heritage Inventory. Place Record Form No. 67.*

Denmark Road Board. 1956. *Road Board Meeting Minutes January 9 1956.* Denmark: Denmark Road Board.

Department of Conservation and Land Management (CALM). 1999. *Draft Master Plan: Wedge and Grey.* Perth: CALM.

Drew, P. 1994. *The Coast Dwellers: A Radical Reappraisal of Australian Identity.* Ringwood, Victoria: Penguin.

Forster, C. 2004 *Australian Cities: Continuity and Change.* 3rd edn. South Melbourne: Oxford University Press.

Gabbedy, J. 1988. *Group Settlement.* Nedlands: University of Western Australia Press.

Graham, B. and Howard, P. (eds) 2008. *The Ashgate Research Companion to Heritage and Identity.* Aldershot: Ashgate.

Hall, C. and Muller, D. (eds) 2004. *Tourism, Mobility and Second Homes: Between Elite Landscape and Common Ground.* Clevedon: Channel View.

Hardy, D. and Ward, C. 1984. *Arcadia for All: The Legacy of a Makeshift Landscape.* London and New York: Mansell.

Hill, R. 2009. Resident of Grey, pers. comm.

Hiscock, P. 2007. *Archaeology of Ancient Australia.* London: Routledge.

Jones, R. 2001. Social Sustainability in the Western Australian Urban Planning System: State Planning Strategies to 2029, in *Urban Sustainability in the Context of Global Change*, edited by R. Singh. Enfield, New Hampshire, USA and Plymouth, UK: Science Publishers, 17–28.

Jones, R. and Shaw, B. (eds) 2007. *Geographies of Australian Heritages: Loving a Sunburnt Country?* Aldershot: Ashgate.

Jones, R. and Shaw, B. 2008. World Heritage Listing, Local Problem? Three Examples from Western Australia, in *World Heritage and Sustainable Development*, vol. 2, edited by Amoeda, R., Lira, S., Pinheiro, C., Pinheiro, F. and Pinheiro, J. Barcelos, Portugal: Green Lines Institute for Sustainable Development, 433–440.

Jones, R., Ingram, C. and Kingham, A. 2007. Waltzing the Heritage Icons: 'Swagmen', 'Squatters' and 'Troopers' at North West Cape and Ningaloo Reef, in *Geographies of Australian Heritages: Loving a Sunburnt Country?* edited by R. Jones and B. Shaw. Aldershot: Ashgate, 79–94.

Landgate. 2009. *History of Country Town Names* Government of Western Australia. Available at: http://www.landgate.wa.gov.au/corporate.nsf/web/History+of+country+town+names+-+L [accessed 30 June 2009].

May, A. and Selwood, J. 1992. Holiday Squatters in Western Australia: Problems and Policies. *Australian Journal of Leisure and Recreation*, 2(2), 19–24.

McIntyre, N., Williams, D. and McHugh, K. (eds) 2006. *Multiple Dwelling and Tourism: Negotiating Place, Home and Identity.* Wallingford: CAB International.

Meinig, D. 1970. *On the Margins of the Good Earth: The South Australian Wheat Frontier 1869–1884.* Adelaide: Rigby.

Powell, J. 1970. *The Public Lands of Australia Felix; Settlement and Land Appraisal in Victoria 1834–91 with Special Reference to the Western Plains.* Melbourne: Oxford University Press.

Remote Research. 2002. *Summary Report on the Findings of Surveys of Unmanaged Camping in the North West Cape Region of Western Australia.* Perth: Remote Research.

Robertson, I. 2008. Heritage from Below: Class, Social Protest and Resistance, in *The Ashgate Research Companion to Heritage and Identity*, edited by B. Graham and P. Howard. Aldershot: Ashgate, 143–158.

Rose, A. 1966. Metropolitan Primacy as the Normal State. *Pacific Viewpoint*, 7(1), 1–28.

Salt, B. 2001. *The Big Shift.* South Yarra: Hardie Grant Books.

Shields, R. 1991. *Places on the Margin: Alternative Geographies of Modernity.* London: Routledge.

Selwood, J. 1991. *Squatters: Central Coast Planning Study.* Perth: Department of Land Administration.

Selwood, J. and May, A. 2001. Research Note: Resolving Contested Notions of Tourism Sustainability on Western Australia's 'Turquoise Coast': The Squatter Settlements, *Current Issues in Tourism*, 4(2–4), 381–391.

Selwood, J. and Tonts, M. 2004. Recreational Second Homes in the South West of Western Australia, in *Tourism, Mobility and Second Homes: Between Elite Landscape and Common Ground*, edited by C. Hall and D. Muller. Clevedon: Channel View, 149–161.

Selwood, J. and Tonts, M. 2006. Seeking Serenity: Homes away from Home in Western Australia, in *Multiple Dwelling and Tourism: Negotiating Place, Home and Identity*, edited by N. McIntyre, D. Williams, and K. McHugh. Wallingford: CAB International, 161–179.

Selwood, J., Curry, G. and Jones, R. 1996. From the Turnaround to the Backlash: Tourism and Rural Change in the Shire of Denmark, Western Australia. *Urban Policy and Research*, 14(3), 215–225.

Selwood, J., Curry, G. and Koczberski, G. 1995. Structure and Change in a Local Holiday Resort: Peaceful Bay on the Southern Coast of Western Australia, *Urban Policy and Research*, 13(3), 149–157.

Shire of Manjimup. 1999. *Management Plan for Windy Harbour.* Manjimup: Shire of Manjimup.

Suba, T. and Grundy, G. 1996. *The Survey of Squatter Shacks on the Central Coast of Western Australia Vol. 1.* Canberra: Australian Government Printing Service.

WAPC. 2004. *Carnarvon-Ningaloo Coast: Planning for Sustainable Tourism and Land Use.* Perth: Western Australian Planning Commission.

Wedge Island Protection Association. 2009. Petition to prevent the loss of leased Shack Sites Communities in Western Australia as alternative family recreational and holiday destinations for the people of Western Australia, Perth.

Whelans Town Planning Consultants. 1997. *Shire of Carnamah Structure Plan and Design Guidelines Coolimba and Bat Cave Coastal Development Nodes.* Perth: Whelans.

Chapter 7

What's in a House? Heritage in the Making on the South-Western Coast of Norway

Gunhild Setten

> ... the heritage debate is persistently couched in terms of ownership, or a form of quasi-ownership. The possessive pronouns "my" and "our", "theirs" and "yours" are constantly deployed. Sometimes these relate to legal ownership, such as "my stamp collection", but often the terms are employed to indicate a kind of stakeholding or wishful possession with little basis in law. (Howard 2003: 112)

'Gone Forever': A Prelude

During one Easter night in 1995, a 150-year-old house was demolished in the district of Jæren on the south-western coast of Norway (Figure 7.1). The house was a traditional *jærhus* [*hus* equals house], a relatively small wooden residential house, historically found on farms in the area (Figure 7.2). This particular house was highly valued by the local cultural heritage authorities, i.e. it was seen as relatively authentic and well kept and was set in a historical landscape. The house was of far lesser heritage value to the farmers who owned the house and decided to demolish it. According to Thu (1996), the farmers claimed that the house was in a bad shape, and if they were to save the house, they would have to rebuild everything.

For the cultural heritage authorities, this was a shattering experience (Thu 1996). The authorities were not aware of the potential danger the house was in, and were at the time about to design more targeted guidelines for both authorities and private owners of cultural heritage on how to manage heritage objects and properties. Also for the owners, this was a highly 'unusual' experience: in several reports in the local newspapers, they were portrayed as being negligent as well as being characterised as vandals. At the same time, they received support from farming colleagues, who commended their courage in exercising their private property rights (Thu 1996). Two camps thus crystallized as an effect of the destruction of the house: on the one hand, public and private cultural heritage authorities and institutions and their sympathizers, and on the other hand, those who fought for their right to exercise their private property rights and the right to develop their farms according to their own wishes. Additionally, the fact that the local branch of the National Farmers Union contributed financially to cover the

fine that eventually was issued to the owners, turned the demolition of this house into a highly controversial and principally complex case for both camps.

I am not siding with any of the parties in the above case. I am rather aiming to set the scene for how a traditional house type, as an example of privately owned cultural heritage, can serve as a tool for both protecting personal lives within the house, and for negotiating and 'protesting' against the public's moral and legal heritage claims on the house. Furthermore, I wish to set the scene for how identities and biographies are formed around the historical *jærhus* through this notion of 'double ownership'.

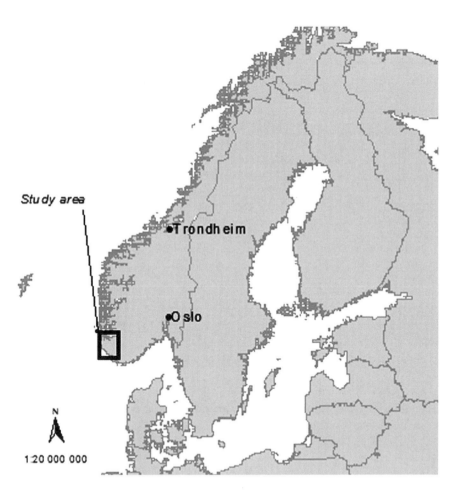

Figure 7.1 Map of the study area

Leder i Hå kulturstyre:

-Rivingen veldig trist

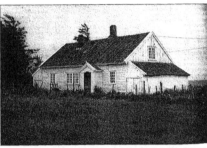

– Det er veldig trist når sånt skjer, sier Mons M. Bjorland om rivingen av det gamle jærhuset på Varhaug. Bjorland er leder for kulturstyret i Hå. Da kulturstyret hadde møte på tirsdag, diskuterte medlemmene rivingen.

JTORALF SANDØ

– Hele kulturstyret mente at dette var trist. Ordet «vandalisme» ble brukt om det som hadde skjedd, sier Bjorland til Jærbladet.

Han kan ikke si om den omstridte rivingen vil føre til at vern av verneverdige bygninger nå blir tatt opp politisk, men han ønsker at andre verneverdige bygg ikke skal lide samme skjebne som det gamle jærhuset på Varhaug.

Må ikke gjenta seg

– Nå er huset borte, og det er lite vi kan gjøre med det.

Men det er mulig for kommunestyret å midlertidig vedta vern av spesielle bygg. Vi må være mer på vakt i fremtiden. Er det noen bygg vi er redde for, er vi nødt til å se på saken. Det er mitt personlige syn, sier Bjorland.

Han håper at det offentlige og private eiere av verneverdige bygg kan samarbeide om verneløsninger. Blant annet finnes det muligheter for offentlig støtte til vedlikehold av verneverdige objekter. Men neverdige bygg kan være problematisk for eierne. Vedlikeholdet koster, og byggene kan båndlegge areal som kan være ønsket til andre formål.

Ikke tillatelse

Overingeniør Alf Kyllingstad ved teknisk etat i Hå bekrefter at grunneieren som rev det gamle jærhuset, ikke hadde søkt om rivingstillatelse. Men dette er ikke uvanlig i Hå.

– Det rives hus engros i kommunen uten at folk søker. Tidligere har vi ikke foretatt oss noe når slik riving har skjedd, for ofte dreier det seg om riving av gamle hus når det skal bygges nytt. Det som var spesielt denne gangen var at man rev et hus som mange mente var verneverdig.

Kyllingstad opplyser om at grunneieren på Varhaug ikke har søkt om å sette opp nytt hus på eiendommen. Kommunen vet derfor ikke hensikten med å rive det gamle huset.

Ingen straff

Ifølge Kyllingstad har riving av hus uten rivingstillatelse ikke vært noe problem i Hå.

Spørsmålet om straffereaksjoner har ikke vært vurdert, selv om plan- og bygningsloven slår fast at det skal søkes før riving gjennomføres.

– Dersom grunneieren hadde søkt om riving, kan jeg vanskelig se at vi kunne nektet så lenge huset ikke var fredet.

Men det som kunne ha skjedd var at vi kunne kontaktet kulturetaten, som kunne tatt kontakt med grunneieren og kommet frem til en løsning begge parter var tjent med. En annen teoretisk mulighet var at det offentlige var så interessert i huset at bygningsrådet kunne nedlagt bygge- og delingsforbud. Så måtte det lages en reguleringsplan der området ble regulert for bevaring. Men spørsmålet er om kommunen ville ha gjort det, sier Kyllingstad til Jærbladet.

BORTE FOR ALLTID: *Slik så jærhuset ved Varhaug gamle kirkegård ut for få år siden. Rivingen av det verneverdige huset har satt mange sinn i kok. (Foto: Oddveig Foldøy)*

Figure 7.2 Newspaper report following the demolishing of the house during Easter 1995

Note: The picture caption reads 'Gone forever: This is how the *jærhus* situated close to Varhaug church yard looked a few years ago. The demolishing of this house, with potential for being protected, has profoundly upset a lot of people'.

Source: *Jærbladet*, 21 April 1995.

Introduction

It is generally agreed that heritage has multiple meanings and uses. In a broad sense we can say that 'heritage denotes everything we suppose has been handed down to us from the past' (Lowenthal 2005: 81). In effect, then, there are 'as many definitions of the heritage concept as there are heritage practitioners' (Harvey 2001: 319, see also Harvey 2008). Heritage, to a large extent, defies definition, and is in consequence slippery and elusive. This, in fact, begs the question of the relevance of a (tight) definition of what heritage *is*. Maybe more importantly, then, is another general agreement, that heritage can be seen as

> a precious and irreplaceable resource, essential to personal and collective identity and necessary for self-respect. Hence we go to great lengths, often at huge expense, to protect and celebrate the heritage we possess, to find and enhance what we feel we need, and to restore and recoup what we have lost. (Lowenthal 2005: 81)

So, 'everyone should have some' (Howard 2003: 6). Heritage, in whatever form it comes, thus carries a moral(istic) message: it is in one way or the other seen as good and necessary for us. This is so widely acknowledged, that heritage has become an obligation or duty, whether we choose to commemorate, commodify, obliterate or forget any heritage. 'What comprises heritage [then] differs greatly

among peoples and over time, but the attachments they reflect are universal' (Lowenthal 2005: 81). This understanding of heritage is echoed in Harvey's (2001) assessment, that heritage is a process or a verb, i.e. always in the making relative to time and place (see also Smith 2006). Importantly, however, 'heritage is not about the past' (Howard 2003: 19). Heritage is about the present and the future, although '… heritage issues are always about what we do with them now', in the present (ibid., see also Harvey 2001, Tunbridge and Ashworth 1996). In consequence, and as Urry (1996: 48) asserts: 'Each moment of the past is constructed anew. So there is no past out there or back there. There is only the present, in the context of which the past is being continually re-created'.

In this chapter I will draw on these general notions of heritage as a spatial and temporal process, and as a carrier of present normativity, in order to reflect on how and why we in complex ways feel, and/or are made feel, obliged to hold on to different versions of a past. I will do this, more specifically, by thinking about heritage and memory through a particular historical house type, i.e. the *jærhus* on the south-western coast of Norway. Even though the past does not exist as such, it is very much materially and symbolically represented. The *jærhus* provides an interesting material and representational perspective on how memories 'are often organized around diverse artefacts such as rooms, buildings, furniture, objects, patina, photographs and so on. These often provoke memories, often in forms which are unpredictable and disruptive' (Urry 1996: 50). Such 'artefactual memory' may thus bring out a number of complexities related to the 'significance of objects and buildings' (ibid.) for our self-identification and senses of the past in the present.

Furthermore, and no matter how we conceptualise heritage, 'heritage is deeply concerned with ownership, and the root concept of inheritance is fundamentally a legal device for the transfer of ownership. A century ago 'heritage' only referred to property transfer …' (Howard 2003: 104). Heritage, thus, belongs to someone, i.e. 'all heritage is someone's heritage and therefore logically not someone else's' (Tunbridge and Ashworth 1996: 21). Ownership is, however, not as straight forward as it is asserted in the well known and hegemonic 'ownership model' which assumes 'a unitary, solitary, and identifiable owner' and that actions taken over property 'concerns only him or her and the things owned' (Blomley 2004: 2). The model also assumes that property is synonymous to *private* property, and conceived as securing people freedom of action, i.e. the opportunity to do what they want with their property. Heritage, however, is a common good, so any private ownership is likely to be challenged by moral (and informal) assertions claiming that whatever heritage we are referring to, it belongs to all of us, or at least to people beyond the traditionally 'private'. In Howard's words, 'The ownership of land, … is countered by the moral assertion that "This land is our land"' (2003: 103). In this vein, Blomley (2005: 281) has questioned the public-private divide, and demonstrated how the 'traditionally private, spill over into public space', not least when it comes to property and everyday life. Ownership to property is thus not a relationship between a person and an object. Ownership and property are

rather social, albeit with reference to an object, and in consequence, 'contested and unsettled' (Flemsæter and Setten 2009: 2270). Some crucial issues thus arise: Who, in fact, owns heritage? This question rests on how we define and conceptualise heritage. How we define something is again fundamentally related to ideas about what we can do to it and use it for. In the current case, this entails analysing how a traditional house type *becomes* heritage by being *defined* as heritage, and how owners and residents juggle their private ownership and the moral claims on their house made by the larger public, i.e. it is at this 'junction' they judge what they can do to their houses. It is hence my claim that this can tell us something about the processual and contested nature of heritage, about property and ownership, and thus also about identities and biographies formed around a house. In other words, this can tell us something about processes related to the 'control' of heritage.

I have adopted a 'house-biographical' approach in order to sustain my above claim. House biographies, as with any biographical study, 'are wide-ranging in their scope, methods, and findings, [but] they often reveal a shared interest in human and nonhuman life stories and a situated particularity that is both grounded and mobile' (Blunt 2008: 551). A house biography is most often a narration of a particular residence, and focuses on the 'relationship between a house, its inhabitants and the wider contexts within which both are situated' (ibid.: 552). A house is thus not a container for domestic life. Rather, a house is a result of its life with its residents over time.[1] Inspired by Blunt's (2008) work on 'house biographies', I employ the notion of a house biography in three interlinked ways, thus stretching the notion to include a short presentation of the 'evolution' of the *jærhus* as a generic term. So through the first biography, we get to know about a house *type* which is 'bound up with wider social, economic and political processes' (ibid.: 551). The second biography follows The *Jærhus* Project (1998–2000), which was set up in order to arrive at a *definition* of this house type. The Project is thus seen as the cultural heritage authorities' attempt to build and control a narrative – or a biography – of a house type for the purpose of protection and management. In the third biography, I concentrate on a particular *jærhus*, at the former farm Lerbrekk in the south of Jæren, and focuses on the current owners and how their lives and the house are intertwined, both in past and present. These biographies are thus used as narrative devices in order to demonstrate that heritage *is* a verb, and always in the making. It should be noted that these are partial biographies, i.e. they are a select version of events and processes. It has not been possible and maybe not even necessary, to account for all possible details in any of the biographies, i.e. to present a full, linear chronology. There are for example a number of uncertainties related to the 'evolution' of what is now architecturally categorised as a *jærhus* (Måseidvåg 2001). Similarly, the house biography situated at Lerbrekk is primarily based in

1 A house, in the current context, is thus also a *home*. I will not problematise notions of home in this chapter, although I acknowledge that one often with great difficulty can separate the two (see e.g. Blunt, A. and Dowling, R. 2006. *Home*. London: Routledge, for a further discussion; see also Malpass 2009).

living memory and oral history, and thus by necessity contains a number of 'blank spaces'. Despite these 'limitations', this approach has proved useful for what I aim to do in this chapter.

In order to unpack this chain of thought, the chapter has been structured as follows: following this introduction, the first section provides some notes on the Norwegian heritage context in general, and the heritage role of (Jæren) agriculture in particular, within which these houses need to be seen. In the following three sections I present what I have termed house biographies. In 'Houses as heritage' I start on the first biography by shortly accounting for a historical house type, which only over the last decade has become a (contested) target for the cultural heritage authorities. This is followed up by looking at 'The *Jærhus* Project', where we get a sense of the contested process of arriving at a definition of the *jærhus*, and as seen from the cultural heritage authorities, a sound basis for the future management and protection of a selection of houses. 'A heritage process' presents the third biography, where I follow a specific house through its current owners. Shifting circumstances, in large measure local, familial and personal, help explain how this house has undergone a number of alterations, at some point *becoming* a *jærhus*, and thus of value within a cultural heritage context at present. This section demonstrates how everyday lives both challenge, accommodates and control the definition, and hence public notions of heritage, that was arrived at. The chapter is drawn to a close by asking 'What's in a house?', where I suggest some tentative conclusions related to what these houses are and can be used for, i.e. how a house might inform how we come to think about and relate to past processes in the present by building select narratives around houses as sites of history and memory in the making.

Heritage in Norway

The concerns of this chapter can usefully be seen in relation to the fact that in 2004 The Norwegian Government designated 2009 as the 'Norwegian Year of Cultural Heritage' (St. meld. Nr. 16 2004–2005). The intention with this designation was to actualise and to demonstrate the increasing diversity in Norway's cultural heritage, as well as the more general relevance of cultural heritage for Norwegian society at current. Focus is explicitly placed on 'cultural heritage in everyday life' (Norwegian Cultural Heritage Association 2009). This focus involves an all-embracing perspective on heritage, both temporally and spatially, and thus supports that heritage more or less defies definition, although by employing the notion of the 'everyday', 'small heritages' and 'ordinariness' are signalled. This democratic 'turn' to small heritages is characteristic for much politics and practice at present, 'as confidence in meta-narratives of heritage purpose is being questioned' (Harvey 2008: 20, see also Robertson 2008). The current chapter tells of such 'ordinariness', by the fact that the *jærhus* have been implicated in ordinary people's social lives for generations. These houses are not the results, nor

representations of grand or famous histories. Their 'ordinariness' is, in fact, very much the reason why they seem well suited to tell something about the dynamic nature of heritage, i.e. as noted above, they have 'lived' with and thus changed with their residents over time (Malpass (2009) makes a similar point).

Before demonstrating this more fully, it also needs to be noted that on a broader basis, the 'year of cultural heritage' underlines the fact that in Norway, as elsewhere, there is much political and legal emphasis put on protecting whatever might fall under the category 'cultural heritage' (Setten 2005; see e.g. NOU 2002, St. meld. Nr. 16, 2004–2005, Daugstad et al. 2006, Swensen and Jerpåsen 2008). In Norway, then, as in other countries, the so-called 'authorized heritage discourse' (AHD) does its work, i.e. attention is often placed on 'aesthetically pleasing material objects, sites, places and/or landscapes that current generations 'must' care for, protect and revere so that they may be passed on to nebulous future generations for their 'education', and to forge a sense of common identity based on the past' (Smith 2006: 29).

This discourse, in which professionals speak to professionals 'within national and international institutions and codes of practice', and where 'the AHD lays claim to cultural capital via elite notions of "inheritance" and "value"' (Robertson 2008: 145), finds its counterpart in more popular and subaltern practices, or in so-called 'heritage from below' (ibid.; see also Smith 2006). Heritage from below 'relies on the recognition of the possibility of the expression of alternative forms of heritage that 'work' from below and within, conceived for, from and by local communities with minimal professional help from without' (Robertson 2008: 143). As 'examples of these are relatively rare' (ibid.), this chapter leans on a belief that 'small heritages' are usefully seen as a result of both discourses, emphasising that any expression of (local) resistance or 'protest' reflects some form of dominance or hegemony.

Of particular relevance for this chapter, is the relation(s) – and their associated expressions – between cultural heritage and the agricultural sector, not only because the *jærhus* typically is and was a farm dwelling, but also more generally: 'A parliamentary paper states that the 'development of Norwegian traditions and culture has had a close connection to agriculture and forestry' (St. meld. Nr. 19, 1999–2000: 52–53, Daugstad et al. 2006: 72). Agriculture is thus an important, although contested, identity marker and caretaker of cultural heritage: diverging values and practices relating to ideas about (limits on) use and the role of protection represent a challenge to the maintenance of cultural heritage, i.e. 'agriculture is … seen as both a threat to cultural heritage and a caretaker' of it (Daugstad et al. 2006: 68). According to Daugstad et al. (ibid.), 'this dilemma is recognised in Norway'. At the same time, 'the responsibility of the agricultural sector as a caretaker of cultural heritage is stressed, perhaps more than in other countries' (ibid.). This not only relates to the nature of past and present Norwegian agriculture, but also to vital historical processes: with the break-up of the political union with Denmark in 1814, among other things, the Danes 'left behind a class of Norwegian farmers who were remarkably independent due to the lack of native

aristocracy' (Setten 2004: 393). The independent farmer provided a symbol of national strength, and despite the fact that farmers constitute an ever decreasing proportion of the population, the Norwegian farming community has managed to maintain a remarkable position in upholding a symbolic relationship between national identity and the rural landscape. This is much due to the fact that there have been strong connections and mutual interests between farmers' organisations and the state agricultural bureaucracy, because of a common goal in being as agriculturally self-reliant as possible. 'Consequently, farmers have by and large been left to secure a sufficient production of food of which the state is the guarantor through its strong intervention' (Setten 2004: 394). Financial and legal means have thus been designed in order to create favourable conditions for a stable domestic market. These means have also been vital for both socially and culturally (re) producing stable rural communities, which in two ways in particular, (re)produces strong normative expectations as to what farming is and should be about. First, agriculture has historically been an important receptacle of 'natural' values and a 'simple' life, often contrasted to disruptive urban industrialisation. This idea, however many blows it has received, is impressively persistent and thus continues to structure much of our thinking about the role of farmers and farming for the protection of both cultural and natural heritage, not least in Norway. Second, rural communities in Norway have by legal means been stabilised (and controlled) through a system where blood ties are privileged over other relations in processes of property transfer. This '… strict regulation of agricultural property is based in the belief that sound use and management of agricultural resources is best attained by keeping land and buildings within one family or kin group over generations' (Flemsæter and Setten 2009: 2272). This normative understanding of land-kin relations adds strongly to expectations related to heritage issues: there is a belief that long-held private ownership almost by definition produces responsibility for and obligations to protect past practices and objects, i.e. what we consider to fall under the rubric of 'cultural heritage'.

Notions of ownership are thus vital for understanding the processual nature of cultural heritage through the current case material. Much of what is subject to protection and preservation is legally owned by the state, i.e. the public.[2] My concern is however cultural heritage that is privately owned, yet morally owned and claimed by the public. Very little is known about how individuals relate to rules and regulations enforced by the state within the context of cultural heritage protection and management. Thus little is known about how individuals and families might be 'caught' between notions of public heritage, private ownership and the public's moral claims on their properties. As conveyed in the prelude, when private and public ownerships meet, property can become a highly contested process, thus raising pertinent questions related to ownership of cultural heritage(s). It is within

2 Within the context of the current chapter, it is thus important to note that some *jærhus* are publicly owned, i.e. they are protected as museums. The heritage role of these houses has, however, not been subject to scrutiny in the current project.

a historically rooted sense of independence and self-determination, materialised in a privately owned property that the following can usefully be seen.

Houses as Heritage

> Up from the beach a poor, grey land stretches out, with brown heathery moors and bleak bogs, strewn with rocks, no trees, barren. Here the wind blows day and night. Overlooking it all is a big, grey sky. One cannot escape the sky. Sometimes it hits the ground with its rain and fog. Here and there are small houses, curled up, as if looking for shelter. Pale green fields are like islands in a sea of heather, fenced in by dry-stone walls. People live in these houses. They are strong people. (Garborg 1998 [1892]: 7–8)[3]

This late nineteenth-century description of the Jæren landscape carries several messages of relevance here: it is a 'tribute to the people who managed to cultivate an inhospitable part of the country, as well as a message to the national elites who were eager to build a nation upon the heritage of the strong and independent farmer' (Setten 2005: 72). It is also an evocative description of an almost symbiotic relationship between a house and a landscape, which is very much at the core of this 'first' biography. The small *jærhus*, which Garborg describes, lay low in the landscape. From a distance they were almost difficult to spot, despite the barren nature of the landscape (see Figure 7.3).

The Jæren landscape of today is very different. With an increasing population, urbanisation processes and a highly progressive and productive agricultural sector in the area (see Setten 2004, 2005 for more elaborate accounts), the traditional *jærhus* have become increasingly difficult to spot, however for rather different reasons: there are not many of them left. It is from this fact that the first house biography takes off.

The processes that help explain the loss of houses are complex, both spatially and temporally: In 1943, Hoffmann reported that there are few houses pre-dating 1800 left. She argues that this is due to the harsh climate conditions as well as the fact that a lack of local timber meant that people had to settle for bad quality timber brought to Jæren from other parts of the country. Furthermore, agricultural progress in the area (see Setten 2004), which made itself particularly felt from the second half of the 1800s, pressured farmers to replace their houses, which at the time were small and impractical, with bigger and more suitable buildings. And particularly since World War II, these houses have been under heavy pressure, again from the farming community. They came to be seen as 'outdated'; small, cold and dark with no bathrooms. A progressive mentality in the farming community is thus a vital explanation for the loss of a big number of houses: in this part of the country it seems that one has been more concerned with protecting progressive farming

3 Translation and abbreviation by the present author.

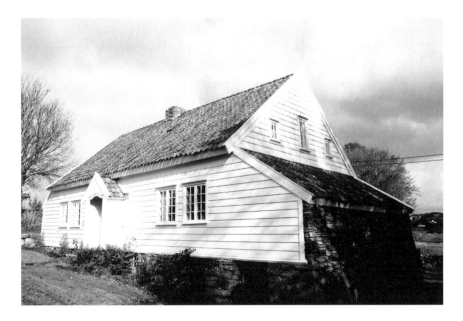

Figure 7.3 The childhood home of novelist Arne Garborg

Note: The house is a 'traditional' *jærhus*, built in 1848, and is a fairly big house compared to a number of houses. *Garborgheimen* (The Garborg Home) is owned by Time local authority district, it is a listed building and used as a museum.

Source: Photograph – Gunhild Setten.

practices rather than material objects from the past. Embodied practices like hard work are valued highly in the Jæren district (Thu 1996, Setten 2004, 2005). The *jærhus* thus became a material symbol of a past not worthy of protection, a past in large measure representing a lack of modernity. The farmers getting rid of the houses furthermore based their decisions on exercising their rights as owners – they were only exercising their private property rights. Furthermore, it should also be noted that regulations in the Land Act (1995, paragraph 9) warrants local authority districts the opportunity to put restrictions on the use of productive land for other purposes than farming. In practice this has meant that one has not allowed the setting up of a third residential house on the farms: very often a younger and an older generation have their lives on the farm, living in a 'newer' and an 'older' house, respectively. With another generation coming up, it has in several instances been desirable to build yet another house, rather than living under the same roof as your parents or grandparents, but for ideological reasons related to the best use of productive land, this has not been possible. The solution, then, was often to replace the old house, i.e. the *jærhus*, with a new house providing suitable and modern living conditions for two and possibly three generations. So, based on a complex set of arguments and circumstances a number of farmers contest ideas about both

'simple rural lives' and expectations related to certain material responsibilities for the past, as it is by many seen as symbolised for example in the *jærhus*.

Throughout the 1990s a shift was to come about. Some of the controversial demolition cases became subject to a lot of media attention, as was demonstrated in the prelude. This led to an increased public awareness of the houses, not only as physical objects of historic value, but also as markers and symbols of local, regional and eventually national identity. As these houses have come to be seen as of value to the wider community and ultimately the nation, they have also come to challenge many owners, people who by several commentators on Jæren agriculture have been seen to lead a-historical lives (see e.g. Lillehammer and Prøsch-Danielsen, 2001), i.e. simply not interested in caring for the past in an explicitly material sense.

Parallel to the heightened public awareness of these houses, cultural heritage authorities as well as research communities realised that there was very little knowledge about them and the vernacular building style they represent (Måseidvåg 2000, 2001). Some of the local authority districts had developed cultural heritage management plans, but the houses did not play a significant role in these plans. There was thus a need for a more thorough mapping and analysis of the houses that were left. This was seen to be of importance both in order to establish basic knowledge about the *jærhus* as a generic term, and for providing the cultural heritage authorities with a broader basis on which they could build their future management (Måseidvåg 2001). Consequently, in March 1997, representatives from the Ministry of the Environment and the Directorate for Cultural Heritage Management came to Jæren. Together with authorities at county and local levels respectively, they wanted to find out what was happening to the houses with the aim of developing a comprehensive plan for how to manage and protect those which were seen to be of highest heritage value. The 'Jærhus Project' was thus a fact, but before addressing the project in more detail, we usefully need to take a quick look at the 'evolution' of the *jærhus*, i.e. what kind of house is this?

The fact that the notion of a *jærhus* was well established stems from the very first mapping of local and regional (vernacular) building styles in Norway which was undertaken in the second half of the 1800s. Eilert Sundt (1976 [1862]), commonly recognised as the founder of sociology in Norway, travelled extensively throughout the country in order to map and describe people's everyday lives and the houses in which they lived. In his work he singled out a house type common in the Jæren district, and named it a *jærhus*. Later, art historian Marta Hoffmann (1943) did fairly extensive work on a selection of these houses in the late 1930s. Sundt and Hoffmann's works have been very influential in how one has and still perceives these houses, much due to the fact that no comprehensive study of the *jærhus* has been undertaken since Hoffmann did her work. Crucially however, the house Sundt categorised as a '*jærhus*' was different to those that today fall under the category '*jærhus*'. This obviously poses a challenge to how they currently come to be seen and managed as heritage. Let us quickly look at this challenge through the lens of the changing nature of the house type itself.

Although not much is known about the evolution of the *jærhus*, there seems to be a general agreement that the *jærhus* historically belongs to the North Atlantic 'longhouse' tradition (Brekke and Schjelderup 1997, Måseidvåg 2002).[4] The coastal areas of Norway, Denmark, Scotland, The Orkney Islands, Shetland, The Faroe Islands, Iceland and partly Greenland, all share fairly similar climatic conditions as well as resource base. This led in large measure to a development of a house consisting of a combination of cold and hotter rooms. The core of the house usually consisted of one or occasionally two timbered rooms. Surrounding this core was a cold(er) room(s) for storage of most often peat, firewood, fishnets and hay, which made the living space(s) more sheltered. These rooms or sheds on all sides of the house save the front, were traditionally built of stone, due to the relative lack of wood.[5]

The house which Eilert Sundt in the mid 1800s categorised as a *jærhus* is rather different to the very simple dwelling described above. Sundt's house is symmetrical, usually containing two timbered rooms. These rooms were commonly a daily living-room and sometimes a room called *bua*, which originally was one of the cold rooms for storage, i.e. there was no oven installed. Gradually, *bua* took on a higher 'status' and became a living room used for special occasions, such as at Christmas. Here the nicest furniture was placed and fine cloth stored. Guests could also spend the night in *bua* as permanent beds were part of the interior. These timbered rooms were bound together by a lighter wood construction containing the kitchen. The *jærhus* is furthermore characterised by the attached sheds, called *skut*. *Skut* is thus local for the (cold) sheds for storage, now built of wood rather than stone, and attached at both ends rather than covering the back side of the house as well. Importantly, these sheds could not be accessed from within the house, only from the outside. This was to mark that they were not part of the living space. This fact was also emphasised by the use of horizontal panelling on the house 'itself' whereas the sheds had vertical panelling. However, during the second half of the 1800s, the sheds increasingly became integrated into the exterior of the house, marked by the use of horizontal panelling also on the sheds (Hoffmann 1943). Characteristic is also that the house is made up of only 1 and a half storeys (see Figure 7.3). The house is moreover most often panelled on all sides due to increased timber availability, more favourable financial conditions, much due to very good herring fisheries in the first half of the 1800s, and a general influence of urban architectural ideas (Måseidvåg 2001).

The houses we find today are yet another generation *jærhus*. The warmer timbered rooms bound by a colder kitchen, surrounded by cold storage rooms, became rarer because of less need for considering the functional relationship

4 Hoffmann (1943: 5) interestingly notes that the *jærhus* has largely gone unnoticed in 'former times', i.e. there was not much about these houses that was worth noting, hence relatively little is known about them.

5 In Jæren, there is only one such house left today, the cottar's farm (*husmannsplass*) Træet, built around 1780.

between hot and cold. Crucially, the house has retained its shape: most importantly through the attached sheds and its 1 and a half storeys. Today, the sheds serve different functions. Because the *jærhus* is a rather small dwelling, the sheds have in many cases become integrated parts of the living space, for example serving as bathrooms or bedrooms. The *jærhus*, as we know it today, is thus to a large degree an aesthetic project (Måseidvåg 2001), bearing witness to the standing of its exterior shape, rather than its original interior functions.

Evidently, the *jærhus* is a temporal and spatial process which has defied a (firm) definition, simply because there has not been a 'need' for a definition. With the *Jærhus* Project this changes. In fact, the Project was preconditioned by a need for a definition. In consequence, the Project was a quest for systematised knowledge which explicitly aimed at defining the house as a 'bounded' object and a target for protection. Let us thus return to the Project, and in consequence, start on the second biography.

Defining Heritage: *The Jærhus Project* (1998–2000)

The *Jærhus* Project (1998–2000) was designed to offer the following: an overview of the remaining houses; updated knowledge on individual houses; a basis on which to assess individual houses related to regional cultural heritage; knowledge about these houses to the Jæren public in general (including owners, schoolchildren, politicians and public administrators) and; insight of importance to antiquarian restoration works in general, and the *jærhus* in particular (Måseidvåg 2001, 90).

The Ethnologist Torunn Måseidvåg was hired to undertake the registration, and she quickly faced the question of what *is* a *jærhus*.[6] As noted, the concept was well established both among the general public in the area and in research and heritage management communities, but nobody had actually offered a *definition*. A mapping would require concise guidelines (Måseidvåg 2001), so one was thus also faced with the task of working out a definition which was acceptable to and a reflection of the public opinion, the research that did exist and, obviously, also accepted by the cultural heritage authorities. Crucially, a definition would also have to reflect the material one was to register, i.e. the houses which were left in the area.

The changing nature of the house type proved a challenge for the process of arriving at a definition, and in consequence, which houses to consider for future protection. Furthermore, Måseidvåg (2001) expressed that for her as an ethnologist, it was a challenge to aim for a rather rigid definition. However, because the task given was very concrete, i.e. to basically produce an overview of how many houses were left in the area, a rigid definition was unavoidable. She states that a socio-cultural perspective, within which an analysis of houses taking account of economical, ecological and social context could be undertaken, would have been

6 Interview, 2 October 2007.

preferable as this would have provided a deeper understanding of these houses' practical and symbolic functions (2001: 93). This was, however, not the request of the authorities, so she eventually settled for a definition that describes a house which is fairly low, has sheds attached at both ends and which is on the whole built before 1900 (Måseidvåg 2000). As a basis for the definition, emphasis was put on form, age, floor plan and authenticity (ibid.). Because the definition which was arrived at was fairly rigid, a number of classical and critical issues related to cultural heritage values were raised during the project work, such as: what are the consequences of selecting some houses before others (for example related to the age criteria); questions of authenticity (in relation to what?); and consequently how much alteration to tolerate before a house is of 'less' heritage value (ibid.).

The Project was fundamentally premised in the need to design management plans for a selection of houses, and the mapping of houses became firmly based in the so-called SEFRAK register.[7] SEFRAK gives an overview of all permanent buildings in Norway built before 1900 (and postdating 1537), as well as cultural heritage objects from the same period. The motivation for establishing SEFRAK was due to the fact that a number of buildings throughout the country were demolished or left to ruin. Important historical knowledge and information was hence also lost. About 515,000 objects were registered over the course of 20 years (1975–1995), of which 400,000 were buildings, and out of which several have been lost since the register was established. Being registered does not in itself give any legal protection. The register rather serves as a source for local history in general, architectural history in particular and as a basis for the cultural heritage authorities to select objects and areas of special heritage interests and values (Directorate for Cultural Heritage Management 2008).

To facilitate the use of SEFRAK, buildings have been classified into three categories: *Class A* denoting buildings worthy of protection and with a potential for being listed, the strictest form of protection;[8] *Class B* describing buildings relevant for special regulations, i.e. buildings set in landscapes where it is seen as desirable to protect and partly restore a larger area;[9] and *Class C* covering buildings which should only be subject to general legal regulations.[10] The local authority districts have classified houses according to the SEFRAK classifications, although some districts only employs two classes, i.e. A and B. Being legally regulated by either the Cultural Heritage Act or the Planning and Building Act, owners are given certain rights and duties in their maintenance and alterations of their houses. In general, owners of houses are asked to alter as little as possible,

7 SEFRAK: SEkretariatet For Registrering Av faste Kulturminner i Norge (Directorate for Cultural Heritage Management 2008).

8 Legally, Class A houses are subject to regulations as stated in the Planning and Building Act (protected houses/buildings) (1985) or the Cultural Heritage Act (listed houses/buildings) (1978).

9 Legally regulated by the Planning and Building Act (1985).

10 Legally regulated by the Planning and Building Act (1985).

in practice involving the maintenance of the basic construction, the use of planed boards and 'correct' skirting boards, and the use of high quality building materials. Owners are also asked to keep the original windows and use traditional roofing (Rogaland fylkeskommune 2007). According to the cultural heritage authorities at county level (ibid.) who oversees the work undertaken by the cultural heritage authorities at local level, any maintenance should, ideally and as far as possible, be undertaken in the same ways as when the house was originally built as 'This will secure the building's authenticity' (ibid.). In order to uphold the value of a house, a number of guidelines thus apply, of which these are some examples:

- It is better to maintain than to repair, and better to repair than to replace.
- Traditional materials and methods must be used when maintaining and repairing.
- Hidden parts of a building – the basic construction – are as important as the visible parts.
- Former changes tell important history about a building and are thus important to protect. (Rogaland fylkeskommune 2007)

And as a general note, the County cultural heritage authorities also state that it is their task to prevent too many alterations in order to prevent ending up with houses which are hardly recognisable compared to the original house (ibid.).

In the Project, the local cultural heritage authorities in the Jæren area were asked to comment and supplement the list of houses generated in SEFRAK, and based in the above definition of a *jærhus*, the final report from the project presented 111 houses (Måseidvåg 2000). At the outset, the number 160 figured, but due to the definition, about 50 houses were excluded. In addition, about 30 houses found in the SEFRAK register, had been lost. During the *Jærhus* Project a further five houses were demolished. It is based in these facts that the local authority districts in Jæren have developed management plans for the houses that eventually were registered and thus seen to fall within the definition.

Hå local authority district, located in the southern part of Jæren, 'houses' the highest number of *jærhus* in the district (Hå kommune 2005–2016), i.e. about 55 houses at the time of the Project (Måseidvåg 2001). They have placed all houses registered in the Project into Class A and B respectively, and states that:

> We have a particular responsibility for communicating this cultural heritage, both in time and space. Every *jærhus* we lose is a drastic reduction in its numbers. We are happy that the owners of such houses also care about their houses and the tradition they represent. Most houses are well kept either as second homes, permanent dwellings or as museums. (Hå kommune 2005–2016: 19)

In the cultural heritage management plan (2005–2016) of Hå local authority district, a set of general expectations related to the protection and management of *jærhus* are conveyed. These expectations can be seen to be set both within the

'authorised heritage discourse' and more localised and dynamic notions of the role of *jærhus* for a Jæren identity. The local cultural heritage authorities thus accept any owners need to own and live in a house that meets their private interests. At the same time, these houses are part of a public environment. In aiming to balance private and public needs, they make reference to the relevant legal framework, although underlining that the heritage values of the houses under protection are not necessarily attached to aesthetical values, neither to age. What is important, they say, is to recognise that every house is historically unique, and that is what should guide any heritage management (Hå kommune 2005–2016: 11).

I will now move on to present the third 'house biography', developed through qualitative interviews with the owners and residents of a *jærhus* at the former farm Lerbrekk. The house is registered as a Class B house in Hå local authority district, and thus subject to the above, rather loosely expressed expectations. Set against the process of arriving at a definition, and in consequence the 'evolution' of the house type itself, this biography demonstrates how personal and situated (hi)stories both challenge, yet accommodate, public heritage expectations as they came to be defined.

A Heritage Process

> How would you define cultural heritage?

> It is our responsibilities towards the past. When it comes to houses, it relates to taking care of the old houses … the fact that we have inherited a building style from the 19th and partly 20th century. If I had removed the sheds, the house would have taken on a completely different form. Some would be angry, but the sheds are not original. It is difficult to define what a *jærhus* is. This house stood for 30 years, they add sheds, and suddenly it's a *jærhus*.[11]

Lerbrekk is situated in the open agricultural landscape of southern Jæren.[12] From the small hill, you can look down from the farm on to the flatter landscape dissolving into the North Sea. The farm is not as visible and exposed as it used to be in the past, because of the planting of spruce and the building of an earth wall for shelter (Figure 7.4). Lerbrekk is, however, still a wind-swept place. There are three houses set around a small court-yard: a workshop, a garage and a *jærhus*. A family counting six members lives at Lerbrekk; four children and their parents, who are in their 50s.[13]

11 Interview with the owners at Lerbrekk, 2 October 2007.

12 Jererudlå is the former name of the farm. I will use Lerbrekk given that this is the current name (see footnote 17).

13 This section draws on two longer interview sessions with the parents. (Interview sessions undertaken 2 October and 9 October 2007.) In addition to orally developing the

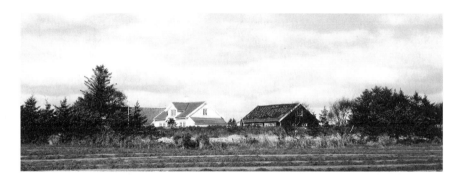

Figure 7.4 Lerbrekk seen from the main road
Source: Photograph – Gunhild Setten.

The *jærhus* at Lerbrekk is presented in the final report of the *Jærhus* Project (Måseidvåg 2000: 210–211), and I contacted the owners based on the short description of the house in the report. I decided to choose this house for a more in-depth account, because their house represents a generation of houses which are from the transitional period between Sundt's classification and a more modern *jærhus*. Additionally, the majority of houses are registered as Class B houses, thus being more representative than Class A houses. The (partial) biography developed thus exemplifies how heritage is an everyday doing, because, as the owners say: 'This house was not a *jærhus* for 30 years, then the sheds were added, and it became a *jærhus*, and that's why this concept [of *jærhus*] ... there's something not quite right with it'. And as will be clear in what follows, they have themselves altered the house numerous times since the late 1970s when they took over. Let us, however, start at 'the beginning' and look at how this house can be seen as a process over the course of some 100 years.

The house was built in 1900 by the current owner's grandfather. At the time Lerbrekk was a cottar's farm and farming was combined with fishing. In 1903–04 the status of landownership changed as the then owner became an owner-occupier. Most of the building materials used to set up the house came from the county of

house biography, the interviews also involved drawing illustrations of the changes of the house, studying old photographs and written material. On a general note, three week's fieldwork in total was undertaken in October and December 2007. Eight current owners were interviewed, in addition to three former owners. All current owners were selected because their respective houses had been presented in the final report of the *Jærhus* Project (Måseidvåg 2000). In addition, interviews were undertaken with an architect involved in numerous *jærhus* projects, two planners at the local authority districts, a professor of art history, a former representative of the local cultural heritage authorities and the ethnologist doing the mapping of the houses and writing the final report. I will also draw on the empirical material which was produced during these interviews.

Nordland in north Norway. The current owner explains this to be a coincidence; 'somebody must have been given an offer [on building materials]'. The lack of local timber, simply because of a lack of forest, is an important factor explaining why wood as building material in general was scarce. Large quantities of timber were thus traded from e.g. inland areas in the south as well as from North Norway. Additionally, some of the beams used to build the house came from a shipload that fell into the sea off the coast of Jæren. This way of acquiring building materials was not uncommon, as the coastline between Stavanger in the north to Egersund in the south is very rough. Remnants of a breakers yard for boats can, in fact, be found in the sea-shore, not far from Lerbrekk. The house at Lerbrekk was moreover built in one go, which was not necessarily the common way of setting up a house; people would rather extend their house when the financial situation permitted it, especially when the herring fisheries were good.

Originally, the house was not panelled, it was rather covered with *halje*, i.e. bundles of straw, preferably from rye: 'Some people have said that it was covered in *halje* for about 20 years, others say 30, but I'm not sure it could last for 30 years'[14] (see Figure 7 5). There is not much knowledge about the use of *halje*, but according to Hoffmann (1943) it was used as a provisional material during a (shorter or longer) period while the beams dried up and the house was finding its final shape.[15] Eventually, then, the house would be panelled. At Lerbrekk, the replacement of the straw and the building of sheds coincided: 'The sheds were … added about 1930. The house was added panelling then, the panel covering the sheds as well'.[16] On my question on why he thinks that his grandfather added sheds, he does not really know, but reflects on the fact that in more urban areas, closer to Stavanger, a number of houses are architecturally quite similar to his. In the Jæren area, some of these houses were added sheds, some were not. Urban influences might also explain the dormer to the west (see Figure 7.5). Dormers appear not to be common (Hoffmann 1943), particularly not on a small farm such as Lerbrekk.[17]

In Figure 7.5 we can also see a common feature on *jærhus*: the door/entrance to the west. These houses were geographically placed so that they would break the wind in the best possible way, and is hence very much a result of the landscape and the climatic conditions. In Jæren, the houses were thus commonly placed in a south-easterly/north-westerly direction, as this prevented them from becoming too cold. The main, official, entrance would in consequence always be facing the west. There would also be an entrance to the east, facing the barn and cowshed, and hence serve as the entrance serving the family's everyday activities. Today, this is

14 Interview, 9 October 2007.

15 The use of straw has a long tradition in Denmark, and it is very likely that in the south-west of Norway this tradition was taken up as a result of contact with Denmark.

16 Interview, 9 October 2007.

17 'Can you believe it, a dormer at Jererudlå?' is, in fact, the title of a book presenting short local (hi)stories (Skretting 2004; see footnote 12).

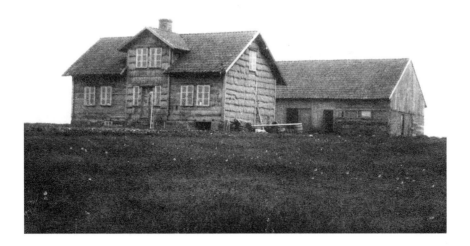

Figure 7.5 The house at Lerbrekk

Note: Photograph taken circa 1923.

Source: Reproduced with the kind permission of Oddbjørn Lerbrekk.

very often the opposite case: the main entrance is to the east, facing the courtyard, with a 'privatisation' of the west entrance facing the garden. This change was in the case of Lerbrekk due to changes in the road structure during the 1940s; increasing urbanisation and changes in means of transport, i.e. from horse and carriage to motorised vehicles, forced major changes in infrastructure.

In Figure 7.6, we can see that the house, photographed in the early 1950s, has gone through significant alterations, and importantly, taking on the shape of a 'classic' *jærhus*. The sheds and the panelling are now about 20 years old, some of the windows have been replaced and the west entrance has been given an extension. According to the current owner, this is the exterior look of the house for about 30 years, up until he starts 'messing with it', as he phrases it.[18]

From 1981 and onwards, the house has undergone a number of radical changes, both the interior and the exterior. When the current owner took over the house in 1976, the original floor plan of the house was intact; the house was characterised by a number of small rooms and the sheds were used for storage. In 1981, they started to rearrange the interior structure; moving and tearing down walls, moving kitchen and bedrooms and extending the house to the east with a fairly big porch so as to accommodate a bathroom (see Figure 7.7). Finally, the rather small windows to the west were replaced by large panorama windows, and in consequence the

18 Interview, 9 October 2007.

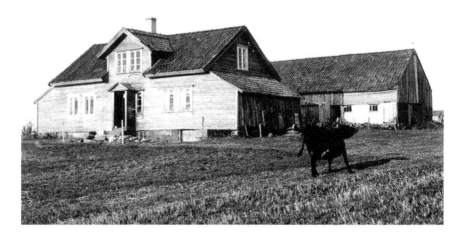

Figure 7.6 The *jærhus* at Lerbrekk
Note: Photograph taken in the early 1950s.
Source: Reproduced with the kind permission of Oddbjørn Lerbrekk.

porch was removed. This changed the house's exterior appearance considerably. Reflecting on these changes, the owner states that

> a number of funny ideas have been put into action in this house. We wanted to keep up with the times, have a practical house, particularly the panorama windows allowed us to walk straight onto the terrace. ... [Today] we would not dream of changing the house's exterior appearance. Back in 1980, when I was young, I didn't care too much, I built a new porch housing a bathroom. ... In hindsight, I *might* regret the porch, but I am not willing to tear it down in order to go all the way back ... for practical reasons.[19]

The panorama windows were again replaced in 1995. By that time, they were facing problems with rot, and decided to insert 'original' windows, giving the house once again the look of a 'proper' *jærhus*. In addition, the kitchen was again moved and the living room extended by the tearing down of two walls. Eventually, in 2000, the shed to the north was included in the family's living space. Two windows were put in in order to provide more light (see Figure 7.7). According to the owner,

19 Interview, 2 October 2007.

this is neither fish nor fowl on a *jærhus*, but you need some light. ... This is done in need of light. You could have left the windows out, the light coming from the north is limited, but you need some smartening up, and you cannot compensate by electric light all year round. ... The question is whether this is right if you think architecturally about the *jærhus*, but you need to swallow a few camels in order to make it liveable.[20]

They have similar future plans for the shed to the south, i.e. they plan to extend the kitchen by including the space provided by the shed. The alterations that the house has been subject to, are by the owners to a large degree explained as being of practical and hence familial reasons. Given that the house cannot be further extended, they have a fixed space to work with once the shed to the south has been included. Additionally, the limited space offered by the house has also meant that two of the teenagers have their bedrooms in the garage. The house thus has a fundamental effect on how people are able to live.

It is a fact that this house is and has been subject to rather fundamental changes (see Figure 7.7 for the current appearance of the house as seen from the courtyard). It is thus timely to raise the question of how much alteration can be accepted before such a house looses what is defined to be its heritage values. It is also thus a fact that including the shed to the north to the family's living space has been met with a certain degree of criticism from the local cultural heritage authorities. The owner explains:

When we were done [with rebuilding the shed], NN from the local cultural heritage authorities came to see us. He wasn't happy about what I had done to the shed. "Why", I said, "it has the same shape as before, yet so much nicer". With the rebuilding, the panelling was changed so that the whole house now has horizontal panelling when there used to be vertical panelling on the shed. I have only put in two windows, you need some light, and a door to the east. There used to be a door, but that was a small, double door. He wasn't happy that I had included the shed into the living room. "What do you want me to use it for", I asked. "Firewood, peat, ...", he said. He wanted to go back to the old. We needed living space and he agreed on that.[21] (see Figure 7.7)

So no further controversies resulted from these alterations.

This leads over into more general reflections on how their personal lives have waxed and waned with their property, and the house's status as cultural heritage belonging to a larger public. 'Lots of people have lived here, lived here all their lives, and died. That gives soul to a house', they say.[22] And on my question on what they have that other people do not have, they underline the notion of 'a house with

20 Interview, 9 October 2007.
21 Interview, 2 October 2007.
22 Interview, 2 October 2007.

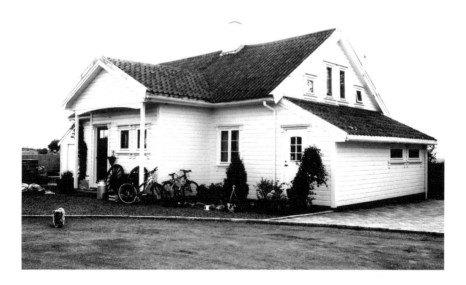

Figure 7.7 The east side of the house, facing the courtyard

Note: The rebuilding of the shed to the right became subject to discussion and some criticism from the local cultural heritage authorities. The windows that were put in can be seen to the right, as well as the door which replaced the former double door. The porch housing the bathroom is a dominating feature on the east side.

Source: Photograph – Gunhild Setten.

a soul!' This is supported by a number of other interviewees, for example: 'I have a very old house with walls saturated with culture, and this is terrific. I have been given the opportunity to take care of what's terrific ...'.[23] This relates to the fact that they consider the *jærhus* to be aesthetically and architecturally outstanding. At some point, the residents at Lerbrekk even considered to build a new *jærhus*: 'We considered tearing this house down and build a new, identical house, although a bit bigger'.[24] Importantly, it also relates to a more personalised reflection on the fact that the current 'father in the house' was born and raised within its walls. 'Obligation', he says, and he is primarily referring to obligations towards his own family as well as a transgenerational family. This is also supported by other interviewees, for example: '... it's [the house] been in the family. I've been in and out of this house since I was a little boy'.[25] A number of interviewees, including

23 Interview with owner of a Class A house, 5 October 2007.

24 Interview, 2 October 2007. This consideration was done before the house was registered in the *Jærhus* Project, and in consequence, classified as a Class B house by the local cultural heritage authorities.

25 Interview, 5 October 2007.

the family at Lerbrekk talked in quite detailed ways about who had lived in their respective houses since they were built (see also Flemsæter and Setten 2009, for a similar point). This not only builds their own family 'biography' and senses of identity, but it also relates to wider reflections concerning the generally high number of people living on the farms in the past and how a fairly small *jærhus* accommodated big, transgenerational families as well as hired hands. Interestingly, and as mentioned earlier, the combination of a small house and a high number of people, has also been used as an argument for demolishing houses: '... bad memories, illness, personal failure', as it was expressed by a former representative for the local cultural heritage authorities.[26]

There is furthermore a close relationship between the house as a provider of a personalised self-identification, and the larger public. When I raised the following question: 'This is private property, but does it make sense that I feel I somehow have a moral right to your house?', the father at Lerbrekk responded to this by saying that

> No: we need enthusiasts in order to protect cultural heritage. Yes: but it doesn't make sense to me that somebody from Trondheim is interested in a *jærhus*. Nobody can come here and claim what I own. We don't do this beyond our private needs, we need to live somewhere. The older we get, the more interested we are in protecting what we have.[27]

A sense of a common heritage is, however, conveyed in the following statement:

> It's crucial that we take care of what's old, but it's not a private matter. There should have been much more financial support from the authorities, but at the same time I don't want it because it means that they want to have a say. I want to be a 100% in control, so it's a tremendous dilemma.[28]

It is interesting, although not very surprising, that the question of private-public ownership is also related to possibilities for public financial support in maintaining the house. A former owner of a Class A house in a neighbouring local authority district, explained how he did not have the financial means to meet the requirements of the authorities. He felt he was offered very little financial support given that the support was conditioned on him restoring the house to its original state.[29] Such reflections were characteristic for the majority of those interviewed,

26 Interview, 10 October 2007.
27 Interview, 2 October 2007.
28 Interview, 9 October 2007.
29 Interview, 11 October 2007. It should, however, be noted that what is perceived to be the 'original state' of a house is highly debatable, both among professionals and the general public. From the interview material with current and former owners, it appears that 'originality' is strongly related to a very costly 'going all the way back'-ideal, implicating a

irrespective of whether they were current or former owners. Financial issues are often a cause for concern among owners, not least because: 'As the definition of heritage has shifted to embrace the cottage and the prefab, ... the heritage owner may be someone of very modest means' (Howard 2003: 108). Although referring to a different context, Howard points at a crucial factor in any heritage work, which underlines the double ownership I am aiming to demonstrate. There are a number of expectations from both private owners and the public as to what it means to take care of cultural heritage, and who is to literary pay for it. The owners at Lerbrekk state that it is their responsibility to maintain the house, 'but there is a lot of 'noise'... they [the cultural heritage authorities] could have offered us a bit more. ... Class B is OK, it is much worse with a Class A house'.[30] Thus, they do not feel that too many restrictions are put on what they can do to their house, but the dilemma stressed in the above statement, is a very real one, and it relates to their motivation for taking care of a common cultural heritage. Most owners express a complex of motivations, of which familial and personal considerations are the prime ones: 'we need to live somewhere', they say. This fact seems to be closely related to another 'fact', that 'if you own a farm, it seems you can do a bit as you wish to'.[31] Thus private property rights do warrant owners a large degree of a historically rooted sense of self determination. However, this self-determination cannot be understood unless seen in relation to notions of heritage as common property, as is also demonstrated. This was well phrased by the owner of a class A house, who had spent three years and a lot of money renovating the house. On my question about whether there is a public motivation in maintaining the house, it was stated that,

> ... yes, there are public concerns, after all I'm taking care of the house. ... It's important to take care of it because it's part of the Jæren history.
>
> GS: ... and national history?
>
> That's a bit woolly. It's Jæren that's closest.[32]

What is also interesting with this statement, is that notions of and limits to public history and identity are drawn around the Jæren region, i.e. the core area of the house type. This is echoed in the above reflections conveyed during the interviews at Lerbrekk. A general impression from the interview material was, in fact, a sense of surprise on the interviewees' part, concerning my (long distance) interest in the *jærhus*. The general point to be made from this is related to an identification

house which is nowhere near meeting current standards. 'Originality', then, can be seen to become a strategy for ridiculing the language and practices of the authorities.

30 Interview, 2 October 2007.
31 Interview, 2 October 2007.
32 Interview, 5 October 2007.

with how a house is 'lived' locally – socially, financially, culturally – both in past and present. The *jærhus* might thus be seen as a local, and importantly, *ordinary* or simple 'way of life', which is maybe best understood locally, although always reflecting the co-constitution of residents and a larger society. This brings us back to the potentially conflicting relationship between the private and the public and their related claims. This is the theme of the final section of this chapter where the question of 'what's in a house?' is raised; i.e. what can we learn from a highly dynamic 'object' in thinking about history and memory, public and private, cultural heritage and ownership.

What's in a House? Heritage(s) in the Making

It is my (and several other's) contention that cultural heritage is dynamic and processual, i.e. '… heritage is about the process by which people use the past' (Harvey 2008: 19. See also Smith 2006). This has been the overall focus of the current chapter. More specifically, through the lens of a particular house (type), I have by way of three interlinked house biographies aimed to demonstrate how a particular house type might inform how we come to think about and relate to past processes in the present by building select narratives around houses as sites of history and memory in the making. Phrased slightly differently, I hope I have shown how a house, i.e. the *jærhus*, comes to be used in order to narrate and control a past in the present. The public-private 'divide' is of particular relevance for these narratives as these privately owned houses are put under legal protection by the cultural heritage authorities, and hence claimed by the larger public. These houses are thus used by different people and bodies in different contexts in order to promote certain pasts in the present. So, any answer to 'what's in a house', then, is very much based on what these houses are used for. Although clearly interlinked, the three house biographies developed can usefully also be seen as three different attempts at narrating and controlling a past for certain purposes in the present. Based in these attempts, I will suggest some tentative conclusions.

'Houses as heritage' takes off from the fundamental premise for the current research, that the substantial decrease in numbers of *jærhus* over the course of some 150 years, in the 1990s eventually came, by the cultural heritage authorities, to be seen as a loss of an important local, regional and national identity marker. This rather modest farm dwelling was not left much credit by a local farming community which looked to the future rather than the past when building their progressive identities. These identities have proven a challenge for relations to a past, if caring for a past is currently seen as some kind of obligation towards material continuity. This can usefully be seen in relation to the fact that what falls under the category 'cultural heritage' are a set of values ascribed a selection of objects they at the outset did not have, i.e. most objects are not *created* for heritage purposes. However, given that these values are related to the physical existence of the objects, without these values being a factual part of the object, the only way

to uphold values is to secure the existence of the object (See Harvey 2008). In Jæren, where practices rather than objects (see Thu 1996, Setten 2004) are highly valued, the farming community has over the last decade become fundamentally challenged by the cultural heritage authorities' focus on the 'thing' rather than the process. In complex ways, social, cultural and legal processes within the farming community itself, have, in fact, paved the way for the current protection of these houses. Protected by legal means regulating the transfer of (agricultural) property, and a modernist and progressive agri-culture, the farmers' demolishing of houses has thus resulted in a 'situation' where they have been recognised as *heritage*. So, by the demolishing of houses, farmers have used the same houses to build a progressive and practiced farming narrative, and in consequence given the heritage authorities an opportunity at current to recognise them as objects worthy of protection. A number of *jærhus* owners, then, have also become owners of a cultural heritage site or venue (cf. Mills 2008), i.e. their homes take on a wider 'iconic' status. This was confirmed through the process of *defining* the *jærhus*, the theme of the second 'biography'.

In 'Defining heritage', we followed the cultural heritage authorities' contested move towards defining what a *jærhus* is and what it might stand for. These houses clearly stand for lives, persons and places. They have been implicated in peoples' social lives in the area, 'and just as people can "belong" to a place, so too can "objects"' (Macdonald 2002: 97). These houses, then, stand for local people's opportunity to identify with and see themselves in them: 'Viewers are being invited here not so much to gaze upon 'others' but on themselves as they might have been: they are being asked to *identify* rather than to position themselves as distanced subjects' (Macdonald 2002: 100, emphasis in original). Although arguing in relation to museums, Macdonald's assertion is highly relevant for the current case in point: these houses provide an opportunity to see oneself in space and time. Singling out the *jærhus* for protection must, however, also be seen as implicated in wider spatial, temporal and moral processes related to identity formation and self-identification, i.e. 'we', as Norwegians, are all invited to gaze upon ourselves as these houses also stand for a common national heritage. Formulating rules and regulations, i.e. setting out what these houses (ideally) can be used for, is an inherent part of these processes. What Smith holds to be the 'authorized heritage discourse' (AHD), is thus relevant here:

> Linked to the idea of the materiality of heritage is the idea of its "boundedness". Heritage has traditionally been conceived within the AHD as a discrete "site", "object", building or other structure with identifiable boundaries that can be mapped, surveyed, recorded, and placed on national or international site registers. This ability to reduce the concept of heritage to "manageable" and discrete locales helps to reduce the social, cultural or historical conflicts about the meaning, value or nature of heritage, or more broadly the past, into discrete and specific conflicts over individual sites and/or technical issues of site management. (2006: 31)

By protecting these houses, they have very much become (bounded) objects or sites, rather than processes. The establishment of SEFRAK had, in fact, already objectified them. Protection is in large measure seen as putting an end to changes, or rather protection allows changes within defined and structured limits. I think it is safe to argue that these houses, by being 'authorized' as heritage, have to a large degree become an aesthetic product. Within a cultural heritage context, they serve a public purpose through their aesthetic appeal and appearance, simply because they are nice to look at. This is supported by the fact that local authorities do accept alterations of these houses, although alterations which are within the boundaries outlined above, and which to a large degree have aesthetic effects.

Finally, in 'A heritage process' we mainly follow a specific house through its current owners. Their personal narrative related to their house demonstrates that people live in houses and not in cultural heritage objects, hence the idea of an AHD is very much questioned. The family at Lerbrekk's dynamic relationship to their house produces a narrative which resists the authority of an AHD, yet at the same time they accommodate public authority. This is supported by several other owners by the fact that they convey a sense of pride in their houses. So private ownership justifies practical needs on an everyday basis, but at the same time people adhere to (most) rules set by the local cultural heritage authorities. It seems that the owners at Lerbrekk meet public expectations by offering an aesthetically appealing house, which is very much a negotiated result of their personal choices:

> "We would not dream of changing the house's exterior appearance";

> "It [the shed] has the same shape as before, yet so much nicer";

> "I have bought machine made tiles for roofing. Some people would say that they should have been handmade, but they are too unstable. Corrugated iron has nothing to do with a *jærhus*";

> "Architecturally it is an outstanding house".[33]

These quotes to a large degree sum up what they see as offering a larger public; their house is a negotiated – and controlled – result of what they see to be personally feasible, as well as an acceptance of historical developments of a house type. Their house thus stands for *their* (transgenerational) lives, yet it also stands for 'larger' (and more distant) lives in a particular part of the country. This they convey in an aesthetic sense: the house, in large measure, has the classical characteristics of a *jærhus*, and that is what they are able and willing to offer in the present. It is furthermore interesting to note the spatial limit inherent in their reflections over their property. The *jærhus* is assigned material and symbolic values on local and regional levels respectively: the interviewees relate to the core geographical area

33 Interview, 2 October 2007.

of the house *type*, and hence the familiar lives that have been led in and related to the houses. The AHD's claim that these houses are of national value, hence becomes too 'woolly' and abstract, and of limited relevance for their daily lives. I finally believe that the ordinary nature of these houses – in the best sense of the term – helps explain owner's outlook on what by the authorities is seen to be or hoped to be an iconic expression of a certain historical identity.

In writing this chapter, I have come to recognise the diverse uses of the *jærhus* – as home, heritage, property, site, object, identity marker, narrative device. These uses offer us an opportunity to see it as a result of many, often conflicting processes. In effect, then, we can also see ourselves as the result of a number of processes, as we are invited to identify with this particular dwelling. It is my contention that who we want to be depends on what we use it for.

References

Blomley, N. 2004. *Unsettling the City. Urban Land and the Politics of Property.* New York: Routledge.

Blomley, N. 2005. Flowers in the bathtub: Boundary crossings at the public-private divide. *Geoforum*, 36(3), 281–296.

Blunt, A. 2008. The 'skyscraper settlement': Home and residence at Christadora House. *Environment and Planning A*, 40, 550–571.

Blunt, A. and Dowling, R. 2006. *Home.* London: Routledge.

Brekke, N.G. and Schjelderup, H. 1997. *Hus på vekstkysten gjennom 4000 år.* Bergen and Stavanger: Fortidsminneforeningen and Norsk Kulturråd.

Cultural Heritage Act [Kulturminneloven]. 1978. Lovdata, available at: http://www.lovdata.no/all/nl-19780609-050.html [accessed 2 July 2009].

Daugstad, K., Rønningen, K. and Skar, B. 2006. Agriculture as an upholder of cultural heritage? Conceptualizations and value judgements – A Norwegian perspective in international context. *Journal of Rural Studies*, 22, 67–81.

Directorate for Cultural Heritage Management. 2008. SEFRAK, available at: http://www.riksantikvaren.no/?module=Articles;action=Article.publicShow; ID=2959 [accessed 16 December 2008].

Flemsæter, F. and Setten, G. 2009. Holding property in trust. Kinship, law and property enactment on Norwegian smallholdings. *Environment and Planning A*, 41, 2267–2284.

Garborg, A. 1998 [1892]. *Fred.* Oslo: Aschehoug.

Harvey, D.C. 2001. Heritage pasts and heritage presents: Temporality, meaning and the scope of heritage studies. *International Journal of Heritage Studies*, 7(4), 319–338.

Harvey, D.C. 2008. The history of heritage, in Graham, B. and Howard, P. (eds), *The Ashgate Research Companion to Heritage and Identity.* Aldershot: Ashgate, 19–36.

Hoffmann, M. 1943. *Jærhuset.* Oslo: Norsk Folkemuseum.

Howard, P. 2003. *Heritage. Management, Interpretation, Identity*. London; New York: Continuum.

Hå commune. 2005–2016. *Kulturminnevernplan*. Varhaug: Hå kommune.

Land Act [Lov om jord (jordlova)]. 1995. Oslo: Landbruks- og matdepertementet, LOV-1995-05-12-23. Lovdata, available at: http://www.lovdata.no/all/nl-19950512-023.html [accessed 20 January 2009].

Lillehammer, G. and Prøsch-Danielsen, L. 2001. Konflikt som kontakt. Kulturminnet alvedans på Jæren, in *Kulturminner og miljø. Forskning i grenseland mellom natur og kultur*, edited by Skar, B. Oslo: Norsk institutt for kulturminneforskning, 35–63.

Lowenthal, D. 2005. Natural and cultural heritage. *International Journal of Heritage Studies*, 11(1), 81–92.

Macdonald, S. 2002. On 'old' things. The fetishization of past everyday life, in *British Subjects. An Anthropology of Britain*, edited by M. Rapport. Oxford and New York: Berg, 89–106.

Malpass, P. 2009. Whose housing heritage? in *Valuing Historic Environments*, edited by L. Gibson and J. Pendlebury. Farnham: Ashgate, 201–214.

Mills, S.F. 2007. Moving buildings and changing history, in *Heritage, Memory and the Politics of Identity. New Perspectives on the Cultural Landscape*, edited by N. Moore and Y. Whelan. Aldershot: Ashgate, 109–119.

Måseidvåg, T. 2000. *Rapport frå registrering av jærhus i kommunane Randaberg, Stavanger, Sola, Sandnes, Klepp, Time, Gjesdal, Hå*. Rogaland Fylkeskommune, Randaberg kommune, Stavanger kommune, Sola kommune, Sandnes kommune, Klepp kommune, Time kommune, Gjesdal kommune, Hå kommune.

Måseidvåg, T. 2001. Systematisering av folkekultur. Erfaringar frå Jærhusprosjektet. *Stavanger Museums Årbok*, 111, 87–104.

Norwegian Cultural Heritage Association. 2009. Available at: http://www. kulturminneaaret2009.no/english [accessed 9 January 2009].

NOU 2002. *Fortid former framtid. Utfordringer i en ny kulturminnepolitikk*. Norges Offentlige Utredninger 2002:1. Oslo: Miljøverndepartementet.

Planning and Building Act [Plan- og bygningsloven]. 1985. Lovdata, available at: http://www.lovdata.no/all/nl-19850614-077.html [accessed 15 June 2009].

Robertson, I.J.M. 2008. Heritage from below: Class, social protest and resistance, in *The Ashgate Research Companion to Heritage and Identity*, edited by B. Graham and P. Howard. Aldershot: Ashgate, 143–158.

Rogaland fylkeskommune. 2007. Fredete og verneverdige bygg og anlegg, available at: http://www.rogfk.no/modules/module_123/proxy.asp?C=33&I=5 60&D=2&mid=17&sid=142&pid=30 [accessed 15 January 2009].

Setten, G. 2004. The habitus, the rule and the moral landscape. *Cultural Geographies*, 11(4), 389–415.

Setten, G. 2005. Farming the heritage. On the production and construction of a personal and practiced landscape heritage. *International Journal of Heritage Studies*, 11(1), 67–79.

Skretting, T. 2004. *Tenk – kvist på Jererudlå! Jærske småstubbar og hermer i fri attfortelling.* Bryne: Jærbladet.

Smith, L. 2006. *Uses of Heritage.* London and New York: Routledge.

St. meld. Nr. 19 [White Paper], 1999–2000. *Om norsk landbruk og matproduksjon.* Oslo: Landbruksdepartementet.

St. meld. Nr. 16 [White Paper], 2004–2005. *Å leve med kulturminner.* Oslo: Miljøverndepartementet.

Sundt, E. 1976 [1862]. *Om bygnings-skikken på landet i Norge.* Verker i utvalg, 6. Oslo: Gyldendal.

Swensen, G. and Jerpåsen, G.B. 2008. Cultural heritage in suburban landscape planning. A case study in Southern Norway. *Landscape and Urban Planning*, 87, 289–300.

Thu, R. 1996. *Vår nye bondekultur – når det moderne vert tradisjon. Ein etnologisk studie frå Jæren.* Hovedoppgave i etnologi, Institutt for kulturstudier og kunsthistorie. Bergen: Universitetet i Bergen.

Tunbridge, J.E. and Ashworth, G.J. 1996. *Dissonant Heritage. The Management of the Past as a Resource in Conflict.* Chichester: Wiley.

Urry, J. 1996. How societies remember the past, in *Theorizing Museums*, edited by S. Macdonald and G. Fyfe. Oxford: Blackwell Publishers, 45–65.

Chapter 8
Commemorating Nations' Workers: The Case of 'The Reesor Siding Incident'

Brian S. Osborne

Introduction: 'The Bloodiest Battle in Canadian History'

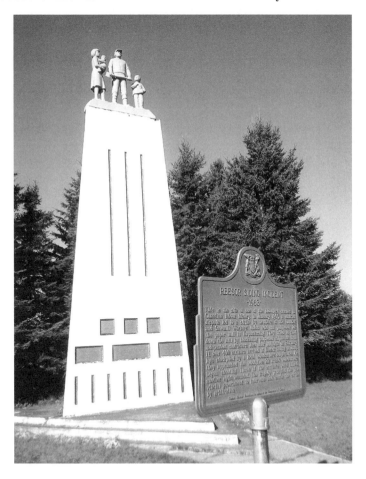

Figure 8.1 One incident: two stories
Source: The author.

Two monuments stand on the side of Highway 11, half-way between Kapuskasing and Hurst in northern Ontario. This apparently insignificant place is called Reesor Siding and yet, on 11 February 1963, it was the site of a bloody confrontation that has since been recognised as a defining event in Canadian labour history. But the monuments there tell two different stories and imply a third. The larger one dominates the landscape and has an impressive, albeit naïve, tone reflected in its massive structure and heroic portrait statuary. Erected by a local union, it is accompanied by an ideologically driven text that employs such emotive signifiers and tropes as 'labour martyrs', 'slain' workers, 'scab' protagonists, and hostile 'gunmen'.

The other (standing at the foot of the column; bottom left of Figure 8.1) is a clone of the hundreds of historic plaques erected by the provincial government's Ontario Heritage Foundation. It is rendered in magisterial bronze and blue and topped by the official provincial coat of arms. It too tells the story of the 'incident' of 1963, but in a different voice. Bureaucratically-researched and committee-written, the conflict is here represented as a 'contract dispute' between 'independent contractors' and 'armed woodcutters' on the one hand, and 'strikers' on the other, with a resolution by peaceful 'arbitration' by the government.

The implied counter-narrative is not monumentalised but it permeates the shadow-landscape of this place. It is the experience of a community riven by the ideological drama that had played out at Reesor Siding. While this was not rendered in statuary, it resonates through the two formal structures as an integral part of, and counter-point to, their particular rhetoric and symbolism. Thus, it too contributes to the triangulation of populist, institutional, and hegemonic forces that produce collective memories of place and time and strategies for survival in ever-evolving lived-in worlds.

So, what is the story behind the events of 1963, the erection of the first monument in 1966, its restoration in 1987, and the addition of the historical plaque in 1996? And what can we learn from this specific case-study about the complex cerebral and emotional calculus of identity formation at sites of past conflict and contested memories?

'What about the Workers?' Some Theoretical Considerations

The way in which human actions are remembered, processed, appropriated, and utilised by successive generations is crucial to identity formation and social cohesion. The roles of eidolons and known heroic actors are rendered variously in myths, historical chronicles, iconic paintings, literature, popular culture, and monumental structures (Osborne 2001, Osborne 2006, Levinson 1998, Gillis 1994, Michalski 1998, Smith 2003). Indeed, humans appear to be hard-wired to seek out iconic models (Johnson 2007). In a chapter entitled provocatively, 'Making Heroes out of Dust', Bruce Meyers, asserts that 'Heroes fascinate and attract us', and that the hero 'is someone who is seen by others as they wish to be

seen: the self created by the imagination'. No mere exercise in narcissism, Meyers argues for a functional rationale for the search for heroes: 'Through them, we are able to discover a broader concept of what it means to be human, what it means to strive and fulfil the dreams we dream and obtain the answers to the questions we ask' (Meyer 2007: 19). But how are heroes and their acts remembered? For Colin Coates and Cecilia Morgan, the relationship between actual events and how they are appropriated by a collective memory is always in a state of 'permanent evolution'. It is 'subject to the dialectic of remembering and forgetting, unconscious of the distortions to which it is subject, vulnerable in various ways to appropriation and manipulation, and capable of lying dormant for long periods only to be suddenly reawakened (Coates and Morgan 2002: 4–5).

The point is that while individuals live in communities whose identities have evolved naturally through shared experience and social practice, another component in the process has been the selection and nurturing of preferred meta-narratives and symbolic spaces. This has been demonstrated by Anthony Smith's impressive *oeuvre* on the construction of the 'ethnie' through the integration of individual identities into a collective national identity, as well as other collectivities such as regions, gender, class, and organisations (Smith 1998, 1999, 2003). In the process, the past is re-constituted as it is being appropriated for current purposes, and often manipulated for contemporary priorities (Coates and Morgan 2002: 4–5, Verdery 1999). David Lowenthal's attempt at deconstructing the triad of identity/heritage/history referred to them as 'swimming in a self-congratulatory swamp of collective memory' in which the past is distilled into 'icons of identity, bonding us with precursors and progenitors, with our own earlier selves, and with our promised successors' (Lowenthal 1994, Gillis 1994: 42, 43).

Perhaps, the best example in western society is how the grim verities of martial conflict have been mythologised, and appropriated in exercises of identity-formation and policy rationalisation (Winter and Sivan 1999). Certainly, wars have bulked large in the imaginations of modern nation-states: the Civil War for the United States; Gallipoli for Australia; the Somme for France, Britain, and Germany; and Vimy Ridge for Canada. The consecration of national war memorials in the combatants' capitals and the beatification of war heroes and veterans have all served to highlight the role of patriotic service and sacrifice in nations' identities. Indeed, patriotic wars and battles, glorious victories and defeats, and personal acts of derring-do and sacrifice cannot function in the complex script of patriotism if they are not communicated in verse, art, or statuary for the edification of contemporary societies and posterity (Tippett 1984, Paret et al. 1992, Oliver and Brandon 2000, Brandon 2006, 2007, Osborne and Gordon 2004, Osborne 2001, 2001a, 2001b, Osborne and Osborne 2004). National collective imaginations are studded with the real and imagined heroic virtues and attributes of its surrogate warriors.

But there are other sites of conflict which, while more prosaic, are no less demanding of bravery, comradeship, sacrifice: workplaces. Mining, fishing, lumbering, the factory-floor, construction sites, transport, and other public

services all exact a daily toll of injury, disability, and death. Indeed, the world-wide statistics provided by the International Labor Organization are staggering: more than 2.3 million persons die because of work-related accidents and diseases annually, or some 6,300 a day (ILO 2010). For example, on 24 December 2009, Christmas Eve, four construction workers fell to their deaths from scaffolding in Toronto. It prompted an article that pointed out that 405 construction workers had lost their lives since 1990 and that 21 had died in 2009 alone 'in a variety of horrendous ways, from being struck by falling objects, accidently cut by machinery, electrocuted, or crushed between vehicles' (Talaga 2010: A13). To drive home my point, on 23 December, a young Canadian soldier was the 134th Canadian to die in Afghanistan (McVicar 2009: 11). Six days later, an emotional 'repatriation ceremony' was held at the Canadian Forces Base, Trenton, and thousands lined the recently dedicated 'Highway of Heroes' as the funeral cortege travelled Highway 401 to Toronto. The well-rehearsed tropes of military ceremonialism and public recognition of sacrifices in war were called upon to mark this tragic death, but little attention was directed to the equally tragic death of the three workers five days earlier.

Clearly, regular, quotidian work kills more people than sporadic, dramatic wars, but there are few memorials recognising the sacrifices made, by ordinary people for the collective well-being (Thomas 2001, Jaworsky, 2001, Beveridge and Johnston 1999). This point is commented on by Dennis Duffy in his review of Jonathan Vance's excellent study, *Building Canada: People and Projects that Shaped the Nation* (Vance 2006: 8). Noting that Vance speaks of 'the heroism of the anonymous crowds' who built Canada, Duffy underscores this assertion with a quote from George Eliot's *Middlemarch* (1871). 'For the growing good of the world is partly dependent on unhistoric acts; and that things are not so ill with you and me as they might have been, is half owing to the number who lived faithfully a hidden life, and rest in unvisited tombs' (Duffy 2006: 8).

In a similar vein, Ralph Waldo Emerson poses an essential existential question of national significance his poem, *A Nation's Strength*: 'What makes a nation's pillars high / And its foundations strong?' His answer rejected the usual patriotic tropes of the 'sword' whose 'blood has turned [empires'] stones to rust, / Their glory to decay', and also the 'bright crown' of pride as 'God has struck its luster down / In ashes at his feet'. Rather, Emerson turned to the oft-unrecognised and inglorious contributions of those whose toil and sacrifice build the essence of a nation's fundamental strengths:

> Not gold but only men can make
> A people great and strong;
> Men who for truth and honor's sake
> Stand fast and suffer long.
>
> Brave men who work while others sleep,
> Who dare while others fly –

They build a nation's pillars deep
And lift them to the sky.

(McGraw-Hill: 43, Richardson 1995)

That is, beyond the metaphors of war and glory, there have been ideological causes that generated martyrs, heroes, and tragic losses. Concerns over conditions of work and the rights of workers were often central to industrial disputes and the early history of labour organisation. In fact, the ensuing confrontations between labour on the one hand, and the power of the state and employers on the other, often resulted in conflicts, injuries, and death. Such hard-fought battles were crucial for the evolution of the social conditions that we now take for granted throughout the democratic world.

So, the central question of this, and the following chapter is, 'What about the workers?' – that symbolic *cri-de-couer* of the 1960s trade-union movement. And what about the civic, philanthropic, and humanist values that they fought for in the past, that we enjoy in the present, and which we aspire to in the future? And how are heroes and their acts remembered? Moreover, this study will look at the context of the rationale for, and opposition to, the construction of hero-figures, identify the principal actors in the process, and analyse the evolution of the memorialisation of ideologies. That is, it seeks to demonstrate how remembrance is often a complex site of conflict between plural populist forces that are often in conflict with hegemonic initiatives emanating from corporate, institutional, and state interests.

Setting the Scene: The Context of the Place and Time

Reesor Siding is located in northern Ontario, a region which was formerly the domain of the First Nations and the fur-trade but which received considerable socio-economic development in the early years of the twentieth century. In 1900, the Department of Crown Lands commissioned a survey of the agricultural, water-power, and timber resources and produced a *Report of the Survey of Exploration of Northern Ontario 1900* (Ontario Department of Crown Lands 1901). It reported that while most of it consisted of the igneous-metamorphic rocks of the Canadian Shield, some sections were part of the Great Clay Belt and offered some options for agriculture, albeit in a topography dominated by numerous small lakes, muskeg bogs, and poor podzolic soils. But what attracted particular attention, were the extensive stands of black-spruce timber, a species that was much in demand for pulp-wood. This natural resource was to prove to be the basis for the establishment of a prosperous pulp and paper industry dependent upon the abundant forests, hydro-electrical power, and both local and immigrant labour (Nelles [1974] 2005, Wood 2006, Bradwin 1972 [1928], Radforth 1987, Morton and Copp 1984).

The development of these resources became possible with the construction of railways, starting with the National Transcontinental Railway that connected this frontier region with the metropole. During World War I, enemy aliens and prisoners of war were brought to internment camps located here and, following the war, the government attempted to stimulate the development of northern Ontario by offering 100 acre land-grants to potential settlers. However, the greatest economic stimulus was the establishment of the Spruce Falls Power and Paper Company in Kapuskasing in 1920. Concentrating on the harvesting of the abundant local black-spruce, the enterprise ensured employment for the local population in the logging camps or the pulp mill. The essential underpinnings of this economy and way of life were the forest, lumber camps, and the market for pulp-wood:

> In the early decades of the twentieth century, pulp and paper promoters found everything needed for a prosperous industry in northern Ontario. Timber appeared to be "inexhaustible" and fast-flowing rivers offered inexpensive and abundant hydro power. Cheap labour was provided by men experienced with axe and frame saw who arrived each winter from farms in Ontario and Quebec eager to earn cash income. They were joined by immigrant workers from Europe (particularly Finland) who were crucial in subsequent union organizing campaigns. (Ontario Heritage Foundation 1996)

Indeed, the Reesor Siding Incident was the outcome of several developments associated with the region's post-World War II economic boom energised by the growing demand for newsprint by the burgeoning North American newspaper industry. This was accompanied by two other critical developments: first, a regional exodus of frontier farmers had eroded the local labour base; secondly, what labour remained in the region had become unionised with the establishment of the Lumber and Sawmill Workers' Union (LSWU) in 1946. In that year, the LSWU won collective bargaining rights for the bushworkers and, through the 1950s, negotiated better wages and improved conditions in the lumber-camps, the number of unionised bush-workers growing from 2,000 in 1951 to 16,000 in 1957 (Ontario Heritage Foundation 1996).

What was to be an important dimension of the Reesor Siding Incident was that some farm families had not joined in the mass-exodus from this inhospitable frontier region. Surviving in the Kapuskasing region of the Clay Belt required adjusting to a short growing season and distant markets and a strategy of combining this marginal agriculture with cutting pulp-wood lumber for the Spruce Falls Power and Paper Company. Some were unionised cutters while others operated with licenses from the Department of Lands and Forests that allowed them to cut a hundred cords of lumber a year. In fact, these independent bush-workers became an integral part of the manufacturing process. It was estimated that as much as 110,000 cords of pulp-wood, some 25 per cent of the company's total need of 450,000 cords, was cut by these local settlers organised in-union co-operatives,

known as *chantiers* or 'settlers' (Ontario Heritage Foundation 1996). This was to evolve into a fractious divide in this hitherto cohesive Francophone frontier society and took on the character of a 'civil war' which divided the community and even families.

A Clash of Ways of Life and Ideologies

On 14 January 1963, a major wild-cut strike erupted in northern Ontario when 1,515 unionised company woodcutters walked off the job (Stein 1963, *The Ottawa Citizen* 1963, Ontario Heritage Foundation 1996). This action virtually halted all operations at the Spruce Falls Power and Paper Company. At issue, was a threatened wage freeze and a company proposal to impose a seven-day work-week for the next two months of the primary cutting and hauling season. Another issue was the matter of living accommodations in the lumber camps. This is where the region's cultural-historical profile came into play. On the corporation side, the macro-economics of the situation was that recent decreases in demand for newsprint by their major newspaper customers resulted in a decreased demand for pulp-wood. In fact, they could survive with only that part of the product produced by the free-lance settlers, the *chantiers*.

Predictably, the union organisers appealed to the settlers to support their strike and cease their cutting operations as they were weakening the impact of the union's bargaining power. For their part, the 'settlers, truckers and independent pulpwood operators' laid out their position in a brief presented to the Prime Minister of Ontario, the Attorney General, and the various ministers of Labour, Lands and Forests, and Agriculture on 18 January 1963 (Ontario Archives RG 7-1-0-75). For them, the disruption of the normal pattern of forest-work and revenue deprived them from 'a legitimate means of livelihood' formerly protected by the *Settlers' Pulpwood Protection Act*, and placed the local economy 'in great jeopardy'. The brief provided measures of the extent of the settlers' pulp-wood economy: 622 permit holders; 261 independent operators in lumber-camps; 100 men engaged in related operations; 1,000 families affected; 90,000 cords of pulpwood produced; a value of some $2 million, including $350,000 in Crown dues; $50,000 invested in preparing bush roads for the 1 January–10 March cutting and hauling season. The main point was that the settlers depended solely on the pulpwood industry as their 'basic revenue' and, therefore, 'it is of vital importance that this source of income be not cut off'. Clearly, the settlers' perspective was that they were protecting their livelihood. In the eyes of the unionised lumbermen, however, they were scabs and strike-breakers.

The two positions were irreconcilable and tensions grew in this small, isolated community. Moreover, the contemporary political climate has to be taken into consideration. These events were taking place at the height of the 'Cold War', the 'Red Scare', and the aftermath of the Cuban Missile Crisis and the Bay of Pigs. For many, trade-unions were on the wrong side of this ideological frontier.

Certainly, several of the journalist accounts idealised the members of the *chantier* cooperatives as, in order to join them, they had to be 'a hard-working man, to be completely upstanding morally, and be a taxpayer to Ontario's Roman Catholic separate-school system' (*Ottawa Citizen*, 6 December 1963). Henri Veilleux, an old settler and book-keeper for three of the cooperatives, agreed: 'They are the cream, the best people in the area. The lumberjacks are wanderers. The settlers stay here. They are the kind of people who build up the country' (Stein 1963: n.p.). Whatever the global and local reasons, tensions were running high and, on 23 January, the mayor of Kapuskasing, Norman Grant, declared, 'The settlers are getting so desperate they are going to go into the bush with guns and shoot anyone who tries to interfere with their cutting' (*Toronto Globe and Mail*, 23 January 1963). It was to lead to the bloodiest labour conflict since the Winnipeg general strike in 1919.

Mayor Grant's portentous forecast was precipitated on 10 February when the settlers stacked 600 cords (2200m³) of their recently cut spruce at the Reesor Siding in preparation for loading onto waiting railcars. All the principal actors in the oncoming tragedy were gathering at the scene. For three nights, 20 settlers had kept a vigil over what was to become the most famous stack of wood in Canadian labor history. They were armed with an array of 12 rifles of various calibers and three shotguns. Some 400 unarmed union members arrived with the intention of preventing the shipment. Twelve Ontario Provincial Police officers had been assigned to protect the loading process. Brushing aside the police cordon, the union men moved toward the stockpiled pulp wood and the settlers opened fire on the advancing union men, 11 of whom were shot. Fernand Drouin and two brothers, Irenée and Joseph Fortier, were killed; eight others were wounded, including Harry Bernard, Ovila Bernard, Joseph Boily, Alex Hachey, Albert Martel, Joseph Mercier, Léo Ouimette and Daniel Tremblay (Ontario Heritage Foundation 1996).

The 33-day long strike was broken and, on 17 February, the strikers returned to work under the terms of their old contract, after agreeing to compulsory arbitration. Following the incident, 237 union members were charged with rioting and were temporarily housed in the former Monteith Prisoner of War camp north of Kapuskasing. Ultimately, 138 of the accused union members charged with illegal assembly were found guilty, and the union paid $27,600 in fines. On the settlers' side, 19 were originally charged with 'intent to maim', charges that were later increased to 'non-capital murder'. The provincial court case against the settlers was held in Cochrane, Ontario, in October. After three days of deliberations, the seven-man jury found all of the settlers to be not guilty of killing the striking employees, but three, Paul-Emile Coulombe, Léonce Tremblay, and Héribert Murray, were charged with firearms violations and were fined $150 (Ontario Heritage Foundation 1996).

The Aftermath: Populist Remembrances

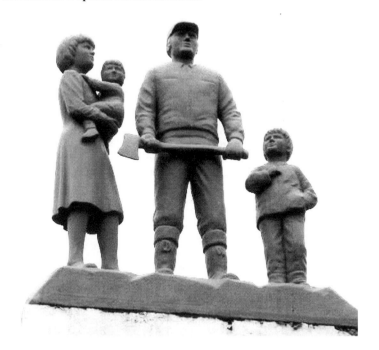

Figure 8.2 Iconic heroes
Source: The author.

Within months of the terrible incident, there were plans in the air for Local 2995 to erect a monument on the site to commemorate it. According to J.K. Laforce, President of the Lumber and Sawmill Workers Union (LSWU), it was to be unveiled on Labour Day 1964 and called the 'Fortier-Drouin Monument' in memory of Joseph and Irenée Fortier and Fernand Drouin who were killed there. It was to consist of life size statues of four figures; carved from yellow pine and surmounting a concrete base 22 feet high and would depict 'a bush worker holding his axe, a bush worker's wife holding a baby, and a small child'. The 'history' of what had happened, together with the union crest and the names of the dead and wounded, were to be engraved onto a polished rock surface, and the whole ensemble was to be floodlighted and landscaped. Appropriately, the statues were to be carved by Abe Patterson of Pembroke, the renowned 'Sculptor of the Ottawa Valley' (*Ottawa Citizen*, 6 December 1963).

But there were other memories. The events of 1963 had riven the community and, ominously, there were rumours that 'once the monument is erected it will be dynamited', rumours that prompted Laforce to declare that 'if this happened it would be rebuilt' (*Ottawa Citizen*, 6 December 1963). Not surprisingly, two

years later, the monument had still not been erected and it was reported that the union's plans were still prompting 'considerable public outcry' and, therefore, construction had been suspended until the spring of 1966 (*Toronto Globe and Mail*, 24 November 1965).

Finally, on 6 July 1966, a 100 car motorcade transported some 200 persons to the dedication of the Reesor Siding monument on an acre of land owned by the union at the site of the killing (United Steelworkers of America, August 1966; (*Toronto Telegram*, 6 July 1966). They included a delegation of the United Brotherhood of Carpenters and Joiners who were attending a convention in Kapuskasing. The dedication was performed by Rev. J.P. Laurin, priest of St. Patrick's Church, Kapuskasing, and the assembled throng was addressed by Rene Brixhe of the LSMU. The text of the plaque rendered the ideologically charged narrative:

> This monument was erected in memory of the labour martyrs slain at Reesor Siding on 10 February 1963. The three men killed were Joseph Fortier, Irenée Fortier and Ferdinand Drouin. They were members of the Lumber and Sawmill Workers Union, which was on strike against the Spruce Falls Power and Paper Company. When the strikers attempted to dismantle piles of scab wood in order to prevent its delivery to the mill, they were met with gunfire. Eleven men suffered gunshot wounds, three of them fatal. In the court proceedings that followed, murder charges were dismissed and three of the gunmen were fined $150 each for possession of dangerous weapons. Meanwhile, 138 strikers were fined $200 each for unlawful assembly.

The union delegates paid tribute to their three fellow workers who had fallen in the conflict between the striking bushworkers and the local woodcutters, noted the discrepancy between the fines for the gunmen and those for the workers charged with 'unlawful assembly', and argued that the dedication of the monument would ensure its role as 'constant reminder of how badly anti-strikebreaker legislation is required' (United Steelworkers of America August 1966).

This theme was echoed in a special edition of *Information*, the newsletter of the United Steelworkers of America/Métallurgists unis d'Amérique, that was devoted to the dedication of the Reesor Siding monument, and 'other outrages carried out against working men of Canada in pursuit of free collective bargaining'. To that end, the *Information*'s cover-page image was of the 'towering monument' erected by the 'labor movement' to commemorate the deaths of the 'three union men' who 'fell to their death under a hail of bullets from the guns of strike breakers'. Further, the opening pages identified other 'martyrs' for the cause: Nicholas Nervan, Julian Hryshko, and Peter Markunt at Estevan, Saskatchewan, 29 September 1931; Viljo Rodval and John Voutilainen, Onion Lake area, Ontario, 18 November 1929; and the iconic Albert 'Ginger' Goodwin, Cumberland BC, 26 July 1918 (United Steelworkers of America August 1966: 'Martyred In The Pursuit of Free

Collective Bargaining').[1] But President Brixhe went further in his analysis of the events of the tragedy and the spirit of the dedication (United Steelworkers of America August 1966: 'Monument to members who died for a cause'). For him, it was simple: 'We have gathered here to honour our brothers who have made the supreme sacrifice in support of the ideals they believed in.' He then proceeded to present a chronicle of the conflict in which the language and allusions reflected his ideological perspective as a committed trade-unionist. The members of the LSWU had been on strike 'to defend their rights and principles'. Despite their 'efforts to make the strike effective, in this field at my right, some non-union pulpwood was being produced to be forwarded from this very site to the strikebound paper mill'. So, union men decided that the 'most effective way to curtail this production, which was jeopardizing the effectiveness of their strike' was to picket. Since their 'main concern' was that this be a 'non-violent strike' they decided to act late at night to 'minimize the chance of contact between the union and non-union elements, thereby minimizing the danger of injury to human beings'. But their efforts were to no avail as the strikers 'were met by a hail of bullets fired from ambush'.

However, Brixhe then went further. His litany of rationale justification, logical strategy, and sensitive concern was accompanied by an attempt to effect community healing and reconciliation with a call for unity of all workers:

> This monument has been erected not to reactivate nor perpetuate the animosity and the bitterness which resulted from this tragedy but to indicate to and remind the world that some people have given their lives for the cause that they believed in, in a cause for which all labouring people should be prepared to give and make sacrifices. (United Steelworkers of America 1966: 2–3)

Unfortunately, reconciliation was far from people's minds as demonstrated when 'Stompin' Tom Connors, appeared in Kapuskasing in 1969. The popular and populist entertainer had released an album, *On Tragedy Trail*, which chronicled in song an array of real and fictitious Canadian tragedies. One such event he immortalised in music and verse was the 'incident' at Reesor Siding and 'Stompin' Tom looked upon it with hope for the future:

> It reminds us in the North,
> not to bring out tempers forth,
> that there may never elsewhere be
> no Reesor Crossing Tragedy.

1 Mike Sokolowski and Steve Skezerbanovicz killed in the Winnipeg General Stike of 1919 could have been added to this list. Certainly, Roy Jones's chapter on the death of Tom Edwards in the Fremantle strike of 1919 resonates with this message.

But the community was still riven by the events of February 1963 and were not ready to forget. Connors received death-threats after his performance and was warned against presenting it in the future (Connors 1995: 462–475). Certainly, his *Reesor Crossing Tragedy* captured the essential dimensions of the dramatic events, underlying ideological issues of what 'Stompin' Tom called, that 'night of death, and destiny', and 'the bloodiest labour battle yet, in all Canadian history'.

The Aftermath: Official Recognition

Clearly, people had not forgotten and both sides in the conflict harboured their own memories of the past. Such all-pervasive sentiments and prejudices prevented other commemorative initiatives. Thus, in 1981 and 1986, the LSWU applied for the erection of an Ontario Heritage Foundation historical plaque to commemorate the 1963 incident. It was rejected by the OHF on both occasions because the event continued to be divisive in the community. But by 1987, the original monument was starting to deteriorate and the LSMW Union President, Normand Rivard, declared the union's commitment to the upkeep of the monument 'so people won't forget' (*Timmins Press*, 1987). The replacement was to be an exact replica constructed out of more durable materials, while the original sculpture was to be restored and put on display in front of Union offices in Kapuskasing. These initiatives were appreciated by Jean Tanguay, one of the 1963 strikers, who commented, 'It's good it's up so people will never forget and never start something like that again'. And so, in June 1987, union members gathered again, 'not to protest against farmers and other laborers, but to replace the tattered statue which has marked the spot for 21 years' (*Timmins Press*, 16 June 1987).

A decade later in 1995, a joint submission for provincial commemoration advanced by the Ontario Federation of Labour (OFL) and the local Industrial Wood and Allied Workers of Canada (IWA) was finally successful. Perhaps somewhat optimistically, naïvely, or because they were ill-informed, the OHF bureaucracy decided to now move ahead with historicising the 'Reesor Incident'. Their rationale was that the original objections were no longer relevant and that the events of February 1963 were no longer as provocative as they had been. Others disagreed, one being the MPP for Cochrane-North, Len Wood, who declared, 'It's still very vivid in people's minds and it will probably remain that way for many years to come' (*Timmins Press*, 16 April 1996).

Given these sentiments, the OHF took special care to claim their plaque was not intended to favour any side in this polemical issue but, rather, that the Province was 'commemorating this tragic event as being of significance to the history of the Ontario labour movement' (Ontario Heritage Foundation 1996). Accordingly, the plaque strove to record the objective facts of the event as history, purported the result to be objective, and did not attempt to locate them in any ideological or philosophical context:

REESOR SIDING INCIDENT

1963

This is the site of one of the bloodiest clashes in Canadian labour history. In January 1963, a contract dispute led to a strike by members of the Lumber and Sawmill Workers' Union who cut pulpwood for the paper mill by blockading pulpwood shipments from independent contractors. Just after midnight on February 11, over 400 strikers arrived at Reesor Siding to dump logs stockpiled by a local woodcutters' cooperative. As they approached the woodpiles, 20 armed woodcutters began shooting. Three of the strikers were killed, another eight wounded. The tragedy prompted the provincial government to intervene and settle the strike by arbitration.

The OHF representative on the day, Professor Mercedes Steedman, attempted a contextualised interpretation of how the events at Reesor Siding fitted into the OHF's mandate (Ontario Heritage Foundation 1996). Noting that over 1,100 plaques had been erected since 1956, the good professor explained that the plaque program intended to 'promote greater public awareness and appreciation of the full range of sites, resources, events, accomplishments and personalities that have contributed to our collective past and continue to influence our future'. In particular, this plaque was 'one of a number of plaques that have been erected in recent years commemorating important but not widely known subjects in Ontario's labour history'. And, in closing, Steedman thanked the unions for initiating the plaque as an action that 'promotes greater public awareness of the tragic event that took place here in 1963, and to encourage more widespread appreciation of the individuals and events that have influence labour history in northern Ontario'.

For some, at least, the new plaque was a signal of another stage in interpreting the events of 11 February 1963. All of these events at the edge of the Ontario ecumene were evolving in an age of a shifting 'real politic' at the centre. The Reesor Siding incident of 1963 had erupted at a time of profound ideological tension globally. It was also a time when the logging industry was encountering technological transformations, shifting modes of corporate, governmental, and union negotiations, and a residual way of life central to the survival of local community identity. By 1996, however, at the national level, there was an emerging new sensitivity to the role of workers in the collective polity. In 1984, Workers' Memorial Day had been mounted by the Canadian Union of Public Employees (CUPE) and, the following year, the Canadian Labour Congress declared 28 April to be an annual day of remembrance on the anniversary of the 1914 Workers Compensation Act. In 1991, the Canadian Parliament passed an *Act Respecting a National Day of Mourning for Persons Killed or Injured in the Workplace*, thus officially adding 28 April to Canada's calendar of iconographic dates (National Day of Mourning 1991).

But these developments did not appease the local union members. In particular, critical attention was directed at the incumbent Conservative government of Ontario. Arguing that 'Anti-Scab laws reduce violence on picket lines, reduce the length of strikes and in fact reduce the overall amount of days lost due to labour disputes', Wilf McIntyre, President of Local 2693, chastised Michael Harris' Conservative government for eliminating the 'Anti Scab laws':

> With the right wing attitude of this Government, we sincerely hope and pray that we do not ever see another Reesor Siding incident occur. It is no coincidence that April 25 has been chosen for the unveiling of this plaque. Today was chosen in connection with the April 28 Day of Mourning which is next Sunday and it is elevate the awareness of the public and to remind us all never to forget what happened in 1963. (United Steel Workers of America 1996: n.p.)

This motif was picked up by Gerry Stoney, National President of the Industrial Wood and Allied Workers of Canada, who had been instrumental in getting the site inscribed on the provincial list of heritage sites. His speech focused on the importance of remembering and memorialising the events of 1963:

> It was not the end, in part because the events left a lasting impression on the people of the region, and because of the Union's determination to leave a permanent monument to the workers who fell and the struggle in which they died. And because the strikers learned that they could stand together through the tough going and that the union was behind them. It was not the end, as well, because out of that strike came a lasting change in the role of the bushworkers in the community. There was a new sense of solidarity, a new sense of belonging and a new pride among them. (United Steel Workers of America 1996a: n.p.)

President Stoney then proceeded to relate the 'grim events' of 1963 and their aftermath to a current 'really serious challenge':

> There's an elected government here that wants to tear down a lot of the things we've fought for over the years. It wants to tear down medicare. It is getting rid of fair labour laws. It wants to sell off Crown Corporations. It wants to scarp environmental standards in the forest sector. It wants to eliminate educational support for the children of working families. And I can think of no better memorial or monument to the workers who fell in 1963 than to be able to tell our children and grandchildren that we stood up to Mike Harris' government. (United Steel Workers of America 1996a: n.p.)

This is the context of the erection of the OHF's plaque in April 1996. It was a signal demonstration of an attempt to historicise and contextualise what had been a classic example of an industrial conflict typical of an earlier stage of economic and political reality. The current ideological imperative attempted to transform

the personal tragedy and community disruption associated with the events of 1963 away from the past ideological context of political and social confrontation into a new meta-narrative of social cohesion and a historicised rendering of past conflicts. However, this bureaucratic agenda was contested by the undiminished voice of the unions speaking the tropes of workers solidarity and militancy. Nevertheless, despite, or perhaps because of these rhetorics, local commemorations of the *National Day of Mourning* no longer turn to the Reesor Siding monument-complex for mnemonic prompts: they are now held in a less inflammatory locale in Kapuskasing.

Finally, a less material but no less effective contribution to the memories attached to the Reesor Siding site was produced in 2003. The events there prompted Doric Germain to engage in an exercise of historical fiction, *Défenses Legitimes* (Germaine 2003). His novel explores the economic verities and existential fears of the settlers as they protected their role as independent loggers. A way of life and survival strategy, logging was at the core of family and community survival throughout the Francophone communities of Northern Ontario. Also captured and personalised are the experiences of those as they move from the stage of the conflict, through the ensuing imprisonment, and subsequent drama of the court-rooms. Historical veracity and artistic creation aside, the novel is also a parable of the essential failure of traditional subsistence strategies and the challenges of modernity and industrialisation. Of significance to this study of memory-making, it too serves as a monument, a textual one, to the experience of the *chantiers/* settlers in the complexity of the Reesor Siding Incident.

Conclusion: So What?

In his *The Great Museum*, Donald Horne observes that most of the

> parliament-palaces of western Europe lack symbols of those working class struggles for the popular franchise that have given them modern legitimacy. Thus, modern parliaments are unable to symbolise the realities of their own democratisation, even though strong working-class organizations – trade unions even more than political parties – are as essential to maintaining aspects of a "free society" as support for the traditional liberties in the critics' culture. (Horne 1984: 137)

By definition, however, these ideological conflicts of the past have been complex and how they are remembered becomes a contested psychic terrain that is often played out in geographical space. At the cerebral level, hegemonic forces seek to mobilise mass-identification with a putative shared ideology and common purpose by the imposition of a 'bureaucracy of memory' that favours 'elite memory' over 'popular memory' (Gillis 1994: 42, 43). Apart from the obvious dissonance between these two polarities, the issue is further confused in that the

populist 'vernacular memory' is often diverse with plural interests that may clash with one another. As Bodnar put it, 'Public memory is produced from a political discussion that involves not so much specific economic or moral problems but rather fundamental issues about the entire existence of a society: its organization, structure of power, and the very meaning of its past and present' (Bodnar 1992: 14). Perhaps the most dynamic expression of public-memory making is the phenomenon of 'spontaneous monuments'. For Senie, they are quintessentially 'populist phenomena, ways for people to mark their own history ... are the sign of an engaged populace responding to personal needs for public mourning and civic protest ... are democracy in action' (Senie 1999: 25, 26, 27).

But what is relevant to this study is that spontaneous monuments can also prompt spontaneous iconoclasm that either prevails or fails and, whatever the outcome, the spontaneous conflict becomes memorised. The point is that, once constructed – either spontaneously or subsequently – monuments 'are frozen in space and time while time moves on around them, their rigid materiality ensuring their estrangement from the ever-changing values of the society in which they are located' (Osborne 2001: 54). Of course, the same applies to the memories of anti-commemoration. This is the central premise for Young's assessment of the relationship between memory and counter-memory: 'Both a monument and its significance are constructed in particular times and places, contingent on the political, historical, and aesthetic realities of the moment' (Young 1999: 6). Their very survival, therefore, may perpetuate old wounds and social dysfunction and insensitive memory projects may revive old tensions and animosities. Indeed, in many cases, the need may be to nurture *lieux d'oublie* to replace the provocative *lieux de mémoir* (Wood 1999).

In particular, an iconoclast exercise of enforced amnesia may be appropriate for sites of violence and tragedy where there are conflicting experiences or remembered constructions of what took place on the 'shadowed ground'. They generate a continuum of options: sanctification; designation; rectification; or obliteration (Foote 1997). Sanctification generates a sacred space because of the desire to remember an event, an individual, or a group connected with a significant heroic event or loss. Designation requires some form of public or institutional marking of the site. Rectification and obliteration are both attempts at eliding evidence of past events from the place of their occurrence and, thus, from the collective memory. Of course, if the events and their significance have been erased from the collective memory, there is no need for rectification or obliteration. And, if they are firmly ensconced in the collective consciousness, there is no need for a material *aide de mémoire*.

Finally, there is also a perspective of place, locale, and community. Geographers have long been driven by *chorography*. That is, representing places as expressions of their ecological, cultural, and experiential distinctiveness in terms of 'natural regions' or *pays*, places that have *genres de vies* or 'personalities' that underpin particular identities (Tuan 1972, Sack 1997, Gregory 1994). For David Harvey, an understanding of social change in particular places can never be achieved 'outside

of space and time, outside of place making, and without the engagement with the dialectics of socio-natural relations' (Harvey 2009: 260). Harvey's 'geographical situatedeness' is crucial to a fuller understanding of the community's remembrance of the events at Reesor Siding as part of the 'chorographic archive' (Wigen 2010, 14) of the 'georegion' (Osborne 2010) of north-western Ontario.

Perhaps that's the essential message of the memorialisation exercises at Reesor Siding. While located in a remote region of Canada and referring to a specific cultural and temporal context, it too played a part in the national, indeed, international narrative of social change. This micro-study of a micro-region underscores the rationale for the inclusion in the collective social memory of other civic sacrifices and domestic battles that also figure in the nurturing and protection of social democracy and complex community identities. And, hopefully, they continue to evolve with the social needs of the future in local, national, and cosmopolitan contexts.

Postscript

As I close off this piece, it has been announced that under the terms of the Occupational Health and Safety Act, some 54 charges with fines totalling $17 million have been laid against two companies involved in the 24 December construction accident I referred to above that killed four construction workers. Noting that more than 400 workers have been killed on construction sites since 1990, Premier Dalton McGuinty asserted he was 'absolutely committed' to ensuring the safety of workers, while his Labour Minister, Peter Fonseca declares, 'Even one death or injury in a workplace is too many' (*Toronto Star*, 15 August 2010). Ironically, the same newspaper reported that drilling was continuing to rescue thirty-three miners trapped for ten days 700 metres underground in a gold and silver mine in northern Chile. The battle continues.

References

Beveridge, K. and Johnston, J. 1999. *Making Our Mark: Labour Arts and Heritage in Ontario*. Toronto: Between the Lines.

Bodnar, J. 1992. *Remaking America. Public Memory, Commemoration, and Patriotism in the Twentieth Century*. New York: Princeton University Press.

Bradwin, E. 1972. 1928. *The Bunkhouse Man: A Study of Work and Pay*. Toronto: University of Toronto Press.

Brandon, L. 2006. *Art or Memorial: The Forgotten History of Canada's War Art*. Calgary: University of Calgary Press.

Brandon, L. 2007. *Art and War*. London: Taurus.

Coates, C. and Morgan, C. 2002. *Heroines and History: Representations of Madeleine de Verchères and Laura Secord*. Toronto: University of Toronto Press.

Connors, T. 1995. S*tompin' Tom: Before the Fame*. Toronto: Viking.

Duffy, D. 2006. 'Making Connections', Review of Jonathan Vance's Building Canada: People and Projects that Shaped the Nation. *Literary Review of Canada*, 8 June, 8.

Foote, K.E. 1997. *Shadowed Ground: America's Landscapes of Violence and Tragedy*. Austin: University of Texas Press.

Gillis, J. 1994. *Commemorations: The Politics of National Identity*. Princeton: Princeton University Press.

Germaine, D. 2003. *Defenses Legitimes*. Ottawa: Le Nordir.

Gregory, D. 1994. *Geographical Imaginations*. Oxford: Blackwell.

Harvey, D. 2009. *Cosmopolitanism and the Geographies of Freedom*. New York: Columbia University Press.

Horne, D. 1984. *The Great Museum: The Representation of History*. London and Sydney: Pluto Press.

ILO, 27 April 2010. *Focus on new emerging hazards in a changing world of work*. For more information on Safety and Health at Work see: http://www.ilo.org/safework.

Jaworsky, B. 2001. *Lamps Forever Lit: A Memorial to Kirkland Lake Area Miners*. Calgary: Cambria Publishing.

Johnson, P. 2007. *Heroes: From Alexander the Great and Julius Caesar to Churchill and De Gaulle*. New York: HarperCollins.

Levinson, S. 1998. *Written in Stone: Public Monuments in Changing Societies*. Durham and London: Duke University Press.

Lowenthal, D. 1994. Identity, Heritage, and History, in *Commemorations: The Politics of National Identity*, edited by J.R. Gillis. Princeton: Princeton University Press, 42–43.

McGraw-Hill. 2003. *101 Patriotic Poems, Songs and Speeches*. New York: McGraw-Hill.

McVicar, W.B. 2009. Emotional ceremony for soldier, *Kingston Whig Standard*, 29 December, 11.

Meyer, B. 2007. *Heroes: The Champions of Our Literary Imagination*. Toronto: HarperCollins.

Michalski, S. 1998. *Public Monuments: Art in Political Bondage*. London: Reaktion Books.

Morton, D. and Copp, T. 1984. *Working People: An Illustrated History of the Canadian Labour Movement*. Ottawa: Deneau Publishers.

National Day of Mourning. 1991. Stature of Canada, c.15.

Nelles, H.V. [1974] 2005. *The Politics of Development: Forests, Mines, and Hydro-Electric Power in Ontario, 1849–1941*. Montreal and Kingston: McGill-Queen's Press.

Oliver, D.F. and Brandon L. 2000. *Canvass of War: Panting the Canadian Experience, 1914–1945*. Ottawa: Canadian War Museum/Canadian Museum of Civilization.

Ontario Archives, RG 7-1-0-75. 1963. 'Chantiers' Petition, 18 January 1963'.

Ontario Department of Crown Lands. 1901. *Report of the Survey and Exploration of Northern Ontario, 1900*. Toronto: L.K. Cameron Publisher.

Ontario Heritage Foundation. 1996. *Historical Background, Unveiling of Provincial Plaque, Reesor Siding*, 25 April 1996.

Osborne, B.S. 2001. Landscapes, Memory, Monuments, and Commemoration: Putting Identity in its Place. *Canadian Ethnic Studies*, XXXIII(3), 39–77.

Osborne, B.S. 2001a. Warscapes, Landscapes, Inscapes: France, War, and Canadian National Identity, in *Place, Culture, and Identity*, edited by I. Black and Robin Butlin. Quebec City: Laval University Press, 311–333.

Osborne, B.S. 2001b. Erasing Memories of War: Reconstructing France after the Great War, in *Canadian Military History Since the 17th Century/L'histoire militaire canadienne depuis le XVIIe siécle*, edited by Y. Tremblay. Ottawa: National Defence, 513–522.

Osborne, B.S. 2001c. In the Shadows of Monuments: The British League for the Reconstruction of the Devastated Areas of France. *International Journal of Heritage Studies*, 7(1), 59–82.

Osborne, B.S. 2006. From patriotic pines to diasporic geese: Emplacing culture, setting our sights, locating identity in a transnational Canada. *Canadian Journal of Communications*, 31, 147–175.

Osborne, B.S. and Gordon, D. 2004. Constructing National Identity in Canada's Capital, 1900–2000: Confederation Square and the National Monument. *Historical Geography*, 30, 618–641.

Osborne, B.S. and Osborne G.B. 2004. The Cast[e]ing of Heroic Landscapes of Power: Constructing Canada's Pantheon of Power on Parliament Hill. *Material History Review*, 60, 35–47.

Osborne, B.S. 2010. Going Glocal in a Globalising World: The Kingston Georegion, edited by G. Nelson *Many Places, Many People: Understanding and Planning the Diverse Georegions of Ontario.* Montreal-Kingston: McGill-Queen's Press.

Ottawa Citizen. 1963. The Night Three Men Died For a Pile of Wood: They Were Victims of the Bloodiest Battle in Canadian Labor History. 6 December.

Paret, P. and Lewis, B.I. 1992. *Persuasive Images: Posters of War and Revolution*. Princeton NJ: Princeton University Press.

Radforth, I. 1987, *Bushworkers and Bosses: Logging in Northern Ontario, 1900–1980*, Toronto: University of Toronto Press.

Richardson, R.D. 1995. *Emerson: the Mind on Fire*. Berkeley: University of California Press.

Relph, E. 1976. *Place and Placenessness*. London: Pion.

Sack, R. 1997. *Homo Geographicus*. Baltimore: Johns Hopkins University Press.

Senie, H.F. 1999. Mourning in Protest: Spontaneous Memorials and the Sacralization of Space. *Harvard Design Magazine*, Fall, 23–27.

Smith, A. 1998. *Nationalism and Modernism*. Oxford: Oxford University Press.

Smith, A. 1999. *Myths and Memories of the Nation*. Oxford: Oxford University Press.

Smith, A. 2003. *Chosen Peoples: Sacred Sources of National Identity*. Oxford: Oxford University Press.

Stein, D.L. 1963. Violence and Death Strikes Ontario's Quiet North Country. *Maclean's Magazine*, 23 March.

Talaga, T. 2010. Construction workers at high risk. *Toronto Star*, 24 January, p. A13.

Thomas, E. 2001. *Dead But not Forgotten: Monuments to Workers*. Canada: Unionized Labour/Seldon Griffin Graphics.

Timmins Press. 1987. Statue remembers shooting of lumber workers on strike, 16 June.

Timmins Press. 1996. Dark day in labor history. Plaque commemorates three deaths at Reesor Siding, 16 April.

Tippett, M. 1984. *Art at the Service of War: Canada, Art, and the Great War*. Toronto: University of Toronto Press.

Toronto Globe and Mail. 23 January 1963.

Toronto Globe and Mail. 24 November 1965.

Tuan, Yi-Fu. 1974. *Topophilia: A Study of Environmental Perception, Attitudes, and Values*. Englewood Cliffs: Prentice-Hall.

United Steel Workers of America. 1996. Local 1-2995, 'Agenda for Ceremony at the Monument', Wilf McIntyre Speech, 25 April.

United Steel Workers of America. 1996a. Local 1-2995, 'Agenda for the Supper', Gerry Stoney, National President of the I.W.A. Canada, Speech, 25 April.

United Steelworkers of America. 1966. *Information*, August 1966.

United Steelworkers of America. 1966. *Information*, August 1966, 'Martyred In The Pursuit of Free Collective Bargaining'.

United Steelworkers of America. 1966. *Information*, August 1966, 'Monument to members who died for a cause'.

Vance, J. 2006. *Building Canada: People and Projects that Shaped the Nation*. Toronto: Penguin Canada.

Verdery, K. 1999. *The Political Lives of Dead Bodies: Reburial and Postsocialist Change*. New York: Columbia University Press.

Wigen, K. 2010. *A Malleable Map: Geographies of Restoration in Central Japan, 1600–1912*. Berkeley: University of California Press.

Winter, J. and Sivan E. (eds) 1999. *War and Remembrance in the Twentieth Century*. Cambridge: Cambridge University Press.

Wood, D. 2006. The last frontier: Rationalizing the spread of farming into the Boreal woods of Canada, 1910–1940. *The Canadian Geographer*, 50(1), 318–55.

Wood, N. 1999. *Vectors of Memory: Legacies of Trauma in Postwar Europe*. Oxford: Berg.

Young, J.E. 1999. Memory and Counter-Memory: The End of the Monument in Germany. *Harvard Design Magazine*, Fall, 5–13.

Chapter 9

Time-specific Martyr or Enduring Symbol? Tom Edwards and Western Australian Labour Heritage 1919–2010

Roy Jones

Introduction

The related chapter by Osborne in this volume provides both an outline and a justification for the remembrance and the memorialisation of work-related heroism. This chapter provides a longitudinal case study of the celebration of the death of a single worker in a 1919 industrial dispute on the Fremantle waterfront. The intervening decades have seen this occurrence variously revered, dismissed, recalled and, perhaps most significantly, invoked as an exemplar in considerably more recent industrial disputes. This long term process can therefore be seen as an illustration and perhaps even as a corroboration of academic contentions both about heritage in general and about heritage from below in particular.

Graham et al. (2000: 2) provide a 'straightforward definition of heritage as the contemporary use of the past'. As such, at different points and by different people in the years since Tom Edwards' death, this incident has inevitably been seen in different lights in those various historical presents. This concept is refined in Robertson's (2008: 143) use of an epigraph from Kundera (1996: 5): 'The struggle of people against power is the struggle of memory against forgetting.'

At various points since 1919 memories of Tom Edwards' death, if not martyrdom, may seem to have been almost forgotten, certainly in official circles and presumably in the wider consciousness. However, this was not necessarily the case within the local labour movement and several recent industrial, planning and heritage 'struggles' have served as triggers to bring the circumstances of his death and the wider issues related to it to the fore once more.

In purely concrete terms, the Tom Edwards Memorial Fountain has stood in Kings Square in the centre of the Western Australian port city of Fremantle since 1982. It is part of a diverse assemblage of public art including plaques bearing the names of local sporting heroes, a statue of Australia's wartime Prime Minister, John Curtin, and a giant chess board (Figure 9.1). It is not large. It was removed from its original site outside the Fremantle Trades Hall in 1968 and spent 14 years in storage prior to its restoration and relocation. According to the Public Art Around the World web site <http://www.publicartaroundtheworld.com/Tom_

Edwards_Memorial_Fountain.html>, the plaque which describes 'Comrade Tom Edwards' as a 'working class martyr' is faded and although '(t)he tap still works, the drainage isn't too flash'.

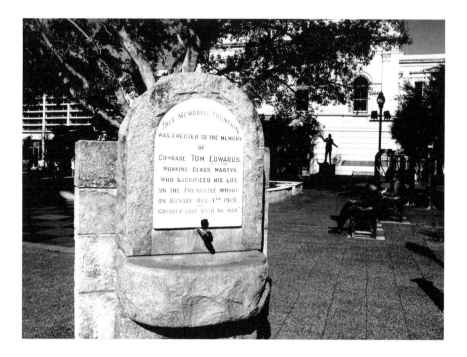

Figure 9.1 The Tom Edwards fountain
Note: The chessboard, Fremantle Town Hall and statue of John Curtin are in the background.
Source: All photographs by the author.

Nevertheless it commemorates Edwards' death in an industrial demonstration involving Fremantle waterside workers in 1919 which was referred to at the time as 'Bloody Sunday' and even as 'Westralia's Eureka' (de Garis 1966: 37) (in the mid nineteenth century, the 'Eureka Stockade' in Ballarat, Victoria was the site of Australia's most famous popular uprising). Until very recently this was the only Western Australian example of a memorial to a worker. Furthermore this worker had died in a struggle against authority and in an attempt to defend the conditions and living standards of his fellows. After a long intervening period, this event has been recalled in relation to a recent waterside dispute, cited in another example of the memorialisation of industrial conflict and of the death of a worker and is under consideration for further memorialisation, this time at the site where the incident occurred. This short chapter will place the Fremantle waterfront clashes of 1919 in their national and political contexts before describing the events that led up to Tom

Edwards' death and its resulting memorialisation. It will then trace some of the links between these events and more contemporary Western Australian industrial conflicts, deaths and commemorations.

The Historical Context

The late nineteenth and early twentieth centuries constituted a formative period in Australian history. The Australian colonies federated to form the Commonwealth of Australia in 1901. Around this time, and in part as the result of the depressed economic conditions of the 1890s, a significant organised labour movement developed. For Western Australia, these changes occurred over a particularly compressed time frame. The eastern colonies had experienced massive population growth, which was strongly related to gold rushes, in the mid-nineteenth century and this led to the, roughly contemporary, granting of responsible government, the widening of the franchise, and the legitimation of organised industrial activity. Western Australia, by comparison remained isolated, undeveloped and politically and socially conservative. It did not become self governing until 1890 and only began to experience large scale population growth with the gold discoveries around Coolgardie and Kalgoorlie in the late 1880s and early 1890s (Crowley 1960, Stannage 1981).

In these circumstances, the port of Fremantle, as the gateway to the expanding goldfields, experienced explosive growth around the turn of the century, a period when Western Australia attracted many migrants – including the Victorian, Tom Edwards – from other states and from overseas. A number of these migrants played leading roles in the formation of Western Australia's first trade unions, including the Fremantle Lumpers (waterside workers) Union, which had been founded (illegally) in 1889 (Oliver 2003). The union movement developed rapidly. A Trade Union Congress, held in 1899, established both the Australian Labor Federation WA (Oliver 2003) and the first Western Australian Labor Party <http:www.wa.alp.org.au/about/history.php>. Fremantle Trades Hall was opened in 1905 as the headquarters for 50 unions and, in 1911, the first majority Labor state government took office in Western Australia. During World War I, however, the Labor party split over the issue of conscription and, in 1916, it lost government at both state and federal levels.

In 1917, the Fremantle Lumpers Union refused to load flour onto a ship bound for the Dutch East Indies on the grounds that it might find its way, via the Netherlands, to Germany. At the same time a general strike occurred in the Eastern States. In these circumstances:

> The federal government regarded the widespread strikes in essential services as a threat to the war effort and as evidence of "disloyalty". Prime Minister W.M. "Billy" Hughes formed the so-called "loyalist" unions – known in the labour movement as "scab" unions – including the National Waterside Workers Union

(NWWU). Waterfront employers gave preference to NWWU members and the conservative State Government provided them with police protection. (Oliver 2008: 8)

From then on resentment grew between the 'scabs' and their employers on the one hand and the Lumpers on the other. Outbreaks of violence were frequent and a pitched battle between the two union groups took place in Fremantle High Street on Armistice Night. As in Reesor, Ontario several decades later (Osborne, this volume), at an isolated transhipment point and at a time of global tension, a group of strike breakers attempted to move materials in order to undermine a union-backed industrial protest.

Bloody Sunday

The ongoing hardships experienced by the Lumpers and their families that resulted from these discriminatory hiring practices provided the fuel for the Bloody Sunday disturbances, but the immediate cause of the riot was the arrival, in April 1919, of a single ship, the *Dimboola*. At that time the Spanish Influenza pandemic was at its height and, even though quarantine procedures were leading to food shortages, all shipping was normally required to remain offshore for seven days before entering Western Australian ports. In view of the food shortages, the state government waived this requirement and allowed the *Dimboola* to berth in the harbour. The Lumpers refused to unload the ship until quarantine regulations had been satisfied and picketed the wharf where crowds of up to 800, including the Lumpers' family members, gathered regularly. This standoff lasted for three weeks until the newly appointed state Premier, Hal Colebatch, undertook 'an act of foolish bravado' (Oliver 2008).

On Sunday 4th May, Colebatch personally led a convoy of small boats containing employers' representatives and non-union labourers down the Swan River from Perth, the capital, with the intention of unloading the *Dimboola* behind barricades which they were to erect themselves. Protesters pelted the boats with 'missiles' (Oliver 2008), 'rocks and projectiles' (Public Art around the World website, accessed 9/8/2009) or 'stones and large chunks of scrap iron' (Weaver 2000) as they passed under the Fremantle road and railway bridges and a crowd of 3–4,000 assembled on the wharf. The Lumpers attacked the barricades. The police, who had been detailed to protect the non union workers, were issued with rifles with fixed bayonets. In one police charge the Lumpers' President, William Renton, was knocked down and, when Tom Edwards went to Renton's assistance, his skull was fractured. Sources differ as to whether Edwards' injury was inflicted by a rifle butt or a police baton, but a rumour spread that he had been shot. Certainly the Riot Act was read and the police were issued with ammunition. However, after Colebatch gave an assurance that no further work on unloading would be done that day (Australian Labor Federation 1920) Alexander McCallum, the Australian

Labor Party Secretary, was able to persuade the Lumpers to leave the Quay and to reassemble on Fremantle Esplanade.

At the same time, the troopship *Khyber* docked. Several hundred returning soldiers, still in uniform, disembarked, joined the protestors' meeting and led a march back to the Quay where the barricades were dismantled and dumped in the harbour (Australian Labor Federation 1920). In all, 26 police and seven Lumpers were injured in the riot.

The Aftermath

Several policemen were beaten in Fremantle High Street on the following day and the Lumpers were 'in full possession' (Australian Labor Federation 1920: 15) of the wharf, if not of the whole town. Numerous public meetings and meetings of unionists and of returned soldiers across the state condemned the government's actions in arming the police and demanded the removal of the 'Nationalists' (the NWWU) from the waterfront.

Shortly after Tom Edwards' death in Fremantle Hospital on the evening of 7 May, the Premier announced that the President and Secretary of the NWWU had agreed to 'withdraw from the wharf entirely' (Australian Labor Federation 1920: 16). Edwards' funeral on 9th May remains the largest ever held in Fremantle with over 5,000 people following the cortege from the Trades Hall to the cemetery. Public transport came to a halt and businesses closed across the state as a mark of respect. Within a month, Colebatch had resigned after serving the shortest ever term as Premier of Western Australia.

Later that year, Edwards' widow and three children received financial compensation from the state government and an appeal by the unions raised funds to purchase a cottage for them. An impressive headstone marks Tom Edwards' grave in a section of the cemetery where many other Lumpers are buried, and noted local sculptor, Pietro Porcelli (whose statue also stands in Kings Square), was commissioned to produce a memorial fountain which was erected outside the Trades Hall.

The Resonances

Bulbeck (1991) identifies two phases in the erection of Australian workers' monuments: in the late nineteenth and early twentieth centuries, during a period of union formation and industrial unrest; and again after 1970. In a national survey of 'unusual monuments' conducted as part of Australia's (1988) bicentennial celebrations, it was noted that no monuments to workers were erected between 1921 and 1962. Certainly by the 1960s both Tom Edwards and Bloody Sunday seemed to be slipping from local consciousness:

Thomas Edwards was soon forgotten and, though the tale of the wharfside riot and the Lumpers' victory is periodically retold, it has never assumed the place in the mystique of the trade union movement that contemporary references to "Westralia's Eureka" attempted to confer on it. (de Garis 1966: 37)

In concrete terms de Garis' opinion appeared to be correct at that time. The Fremantle Trades Hall was sold in 1968 and became a theatre restaurant. The memorial fountain was removed and stored in the offices of the Waterside Workers Federation, the successor of the Fremantle Lumpers Union, for many years. In 1982, however, and with the support of Fremantle City Council, it was restored and re-erected in its present location. At this time, Fremantle was gentrifying and the Council membership was becoming increasingly committed to the preservation and celebration of the City's heritage (Jones 2007). Since then, the memorial, Tom Edwards and Bloody Sunday have been invoked in relation to the placement of Solidarity Park on the state's Register of Heritage Places in 2003 and to the Patrick Stevedores/Maritime Union of Australia (MUA) dispute of 1998 and the placement of a further memorial at the site of the incident on Victoria Quay is under consideration (Bobbie Oliver, pers. comm. 2010).

Solidarity Park

The small patch of land now known as Solidarity Park is located between a car park and the road at the rear of Western Australia's Parliament House. For several months from the 29th April 1997 the site was occupied (initially by a caravan) as 'The Workers' Embassy' by unionists protesting against the so-called 'Third Wave' of industrial relations legislation which, at the time, was being taken through state parliament by the Richard Court Coalition (conservative) government. Over the course of the occupation, gardens and trees were planted, and a barbeque and sand pit installed. The site was kept permanently occupied by unions on a roster basis and many social functions such as birthday celebrations; family days; visits by school and international groups occurred (Heritage Council of Western Australia 2003).

In June the occupiers began to create more permanent structures, beginning with a memorial to Mark Allen, a young union official who died in an accident while inspecting a worksite in Perth in 1996 (Figure 9.2). In July the site was renamed Solidarity Park and a plan for further structures was drawn up and subsequently approved by the Trades and Labour Council Executive (Heritage Council of Western Australia 2003). Construction ensued on the basis of this plan and the site now contains several structures completed by tradespeople during the union occupation (Figure 9.3). These include a 'Fountain of Youth' and a 'Wall of Remembrance' in memory of all those killed or injured in the workplace. Interdenominational services are held annually at the Wall of Remembrance on the International Day of Mourning for those killed in the workplace.

Figure 9.2 The Mark Allen plaque

**Figure 9.3 Solidarity Park and the back of the Western Australian
 Parliament Building**

The site was officially vacated by the unions in November 1997, but it is regularly used by the unions on the Day of Mourning, the anniversary of Mark Allen's death, May Day and International Womens' Day. It has also been used as a base by other protest groups during relevant parliamentary debates. A Labor state government placed Solidarity Park on the state's Register of Historic Places in 2003 because of its relevance (*inter alia*) to the 'Principal Australian Historic Themes' of 'Protesting', 'Remembering the Fallen' and 'Mourning the Dead' (an action strongly criticised by the Opposition). In the Assessment Documentation its significance was specifically linked to that of the Tom Edwards memorial as the only other workers' monument in the state.

The Patrick Stevedores/MUA dispute

On the night of 7 April 1998, the national company Patrick Stevedores sacked their workforce, sent security guards with dogs onto their wharves throughout Australia and ordered the workers to leave (Oliver 2003). At Fremantle, MUA members only left after the police were called in and a picket line was set up at Patrick's Wharf. As in 1919, the protesters enjoyed community support. Local clergy blessed the picket line at a candle light service on the morning of Easter Day and conducted regular Sunday services. Many non union supporters joined the picket line which boasted 'a crèche, meeting rooms, entertainments and artists, public facilities, power, lights, and even a giant TV Screen' (Oliver 2003: 359).

In a further echo of the 1919 dispute, the employers again brought in non-union labour, though on this occasion they were trained in Dubai and flown to the wharves at night by helicopters. At Fremantle, police in riot gear from the Tactical Response Group were also used (unsuccessfully) to break the picket line. The dispute ended on 21st April when a court ruling called for the reinstatement of all the Patrick workers. Given the numerous – but fortunately not fatal – historical parallels, the MUA named their picket line the Tom Edwards Stand ('Mobilisation: pickets, priests and public protest' at <http://mua.tlp.net.au>, cited in Oliver 2003: 360).

The Patrick dispute was part of a much wider campaign by the Howard federal government (1996–2007) to modify the Australian industrial relations system. Its final stage, the controversial 'Work Choices' system was a central issue in the 2007 election campaign at which the Liberal-National coalition lost government and Howard became only the second serving Australian Prime Minister to lose his seat. In the debate to introduce a new industrial framework to replace the Work Choices system, Melissa Parke, the federal member for Fremantle, was quoted as follows:

> In Kings Square in central Fremantle is the Tom Edwards Memorial Fountain. This fountain commemorates the Fremantle wharf crisis of 1919 during which Tom Edwards of the Fremantle Lumpers Union received a blow to the head from a police rifle butt and later died. On that event, I quote from the

Westralian Worker of 1920, whose editor at the time was one John Curtin. He said that Tom Edwards was: … "the first man in Western Australia to give his life for his fellow workers, when seeking to preserve industrial freedom in conflict with the armed forces of the government of the day". (http://www. melissaparke.com.au/Speeches/house-debates-fair-work-bil-2008-31208.html [accessed 9 August 2009])

Conclusion

Figure 9.4 The location of the Tom Edwards fountain

Bulbeck (1991: 16) notes that 'a hierarchical pluralism relegates the monuments of the "new histories" to the friendly surrounds of parks and gardens, or to private property or lonely roadsides'. Certainly the Tom Edwards Memorial Fountain began its life on a side street outside the Trades Hall. This was because, in the immediate aftermath of Bloody Sunday, the port and state authorities feared that a memorial on the actual site of the incident would be a threat to public order. Even now the fountain occupies a peripheral position on Kings Square facing a row of parking bays (Figure 9.4). Similarly Solidarity Park is on a side street at the rear of Parliament House. These locations seem to lend support to Bulbeck's argument that it is the 'monarchs, rulers and explorers that look down on the

passing crowds', while memorials to what might be termed lesser folk occupy less elevated positions. In Western Australia, however, by far the most prominent and impressive memorials honour the large numbers of predominantly ordinary people who died in Australia's wars and, in particular, since this has determined both the sites and the designs of such memorials, those who died in the First World War. However, on Bloody Sunday, the issues of sacrifice in war and sacrifice at work became conflated when returned servicemen from the *Khyber* joined the protest and many of the Lumpers were themselves returned servicemen who may have hoped for better treatment from the country for which they had fought. Interestingly, both Bean (1934), the official War Historian, and Monash (1920), the leading general, sought to relate the heroic military qualities of the World War One 'diggers' to those of ordinary Australian workers (Jones and Birdsall-Jones 2008), The invocation of such associations for heritage purposes are, of course, not uncommon; Robertson (2008) notes the links drawn between the 'land wars' of protesting Hebridean crofters in the early twentieth century and the earlier and much more widespread Highland clearances.

Finally with regard to the spatiality of the memorialisation of Bloody Sunday, serious consideration is now being given to the location of at least a plaque commemorating the event at the site of its occurrence at Victoria Quay. In this regard, however, it must be conceded that this is in the context of the Quay's deindustrialisation. Much of the active ship handling is being moved to other parts of the Fremantle port and Victoria Quay is being redeveloped for cultural, commercial and touristic purposes (Jones 2007). In this light, a memorial to Bloody Sunday – like the Quay's relatively recent 'Welcome Walls' which contain the names of the (mainly non-Anglo-Celtic) migrants who arrived at the port – may be seen as items of historical interest, rather than as the threat which many perceived such a memorialisation to be at the time.

This changing temporal resonance of a memorial on the Quay perhaps suggests a further link back to the changing roles of heritage both in general and from below. In Kipling's poem 'Tommy', the soldier is despised by the wider community until there is a need to fight, presumably to protect the wider community's interests. The memorial to Tom Edwards could be forgotten and abandoned during periods of industrial peace, as de Garis argues, but (t)his heritage of protest from below, however small and out of the way, remained to be invoked and revived in times of threat when, as certainly occurred in the case of the Patrick dispute, it could even attain national significance.

References

Australian Labor Federation. 1920. The Fremantle Wharf Crisis of 1919. *Westralian Worker*, Perth.

Bean, C. 1934. *Official History of Australia in the War of 1914–1918*. Sydney: Angus and Robertson.

Bulbeck, C. 1991. Australian History Set in Concrete? The Influence of the New Histories on Australian Memorial Construction. *Journal of Australian Studies*, 28, 3–16.

Crowley, F.K. 1960. *Australia's Western Third; a History of Western Australia.* Melbourne: Heinemann.

de Garis, B. 1966. An Incident at Fremantle. *Labour History*, 10, 32–37.

Graham, B. and Howard, P. (eds) 2008. *The Ashgate Research Companion to Heritage and Identity.* Aldershot: Ashgate.

Graham, B., Ashworth, G.J. and Tunbridge, J.E. 2000. *A Geography of Heritage: Power, Culture and Economy.* London: Arnold.

Heritage Council of Western Australia. 2003. *Register of Historic Places – Assessment Documentation, Solidarity Park.* Perth.

Jones, R. 2007. Port, Sport and Heritage, Fremantle's Unholy Trinity, in *Geographies of Australian Heritages: Loving a Sunburnt Country?* edited by R. Jones. and B.J. Shaw. Aldershot: Ashgate, 169–186.

Jones, R. and Birdsall-Jones, C. 2008. The Contestation of Heritage: The Colonizer and the Colonized in Australia, in *The Ashgate Research Companion to Heritage and Identity*, edited by B. Graham, and P. Howard. Aldershot: Ashgate, 365–380.

Jones, R. and Shaw, B.J. 2007. *Geographies of Australian Heritages: Loving a Sunburnt Country?* Aldershot: Ashgate.

Kundera, M. 1996. *The Book of Laughter and Forgetting.* London: Faber and Faber.

Monash, J. 1920. *The Australian Victories in France in 1918.* London: Hutchinson.

Oliver, B. 2003. *Unity is Strength: A History of the Australian Labor Party and the Trades and Labor Council in Western Australia.* Perth: Australian Public Intellectual Network.

Oliver, B. 2008. Remembering a Working Class Martyr: Tom Edwards and 'Bloody Sunday', May 1919. *Trust News Australia*, May 2008, 8–9.

Robertson, I.J.M. 2008. Heritage from Below: Class, Social Protest and Resistance, in *The Ashgate Research Companion to Heritage and Identity*, edited by B. Graham and P. Howard. Aldershot: Ashgate, 143–158.

Stannage, C.T. 1981. *A New History of Western Australia.* Nedlands: University of Western Australia Press.

Weaver, P. 2000. Tom Edwards' Grave. *The Australian Association for Maritime History, Quarterly Newsletter*, 78, March 2000, 9.

Chapter 10

The History of the Transatlantic Slave Trade and Heritage from Below in Action: Guerrilla Memorialisation in the Era of Bicentennial Commemoration

Alan Rice

> We must face the ultimate contradiction that our free and democratic society was made possible by massive slave labor. (Davis 2006: 6)

2007 Commemorative Plenitude?

As John Oldfield relates in his excellent book *Chords of Freedom: Commemoration, Ritual and British Transatlantic Slavery* the commemorations of the centenary of the Abolition of the British slave trade in 1907 'passed with barely a murmur' (Oldfield 2007: 91) as Government and its agencies as well as extant anti-slavery groups such as the *British and Foreign Anti-Slavery Society* (*BFASS*) virtually ignored the marker date of 25 March. At the height of Britain's imperial power, there seemed little incentive to mark a date that celebrated a landmark social reform which in the conception of many influential commentators impacted on few current British citizens. What a difference in the multicultural Britain of 2007 where, as James Walvin in reviewing Oldfield's book and detailing a host of local and national initiatives comments that, '(E)ven for those working in the field and involved in some of these activities, the volume and ubiquity of the commemorations have been staggering' (Walvin 2007: 398). Of course, the commemorations have not been unproblematic with many questioning the almost universal veneration of the Parliamentary white man's role whilst Black British contributions have sometimes been marginalised. This vision of white philanthropy and black subservience reached its apotheosis in the film *Amazing Grace* (2007) where black contributions to Abolition are marginalised and yet another opportunity to tell a more nuanced narrative of inter-racial radicalism is spurned to follow the Hollywood dollar.

One of the few publications to mark the anniversary in 1907 had been the *Manchester Guardian* which in an editorial on the legacy of Wilberforce named him as the 'apostle and evangelist of abolition' (Oldfield 2007: 92). In 2007 and indeed in the run up to the commemorations during 2006 print and broadcast media (with the contemporary *Guardian* and the BBC taking a leading role) have served

up a bumper crop of articles dramas and documentaries about the anniversary, debates about reparations and links to the struggle against contemporary forms of slavery which still effect millions of people in cocoa plantations, domestic service, the sex trade and textile manufacture in all corners of the world. Notably, contemporary campaign groups such as Anti-Slavery International have been able to proselytise in a favourable context where the subject is at the forefront of the British public's consciousness. People trafficking was highlighted most effectively in an advertising campaign which riffed on the famous image of the Slave Ship *Brookes*. The 1789 image of a Liverpool slaver with serried ranks of enslaved Africans packed into the hold of the ship was brilliantly juxtaposed onto a diagrammatic image of a modern passenger jet showing how the exploitation of human labour for profit continues into the twenty-first century. If nothing else the commemorations of 2007 have thankfully not allowed us to merely view slavery as an historical issue, its contemporary face has, thanks to the campaigners for Fair Trade and against modern slavery, been very much pitched to the foreground.

Slave Memorials in Post-Imperial Britain

If there have been positive signs in the reaction to the Bicentenary commemorations in Britain which show a growing sensitivity to the trans-generational implications of the historical slave trade, this has often been a response to campaigners from (usually local) community groups who have not allowed civic pride to gloss over uncomfortable historical facts. What I would call a *guerrilla memorialisation* has ensured that historic slave ports such as Bristol and Lancaster have increasingly been reminded of their slaving past. In Bristol, the repeated vandalism of the renowned local philanthropist Richard Colston's statue with the graffiti 'slave-trader' throughout the late 1990s and into the noughties as well as the daubing of his statue with red paint in 2007 as a signifier of his bloody involvements in the slave trade shows an effective guerrilla memorialisation that refuses to accept his status as civic hero for his civic munificence, preferring to foreground his activities as 'a sugar merchant in the Caribbean island of St. Kitts' (Wallace-Kowaleski 2006: 61) and an official of the Royal African Company who 'organized and approved the sale and transport of Africans to the Caribbean' (Dresser 2001: 3). As Elizabeth Kowaleski-Wallace emphasises, the self-guided slavery trails around the city devised by Madge Dresser et al. (1998) reveal the slave-trading history elided by the memorial architecture of the city.

In Lancaster, the community group the Slave Trade Arts Memorial Project (STAMP) established in September 2002 were instrumental in raising the issue of Lancaster's slaving past and the city's lack of acknowledgement of it. As an academic in the field and founder member of the group, I became STAMP's academic advisor in 2003. Throughout the project, our committee were aware of the tortured history of British imperialism and the city's own contribution to some of its excesses, made worse by a wilful historical amnesia. Barnor

Hesse articulates this problematic and the way forward to overcome it with a welcome articulacy:

> Part of the difficulty with the dominant cultural form of Britain is the inability or reluctance of its institutions to accept that European racism was and is a constitutive feature of British nationalism. While this remains unexamined, resistant to decolonization in the post-colonial period, it continues to generate a myriad or resistances and challenges to its historical formations. These dislocate the narration of Britain as a serialized essence, articulating the story-lines of a nation that is diversely politicized and culturally unsettled. Residual multicultural disruptions are constituted as forms of disturbance and intrusiveness by those resurgences of meaning, arising from the imperial past. They continually put into question, particularly in unexposed places and at unforeseen times, matters deemed in hegemonic discourses to be settled, buried and apparently beyond dispute. (Hesse 2000: 18)

I quote Hesse in full because his intervention speaks to the legacy of British cities like Lancaster and the possibilities of overcoming the straitjacket imposed by amnesia and indifference. For the committee there was much unfinished business, a colonial legacy that still informed relations and ideas in the city, which the city's involvement in the Transatlantic slave trade highlighted. However, because it had never been properly debated there was a vacuum which we felt needed to be filled so that the link between current racism and the historical chattel slavery which had helped form the very bricks and mortar of the city could be foregrounded and exposed. Our aim was to use the memorial and other project activities as 'residual multicultural disruptions' in the city to help undermine what we might, following Paul Gilroy's adaption of Patrick Wright's phrase, call 'the morbidity of heritage' (Gilroy 2004: 109).

We wanted to make a vibrant living response to the historical legacy of slavery and imperialism that would reawaken debate and not allow a complacent settling of the debate in favour of a monoglot British nationalism. Perhaps our agenda is best discussed in the light of the unveiling ceremony in October 2005 which was attended by around 200 people, most of them local, and included African ceremonials such as the launching of a burning wicker boat festooned with plants used on that continent for burial ceremonials. Although the mayor of Lancaster and civic dignitaries were present, their presence did not dominate the agenda of the ceremonial which reflected the roots of the project in the local community. Nowhere was this more evident than in the local schoolchildren playing percussion after intensive workshops with African drummers. Even our international speaker, the distinguished African American political scientist and civil rights activist Preston King, had been a resident of Lancaster for over a decade whilst in political exile in Britain. The project was interested in embedding memorialisation about slavery in the city and intent on leaving a legacy so that the memorial statuary was not felt to be imposed from above by the elite but that the city and its residents had

ownership of the process and finally of the monument itself; however, it was felt that this ownership should be in the context of a critical take on local and national histories that did not allow them to remain 'settled, buried and apparently beyond dispute' as Hesse had warned in his prescient commentary in 2000. Lubaina Himid spoke at the public meeting which launched *STAMP* and articulated the need we all felt to honour the African dead and abused who had been loaded onto ships which had been fitted out on Lancaster's quayside and the profits from whose sale had helped build the wealth of the city:

> If you are going to honour the dead who have been ignored, suppressed or denied when in peril in the past, you must do it because as a city you want to show that you would do differently now, that you would be able to defend those people now. You will first have to acknowledge that your city would not be the city it is, without the sacrifice of those who were sold by or used by the city in the past. This city can only aspire to being truly great if it can I suppose in some way seek forgiveness.
>
> Could it be that a monument is a tangible seeking of forgiveness? (Himid 2003)

The very notion of 'forgiveness' in the context of a historical wrong from two centuries ago was bound to provoke uneasiness in some sections of the populace and a number of local residents vented their fury, particularly when the proposal originally planned to site the Modernist monument directly in front of the Custom House on the quayside.[1] Probably the most splenetic response came after the memorial design was published in the local paper the *Lancaster Guardian* on 6 January 2005. James Mackie's letter left no doubt about his disgust:

> … to find that a green light has been given to the erection of this nonsense is just upsetting.
>
> The quay is one of the few near-perfect parts of Lancaster that still remain and the old customs house is one of the most beautiful and interesting landmarks in the county.
>
> Who in their right minds thinks that the area will be improved by a mosaic-encrusted plinth and a vessel in the grass verge containing 20 cast iron enslaved figures?

1 The monument was eventually placed above Damside slipway at the opposite end of the quay from the Custom House due to plans for new flood defences that would have complicated its erection on the original site.

The artist's impression that you printed with the article was not very large or detailed but is quite enough to show that the proposed artwork is simply repulsive. (Mackie 2005: 6)

Mackie was not alone in his opposition and the erroneous belief that the City Council was funding the monument added to the venom. *Guardian* reader Betty Norton wrote that a monument 'depicting misery and shame is no enhancement to the city, it will turn visitors away' (Collins 2005: 2). However, at no point did the opposition to the monument gain any political leverage on the Council, never attracting vocal opposition from any councillors in the ruling Labour group, their Green opponents, let alone the opposition Conservative or Morecambe Bay Independent councillors. In fact the Council Leader Ian Barker sprang to the defence of the *STAMP* committee in response to Mackie's letter, crafting an informed and elegant response:

History is more than the sanitised version sometimes served up by the heritage industry. We are privileged to live in a historic town. An understanding of its history can teach our children and us a lot. But it won't do so if we deceive ourselves by ignoring the painful and repellent aspects of that history. I have no doubt that some of Lancaster's prosperous slavers were outstanding men in the local community, kind and considerate to their family and neighbours and yet simultaneously capable of inflicting barbarous treatment on unknown Africans. If the Slave Trade Arts Memorial Project (STAMP) helps us reflect on that contradiction and how it could happen, it will be worthwhile. (Barker 2005: 6)

Barker's articulate support makes the point that citizens like Mackie who worry about the disruption to the 'near-perfect' quay by the visual complications of a memorial to the victims of the slave trade are merely supporters of a sanitised history that the city has been complicit in for too long. Opposition voices continued, but they never gained any coherent body of support. Maybe the fact that the Council fully endorsed *STAMP* but did not provide any of the core funding meant that opposition was neutralised. Most of the money for the project came from the North-West Arts Council and the Millennium Commission with the Council providing vital logistical and technical support which meant there were no specific Council grants for opponents to identify and build opposition around. Another key factor in neutralising opposition was the way the *STAMP* project used the money from the Arts Council to engage with local schools and community groups, running workshops that enabled hundreds of locals to be engaged with the project well before the final monument was unveiled, providing a legacy with ramifications for citizens from many backgrounds and not just the intelligentsia.

Allied to this community work was an awareness in the committee of the need for a different kind of engagement with the past than would normally happen in the cityscape. The committee had decided early on that they should make the encounter with this past an everyday occurrence rather than a pilgrimage or part

of an educational tour. This was key to moving slavery and its important lessons about human rights and injustice from the periphery to the centre of consciousness. As Lubaina Himid articulates, this is done not by the grand gesture, or by shock tactics, but by everyday encounter:

> If the person pushing their buggy past the memorial isn't thinking, "Oh dear what a pity all those people died", but is thinking or just catches a glimpse of fabric out of the corner of their eye or a sparkle of water then there's a kind of flowing imprint, visible, physical, the sound of the water or the flash of the colour that flows into their life as they go past. There's no point even in trying to place something like that in people's lives. But memory is not about that, it's about tiny moments, little flickers of recognition. I'd want people to meet at the memorial; a place where you feel there's a kind of continuum, where there's a going on, a tomorrow. It would be there to enter into the fabric of the day. (Rice 2003: 24)

The everyday nature of the encounter with the public work of art is key to its quiet effectiveness and Himid's future-focused intervention informed Kevin Dalton Johnson, our commissioned sculptor, as he completed the designs for his *Captured Africans* memorial.

**Figure 10.1 The Captured Africans Memorial at its unveiling
in Lancaster, 2005**

Source: Kevin Dalton Johnson.

The final design of the memorial uses a variety of materials including, stone, steel and acrylic to create a multi-textured take on Lancaster's slave trade history. The plinth is a circular stone with an inlaid mosaic of the Atlantic triangle with lines showing the movement of ships between the continents of Europe, Africa and the Americas. Above it are a series of acrylic blocks named for the goods traded, cotton, sugar, mahogany and tobacco with wealth named at the top because it is the prime motivation and slaves named at the bottom because they are the goods upon which the whole trade depends. Inlaid in the acrylic are icons of the goods, so that for wealth at the top there are coins and notes whilst for the slaves at the bottom there is a diagram based on the famous depiction of the slave ship *Brookes*. Just beneath this bottom block are small bronze casts of black slave figures which Johnson developed with young people at risk in Lancaster. He felt it was very important that at least one part of the sculpture should be created by local people who do not consider themselves artists in any professional sense. The acrylic blocks are hung by poles between a steel panel and a carved piece of local Peakamoor stone, both of which image the shapes of a ship.[2] In an interview with Johnson, I discussed how the sculpture as commissioned fits into the environment where it is so that it can become part of the everyday life of the citizens of the town:

> as the public come down and round the bend, just at the top of Damside, you're looking straight at the side of the sculpture, so you're looking through the spaces in between the acrylic blocks to the water on the other side, and that's picked up again by the blue of the mosaic, because it's predominantly blue, so that works really well. And the stone which is going round the outside, that once again fits with the new buildings on either side. It operates on very different levels in as much as that it suits the context of a ship in the triangle, going down the slipway, off it goes after it's just dropped its cargo off. It also fits very well with aesthetic context where it's positioned, the colours of the apartments and the buildings that are built either side, and it works perfectly with the slipway going straight into the river. Having seen it erected, I'm quite confident that it'll work on different levels, both in terms of subject matter and also aesthetically in terms of the environment in which it's been placed.[3]

What the memorial successfully does is arrest the attention of citizens as they first encounter it. For instance, a woman who did not know about the town's slave past told me how she caught out of the corner of her eye the words *Captured Africans* on the metal side of the sculpture and was compelled towards it to find out more. What Johnson wanted to do was to make the slave trade and its history

2 Images of the sculpture and an explanation of the *STAMP* project can be found at: http://www.uclan.ac.uk/abolition.

3 Alan Rice, 'Interview with Kevin Dalton-Johnson', August 2005 and February 2006 (unpublished m/s).

central to the stories the city told about itself, so that they could never be elided again. Exhibiting the slave trade in a public space[4] away from its usual relegation to an often tired museum gallery enables its full historical and contemporary implications to be teased out. Sue Ashworth from Lancashire County Museum Service and a founder member of the *STAMP* committee discussed how important it is to move beyond the walls of the museum and how Dalton-Johnson's sculpture had achieved this:

> We've always acknowledged the slave trade ever since the Maritime Museum first opened 20 years ago. But it was always dealt with in a very dry way that just focused on the facts, the tonnage and the products involved. We saw an opportunity to let people actually contemplate what had happened rather than just be bombarded with figures. There doesn't have to be a disparity between something that's informative but also appeals to your senses. (qtd in Collins 2005: 2)

Ashworth underlines the importance of the memorial doing different memory work that foregrounds the emotions as well as the intellect. The contemplative aspect of the sculpture, however, is at the service of serious political goals as Dalton-Johnson has a strong message for contemporary race relations from his engagement with this tortured history.

> Well, it's just a fact that black people could be treated like that, and if it could happen then, it can happen again now. The reason why we need to have a memorial is so it isn't repeated – it operates on that level. There's also the other political level, in that I'm not trying to get my own back, but I'm turning the tables, as if to say, you're getting a taste of how that feels. Putting the slave trade almost on trial, on exhibition, in the way that it's actually being presented, and the fact that it's a black artist doing that, re-emphasises the political statement.[5]

His desire to put the slave trade on trial is because of its implications for race relations in the here and now. As Johnson himself says the pedagogical aspect of the memorial is very important so that 'the reason why the ships' names are there, and the actual numbers of slaves that were on those ships. They're very clear, and they're not abstracted in the way that other parts have been'.[6] Additionally, the names of the ships' captains are listed in all their Anglo-Saxon banality.

4 The public space where the memorial has been placed is on a main thoroughfare into the town right on the quayside. The committee and the artist felt it more important that the memorial was close to the water which enabled the trade than in the town centre where it would have been dwarfed by buildings and, in part at least, decontextualised.

5 Alan Rice, 'Interview with Kevin Dalton-Johnson', August 2005 and February 2006 (unpublished m/s).

6 Ibid.

Many of them are traditional Lancashire surnames which they might well share with their viewers. The sculpture does not resist such uncomfortable realities, in fact it foregrounds them to make them part of the public memory so that white Lancastrians have to acknowledge these atrocities and hopefully learn from them before moving on. At the moment slave traders are primarily remembered as citizens of note and many were prominent in the eighteenth century polity such as Thomas Hinde who became mayor of the city in 1769 and is named and glorified by a prominent memorial plaque in the Priory church. Johnson's statue in naming names is a guerrilla memorialisation that works against traditional municipal historical hagiography. Such guerrilla memorialisation confronts Lancaster's citizenry with their past in ways that work against traditional memorial praxis which has tended toward unifying viewers principally around sympathy with the victims. Johnson does this, but also acknowledges that the perpetrators of the historical atrocity should be remembered and marked lest Lancaster's citizens forget their ancestors' role in the trade. James E. Young has talked about the importance of such reminiscence in comments about Holocaust memorials which can be related to *Captured Africans*: the 'aim is not to reassure or console, but to haunt visitors with the unpleasant – uncanny – sensation of calling into consciousness that which has been previously – even happily – repressed (Young 1993: 194).

The repression of uncomfortable historical facts has been key to white British responses to slavery and colonialism and Johnson's 'haunting' of visitors to his memorial through the uncannily familiar names is a device he uses to counteract complacency about the historic responsibility of white Lancastrians for the trade that helped to make the city's wealth. As Johnson explains the memorial has different resonances for black people, himself included: 'I don't feel I have to do the sculpture in order to remember, because I won't forget'. He continues:

> So myself, and many other black people, do not necessarily need something physical in order to remember, because we live it every day, and the way that we're treated brings it all back, what our ancestors went through, even though it's not the same degree. Outside of the black perspective, inside the white community, it's very easy to forget, and I think there are many people that would like to forget – there's a combination, a mixture there, and for that reason I think this is very important, just to remember the atrocity that happened to the slave because that's got to be core.[7]

Thus the memorial is not simply designed to honour the memory of the slaves carried on the ships but to engage with the complexities of that history, to name the perpetrators and highlight the centrality of slavery to the fiscal and cultural economy of the city as a means to move forward. As Paul Ricoeur says of such kinds of memory work: 'it is justice that turns memory into a project, and it is this same project of justice that gives the form of the future and of the imperative to

7 Ibid.

the duty of memory' (2004: 88). Memorials at their most effective speak to their future contexts as much as to the past they commemorate, to a future-orientated responsibility, rather than a guilt-charged retrieval of a static past.

Ricoeur's statement is particularly pertinent in the wake of the Morecambe Bay tragedy of February 2004 where 23 ethnic Chinese cockle pickers died due to Victorian working conditions and a bonded labour regime that must to them have seemed akin to slavery.[8] Hence, the memorial now has local contemporary resonances and can speak to modern forms of bonded labour too; how the local community in Lancaster has not only to respond the human rights struggles of the past but also the corrupt practices of global capitalism that continues to throw up bodies on our beaches over 200 years after the Lancaster slave trade. It reflects the tragedy of countless slaves' social and actual deaths, albeit most of these on foreign shores far from its siting here in a British provincial port. If memorialisation is contested here, thousands of miles from the plantation economies, then surely battles over the memory of slavery are even more acute in the belly of the beast that is the American South.

Plantation Houses and Contested Memory

Figure 10.2 The Wye Plantation House, home of the Lloyd Family and Frederick Douglass, taken in 1999

8 Nick Broomfield's film *Ghost* (2007) highlights these aspects of the tragedy.

Contestation over historical sites which have links to slavery are hardly new and some of the most iconic signs of the slave locale are the 'everyday' plantation houses that dominate the landscape of ex-slave societies. The Wye plantation house and grounds on Maryland's Eastern Shore a few miles outside Baltimore is at first sight a typical site of mythological Southern aggrandisement. The long drive leading to a large house resplendent with Georgian columns, befitting a house constructed in the late eighteenth century, betokens a conventionalised encounter with Antebellum myths of Southern Belles and martial heroism. This particular plantation's historical originality is emphasised by the orangery a few paces behind the kitchen which is the oldest such building in North America. Opulence and conspicuous consumption are still foregrounded in the central wing of the house where Staffordshire chinaware adorns the Chippendale furniture and European seascapes festoon the walls, showing how this family, like many others in the South, used their fantastic wealth to indulge in luxurious goods imported from Europe. These rooms are preserved in aspic in the style of the 1830s, the height of power for the Lloyd family whose descendants still enjoy the luxuries of the plantation. This is no open site, turned over to the garrulous public, however, but still a private home, preserved by the riches attendant on the wealth created by a plantation that at its height had over 500 slaves working on it and at other sites around Chesapeake Bay on thirteen farms containing over 10,000 acres of arable land for the cultivation of the atypical slave crop of wheat (Mcfeely 1991).

For the radical cultural historian, such a site of elite myth-making would call forth a demand to look beneath the surface to the materiality that made such wealth possible on the backs of the enslaved labourers. For as Ola Oguibe reminds us:

> … another notable fact of the diaspora experience, namely that the tropes of (African) survival in the Americas are lodged not only in cultural retentions among the descendants of slaves, but also in the master's annals of their violation. Memory finds its anchors in unlikely crevices and interstices of history. (2001: 99)

These tropes of survival are littered throughout the archive of Anglo-European history and in the archaeological detritus of plantations, graveyards and even shipwrecks. However, for once, at the Wye Plantation we have a literate, non-elite witness to the realities behind the façade we are presented with at this troubling site; the imposing figure of that great scion of the black Atlantic, Frederick Douglass who was born in the shadow of the Wye Plantation in 1818. He was born, Frederick Bailey, at Tuckahoe Creek, as slave of Captain Aaron Anthony, sloop captain and chief overseer at Wye. Soon, Douglass joined his master on the plantation and he describes the impressive building that confronted him for the first time:

> … above all stood the grandest building my young eyes had ever beheld, called by everyone on the plantation the great house … a large white wooden building

with wings on three sides of it. In front extending the entire length of the building and supported by a long range of columns, was a broad portico, which gave to the Colonel's home an air of great dignity and grandeur. It was a treat to my young and gradually opening mind to behold this elaborate exhibition of wealth, power and beauty. (Douglass 1881: 488)

Douglass is in awe of the building, but in his recollection of his first encounter with it he is keen to show his adult awareness of how the Lloyd family are involved in a very public display of their Southern white power. This "elaborate exhibition" is a public avowal of status that he as a young slave has access to only as a feast for his eyes. Douglass fills in for us the vast industry around the great house replete with fields under cultivation, barns, a windmill and numerous slave cabins to house the workers. However, as with most Southern plantations, by the twenty-first century all that is left are the big houses themselves that have become eye candy for the tourists who flock to them to indulge in *Gone With the Wind* myths of an honourable South destroyed by the ravages of the American Civil War (1861–65). The 'symbolic annihilation' of black presence at such sites is well documented in books such as Jennifer L. Eichstedt and Stephen Small's seminal *Representations of Slavery: Race and Ideology in Southern Plantation Museums* (2002). The eye candy is contextualised through tours that concentrate on the fixtures and fittings of the house to the almost total exclusion of slaves that make the wealth possible so that on average there are 'thirty-one times as many mentions of furniture at these sites than of slavery or those enslaved' (Eichstedt and Small 2002). Such 'sites engage in the work of social forgetting' with 'deep wounds and anxieties being confined to oblivion' and thus 'meeting the need of whites to create a vision of the nation and themselves as noble and disassociated from racialized atrocities' (ibid.: 15).

Although the Wye plantation is not a museum, but still a family home, its "symbolic annihilation" of black presence is as marked as in the most regressive Plantation Museum. There are significant memorials to Frederick Douglass in Rochester, New York and in Anacostia, Washington DC, where the Frederick Douglass House is a National Park Memorial site, however, at his birthplace there is no acknowledgement of his fame. In fact as our party, only the second officially organised tour of the house ever, was escorted around the house Frederick Douglass was not mentioned once by name. If one of the international group of academics asked about him, the Lloyd descendant escorting us would refer to him in the third person as 'he' or 'him'. His fame was an obvious embarrassment to the family and the tour a necessary trial to be got through in order to appease a National Parks Service whose financial support they might need in the future. This trial was made even more excruciating for them by the presence in the party of Frederick Douglass IV a direct descendant of Douglass himself.

Despite the lack of help from our guide in placing the slaves as central to the story of the big house and its surrounds, as Douglass scholars, we had the landscape of the plantation from his autobiographies to help us. Thus, the smokehouse and

plantation bell still extant as mentioned in Douglass's *Narrative of the Life of an American Slave Written by Himself* (1845) authenticated the site as redolent with images from Douglass's childhood. However, the most chilling site for Douglass scholars was the Aaron Anthony House, a small cottage tucked in behind the big house where Douglass informs us he entered 'the blood stained gate, the entrance to the hell of slavery' (1845: 18) when he witnessed the brutal whipping of Aunt Hester by Captain Anthony. This is probably one of the most famous scenes in the history of black literature and yet the house is pathetically ordinary (Figure 10.3) If any house is haunted by the presence of atrocities against slaves this is, and yet the Lloyd family plans for it are foregrounded by the builder's sign outside. The house was being modernised to serve as a retirement house for the matriarch of the family.

Figure 10.3 The Aaron Anthony House at the Wye Plantation, taken in 1999

Pierre Nora has talked about '*lieux de memoire*, sites of memory ... moments of history, torn away from the movement of history' (1994: 289), the Wye Plantation is such a lieux de memoire where the official family/Southern historical frame is contested by a dissident memory which haunts the buildings and that transforms them from the idyllic to the horrific. As readers of Douglass look at the glories of the plantation and the sweetness of the Anthony cottage, the counter-memory of the famous African American cannot help but be imagined. Douglass describes:

> Before he commenced whipping Aunt Hester, he took her into the kitchen, and
> stripped her from neck to waist, leaving her neck, shoulders, and back entirely
> naked. He then told her to cross her hands, calling her at the same time a d----d
> b------d. After crossing her hands, he tied them with a strong rope, and led her
> to a stool under a large hook in the joist, put in for the purpose. He made her get
> up on the stool, and tied her hands to the hook ... after rolling up his sleeves ,
> he commenced to lay on the heavy cowskin, and soon the warm, red blood ...
> came dripping to the floor. I was so terrified and horror-stricken at the sight,
> that I hid myself in a closet, and dared not venture out till long after the bloody
> transaction. (1845: 19)

The most chilling aspect of this description is Douglass's description of a 'hook
in the joist, put in for the purpose'. This foregrounds how the plantation is a
punishment factory with even aspects of internal décor adapted for the torture
regime. The meat hook in the kitchen of the Anthony house is transformed into a
device to hang live human meat for whipping.

From such examples we can see that as constituted by the Lloyd family the
plantation and its surrounds is in Nora's words in fact a *lieux d'oubli* where the
slave presence is elided or even worse misrepresented (qtd in Wood 1999: 7).
This is nowhere more apparent than in the slave burial ground which according to
the segregationist tradition is separate from the luxuriant family plots with their
elaborate tombstones behind the house. It is across a corn field and marked by no
headstones except a recent general stone placed by the contemporary Lloyd family
with the moniker 'for those who served'. Obviously the choice of words here is a
deliberate misrepresentation, glorying in a faithful service that elides the forcibly
enslaved position of those buried in the gravesite.

The ghostly presences at the Wye enable a counter memory to the Lloyd family's
attempt at whitewashing history. But even officially sanctioned memorials need
to be accorded a sceptical investigation in this locale. Douglass is remembered
by a plaque in the township of St. Michaels, the nearest town to his birth on the
Tuckahoe Creek. Erected by town commissioners and the Maryland Historical
Society, the marker reads:

> Born on Tuckahoe Creek, Talbot County, raised as a slave in St. Michaels area
> 1833–36. Taught self to read and write, conducted clandestine schools for blacks
> here. Escaped North. Became noted Abolitionist orator and editor. Returned
> 1872 as U.S. Marshal for the Distict of Columbia. Also served as DC Recorder
> of Deeds, U.S. Minister for Haiti. (Plaque 1999)

This historical marker would seem at first glance to be an exemplary brief
biographical description of a local hero who gained national and international
fame as an Abolitionist and leading black political activist after his escape from
slavery in the community. However, the neighbourhood of St. Michaels was not
only the venue for the illicit school for his fellow slaves which Douglass bravely

ran during 1835, but more pertinently had been the town through which he and his fellow co-conspirators had been led in chains after their failed attempt at escape in April 1836. The townspeople shouted that he should 'have the hide taken from (his) back' (Douglass 1855: 320) and '(O)n reaching St. Michaels', he recalls, 'we underwent a sort of examination at my master's store' (ibid.: 321). There is no hint on the plaque that St. Michaels was the location of such dramatic events in Douglass's life, events that could have led to him being arraigned and sold away South to an even more pernicious slave regime. Pivotal to his maturation and to his later escape from the institution of slavery, this first attempt is wilfully omitted from the information provided in an attempt to place the township in the best possible light.

Obviously, for the brief notation on a plaque, there has to be a brevity which will leave out the extraneous, but the choice to foreground Douglass's illicit school rather than his radical act of attempting to steal himself away from his master points to a municipal manipulation of facts that together with the version of history told at the Lloyd plantation means that the locations of Frederick Douglass's birth, boyhood, youth and young manhood are replete with lieux de memoire which must be dialogised through the information of his autobiographies to yield their full radical meanings. Official History (here with a capital 'H') could be characterised as grossly inadequate in its representation of such slave experience even at the home of probably the most famous enslaved American of the Ninteteenth Century. Thus, although Seymour Drescher in talking about the interface between monuments and history makes a good point about the limitations of memorials when he says that, 'monuments alone will not, in themselves, stimulate a constant rethinking of the past. That remains the task of historians' (Drescher 2001: 112), one cannot help but think that his special pleading for historians minimises the profession's shortcomings which arise, in part at least from its often obsessional empiricism that often gives less credence to non-standard evidence such as oral accounts. The Angolan artist Miguel Petchkovsky highlights the interface between history and memory: 'Memory is an essential attribute of the human psyche and is therefore more personal than historical or material knowledge. History alone cannot enrich memory, because it is systematic and sequential' (qtd in Oostindie 2001: xxxvi). Dialogising history with other forms such as biography, folklore, memorials and artistic representation helps to make that contested history fuller of the memories and experiences it needs in order to reflect a more accurate and human face, to literally 'find an anchor for memory' (Oguibe 2001: 100). The tour of the Wye plantation and environs allowed for such anchoring through a dynamic and performative counter narrative, a guerrilla memorialisation that we tourists obtained from our knowledge of slavery and Douglass's biography. Pierre Nora had described how, '(H)istory is perpetually suspicious of memory and its true mission is to suppress and deny it' (1994: 285) and at sites like the Wye plantation there is plenty of evidence to show how dissident memory is denied by the weight of traditional historical narrative and must fight back.

Sambo's Grave and Guerrilla Memorialisation

If the ramifications of Frederick Douglass's biography, probably the most famous African diasporan figure of the nineteenth century, are so readily manipulated by the forces of reaction within an official history that passes for truth, what hope is there for the countless unknown or vaguely known figures who left little or no written record of their Transatlantic sojourns in the eighteenth and nineteenth centuries. Such a figure was the adolescent Sambo whose grave can be found at the mouth of the Lune Estuary near Sunderland Point. According to the *Lonsdale Magazine* of 1822, he had arrived around 1736 from the West Indies in the capacity of a servant to the captain of the ship (to this day unnamed):

> After she had discharged her cargo, he was placed at the inn ... with the intention of remaining there on board wages till the vessel was ready to sail; but supposing himself to be deserted by the master, without being able, probably from his ignorance of the language, to ascertain the cause, he fell into a complete state of stupefaction, even to such a degree that he secreted himself in the loft on the brewhouses and stretching himself out at full length on the bare boards refused all sustenance. He continued in this state only a few days, when death terminated the sufferings of poor Samboo. As soon as Samboo's exit was known to the sailors who happened to be there, they excavated him in a grave in a lonely dell in a rabbit warren behind the village, within twenty yards of the sea shore, whither they conveyed his remains without either coffin or bier, being covered only with the clothes in which he died. (J.T. 1822: 190)

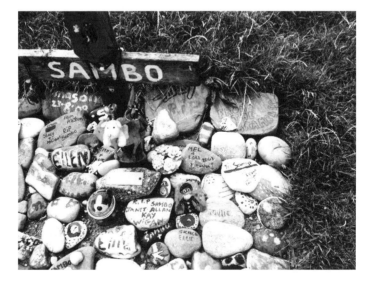

Figure 10.4 Sambo's Grave, taken in 2010

Sambo was buried in such a lonely grave because he was not baptised so they had to find unconsecrated ground in which his remains could rest. Like most Africans arriving in Britain as 'servants' (usually slaves), he appeared to suffer a profound sense of culture shock being landed amongst strangers with whom he could not communicate. There has been much speculation about the cause of his death ranging from the pragmatic (pneumonia) to the sentimental (profound homesickness). The latter provided the grist for anti-Slavery panegyrics such as the Reverend James Watson's 1796 elegy, which was eventually appended to a brass plate on a freestone slab at the site itself. Watson collected the money for the memorial from visitors to the Point. His interest in the slave grave is not without irony, however, as his brother was a leading light in the Lancaster slave trade. The tone of the memorial is sentimental in the extreme, praising Sambo as a 'faithful Negro' who had died because of his "service" to his master. The poem consists of 17 verses including the epitaph of the final three verses which appears on the grave. It reads:

> Full sixty years the angry winter wave
> Has thundering dash'd this bleak and barren shore,
> Since Sambo's head, laid in this lonely grave,
> Lies still, and ne'er will hear their turmoil more.
>
> Full many a sand-bird chirps upon the sod,
> And many a moon-flight Elfin round him trips;
> Full many a Summer's sunbeam warms the clod,
> And many a teeming cloud upon him drips.
>
> But still he sleeps, till the awak'ning sounds
> Of the Archangel's Trump new life impart;
> Then the great Judge his approbation founds,
> Not on man's colour, but his worth of heart. (J.T. 1822: 191–2)

Such a clarion call for the humanity of the slave reflects the late eighteenth century construction of an anti-slavery sentiment that simultaneously elided Africans as actors in their own struggles at the exact time of the Santo Domingo uprising (1791–1803), which exemplified a dynamic revolutionary African diasporan tradition. African agency is downplayed by such a discourse and a character like Sambo is saved from obliquity by the workings of English sentiment long after it does him any practical good. It is the hypocrisy of such sentimental appropriations of dead Africans' bodies which the London born, Bajan-descended poet Dorothea Smartt is most disgusted with and her poem sequence *Lancaster Keys* specially commissioned for the 2003 *Litfest* writes back directly to Watson's elegy and provides at the same time a commentary on Lancaster's wilful forgetting of the trade that made it rich. *Litfest's* decision to print a limited edition of 24,950 of the poems 'each representing a person shipped into slavery by Lancaster slave traders

between 1750 and 1800' and deliver them to all secondary school pupils in the district attempts to make a dramatic gesture of rememory in the cultural life of the city. This public acknowledgement of the dissident memories that Sambo's history ignites outlines a politics which seeks to intervene in the traditional amnesia of the city about its slave past and reinvigorate the narrative, not as sentimentalised panegyric, but rather as radical counter-memory and is in keeping with Richard Price's impassioned call for diasporic memorials to run beyond building materials; his view is that: 'memorials (should) run less to bricks and mortars than to knowledge and its diffusion. What if we tried to make sure that every schoolchild in Europe, the Americas and Africa is exposed as fully as possible to the history of slavery and its legacies?' (Price 2001: 61).

Smartt's poem is reproduced alongside information on Lancaster's involvement in the trade and with quotations about the importance of memory. Such a pamphlet has the kind of memorial function that Price demands. It is not only the direct slave trade, which indicates the interweaving of Lancaster with the slave economy but also its trade in slave produced and harvested goods such as rice, cotton, sugar and particularly mahogany which made the fortune of the Gillows furniture company in the eighteenth century. As in many British slave ports, there has historically been a real amnesia about the slave trade; in Lancaster, for instance, until the building of the *Captured African*s memorial in 2005 there was no specific memorial to those who were affected by the trade that originated in the city itself. Smartt's poem sought to redress this amnesia as the opening of the section *The Brewery Room* reflects on how the routes that Sambo took to get to Sunderland Point were smoothed by the commercial networks established by Lancaster merchants:

> Keys to the city awarded
> to entrepreneurs in the new world trade.
> Adventurers of high finance.
> Slavery a key to England's glory days,
> civic largesse and the city's architecture,
> of streets and the high seas
> glistening with gold. (Smartt 2003: n.p.)

As the poem indicates many of those involved in the trade were prominent members of the elite that ran the city including mayors of the city such as Dobson Foster. Moreover, the poem delineates how the raw materials exchanged for slaves in the West Indies came back to Lancaster too, helping to create distinctive, prestigious industries at home that belied the trade in human bodies that made them possible. The most famous such factory in Lancaster was Gillows founded in 1728, where mahogany from the Caribbean was fashioned into high class furniture. Smartt's poem shows the interrelatedness of such industry and the slave economy positing Sambo and his fellow slaves as the labourers on whose backs large profits were made:

> The Plantation Estate, brewery source,
> furnished salon of mahogany, Gillows crafted
> wood, the Sambo farmed and forested.
> Torn from root system to harden and die.
> To be shaped into something new
> and of use to Lancaster Town.
> A primrose path of mahogany furniture.
> Fallen nature, hardness of heart,
> shameless dishonesty, blood courses,
> evil courses, water courses. (Smartt 2003: n.p.)

Just as the mahogany has been 'farmed and forested' so the Africans have been uprooted to furnish labour for the Plantation, a human commodity which hardens and dies just like the wood that it contributes labour value to. In this way Sambo's death in Lancaster is a function of his use as a commodity and the denial of his humanity by those who benefit from the trade in all its three corners. The economy of language here so that Sambo is both the subject and object of the verbs 'farmed and forested' points to the duality of the slaves' position, crucial to harvesting the mahogany, but also harvested in Africa to provide the labour power that makes possible the operation of the colonial economy. Both labourer and commodity, Sambo is tremendously overdetermined in his meanings within the British slave-owning Empire. This is never more so than when mercantilism is superseded by sentiment in the late eighteenth-century and Smartt speaks to this in reinterpreting Sambo's perceived pining for his master that according to such self-serving views led to his death.

> This Sambo
> pines for his master, mythical, imagined,
> key and the centre-piece of his room
> But the room is but many,
> in one house, in one compound, in one
> village, in one district, in one country, in one
> empire, in one continent spanning continents.
>
> The 'Ship's Inn',
> I the Sambo pour out of this Brewery Room
> into my fermenting home brew spilling
> kicked from its calabash pot. (Smartt 2003: n.p.)

The meaning of Sambo here as sentimentalised torch-bearer for his beloved master is transformed to Sambo as avenger whose legacy has the power to leap out of the confines of white guilt-ridden sentimentality and reinvigorate debates around slave history from the village of Sunderland Point, through cities like Lancaster to Britain and across the seas to the intertwining nexus of slave-owning Empires.

In such a reading Sambo's fertile tale cannot be confined to its historical trace but erupts like the 'fermenting home brew' of the brewing room he is confined to by illness. Sambo's revenge is in his re-imagination by later generations, that as Smartt shows, relate how Anglo-American cultures kept 'for themselves the harvest' yet in doing so 'ferment a bitter brew'. Hortense Spillers has talked about how, 'African persons in the middle passage are literally suspended in the Oceanic' (Spillers 1994: 466) and Sambo is a prime example. His known life was conducted almost exclusively shipboard and in Smartt's imagination his after-life legacy permeates the Transatlantic world where his memory despite all attempts cannot be repressed or neutralised. Suspension, a negative in Spillers' theorisation is dialogised by Smartt's lyrical intervention. As Aldon Nielsen succinctly describes in talking of such black Atlantic texts, '(A) different kind of scholarship may be called for here, a study that listens to seas and is owned by their terrible poetry' (1994: 104). If nothing else Smartt's brewery room lyric needs this kind of transnational, oceanic scholarship to fully interpret its black Atlantic resonances. Her guerrilla memorialisation interprets the gravesite anew articulating an African presence that is often (as in the original gravesite epigraph) sentimentalised and objectified.

As Smartt details in her poems on the site, Sambo's Grave provides a memorial touchstone despite its lonely isolation many road miles from the city centre itself. The grave's isolation leaves it vulnerable to reactionaries such as the racist vandals who defaced the brass plate on the grave in the early nineties. The importance of the gravesite to locals was shown by its rapid replacement with a new plate showcasing Watson's poem and a new invocation to 'Respect this lonely grave'. This 'respect' is shown by a recent phenomenon in which schoolchildren have been leaving coloured and painted stones with messages for Sambo to go along with the marker stones and flowers left by adult visitors. This means the grave has become alive with colour and resembles African and African American graves with their relics of the dead placed over the body. Sambo is now remembered, but how? There is a sense in which the schoolchildren's bathetic messages – 'I made this for you Sambo love from Hayley' (with picture of a ship), 'Rest in Peace Sambo, Margaret and Pauline' (with picture of a bridge and the Lune), and 'Sambo as promised, Kirsty' (abstract coloured stone) – could be interpreted as just an extension of the Reverend Watson's sentimentality imbued by the infants from an over-enthusiastic liberal schoolteacher. I prefer not to be so cynical. Without memorial sites, memorialisation is problematic especially in such a contested terrain as Britain's slave past and Sambo's grave gives all Lancastrians an opportunity to remember without being guided by museum curators or politicians on the make. Its very isolation with views across the sea means it serendipitously places visitors at the point of arrival and departure for the ships, which had taken part in the trade.

Lubaina Himid has talked of such spaces, describing the importance of the beach as a border zone, 'a site of pleasure and absolute conflict and division'.[9] Her succinctly expressed point, that the beach cannot be an incontestably Utopian space in the context of a Transatlantic slave trade that began its horrors on West Africa's golden beaches and ends them here in a site used since the eighteenth century as a leisure destination points to the presence of conflict and division from the moment of first contact between African and European cultures continuing until today. As Aldon Nielsen reminds us, '(W)e hear the waters of the slave trade's history everywhere lapping at our shores' (1994: 101). The grave negotiates Himid's stark binaries of pleasure and disgust as a visit across the tidal bridleway with wonderful views back to land and out to sea means this touristic pleasure is interrupted by the chill breeze of the reminder of the more sinister sea-borne exigencies that the international trade in human bodies has fostered. Even here, even now, there is no escaping the legacy of the trade that helped to make Lancaster's fortune.

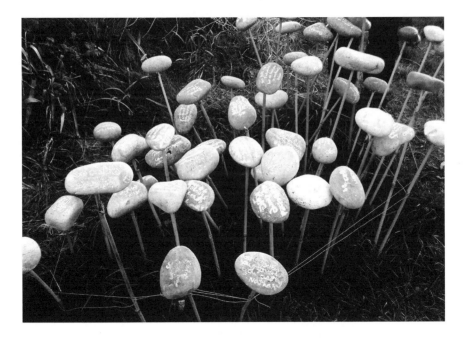

Figure 10.5 Memorial close to Sambo's grave, erected in 2009

The appropriateness of the schoolchildren's gesture of memorialisation is emphasised by earlier memorials left at the grave over the centuries. For instance

9 Lubaina Himid from a talk at the University of Central Lancashire, given on 6 March 2001 entitled 'Revenge: A Masque in Five Tableaux'.

one visitor left a crucifix and more recently a more permanent cross has been affixed, all of which is highly ironic in light of Sambo being forced into burial on unconsecrated ground. The landscaping of the grave changes as sojourners visit and leave different tokens making it an extremely dynamic *lieu de memoire* (Figure 10.5). The space around the grave has also allowed for more extensive memorialisation so that in March 2009 local school pupils built on the idea of the gravesite coloured stones and constructed a memorial close by the grave which placed small stones, many with messages related to Sambo's story, on bamboo sticks. These mushroom or flower-like objects resembled an organic planted area showcasing a cacophony of responses to the gravesite without cluttering the immediate area of the grave itself. This highly effective addition to the memorialisation of Sambo indicates that his story continues to be redolent for those trying to interpret the human cost of the slave trade. I would contend that it is a malleable site like this with the opportunities it gives for varied forms of memorialisation that is the most effective memorial to those that died in the slave trade. Not erected by civic guilt or sustained by false ideologies of a slave-freeing British imperium, it takes on a life of its own sustained by what Pierre Nora would call our 'commemorative vigilance' (Nora 1994: 289) that guards against amnesia. Nora has the perfect symbol for such a coastal site: 'moments of history torn away from the movement of history, then returned; no longer quite life, not yet death, like shells on the shore when the sea of living memory has receded' (ibid.).

Watson's eighteenth-century plaque, its vandalism and replacement, the crucifix appended, flowers placed, dying and replaced, the childrens' coloured stones and finally Smartt's poem handed out to all Lancaster's schoolchildren, all build a bricolage of memory that rescues Sambo from the obliquity traditional historiography had reduced him to. In visiting his grave we remember and memorialise (as far as we ever can) Sambo and slavery, but, more pertinently, we realise how fragile these memories are, plucked from obscurity by guilt and historical chance. Sometimes as in the vandalism of the grave there are reactions which are at the least problematic and sometimes deeply disturbing. For instance, in August 2008, I visited the gravesite where a visitor had placed a small golliwog amidst the flotsam and jetsam dispersed over the grave. This example of racist memorabilia was the equivalence of graffiti deserving to be removed, undermining the joyous cacophony of objects that spoke to a more appropriate memorialisation. It shows that guerrilla memorialisation is not necessarily always positive and that our memorial sites cannot be left entirely to the serendipity of strangers whose knowledge of the appropriate gesture might be grossly out of kilter with the site's historical resonances. Despites such potential problems, enslaved Africans dispersed throughout the Atlantic triangle are, I believe, most effectively remembered at such local sites that conjure up their thoroughly routed existence. Remembering slavery from nearby is an urgent task in all parts of the Circum-Atlantic and beyond as Livio Sansone reminds us:

Transatlantic slavery was by definition a transnational phenomenon, which has created a universe of suffering, dehumanization and racialization, spanning across many regions of what we now know after Paul Gilroy as the black Atlantic – a region that reaches to the tropical lowlands of the Pacific Coast of Central and Latin America. Yet the way in which it is remembered as well as the legacy felt within today's life and race relations, show that the memory of slavery is often a surprisingly "local", relational and contingent construction. (2001: 89)

The imaginative leaps that Smartt makes from this lonely and unremembered gravesite to invigorate such lives lost in the black Atlantic is an exemplary move in the light of Sansone's comments – a poem that uses the local site to make links across geographies and chronologies. It is of course a memorial gesture in itself, a guerrilla memorialisation and one that is replicated in the writing of black Atlantic artists throughout the diaspora that in themselves take issue with historians' and Caribbean philosophers' contention that there is a collective amnesia caused by the unique destructiveness of the Transatlantic Slave Trade and the brutality of chattel slavery in the islands. Orlando Patterson grasps at an important truth when he writes that 'The most important legacy of slavery is the total break, not with a past so much as with the consciousness of the past. To be a West Indian is to live in a state of utter pastlessness' (qtd in Price 2001: 60).

However, Kamau Brathwaite's marvellous anecdote about a woman sweeping her yard works against such a generalisation, showing how knowledge of the past is passed down the generations as folk memory. Kamau Brathwaite describes how flying legends that bridge the Atlantic Ocean (like the ones I have describe in my *Radical Narratives of the Black Atlantic*, 2003) have become everyday in the Caribbean locale, and crucially continue long after their development as a response to the horrific conditions in slavery. He describes a contemporary old Jamaican lady sweeping her yard, 'labouring' to stop her household from collapsing. That labour ultimately connects her to Africa ritualistically and imaginatively as Brathwaite relates:

So she's in fact performing a very important ritual which I couldn't fully understand but which I am tirelessly tryin to …

And then one morning I see her body silhouetting against the sparkling light that hits the Caribbean at that early dawn and it seems as if her feet were walking on the sand … were really … walking on the water … and she was travelling across the middlepassage, constantly coming from where she had come from – in her case Africa – to this spot in North Coast Jamaica where she now lives … (1999: 32–33, ellipses in text)

Her walking on the water means the woman does not leave her American shores but travels eastwards in her and Brathwaite's imagination. Legends of transmigration can be shown, through such examples, to continue long after the end of chattel

slavery as an important and defining imaginative mode. Moreover, the important presence of manual labour within such imaginative flight shows that Brathwaite amongst other contemporary interpreters of such myths underpins the fantastic with the realistic. His use of the flying myth is not mere Afrocentric Utopianism but pays close attention to the economic facts of Caribbean poverty and the way that the dream of 'homecoming' provides solace and grounding in the woman's current situation. Laura Chrisman critiques Paul Gilroy's interpretation of the black Atlantic for its 'dominant paradigm of "culturalism"' which she contends risks the abandonment of 'the tenets and resources of socio-economic analysis' (2000: 453). Brathwaite's nuanced example shows how the paradigm need not be merely otherworldly. His routed flying myth is rooted in a celebration of the labouring power of black women. It does not provide otherworldly escape but grounds the imaginative transatlantic leap in the daily workload of ordinary Caribbean folk. Such an example shows how Gilroy's much criticised utopianism can be nuanced by the contradistinction of examples that foreground routedness whilst paying attention to class and nation. The specificity of Brathwaite's North East Jamaican locale and of his protagonist's domestic labour makes her dynamic, imaginative, Transatlantic leap as everyday as her domestic travail and again shows us how Sansone's elevation of the importance of the local is key to the development of a cultural memory of slavery and its consequences in the black Atlantic.

It is specificity that I want to emphasise here. The local space is where engagement with the legacy of Transatlantic slavery is best expressed, for despite the success of memorial efforts like the national memorial for victims of the slave trade in the Netherlands, such grandiose gestures are always at risk of political infighting, grandstanding and special interest usurpation. It and the newly constructed (2007) French national memorial in the Luxembourg Gardens in Paris are both problematic. The French memorial, an abstract of two interlinked chains with various phrases such as liberte and fraternite engraved on them is placed amidst a welter of other memorials so it is not only hard to find, but seems already abandoned in sculpture-park hell with few people knowing of its existence – France officially remembers, but without a memorialisation that makes an impact. The Dutch memorial in Amsterdam is more successful, shaped like a ship, Soviet-like and triumphalistic, it depicts an enchained slave coffle walking through an arch of freedom and striding forth into freedom as the ship's prow. The ceremony to inaugurate the memorial in July 2002 made an entirely understandable political statement in asking Queen Beatrix to lead the ceremonials. However, the security felt necessary in the wake of the post 9/11 terrorism threat and the number of dignitaries drawn because of her presence meant that many local people of African descent, the very descendants of slaves whom the memorial was meant to be about, were denied entry to the Ostpark. In reflecting the need for national atonement, the Dutch failed adequately to represent local black aspirations and needs. As the first national memorial to victims of the slave trade in Europe the Dutch monument is an important marker and is already becoming a memorial site: when I visited in November 2002 it was festooned in floral tributes reflecting how already it has

become a place where people come to remember their enslaved ancestors. As such it has the potential to become an effective memorial, one used by local people to remember the horrors of the past. Lubaina Himid talked about the possibilities of building such a memorial in launching the STAMP project

> The monument could be for the people of a city and its visitors to be able to learn to accept and give forgiveness. In which case it could relate to today, to the past, to the future and could work visually on several levels. There could be texts, there could be water, there could be structure, there could be movement, colour, and even growing, living things.

> A monument needs to move, to move on, to help the people who engage with it to move on, it needs to be able to change with the weather, the seasons, the political climate and the visual debates of the day. (Himid 2003)

Any successful memorial needs to be a dynamic *lieux de memoire* that will adequately represent generations to come as well as the past and the present. A memorial that conserves memory without being conservative. That is, so that it truly helps 'the people who engage with it to move on', so that it becomes associated not with stasis but with dynamism. Such a task is daunting and humbling, but surely our collective amnesia must be overcome by local gestures of remembrance (however small) that raise the collective consciousness of slavery's ghostly presence that still haunts our shared Circum-Atlantic space. Such memorialisation is born out of the struggle with conservative forces that prefer to bury difficult histories and born through a guerrilla memorialisation that refuses to accept the status quo.

References

Barker, I. (Coun.). 2005. Slavery is Part of What We Are. Letter to *Lancaster Guardian*, 14 January, 6.

Brathwaite, K. 1999. *Conversations with Nathaniel Mackey*. New York: We Press & Xcp: Cross-Cultural Poetics.

Collins, P. 2005. Lancaster Faces Up to its Shameful Past. *Lancaster Guardian*, 28 October, 2.

Chrisman, L. 2000. Journeying to Death: Gilroy's Black Atlantic, in *Black British Culture and Society: A Text Reader*, edited by K. Owusu. London: Routledge, 133–156.

Davis, D.B. 2006. *Inhuman Bondage: The Rise and Fall of Slavery in the New World*. Oxford: Oxford University Press.

Douglass, F. 1845. Narrative of the Life of an American Slave, Written By Himself, in *Autobiographies*. 1996. New York: Library of America, 1–102.

Douglass, F. 1855. My Bondage and My Freedom, in *Autobiographies*. 1996. New York: Library of America, 103–452.

Douglass, F. 1881. The Life and Times of Frederick Douglass, in *Autobiographies*. 1996. New York: Library of America, 453–1045.

Drescher, S. 2001. Commemorating Slavery and Abolition in the United States of America, in *Facing up to the Past: Perspectives on the Commemoration of Slavery from Africa, the Americas and Europe*, edited by G. Oostindie. Kingston, Jamaica: Ian Randle Publishers, 109–112.

Dresser, M. 2001. *Slavery Obscured: The Social History of the Slave Trade in an English Provincial Port*. New York: Continuuum.

Dresser, M., Jordan, C. and Talory, D. 1998. *Slave Trade Trail Around Central Bristol*. Bristol: Bristol Museum and Art Gallery.

Eichstedt, J.L. and Small, S. 2002. *Representations of Slavery: Race and Ideology in Southern Plantation Museums*. Washington DC: Smithsonian Books.

Elder, M. 1992. *The Slave Trade and the Economic Development of 18th Century Lancaster*. Keele: Ryburn Press.

Gilroy, P. 1993. *The Black Atlantic: Modernity and Double Consciousness*. London: Verso.

Gilroy, P. 2004. *After Empire: Melancholia or Convivial Culture*. Abingdon: Routledge.

Hesse, B. 2000. *Unsettled Multiculturalisms: Diasporas, Entanglements, Transruptions*. London: Zed Books.

Himid, L. 15 November 2003. *Monument Talk*. Presentation at the Slave Trade Arts Memorial Project launch, Dukes Theatre, Lancaster. Available at: http://www.uclan.ac.uk/ahss/journalism_media_communication/literature_culture/abolition/meanings_and_significance.php [accessed 19 June 2009].

J.T. 1822. Samboo's Grave. *The Lonsdale Magazine and Kendal Repository*, III(xxix), 31 May, 188–192.

Mackie, J. 2005. Why be Slaves to Our Past? Letter to *Lancaster Guardian*, 7 January, 6.

McFeely, W.S. 1991. *Frederick Douglass*. New York: W.W. Norton.

Morrison, T. 1989. A Bench by the Road. *The World*, 3(1), 4–5 and 37–41.

Nielsen, A.L. 1994. *Writing Between the Lines: Race and Intertextuality*. Athens, GA: University of Georgia Press.

Nora, P. 1994. Between Memory and History: Les Lieux de Memoire, in *History and Memory in African American Culture*, edited by G. Fabre and R. O'Meally. Oxford: Oxford University Press, 284–300.

Oguibe, O. 2001. Slavery and the Diaspora Imagination, in *Facing up to the Past: Perspectives on the Commemoration of Slavery from Africa, the Americas and Europe*, edited by G. Oostindie. Kingston, Jamaica: Ian Randle Publishers, 95–101.

Oldfield, J.R. 2007. *Chords of Freedom: Commemoration, Ritual and British Atlantic Slavery*. Manchester: Manchester University Press.

Oostindie, G. (ed.) 2001. *Facing up to the Past: Perspectives on the Commemoration of Slavery from Africa, the Americas and Europe*. Kingston, Jamaica: Ian Randle Publishers.

Price, R. 2001. Monuments and Silent Screamings: A View From Martinique, in *Facing up to the Past: Perspectives on the Commemoration of Slavery from Africa, the Americas and Europe*, edited by G. Oostindie. Kingston, Jamaica: Ian Randle Publishers, 58–62.

Read, A. (ed.) 1996. *The Fact of Blackness: Frantz Fanon and Visual Representation*. London and Seattle: Institute of Contemporary Arts/Bay Press, Seattle.

Rice, A. 2003. Exploring Inside the Invisible: An Interview with Lubaina Himid. *Wasafiri* 40, 24.

Ricoeur, P. 2004. *Memory, History and Forgetting*. Translated by K. Bramley and D. Pellauer. Chicago: University of Chicago Press.

Sambo's Gravemarker. 1796. Lancaster City Museum Collection.

Sansone, L. 2001. Remembering Slavery from Nearby: Heritage Brazilian Style, in *Facing up to the Past: Perspectives on the Commemoration of Slavery from Africa, the Americas and Europe*, edited by G. Oostindie. Kingston, Jamaica: Ian Randle Publishers, 83–89.

Smartt, D. 2003. *Lancaster Quays*. Pamphlet.

Spillers, H. 1994. Mama's Baby, Papa's Maybe: An American Grammar, in *Within the Circle: An Anthology of African American Literary Criticism from the Harlem Renaissance to the Present*, edited by A. Mitchell. Durham, NC: Duke University Press, 454–481.

Wallace-Kowaleski, E. 2006. *The British Slave Trade and Public Memory*. New York: Columbia University Press.

Walvin, J. 2007. Public history and abolition, a Review of John Oldfield's 'Chords of Freedom: Commemoration, Ritual and British Atlantic Slavery', *Patterns of Prejudice*, 41, 398–399.

Wood, N. 1999. *Vectors of Memory: Legacies of Trauma in Post-War Europe*. Oxford: Berg.

Young, J. 1993. *The Texture of Memory. Holocaust Memorials and Memory*. New Haven: Yale University Press.

Index